Contents

Perfect Digital Photography

JAY KINGHORN
JAY DICKMAN

McGraw-Hill/Osborne

New York Chicago San Francisco
Lisbon London Madrid Mexico City
Milan New Delhi San Juan
Seoul Singapore Sydney Toronto

The McGraw·Hill Companies

McGraw-Hill/Osborne
2100 Powell Street, 10th Floor
Emeryville, California 94608
U.S.A.

To arrange bulk purchase discounts for sales promotions, premiums, or fund-raisers, please contact
McGraw-Hill/Osborne at the above address.

Perfect Digital Photography

234567890 QPD QPD 019876

ISBN 0-07-225921-3

Acquisitions Editor	Megg Morin
Project Editor	Patty Mon
Acquisitions Coordinator	Agatha Kim
Technical Editor	Richard Chang
Copy Editor	Lunaea Weatherstone
Proofreader	Paul Tyler
Indexer	Valerie Robbins
Composition	Jimmie Young / Tolman Creek Design
Cover Design	Pattie Lee
Creative Director	Scott Jackson

This book was composed with Adobe® InDesign®.

SECTION II | The Digital Darkroom

About the Authors

Jay Kinghorn is an Adobe Photoshop Certified Expert. He teaches photographers of all levels, from beginner to professional, in one-on-one training sessions, small group workshops, and seminars. As the instructor for Digital Days, an 18-city digital photography workshop, he has helped hundreds of photographers on their way to perfecting their craft. Additionally, Jay works as a consultant to corporations seeking to improve the quality of their photo reproduction. Recent clients include Vail Associates and the *Rocky Mountain News* in Denver.

Jay is an avid photographer, rock climber, mountain biker, and trail runner based in Boulder, Colorado.

A Pulitzer Prize winner and *National Geographic* photographer, **Jay Dickman**'s work has appeared in 15 of the high-profile *A Day in the Life of...* series. His work also has won several awards in the World Press International Competition, including the "Golden Eye" award and the Sigma Delta Chi Award for Distinguished Service in Journalism. Jay has worked in the photojournalism field for over 30 years, covering events as diverse as the war in El Salvador to the Olympics, from a half-dozen Super Bowls to photographing Shirley MacLaine. He's spent three months living in a Stone Age village in Papua New Guinea, traveled a week under the Arctic ice in a nuclear attack sub (both of these for *National Geographic*), and sank on a boat in the Amazon. The range of what Jay's covered is quite extreme, and he feels incredibly fortunate to work in a business he loves. Jay conducts his own series of digital photographic workshops, "Firstlight Workshops", which can be found on the internet at www.firstlightworkshops.com.

Acknowledgments

Although only two authors are listed on the front of this book, a number of outstanding individuals made this book possible. I'd like to thank Jan Kabili, Chris Murphy, and Ben Willmore for their patient and sage advice on writing a technical book, Cynthia Pagan of Nikon, John Knaur of Olympus, Dennis Halley of Digital2You, Jim Christian of Picture Code, Gregory Schern of Moab Paper, Kathy Madison and Joy Remuzzi of iView Multimedia, Alphonse Goettler of Extensis, Josh Lubbers of ColorBurst, Joni Clark of Seagate, Liz Quinlisk, Sandra Sumski and Paul Hultgren of Gretag MacBeth, John Nack of Adobe, Michael Conley at Kodak, Ulrich Knoke of Canto, Eddie Murphy at Epson, and Kyle Bajakian and Paul Roark for contributing technical information to the book. I would also like to thank Megg Morin and Patty Mon for expert editing and direction. I would like to give an extra special thanks to Jessica Gleich, whose continued encouragement, patient editing, and unfaltering support helped bring my ideas to fruition. Thank you.

I would like to dedicate this book to my grandfather, Charlie, who has been my greatest champion and eternal source of encouragement, and to my mom, Nancy, who taught me the importance of clear communication and who encouraged me to always look at the world outside myself.

—Jay Kinghorn

Without these folks, this book would have been impossible: John Knaur of Olympus; John Omvik with Lexar; Joe McNally, whom I am fortunate to count as a friend and photographer nonpareil; Hákon Ágústsson, who hosts the incredible site, Photo-Quotes.com, where I found the great words of other photographers; John Isaacs, another Olympus Visionary and great photographer; Bert Fox of *National Geographic* and longtime friend; Skeeter Hagler, my Pulitzer Prize–winning best friend; and Cynthia Pagan of Nikon. And I can't forget my roots: John Mazziotta of the *Dallas Times Herald*, who saw enough raw potential in a 21-year-old kid to hire me, and Ray Adler, who later became Director of Photography at the *Times Herald*. Can't forget Bobby Brent, we go back a long ways. Thanks also to Megg Morin and Patty Mon for supporting this project when I didn't think I could do it.

I'm dedicating this book to my wife, Becky, who also happens to be my best friend and editor, and to my kids, Kristi, Gavin, Matt, and Maggie, who have to put up with my travels and the stories that come from those trips, and to Beverly Skelton for your support and creating the person I married.

—Jay Dickman

Introduction

Welcome to the world of digital photography! This book was expressly designed to help you make better pictures. The world of digital makes it easier than ever for you to judge exposure, composition, and camera settings with the immediate preview on the back of the camera. The digital darkroom allows you to correct tone and color, isolate specific areas of your photograph, and make stunning prints from your desktop.

This book is divided into two halves. The first, "Creating the Image," written by Jay Dickman, looks at the camera and its use. Along the way, we demystify terms like white balance, aperture priority, and ISO sensitivity. This section is jam-packed with helpful tips and tricks for shooting wildlife, people, travel, and landscape photographs.

The second half of the book explores the digital darkroom in great detail. Whether you are new to Adobe Photoshop or have been using it for many years, you'll find a wealth of information to help you refine and shape your digital photographs into masterpieces. We'll help you learn to correct tone, color edit and adjust camera raw files, and create stunning prints from your desktop printer.

Digital photography offers a wealth of new tools and techniques for you to make the most of your photographs. For most of us who have been shooting for a long time, we've accumulated hundreds, perhaps thousands, of treasured images on film. Going digital doesn't mean abandoning our favorite film photographs. In fact, scanning your film images and printing them digitally can bring images to a level of brilliance and clarity that you've probably never experienced. This book is illustrated with a combination of images that were originally captured on film and scanned, and images that were captured with a digital camera. We chose not to label which images were film and which were digital because our philosophy is that a strong picture transcends the tools used to capture it. Photographs are windows into the soul of the creator. Our goal is to equip you with the latest tools and techniques you need to jump into the digital age and to perfect your digital photography.

Digital photography is a dynamic and rapidly changing field. To keep you up-to-date on the latest equipment, techniques and software available, we've created the Perfect Digital Photography companion site at www.PerfectDigitalPhotography.com. We'll post tips on taking better pictures with your digital camera and provide tutorials on optimizing your images in the digital darkroom. To stay abreast of the latest information in the world of digital photography visit www.PerfectDigitalPhotography.com!

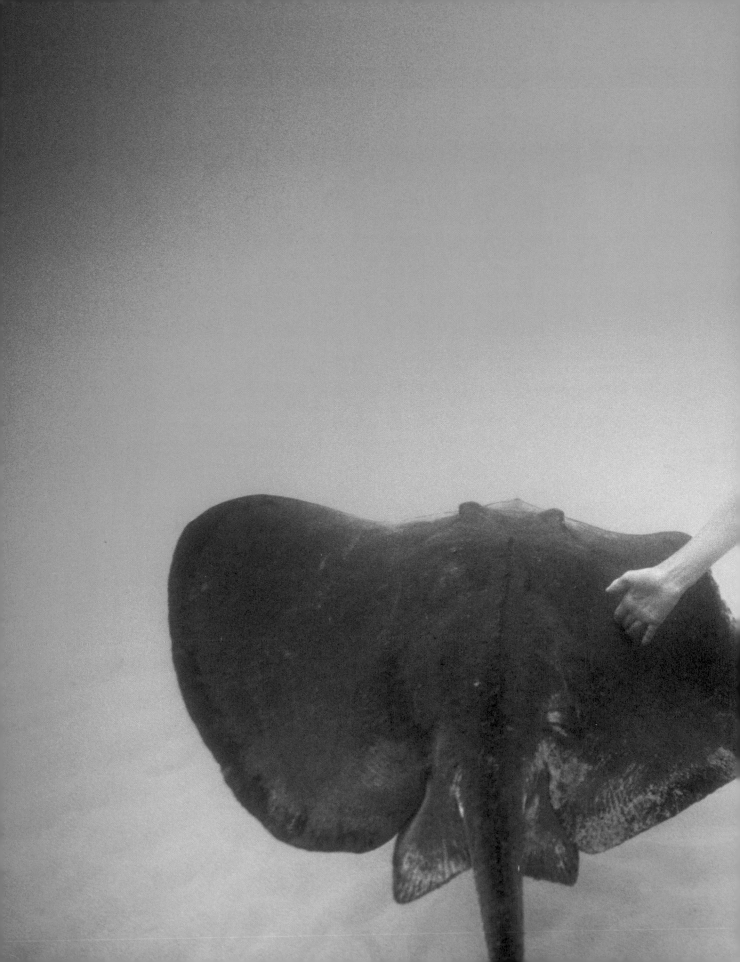

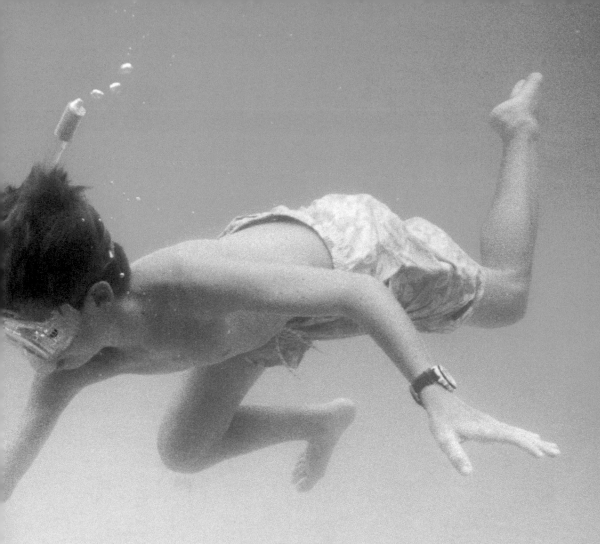

CREATING THE IMAGE

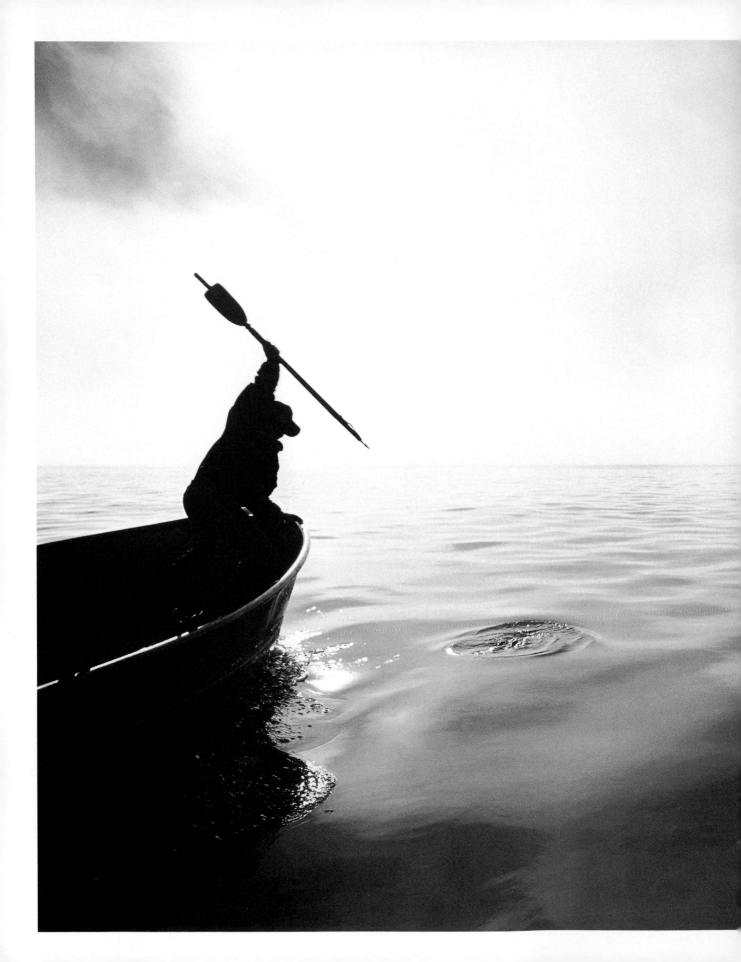

THE POWER of PHOTOGRAPHY

Any sufficiently advanced technology is indistinguishable from magic.

—Sir Arthur C. Clarke

We are a nation of photographers. With millions of film cameras in homes and a hugely growing market in digital photography, our life and times are the most documented events in history. Magazines and newspapers have the capability of going to press with photos shot moments before. TV newscasts utilize viewers' digital images, sent in via the Internet, with photos ranging from news events to weather photos to a beautiful sunset. We send our relatives electronic "photo albums" of our vacation or the baby's

While on assignment for *National Geographic*, photographing the over 2,000-mile long Yukon River, I spent several days with a group of Yupik hunters as they hunted in traditional ways for seal and Beluga whale. One morning, six boats followed several seals as they moved through the shallow waters. Here, a Yupik throws a harpoon at a submerging seal in the ethereal morning light. 20-35mm lens, 1/500 second at f4.5

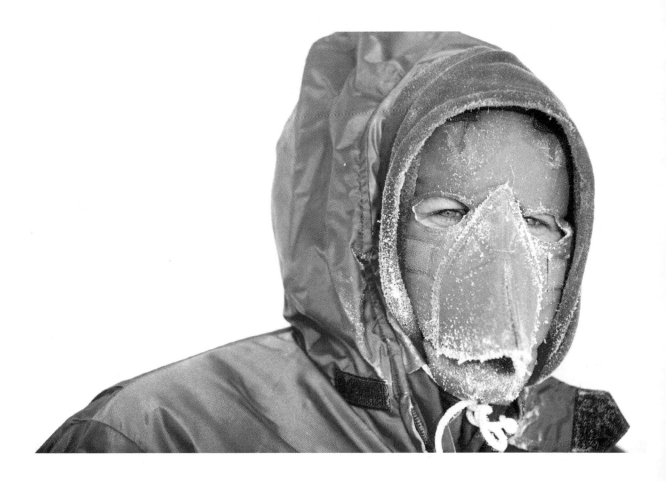

This off-center, high-key image works in its simplicity of pulling the viewer's attention to the eyes and ice-encrusted mask. Shot on assignment in the Arctic for *National Geographic*, while I was covering a story on SCICEX, a scientific program supported by the U.S. Navy to explore the vastly unexplored area of the Arctic under the ice. This is a photo taken while setting up the ice camp a few hundred miles out on the Arctic ice as we awaited the arrival of a nuclear attack submarine that surfaced through the ice (see Chapter 5). 80–200mm lens, 1/250 second at f4

first year. We now have the ability to produce high-quality books, containing photos and text, at the click of a mouse and at a next-to-nothing cost.

Not only are we a nation of photographers, we're a nation of digital technology. Photography archives our history, linking us to our past by creating a visual diary that defines us for future generations. This simple box ties us to our past and connects us to our future. Point-and-shoot cameras, known affectionately as PHD (push here, dummy) cameras, are mastering the once arcane task of exposure, producing consistent results.

Today's generation is visually sophisticated; young people are bombarded with intelligent, well-composed, and compelling images hundreds of times a day. To put a weak image in front of this audience is almost unforgivable. So why is it that most people's photos lack the "oomph" that makes a boring snapshot into an image that will at least stick in your mind, if not become an iconic image?

In this section, I'll talk about the power of photography and how it impacts our lives, as well as how to become comfortable with

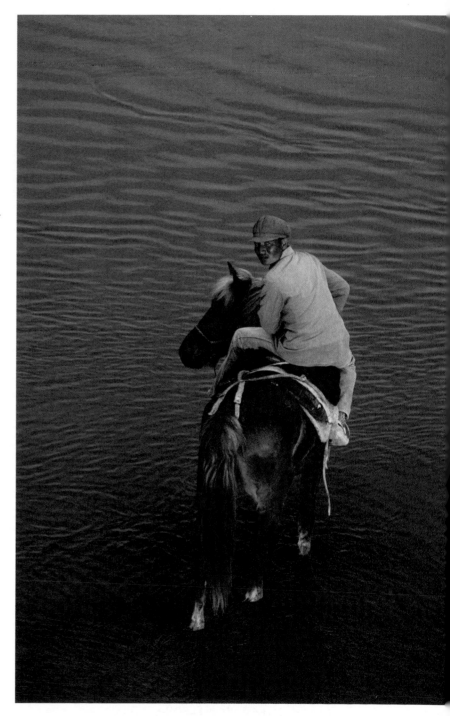

One of those moments that lasts for two frames. I was photographing the Kazakh peoples of far western China for *A Day in the Life of China*. Wandering around a collective horse farm near the village of Yining, I walked to a bridge crossing a small river, saw this fellow watering his horse, shot two frames, and the moment was gone as he looked away and the light fell off. 300mm lens, 1/125 second at f4.5

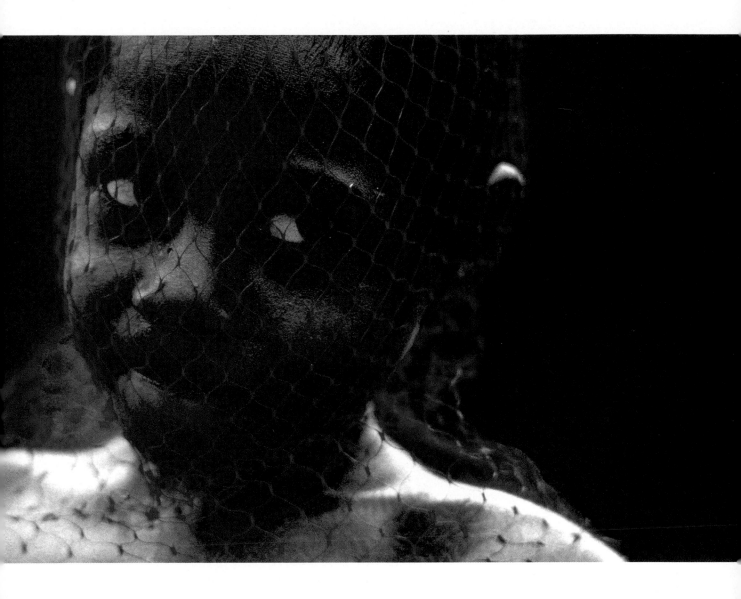

Working closely with people, especially strangers, can be intimidating for the aspiring photographer. Photographing an assignment for *National Geographic* in Papua New Guinea, I saw this little boy in the village of Wagu, off the Sepik River. He was playing with an old potato bag when I shot his portrait.

Shot close and tight, with a medium length lens, the background does not compete for the viewer's attention. I spoke very little to him, just let him get used to my being there, then the picture happened. 180mm lens, 1/60 second at f2.8

the equipment and working with people, one of the most difficult areas for aspiring photographers. It's like exercise; as a famous ad slogan says, "Just do it." The first few times will be challenging, but soon it will become second nature.

EVERYONE IS a PHOTOGRAPHER NOW

Part of the problem is this: today, everyone *is* a photographer, with the availability of sophisticated photo equipment, the attendant technology, and falling prices of top-quality equipment. But few people desire to put the time and effort into producing good photography. Few understand the idea that the camera is very objective. It records everything—*everything*—it sees. The aspiring photographer puts the camera to his eye, then lets the eye become the zoom lens, mentally moving in and out until the photo is perfect… in his mind's eye. The simple trick of physically moving in closer is not actually done, just the zooming of the eyeball. And the response once the photos are viewed is almost always the same: "It doesn't look like I remember it looking." A mantra to repeat as you're composing your award winner: "If your pictures aren't good enough, you aren't close enough." This maxim by the great photojournalist Robert Capa will hold true for many situations. Move around. Get closer. Fill the frame. Think close, think low, look around, up and down. Don't be so zoned into one view that you miss other elements that may make your photo better.

Do you remember going to your Uncle George's house for a slide show of his latest trek to Africa, Asia, or other exciting destination, and being near tears with boredom by the fifth photo (of a stack of hundreds)? The images had nothing going for them, nothing to grab you, to transport you to the location, to make you feel what that place felt like. In other words, no magic.

As a kid, I used to race home to check out the latest *LIFE* magazine, to see what was going on in space or Vietnam, or whatever "hot moment" had occurred somewhere in the world. And the rush when I saw the latest *National Geographic* arriving—TV could not hold a candle to these publications. And what made them great was the power of their photography.

The mind thinks in terms of images. Think of the Vietnam War, and more often than not, Eddie Adams's photograph of the Viet Cong suspect being executed comes to mind. The Hindenburg is a name that instantly brings up the image of the airship coming down in flames. The tragedy of 9/11 will be remembered with mental images. Photographs remind us of so many historical moments. The history of our own lives are also archived in photos. In the brief time it

Family heirloom photographs are not only touchstones to the past, they define who we are by freezing the subject at that moment in time. Many old photographs contain visual keys to that era by clothing or signage, as seen here in an old photo of my wife's family.

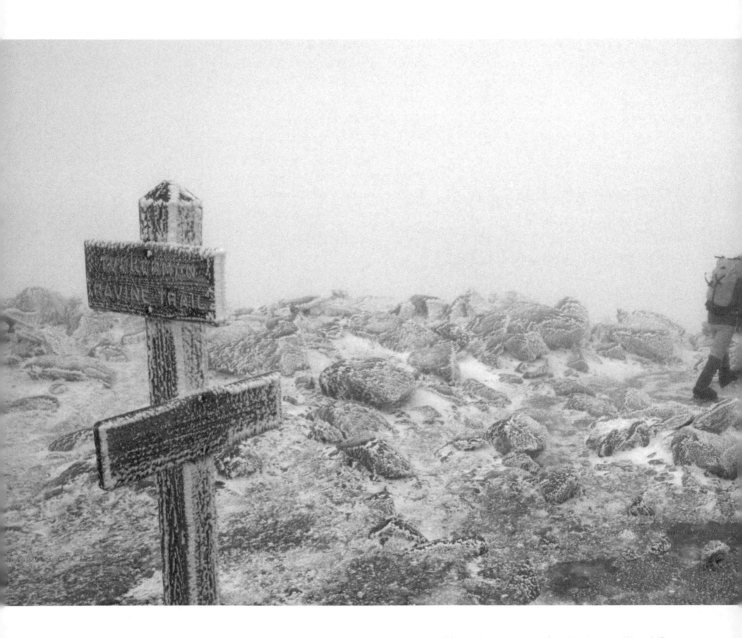

My assignment was for the best-selling *A Day in the Life of America*, and I was sent to the top of Mt. Washington in New Hampshire, which lays claim to the worst weather in the world. That evening a monster storm moved in with wind speeds exceeding 100mph. Early the

next morning, mountain guide Joe Lentini met me to lead the hike down, which was done in minimum 70mph winds. Joe did carry the majority of my gear. 24mm lens, 1/60 second at f5.6

took to gather everyone together at a family picnic in the 1920s for a photo, little did they realize how we would study those images today, defining who we are by seeing our visual history.

Some Key Elements to Great Photography

When you employ the understated power of KISS (keep it simple, shutterbug), many great photographs have a commonality in their simplicity and directness. But this simplicity is part of the photo's elegance; the photographer has used the viewfinder like a canvas. Everything in the photo is relevant to the message of the image. You pick up the image, study it, move it closer or further away, and absorb the moment. The beauty of still photography is how personal and powerful it can be, when it is at its peak.

Great photography consists of a few key elements: composition, lighting, and a great moment. Sounds easy, but these three components, in various forms, are what are missing in most photographs you see. To combine the three is the aim of all good photographers, and a time-consuming, laborious, frustrating effort it can be. But when it does come together, when that magic image appears on your screen, not much can touch that feeling.

This is one of the major differences between still photography and video—the personal aspect of the still image. Television

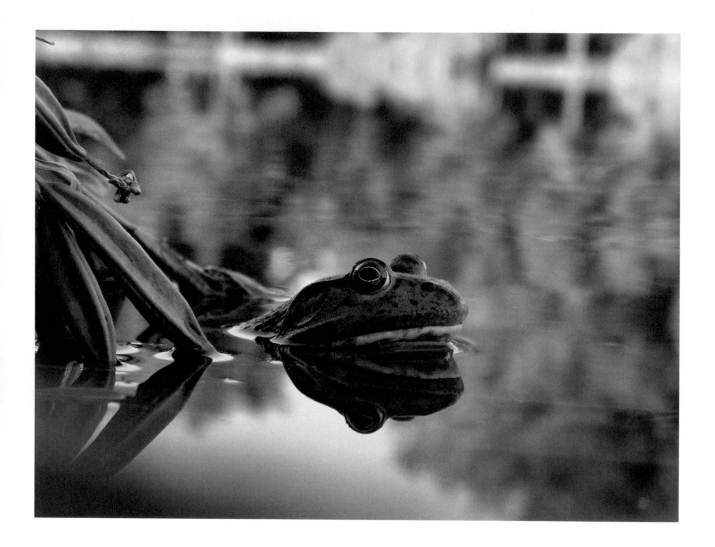

The ability of the camera to capture a simple
moment and allow us to share that moment
is one of the great powers of photography.
On a walk by a pond I've passed many times,
I noticed a frog sticking its head out of the
water. Using the monitor on the compact
digital camera I was carrying allowed me to
put the camera at water level, providing a
frog's eye view of this guy. 35mm lens, 1/60
second at f3.5

or video requires a person to watch from start to finish, in a continuum, the story contained in the clip. The still image, at its peak, is that perfect moment that speaks volumes in 1/125 of a second. "A picture is worth a thousand words" may fall short—think of how many words are required to describe certain photos. The mind absorbs, describes, and defines the photo rapidly, leaving the viewer, at the least, with a sense of place and event.

Improvisation is a powerful modality to the emotional things we love; music and cooking come to mind as examples. When we have instinctual control of our craft we can "stir up" images that have more feeling than imagery that follows a recipe, typical of the unstudied, uninvolved, and emotionally unattached photographer. At no time in the history of photography have we had more control of the image-making process, and now is the perfect time to get really good at making images.

Still photography archives our personal lives, just as it archives our history as a people. With a few basic principles of composition along with an understanding of what different lenses can do for you, improving the power of photography in your own work will be within reach.

Digital Photography: The Future Is Here

Digital technology is one of the greatest tools ever to impact photography. No longer do we have to wait hours, if not days, to see the results of our photographic endeavors. The image appears instantly in the monitor, allowing you to check exposure, composition, and content. The power of this availability cannot be overemphasized. As photographers, we all try to work a situation, capturing the decisive moment. To be able to check out images while you are still in the moment, not two days later when that moment is just a memory, facilitates better photography.

Another obvious advantage: no film costs! A great photojournalist and friend, Joe MacNally, shot *National Geographic*'s first assigned digital story, "Aviation," which ran in early 2004. I talked to Joe and he made the surprising comment that he actually shot *less* on this story than he would have on a film-based shoot. Normally, Joe would have shot about 500–700 rolls of film on a shoot like this; digitally he shot about 7,500 images (the equivalent of about 200 rolls of film). Shooting a lot of "static" scenes, such as portraits and photos of stationary planes, Joe was linked by a cable to the computer, so the images were showing up on the screen as he shot. Thus, the tendency to bracket and overshoot was not necessary. While on assignment for a publication such as *National Geographic*, photographers tend to overshoot, sometimes using two or three rolls on the same image to make sure they've got it, and sending the film in a couple of different mailings to ensure against loss. Digital photography, by nature, creates a "reduction in paranoia," as Joe eloquently put it.

We now have the ability to have a *closed system*—that is, from shooting the photo

to editing and correcting on our computer to outputting or printing on our own printers—which has given the photographer even more control over the image. The closed system means the photographer, with camera, computer, and printer, never has to go outside his own work area. Computer-produced prints, with an expected life that rivals or exceeds a commercially done print, are available to anyone who wants to invest the time and effort. We have the ability to share our images from web-based services that store images, allowing virtual photo albums to be constructed at the click of a mouse, and shared instantly with friends and relatives.

Apple's iPhoto (for Macintosh) and Adobe's Photoshop Album (for PC) are two simple yet powerful software programs that facilitate your closed system. These programs give the photographer the power to download, edit, and catalog photos along with a powerful search capability. You can print images within a very intuitive framework. We'll discuss these in depth in later chapters.

Photography is a powerful form of communication; it's how I connect with my world. I've had the good fortune to travel throughout the world with my cameras, and I've found that the camera has opened worlds to me. From covering the war in El Salvador to hanging from a helicopter photographing Venezuela's Angel Falls to hunting with Yupik Eskimos on the Yukon, the camera has taken me to places beyond my imagination.

While traveling on assignment, I used to carry a Polaroid camera, so I could hand over an image immediately to a prospective subject. I was on a shoot for *National Geographic* in Papua New Guinea, living in a stone-age village for almost a three-month period. Being able to hand someone a Polaroid I'd shot of them helped them understand what I was doing there, and was a great door opener. Almost everyone was pleased to see their likeness on the spot. More common today: a photographer on location, with the subject of the photograph and others, huddled around the digital camera, looking, commenting, and enjoying the photograph displayed on the monitor. That's the power of photography.

In the Ukraine, two expert equestrians perform a traditional horse-riding drill, "Kiss a Maiden," as part of a demonstration of their ability. Shot for *A Day in the Life of the USSR*, this photo illustrates the power of still photography to freeze an otherwise fleeting moment, allowing the viewer to study the many aspects of the photo. 600mm lens, 1/250 second at f4

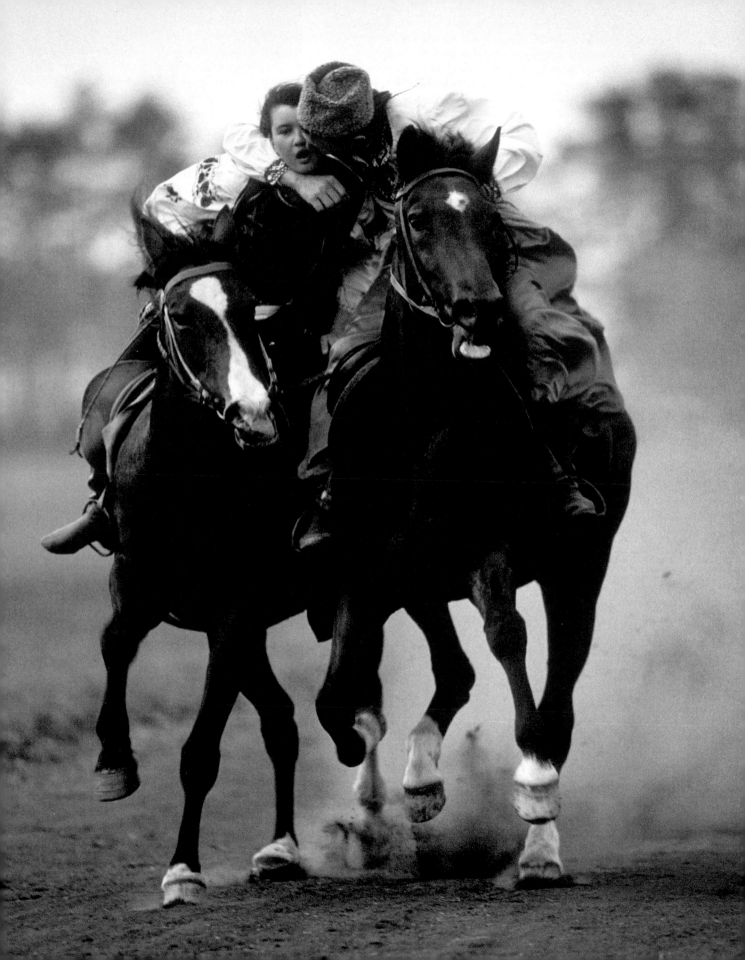

The power of the camera to affect change in the world is huge. We document events and those images can impact the thinking and opinions of the viewer. Eddie Adams's photo of the Viet Cong suspect being shot in the head has been credited with having great impact on the Vietnam War drawing to an early close, as Americans were graphically shown the horror of war. I photographed the war in El Salvador in the early 1980s, and this photo is from the Pulitzer Prize–winning series. This skull belonged to a death squad victim who had been executed in a remote area outside the capital city of San Salvador. 300mm lens, 1/500 second at f8

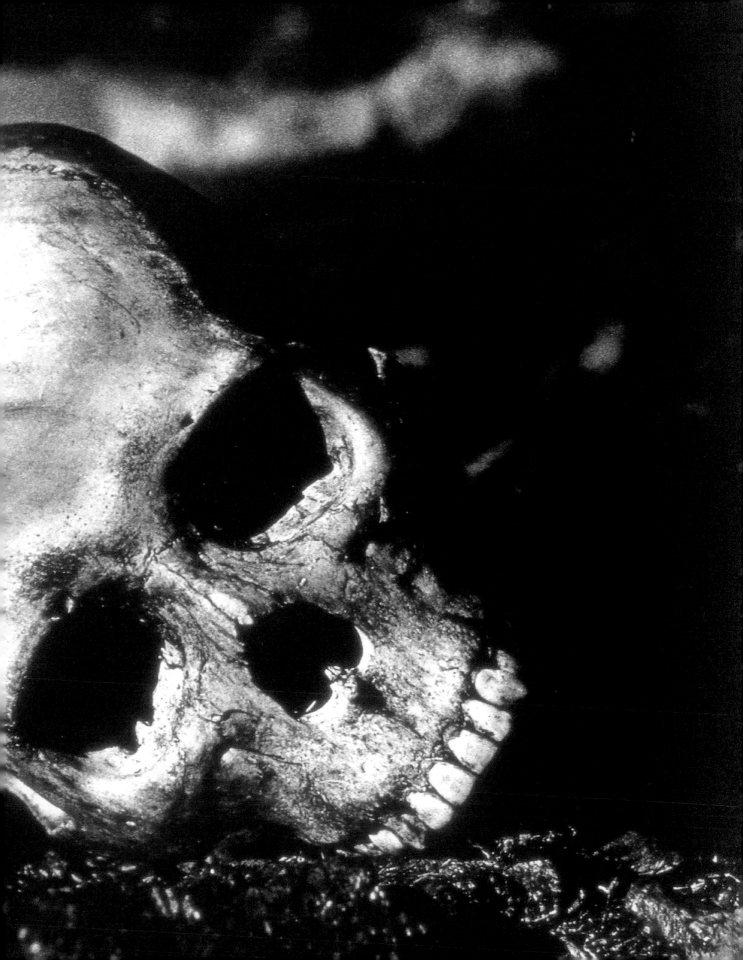

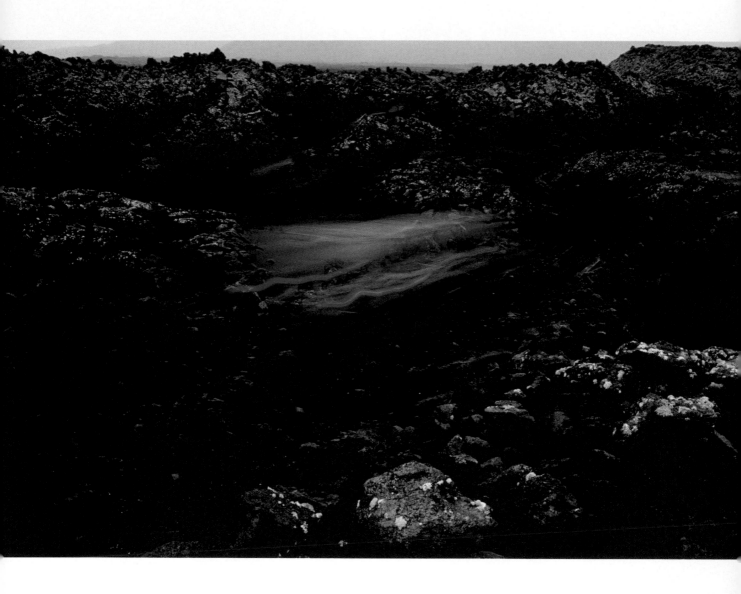

We take our cameras everywhere we go to document our travels and our lives. The interior of Iceland was my assignment for the *National Geographic* book, *Beyond the Horizon*. I wanted to convey the desolation and the coldness of the lava fields in the interior of this amazingly beautiful and pristine country. I asked Tom O'Neill, the writer for the piece, to drive his 4x4 vehicle past my camera mounted-tripod to bring a touch of warmth from the taillights into the photo. 20mm lens, 1/2 second at f4

What Is There to Photograph? As a working photojournalist, I either propose stories or I am assigned a shoot. Publications have space to fill every month, so stories must be generated, from within their staff or from outside story proposals. Part of the luxury of being assigned a story is that the subject material has been researched and found as credible, having interest for the readership. Upon accepting the assignment, the photographer goes into research mode, deciding how to visualize the story. Every publication is different in their makeup, in what visual flow the photographer is trying to create. What story are you trying to tell?

I've found one major concern for aspiring photographers is determining what to photograph. I teach my own series of photographic workshops (www.firstlightworkshops.com), and we provide assignments for the participants in the area where we are hosting the workshop. These assignments have been arranged beforehand on a scouting trip (Auvillar in France and the western highlands of Scotland were the two most recent). In the same way, there is a lot to shoot in your own neighborhood. Check out your local newspaper to see what outdoor events are going on, such as street fairs, community events, or youth soccer games. These can provide an abundance of photographic subjects. If you have a national or state park near you, venture out to check the location, deciding where you want to be at the "golden hour," that time of day in the late afternoon when the sun bathes everything in a golden glow. It only takes a bit of research to come up with many such items.

The camera is a tremendous passport, not a barrier as I've heard a lot of aspiring photographers claim. Countless times I've walked up to people, domestically or internationally, and used words or gestures to ask if I can take their photo. I have made friends around the world as a result of this simple and direct act of showing interest. Next time out, if you take a deep breath and approach that person you'd like to photograph, you'll probably get the okay, and one of the first steps toward becoming a better photographer will have been accomplished. Everyone has a "comfort zone"—a distance where coming closer is an invasion. Time will teach you how closely you can work with a person, so you're not invading their zone.

We are a nation of photographers, and throughout this book, we will give you hints, show you tools, and—we hope—inspire you to take this marvelous craft to greater heights.

HOW TO: RESPECTING HUMAN DIGNITY, PROMOTING SOCIAL CHANGE

by John Isaac

I served as a photojournalist for the United Nations and UNICEF for over 20 years. During that time my work focused mostly on international social issues such as wars, refugees, and the plight of humanity in general.

I feel that I am a human being first and a photojournalist second. During my career, I followed one simple guideline: Never take away someone's dignity, just as I would not want someone to take away my dignity. I learned about human dignity from three important people: my own mother, Mother Teresa, and Audrey Hepburn. They all emphasized human dignity in their own way. This guideline has prompted me to put down my camera in several situations where it would not have been appropriate for me to be making pictures. Sure, I may have produced some powerful photographs, but only at the expense of another human being.

Many years ago, I covered the plight of the Vietnamese boat people in Southeast Asia. For over 10 weeks in 1979 I traveled around that region photographing the beleaguered people who had washed ashore after several days adrift in the ocean in small boats. I met a young Vietnamese girl who had been raped by several Thai pirates while she was in a boat with no food, water, or protection. She had lost her father and her mother during the scuffle with the pirates and was very alone. When I heard the story and saw her sitting by the beach staring into the sky, tears rolled down my cheeks. She had not spoken a word to anyone in days. I had no desire to take her photograph. All I wanted was to show her that there was somebody in this world who cared for her. I had taped some Vietnamese music in my tape recorder in another camp a few days before. I played the music while sitting next to her on the beach. I had some chocolates in my hand that I offered her. I was praying that she would just look at me and take the chocolates from my hand. After some time she finally looked at me and took the chocolates. That was all I wanted from her. Several days earlier, I had met a few Catholic nuns who were doing aid missions in that area. I went and got them in the middle of the night and rescued this little girl to a better life. I know she is living somewhere in California today. I did not take a single photo of this girl nor did I take her name and particulars. I have many stories like this from my career, where I did not point my camera at situations where I felt that I would diminish someone's dignity.

There were many people who did not agree with me. Many felt that my job as a photographer was to document

a situation and tell the world the story and not to play the role of rescue worker. When I was covering the Ethiopian famine in 1984, I saw a woman who had fainted on the ground with her newborn child still attached to her umbilical cord. She had traveled several miles to get to a medical tent, but had fallen before she could reach help. She was naked, her clothing having come unwrapped. My first reaction was to put her clothing back in place, since it was taboo for a woman to be naked in front of strangers. After clothing her, I ran to get the doctor. At the same time, a TV crew that witnessed this scene had gone back to their Jeep to get their equipment to film her in her incapacitated state. When the cameraman returned to the scene, he was not happy to see her with her clothes on. He almost punched me for interfering with his subject and the situation.

I have told you of times when I didn't take a picture. Thankfully there are many more times when taking pictures can make a positive difference, and not only in the midst of famines, war zones, or social emergencies. Start with community issues where you live. *Think globally and act locally*. The first step in addressing a community issue is to bring attention to it. Words alone often are insufficient to arouse the public's interest, but one photograph can speak a thousand words. The best way to let large numbers of people know about your cause is through the news media. You'll be surprised how easily you can get local newspapers, or even national magazines, to run your story if it is compelling and well illustrated. A poster that I donated to UNICEF showing a collage of children's faces from around the world sold more than 100,000 copies (in several languages)—and raised more than a quarter-million dollars to benefit children in need.

Perhaps you could arrange a personal or group exhibit, with proceeds from photo sales benefiting a charity. How about taking pictures of the animals at a pound or pet adoption agency? Ask the manager of your local mall or shopping center to let you hold an exhibit to attract people to adopt them. I have been photographing tigers and donating my images to make posters to benefit the Save the Tiger organization, and I show the images in my presentations at schools and colleges. I want people to be aware of the delicate position of tigers in today's rapacious world.

How about sharing some of your photographic enjoyment with others? Residents of retirement communities, shut-ins, and hospital patients, for example, always can benefit from additional attention and a change in routine. Showing pictures from your travels can bring pleasure to those whose travel opportunities are unavoidably more limited. Or consider giving a talk on photographic tips and techniques liberally illustrated with examples of your own pictures. A little of your time can go a long way. We are all busy with tight schedules. But no matter how busy you are, you can always swing a little time to share your photos in a retirement home. You will surely cheer those people on a lonely cold night with your images. The smiles you will receive in return for sharing the joys of your photography will be such a huge reward for you. Probably more than winning first place in a photo contest.

There is another simple guideline I try to follow. As Antoine de Saint Exupéry writes in *The Little Prince*: "It is only with a heart that one can see rightly; what is essential is invisible to the eye." I try my best to capture images with my heart and not just with my eye alone.

Cameras courtesy of Mike's Cameras, Boulder, Colorado

EQUIPMENT

I hate cameras. They are so much more sure than I am about everything.

—John Steinbeck

Photography is a technical art. As a consequence of this, many photographers become equipment junkies, and the many options available to the digital photographer certainly can satisfy the equipment junkie's cravings. But it makes choosing a camera more difficult for someone new to the world of digital photography. Ultimately, when it comes time to head out on the shoot, every photographer should be looking at ways to minimize the amount of equipment and weight needed for the type of photography you like to shoot. You don't want your camera bag to get in the way of what you love to do: shoot photos.

Choosing the correct camera does not have to be a daunting task, if you buy according to your needs.

This chapter is dedicated to helping you choose a digital camera that fits your needs, your budget, and ultimately, your photography. Don't lose sight of the fact that the camera is a tool, and the primary function of that tool is to make photographs. The best camera on the planet won't turn you into a great photographer, but an inadequate camera can interfere with your ability to get the shot. I've compiled a list of sage advice for camera selection based on over 30 years as a professional photographer.

If you're a first-time digital buyer or the prosumer moving up to a top-of-the-line model, this chapter will help you find the right gear for your needs.

THE FIRST-TIME DIGITAL BUYER

You've been taking photos for many years and you're contemplating making the big switch to digital. What are your needs? Will your existing body of 35mm equipment become obsolete? How much of your film equipment can be used with the new digital technology?

Since you're reading this book, more than likely you were a 35mm point-and-shoot or a 35mm SLR (single lens reflex) user. Easily providing the most functionality and depth of equipment, 35mm was the benchmark in upper-end consumer and professional photographic gear. The benchmark for digital to the working pro was when the quality of the digital image finally equaled that of the 35mm film image. And that time has come.

The last decade was witness to the evolution of ultra-sophistication in camera gear. More technology and better glass were put on a broader range of cameras than ever before. Highly capable auto-exposure and auto-focus became standard with almost every level of camera, and this trend has continued in the digital realm. Digital cameras are evolving at a blistering pace, with new cameras improving on the quality and speed of their predecessors. Then, how do you buy the right camera so you don't feel like the day you walk out of the store your equipment is already outdated? With all the voices giving advice on the Internet, whose advice should you follow?

Camera Types

Cameras fall into three classes: consumer, prosumer, and professional. Although the dividing line between the classes can be a bit fuzzy, we'll point out features you can use as a landmark to help compare apples to apples and oranges to oranges.

Consumer-Level Cameras

Consumer-level cameras encompass a range from the basic point-and-shoot camera with little or no control over exposure up to pricey point-and-shoots that provide quite a bit of creative control. These are all fixed-lens cameras, eliminating the ability to change lenses. To many entry-level shooters out there, this is a plus as these cameras can be small enough to fit in a pocket and the automatic exposure features are great for snapshots.

This entry-level camera from Olympus is an excellent choice for the casual photographer.

With the current state of the art of digital equipment, this level of camera has a few inherent problems. Generally these have a lag time between when the shutter release is pushed and when the photo is made due to the large amount of information—such as exposure and focus—that has to flow through the cameras' circuits. For a serious photographer, this can cause hair loss as you'll spend a lot of time yanking follicles out in frustration at the missed moments.

It's a direct correlation that the more you spend the less lag time there will be. If you are shopping in this range, one of the first questions I'd ask would pertain to the lag time. While you are in the camera store, try shooting the camera several times and gauge if the lag time could be an issue.

Consumer-level considerations to be aware of:

- **Lag time** Make certain the camera reacts quickly to the pressing of the shutter.

- **Speed of the lens** This dictates how much light the lens allows to pass and therefore will affect the shutter speed. The little pocket cameras are cute, but they will generally have a slow lens, probably an f4 or f5.6, which can slow things down.

- **Speed of the in-camera processor** After you take the photo, it's stored in the camera's buffer (memory) as it processes the image and downloads it to your capture media. The buffer also has a limited amount of images it can hold. Ask about this, as the less expensive models will hold fewer images. This can be extremely frustrating on a limited buffer as the camera will not allow you to shoot more photos until it's cleared its buffer.

- **Zoom length of the lens** Most consumer-level cameras will provide a 3× or 4× lens. For most amateurs this will be enough until you want to photograph the elk bugling in the state park. If photographing animals or sports is of interest, consider one of the new breed of "ultra zoom" cameras, such as the Olympus 5060. Digital zoom will offer greater length, but the quality goes downhill quickly the more you use this zoom.

- **Image quality** The cost of a consumer camera is lower than the prosumer or professional DSLR for a reason. The chip (the electronic device that captures the photo, analogous to film) is generally smaller, and enlarging the image will show less quality than the images of this camera's bigger siblings.

■ **File size** The same issues here as with the image quality—in general, the more money you spend, the larger the file size. And the size of the file indicates the maximum size that the image can be enlarged to while retaining quality.

■ **Noise** In film images, this refers to graininess. Due to the smaller sensors on point-and-shoot cameras, greater noise is the natural byproduct of the smaller sensor size. This will show up more readily in shadows and dark areas.

■ **Pixel size** Smaller sensors typically have smaller pixels. Smaller pixels hold fewer electrons and are therefore noisier than bigger pixels.

■ **ISO settings** In the consumer-level camera there is a narrower window of the ISO (image speed) settings. Limited to the lowest ISO of 100 to 400 or so, this restricts the camera's (and thus the photographer's) ability to increase the ISO to shoot faster exposure in lower light. This can be an issue if you enjoy photographing sporting events. The ability to shoot a higher shutter speed requires either a lot of light or an increased ISO setting. The pro cameras will go up to 3200 ISO, which enables very fast shutter speeds necessary to stop action.

Prosumer-Level Cameras

The camera shown here straddles the line between the consumer camera and the pro model. Usually in the 8-megapixel range, these cameras often provide a fixed lens with a zoom

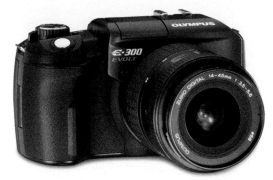

These prosumer cameras bridge the gap between the ease of a point-and-shoot and the full control of a pro-level DSLR.

range from 3:1 all the way to 6:1. In addition, most prosumer cameras have fast apertures, fast processors for moving the images from buffer to the media card with little or no lag time.

Prosumer features include:

■ Short or no lag time between the time the shutter is depressed and the time the picture is taken.

■ Good zoom range; 4:1 or 5:1 is ideal.

■ Most pros prefer a wide-angle length in the zoom equivalent to about a 28mm.

■ Fast aperture; at the wide setting of f2.2 to f2.8 is preferable.

■ Ergonomics to fit your hands and shooting style.

■ More control over the exposure modes for shooting. This would include the ability to set the camera to over- or underexpose by an amount determined by the photographer.

■ A greater range of available ISO settings. This feature may approach the pro

DSLRs in providing an extended range of available ISO.

- Larger chip for better quality.
- Availability of a "hot shoe" so an auxiliary flash can be used with the camera. The hot shoe is a receptacle on the camera that accepts the "foot" of the strobe to attach a flash to the camera, allowing manual, automatic, or TTL (through the lens) flash capability.

Professional or Expert–Level Cameras

The advantages of the SLR camera are multifold: the method of focusing and composing through the lens, being able to see exactly what the lens is seeing, the accuracy of the metering as it too is able to meter off the composed image, and so on. Several top-of-the-line digital cameras, such as the Olympus E1, the Nikon D2X, and the Canon EOS-1Ds Mark II, give you 100 percent of the image you see in the viewfinder. Others are somewhere in the 90–94 percent range, a holdover from the days when most avid amateurs and pros were shooting slide film, and the slide mount cut off 4–6 percent of the edges. Another advantage of the SLR is that any effect from filters—such as polarizers, graduated filters, and special effect filters—is readily seen through the viewfinder.

Other advantages include interchangeable lenses, state of the art buffers and processors for moving images rapidly to the media card, and nonexistent lag. When you press the shutter, the camera reacts.

The pro camera will also give you manual control over every aspect of your photography. This may seem like too many decisions at your current knowledge level, but throughout this section of the book, I will show you how to use the manual features to improve your photographs. The pro-level camera also offers better metering, faster shutter times, more control over ISO, less picture noise, and a greater choice of lenses. Other features include:

- **Very fast processor** Most top-of-the-line cameras are now capable of shooting a minimum of 10–15 high-quality JPEGs (SHQs, or super high quality) at a frame rate of 3–5 frames per second. This may sound like overkill, but when you're shooting an event like the running of the bulls in Pamplona, the ability to keep shooting and not being hampered by the camera stopping while processing images cannot be overstated.

- **Sturdy construction** Check the lens mount. It is preferable to have a steel lens mount instead of a plastic or synthetic mount. Steel will support larger and longer lenses, and will withstand the abuse of quickly changing lenses many times, which will make the camera last longer.

- **Proprietary lenses, especially in the wide range, that are digital specific** Many manufacturers build digital cameras that will allow you to use existing 35mm lenses on the body. But there is an issue with the film lenses' method of focusing the light from the rear element to the

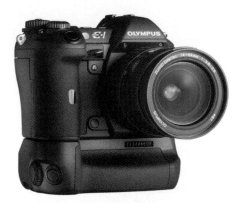

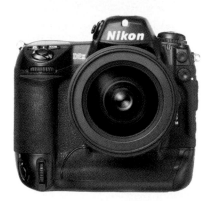

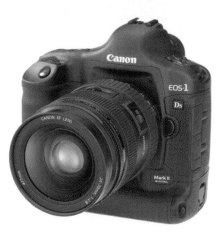

Three professional-level digital SLR cameras: the Olympus E1, the Nikon D2X, and the 16-megapixel (or MP) Canon EOS-1Ds Mark II

chip. Evidence has mounted that 35mm wide angle lens design has the light striking the chip array at an angle, causing softness on the edges of the frame due to a shadowing by the grid containing the pixel grid. Following Olympus's lead, most companies are now producing digital-specific lenses.

Whose Advice Should You Take?

The older neighborhood pro is always a good bet for advice and they usually have plenty of it. Years of experience working with good and not-so-good equipment provides a lot of insight into the performance of camera gear. An informed camera shop salesperson can be a good source of information, as long as you don't feel you are constantly getting the sell job. Find a shop that doesn't mind your hanging around for extended lengths of time while handling several different cameras.

Your neighborhood pro will often have a favorite camera store and salesperson they deal with. And how do you find that friendly pro? Try going to the local ASMP (American Society of Media Photographers) meeting. This professional organization has monthly meetings in most major markets, and guests are welcome for a small fee. Talk to the photographers there and ask about the best stores in town. While you are at the meeting, ask the professionals what they feel is the best equipment on the market. While the camera salesman probably has a better overview of the products on the market, the professional has a lot of experience in the field. Problems with

durability or failures due to environmental conditions are acutely registered by professional users.

As a rule of thumb, most magazine reviews of equipment can be totally ignored. The bottom line on those reviews is the magazines are financially driven by the advertising of the camera manufacturers and large stores. There is no way a magazine is going to financially slit their own throat by panning a camera from a company that is paying their way. Look at the general quality of photographs accompanying the articles: most reviewers are not photographers, and how can someone without a sense of what photography is about really review a piece of gear?

Local camera clubs will have aspiring photographers who will know the ins and outs of the local markets and should be more than happy to share that information. Go through the Yellow Pages in the photographic supplies area, find a major store, and ask about local clubs in the area. But before giving credence to someone's opinion, look at their photography to see if they are legitimate. There are a lot of wannabes out there with a lot of opinions based on camera brand cheerleading. If the photographer's work is good, I would be much more prone to respecting their opinion on gear.

DON'T BE INTIMIDATED by GOING DIGITAL

Even the big boys worry about this technology. I think this is as revolutionary a time in photography as the invention of the glass plate in the mid-1800s. This is a new learning stage of technology, but it is still about photography. The idea was and still is to capture the moment before you with this little box with a lens on it. Photographers are still dealing with light, the moment, composition, storytelling, and every other component of silver-based technology. I've yet to meet a photographer who has decided to make the move back to film only. This is another tool in your bag.

With those thoughts in mind, it's time to head to the corner camera store and explore your options. Part of the process of buying smart is understanding what your needs are. This checklist can be used as a general guideline for different types of photography and what to look for in the equipment for that discipline.

General

- Compact size
- 3–5 megapixels
- Fixed lens
- Built-in flash

Sports

- Interchangeable lenses
- 4+ megapixels
- Fast processor and buffer

Travel

- Compact size and weight
- Interchangeable lenses

–Or–

- 4–6 power zoom on a fixed-lens camera
- Built-in flash

Outdoors/Wildlife

- Rugged body with weather resistance
- Interchangeable lenses with long telephotos available
 - This would include zoom lenses in the 10–12 power range.
 - Telephoto lenses as long as 600mm are very common in outdoor photography.
- Lenses that have a fast aperture
 - In a long telephoto of 400–600mm, really fast lenses are in the f4 maximum aperture range and very expensive. A lens in this length in the f5.6 or f8 range is a good choice for wildlife.
- Quick processor and buffer

Portraits/Weddings

- 5–11 megapixels
- Prosumer level may work with a fixed lens and moderate zoom
- Quick processor and buffer
- External flash capability

Pixels and Resolution

In the 3/2 format, for cameras that produce images in the same proportion as 35mm film cameras, the following is a list of image sizes and what they are marketed as in megapixel lingo:

$1280 \times 960 = 1,228,800$ megapixels = 1-megapixel camera

$1600 \times 1200 = 1,920,000$ megapixels = 2-megapixel camera

$2048 \times 1536 = 3,143,680$ megapixels = 3-megapixel camera

$2272 \times 1704 = 3,871,488$ megapixels = 4-megapixel camera

$2560 \times 1920 = 4,915,200$ megapixels = 5-megapixel camera

$2816 \times 2112 = 5,947,392$ megapixels = 6-megapixel camera

$3008 \times 2000 = 6,016,000$ megapixels = 6-megapixel camera

$3072 \times 2304 = 7,077,888$ megapixels = 7-megapixel camera

$3265 \times 2448 = 7,990,272$ megapixels = 8-megapixel camera

$4064 \times 2704 = 10,989,056$ megapixels = 11-megapixel camera

$4288 \times 2848 = 12,212,224$ megapixels = 12-megapixel camera

$4992 \times 3328 = 16,613,376$ megapixels = 16-megapixel camera

A "new" format, four-thirds, is currently used in Olympus cameras, and this 4/3 standard is being supported by a number of manufacturers, including Kodak, Fujifilm, Sanyo, and Sigma. The 4/3 format is quite convenient as it prints almost a perfect 8×10, or for the pro market, it is almost the exact size of a standard magazine double-page spread.

A couple of the pixel dimensions in the 4/3 world:

$2288 \times 1712 = 3,917,056$ megapixels = 4-megapixel camera
$3072 \times 2304 = 7,077,888$ megapixels = 7-megapixel camera

Using the Files for Printing

Let's say you want to print an image from an 8-megapixel camera. That camera produces a file size of 3265 pixels by 2448 pixels. To establish the size—width by height—that this file would print, you'll divide the pixel dimensions by the resolution. Generally the resolution will be 300 dpi (dots per inch), which produces a very nice looking print. Ideally prints should have a dpi in the range of 100 (anything less than this will start to look bad as the pixels will be very evident) to about 360 (more dpi at this point will not be seen by the naked eye). Images can be printed at a resolution of 200 dpi with little loss in detail to the eye. Divide 3265 (the number representing the longer of the two pixel dimensions in the image) by 300 (the intended dpi of the image). This will result in the size the image can be printed on the longer dimension.

A 12.4-megapixel camera, based on a 3/2's format, will contain 3265 pixels per inch on the long dimension. Dividing the 3265 pixels per inch by 300 ppi (pixels per inch contained in the photo) results in 10.88, which is the size in inches the photo will measure on the long side. Here's that formula: width dimension of the photo divided by the desired resolution equals the resulting width of the photo when printed as the file comes out of the camera.

--------- 4288 Pixels---------

------2848 Pixels------

The standard for 35mm photography for decades, the 3/2's box provides a very horizontal image format.

Using this same formula, if the shorter pixel dimension of the 8MP camera image is 2448, when you divide that figure by the intended ppi resolution (300), the short side would be 8.16 inches.

--------- 3264 Pixels---------

------2448 Pixels------

A bare-bones illustration of the 4/3's format

The relatively new 4/3 format allows an 8 × 10 print to be made with almost no cropping, as well as a double-page magazine spread. This is an "open" format, meaning that all lenses will fit all 4/3 manufacturers' bodies.

Changing the resolution (dpi) of the image will change the size of the finished print. If you went to 200 dpi on the same 8-megapixel image, the finished print would be 3265 divided by 200, equaling 16.36 inches on the long side of the photo and 12.24 inches on the short side.

The short dimension divided by the desired resolution (300) equals the resulting size of the short side of the image when printed as the file comes out of the camera.

Enlarging or reducing the image size from the native file size is easily done, and the tools in Photoshop give the digital darkroom quite a lot of power. Printing at different sizes is discussed at depth in Chapter 18.

HOW DO I KNOW the CAMERA IS RIGHT for ME?

Digital cameras aren't cheap. To help prevent buyer's remorse, I've compiled a few tips to help you find the camera that is right for you.

- **What is the maximum size you can imagine you'll print from the files?**

 For an 8 × 10, a 5-megapixel camera should easily suffice. If you love printing images in the 16 × 20 size, you should be looking for equipment in the 8-megapixel range. Be aware of Photoshop's ability to upsample images well. This means that the software will take your smaller file and use algorithms to sharpen the photo for larger prints. See "Going Big: Image Interpolation" in Chapter 16.

- **What will you be shooting primarily?** If it's the family vacation and documenting the life of your brood, a Canon EOS-1Ds Mark II (a 16-megapixel, $8,000 body) would be a major case of overkill. Look at the Olympus E300, which is a step down from that company's top-of-the-line camera, at a considerable cost savings. Not quite as rugged, as it does not have the weather resistance of the Olympus E1, but that may not be an issue if you don't plan on shooting regularly in rain.

- **How does the camera feel?** Is it an extension of your hand, heart, and eye? The camera should never get in the way and should enable the process of picture taking.

- **Will the camera grow with you?** Does the system you are looking into have the expandability for your future growth as a photographer? A point-and-shoot will not accept much in the area of an expanded system of lenses. If photography is a passion, this is an important consideration.

GUIDELINES for BUYING a DIGITAL CAMERA

In the course of workshops or assignments, I'm often asked for good guidelines to follow when buying a digital camera. Here's a list of my ideas, combined with buying pointers from other pros.

- How much can you spend? Be specific and set a realistic maximum price that you are able to afford.

- Realize that generally price, quality, and features go hand in hand. Expect to pay more for a top-of-the-line DSLR than for a compact point-and-shoot camera.

- Don't entirely fall into the "megapixel myth." I'm shooting with a 5-megapixel camera and getting very good results up to 16 × 20. The quality and size of the image sensor often plays a more pivotal role in the quality of the finished image than the sheer number of megapixels.

- As we discussed in the previous section, know what equipment you need for the type of photography you prefer. If you don't need lens interchangeability, a "prosumer" camera may very well suffice. However, if you are passionate about wildlife and sports photography, you'll be hamstrung by a camera that doesn't have interchangeable lenses.

- If you already have a 35mm camera system going, and the lenses will work on a digital camera of the same brand, consider purchasing a DSLR by the same manufacturer as your film camera. You'll be able to use your old lenses and upgrade to digital lenses as your budget allows.

If you take anything useful from this chapter, I would hope it would be that our focus is still about photography and the digital camera is simply another tool in your bag. The core elements of a great photograph stay the same: composition, exposure, content,

and the decisive moment. A great photograph transcends equipment. The camera is the vessel to help you capture your artistic vision.

WHAT to LOOK for in the CAMERA STORE and ONLINE

- Look for an organized display with multiple brands out and available to test. You need to know how the camera feels in your hands. Are the dials and knobs easy to access? This is a particular concern for women with small hands. Does the camera feel like an extension of your arm, or is it a lead weight requiring finger gymnastics to access the controls?

- Does the salesperson have a real working knowledge of the equipment brand? If there is a bit of hesitation or uncertainty, ask for a clerk who is knowledgeable in the specific brands you are interested in. Be leery of anyone reading you the camera's specifications from the manufacturer's literature. Spec sheets don't have much value out in the field.

- Is the salesperson working with you to fit your needs to a specific camera or are they trying to "upsell" the equipment?

- Ignore any talk that a store has quit selling a brand because of too many returns or too many failures. Just doesn't happen with the quality of today's equipment. If you hear this, go on to the next store.

- Don't expect to get the same level of knowledge and expertise when visiting

one of the "box stores." Support your local camera store. The salespeople are often more knowledgeable and are better able to answer questions. You may save a few dollars by going to a discount store, but you are losing the knowledge infrastructure that a store with expert salespeople can provide.

- Used equipment is also an option. If the camera is in good shape *and* has been checked out by a reputable source, I would not hesitate in buying a used piece of gear. Look in the Yellow Pages under "Photographic Equipment: Used."

- Turn around and leave if the advertised price on a camera you are interested in is raised because you need the battery or cables that were not part of that great price. A digital camera will come with all accessories necessary to shoot photos. More than likely a minimal capture card, but cables, covers, and the obvious pieces will be included. However, with upper-end equipment, lenses are often *not* included in the price unless noted.

- If it sounds too good to be true, it probably is.

The World of Buying Online

- Over the years, I've had great luck with B&H (www.bhphotovideo.com/) and Roberts Imaging (www.robertsimaging .com/). If you know what you're looking for, this can be a great way to go, as reputable firms allow returns within reasonable lengths of time on equipment, giving you the opportunity to check out the equipment at your leisure.

- Do not—repeat, *do not*—pay via Western Union, cash, or money orders for online purchases. This is a world where your credit card can offer tremendous protection against unscrupulous sellers. Cash and money orders can leave you hanging if the seller is a thief.

- If you can't pay with a credit card, then use PayPal or another third-party payment system that holds the funds for you until the equipment is in your hands and verified.

- There are some companies advertising unbelievable prices for equipment. Once you call them, usually the story is the camera is sold for that price when it is purchased as part of a "kit," which usually consists of a bunch of stuff: bag, cheesy flash, snazzy neck strap, cleaning fluid, perhaps extra lenses… almost always stuff you could purchase separately for less money. Again, beware of offers that sound too good to be true.

Photography is an art form that requires equipment, and this gear can be dizzyingly attractive—one reason so many people collect cameras. But as I stated earlier, remember why we have this gear: to provide access to this magical art form we love.

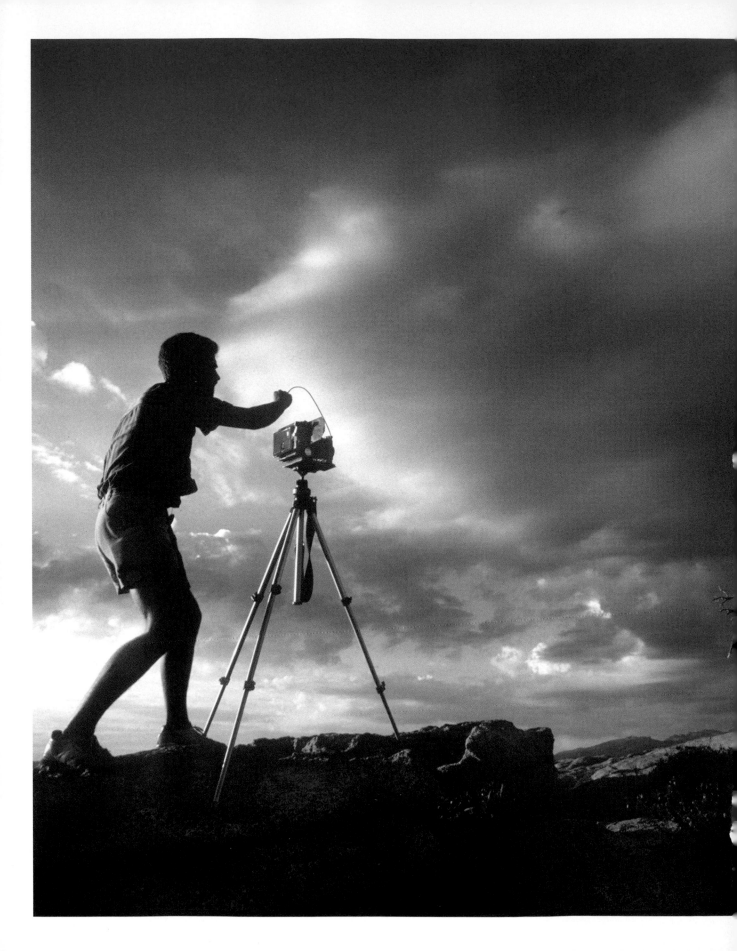

DEVELOPING TECHNICAL PROFICIENCY with YOUR CAMERA

The craftsman who wishes to do his work well must first sharpen his tools.

—Confucius

Such a simple little box, yet the complexity of today's cameras is staggering. Precise exposure, the closely guarded secret of all serious photographers, is now just a half-pressed shutter button away. Even the lowly PHD ("push here, dummy") cameras, which account for the majority of cameras sold, have a technical capability that could only be dreamed of ten years ago. Programmed into the camera's memory are perhaps thousands of sample photos that the onboard computer scans to see what the likely shooting situation is. Say you're shooting your white dog

Photographer William Neill photographs Jeffrey pine in Yosemite National Park. This ancient symbol of the park has since succumbed to centuries of age. 24mm lens. 1/15 second at f5.6

against a snow bank. A test photographer has shot that situation, and those conditions are stored in the memory of the camera's chip for comparison.

The bottom line is that the camera, in all of its resplendent glory, is still a box with a small hole at one end and a sliver of light-sensitive material at the other end. The sole purpose of this box is to let an instant's worth of light fall on the light-sensitive material. In 1827 Joseph Nicéphore Niépce exposed the first photographic plate, a heliograph, heralding billions upon billions of images that would follow during the following centuries. This camera was as simple as it gets: a box with a lens and a treated metal plate. The exposure was relatively quick for the state of the art at the time, about eight hours. The scene was a dovecote viewed from his window in Le Gras, France.

Flash forward to today. Dad is arranging the family in front of the Grand Canyon. The camera is lifted, the shutter pushed, setting off a chain of events. In a millisecond, the camera reads the light levels, sending that information through the onboard computer. The processing chip then sends a signal to adjust the lens aperture and opens the shutter for the correct duration. If needed, the flash will be fired, the light pulsed out will be measured during the exposure, and turned off at the exact moment that produces a proper exposure. Also, during this time, from the lowly disposable camera to the top-of-the-line Canon EOS-1Ds Mark II 16.7-megapixel camera, the auto-focus will determine correct focus, and the camera will

"auto white balance" the exposure. All this happens in the time it takes Dad to put the camera to his eye and fire.

What are the components that make up this scenario? The camera, the flash, the tripod, and so on, obviously, but more importantly the comfort level and knowledge one has of this equipment, all of which translates to creating better photographs. That's what we'll cover in this chapter. We'll take a look at the parts of your camera, its settings and controls, and some critical accessories. Then we'll look at some guidelines for developing the technical proficiency that empowers your creativity: different media, white balance, file types, all the tools at hand to make you a better photographer.

THE PARTS of YOUR CAMERA

First, let's look at the camera and its components. More than likely, you've owned cameras of varying complexity over the years. These have all had some common elements.

The camera will contain a shutter, which opens and closes, allowing a measured amount of light to fall on the chip. This is no different from a film-based camera.

There will also be some variation of a viewfinder. The simplest is an optical viewfinder, a small window above the lens that gives you a pretty good idea of what you're shooting. Next, we have the SLR (single lens reflex, see Chapter 2), which uses a system of prisms and mirrors to actually see exactly what

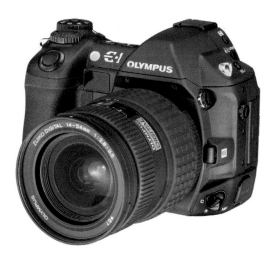

A modern DSLR is great for all-around photography. Accuracy of exposure, speed in handling, and great image quality are hallmarks of this type of equipment.

the lens is viewing, as it is sighting through the lens. This type of viewing system is found on almost all professional-level digital cameras. The relative newcomer to the field is the EVF (electronic viewfinder). This small screen provides an electronic image, like a mini-TV, of what the lens is seeing. To some people, this takes a bit of getting used to, as it does not visually replicate reality very well. These are used on consumer- and prosumer-level cameras, primarily with lenses with extended zoom range or very wide-angle capabilities, as an optical viewfinder could not give you an accurate approximation of the image through those types of lenses.

An LCD display screen provides information on almost all camera settings. From shutter speed to ISO to file type, all the user-controlled settings are shown here. With

a quick glance, the photographer knows where he stands, technically speaking.

Also found on the camera body are a multitude of buttons addressing many digital-specific settings. These include white balance, file type, monitor review, menu access, erase, auto-exposure lock, and info. These will be discussed a little later on. Knowing and understanding the function of these buttons is important in the photographic process. Developing proficiency with these basic components will allow you to focus on the photograph, rather than the process.

What Are Those Camera Settings All About?

Today's digital camera does have many settings available, but they are not radically different from 35mm. Several of the settings have a direct correlation between the digital and film technology, and some are unique.

Upon startup of the camera, a number of figures, icons, and numbers will appear in various forms, depending on your camera manufacturer. Here are some common ones.

- **Shutter speed** This is the number represented as either a whole number (250, 500, 1000, and so on) or a fraction (1/250, 1/500, 1/1000). If you took one second and divided it into 250 exactly equal parts, that would be 1/250 of a second. This setting tells you the duration the shutter is staying open. Obviously, the longer the shutter stays open, the more light and movement will be recorded.

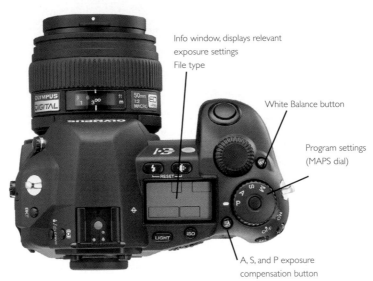

Info window, displays relevant
exposure settings
File type

White Balance button

Program settings
(MAPS dial)

A, S, and P exposure
compensation button

Every manufacturer
applies its own "feel"
to the ergonomics of
the camera, but the
controls are common
among all models.

- **Exposure compensation** This will look like a small ruler, with markings running from the center to the left to –2 and to the right to +2. Have you ever shot a photo in bright snow, only to have the subject of the photo appear as a silhouette? This was due to the camera trying to compensate for that terribly bright level of light coming off the snow, sacrificing the exposure on the subject. With the exposure compensation, the camera can be forced to *under-* or *overexpose* the photo, by whatever degree you want.

- **Aperture** This is the variable opening in the lens that controls the amount of light striking the light-sensitive material. This figure will be 1.4, 2, 2.8, 4, 5.6, 8, 11, 16, 22, or some fraction in between. The aperture setting controls the depth of field; the larger the number, the larger the

Shutter Speed Equivalents

Shutter Speed	Aperture Setting
I second	f22
1/2 second	f16
1/4 second	f11
1/8 second	f8
1/15 second	f5.6
1/30 second	f4
1/60 second	f2.8
1/125 second	f.2.0
1/250 second	f1.4

These shutter speed and aperture com-
binations all result in the same exposure.
The photographer can use shutter speed or
aperture to increase their creative control—
one of the best reasons to learn and use
manual exposure!

zone of focus (area that is in focus) from front to back.

A photographic example to illustrate depth of field is shown on the following page. I started wide open at around f2.8 and progressively stopped the lens down to f22, illustrating the increased depth of field impacted by the aperture. The first photo was shot at f2.8, which is the maximum aperture on the 100mm lens I was shooting these photos with. Notice the rolls in the foreground and in the background, how they are out of focus and how the only real area of sharpness is the film in the middle of the frame. As the lens is progressively stopped down, f4 in the second frame, f5.6 in the third, f8 in the fourth all the way to f22 in the final image, the depth of field, or area of apparent sharpness, deepens with the stopping down of the aperture.

- **ISO setting** Back in the old days, when I was shooting film for a major daily newspaper, we'd carry Tri-X black and white film (this was before daily color usage in the paper) and we'd physically change the ISO setting on the camera (it was ASA then), which affected the sensitivity of the film to light when the situation called for it. With a higher ISO, one could go to a higher shutter speed. We'd even push the film to 12,000 ISO with some exotic blends of developers. The grain was the size of your fist, true, but you could actually photograph high school football in dimly lit stadiums without a flash. However, you were stuck with the speed of the film in the camera. If a great event took place in front of you, and it required going higher or lower on the ISO, the other images on the roll would have to be sacrificed.

With digital, each frame is its own event. ISO can be changed accordingly for one frame, or several, and changed back. This empowers the photographer with the ability to react to the moment, going to a higher ISO to capture high-speed action in lower light, or to drop it back to a low ISO for the better quality it produces.

ISO can also be a creative tool, using the ISOs in the range of 1200 or more to create a grainy (called noise in the digital age) ethereal-looking image.

Deciphering the MAPS Settings

Looking at the controls on a camera, many contain a dial that gives you the choices MAPS. Is this a compass device? Nope. M gives you the power to manually control everything. A is for aperture priority, S for shutter priority, and P for program mode. It's actually a pretty easy choice; let's take a look.

- **Manual mode** is often the choice of avid enthusiasts, advanced amateurs, and pros. In this mode, the full power of the camera is in your hands. You must know the basics of exposure to utilize this setting to its fullest. All modern cameras have meters built in, and Manual is one setting where you will be using the meter religiously. You set the shutter speed, the aperture based on the meter, and fire away.

1/250 second at f2.8 1/125 second at f4 1/60 second at f5.6

1/30 second at f8 1/15 second at f11 1/8 second at f16

1/4 second at f22

I finally found something to do with all those rolls of film sitting in the freezer.

- **Aperture priority** is a semi-automatic mode that gives you the ability to control the aperture (the f-stops), and the camera will then set the proper shutter speed. Many pros I know use this setting often. You have the ability to control the depth of field, which is directly impacted by the aperture. The more you close down the lens, the deeper the zone of focus you create in your photos. If you are photographing Aunt Martha in a field of flowers, and you want the flowers in the foreground to be in focus, the more you "stop down" the aperture, the more in focus the flowers will be closer to the camera, as well as on the other side of Aunt Martha. When looking through the camera, you will see (in the display) numbers representing the shutter speed and the aperture. The shutter speed is the number represented in steps of 1, 1/4, 1/2, 1/8, 1/15, 1/30, 1/60, 1/125, 1/250, 1/500, 1/1000. The f-stops, or aperture, will be seen as f2, f2.8, f4, f5.6, f8, f11, f16, f22. These numbers tell you the actual size of the opening the blades in the lens create in relation to the length of that particular lens. The larger the number, the more closed down the lens and the deeper that zone of focus. Every f-stop is doubling or halving the quantity of light striking the digital chip. Also, wider lenses have more inherent depth of field than do long, telephoto lenses. Think of those photos in *Sports Illustrated* where the receiver leaps for the ball, with all the background out of focus. Those are very long lenses, often shot wide open or with the aperture at a smaller number. Look for a more detailed explanation about depth of field a little further on.

- **Shutter priority** The photographer has the control of the shutter speed, allowing the camera to take over setting the correct f-stop or aperture. This allows you to slow down the shutter—say, to 1/60—to track a runner going by you and to get that cool blurry background, maybe with a little motion in the athlete's body, but keeping the focus fairly sharp on the runner. This is a good way of creating a sense of motion in a still photograph. Set the shutter speed up to around 1/1000 of a second, and that helicopter flying overhead will look like it is about to fall out of the sky, because the blades are not moving.

- **Program** mode authorizes the camera to take control and set optimum shutter speed and aperture. Other settings, ISO, and white balance are often left in your control.

Mode indicator

Other Shooting Modes

Designers of modern digital cameras have figured that a lot of their market does not want to deal with the perceived complexity of the controls we just listed, so they have taken it another step and included modes for different types of scenes. These modes set the camera to function best for the style of photography indicated by the icon.

Movie Night Landscape Sports Portrait

My Mode/
Custom

- **My Mode/Custom** or something similar. This will allow you to make specific settings on the camera, and save it to come back to later. Perhaps you want a mode that can be switched to and immediately have the camera in a black and white mode or with a higher ISO (to be able to shoot in lower light). This would be the place to save those settings.

- **Movie** mode, indicated by a movie camera image. Many cameras also have a movie mode that will capture a small MPEG video. This is usually about a 640 × 480 movie file that can be several minutes long.

- **Landscape** mode, indicated by an image of a mountain. This mode will set the camera so you achieve the maximum depth of field, gaining as much sharpness foreground to background. Be aware, if the photo is taken in late daylight or other low light conditions, the shutter speed will drop accordingly, and you should think about using a tripod. Many cameras will optimize the color settings, figuring you are probably shooting natural scenery, and will emphasize blues and greens.

- **Sports** mode, usually indicated by an image of a running person. The camera will set the exposure, pushing the shutter speed to its highest point, taking in the exposure for the scene so the images will be as "frozen" as possible.

- **Portrait** mode, indicated by a likeness of a person's head. The camera will set itself so the aperture will lessen the depth of field, throwing the background out of focus. This will make the subject stand out, as the background will be soft. Try and zoom the lens out and fill the frame with the person you're photographing, as the closer you are, and with the lens wide open, the shallower that zone of focus will be.

- **Night** mode, indicated by a moon and/or star. The camera will operate at slower speeds than normal, so you can shoot the night view of San Francisco and get detail. Often, this can be combined with flash, so both the flash-illuminated foreground and the background will

have correct exposure, making the photo more interesting. I often see people shooting pictures of someone in the foreground with a flash, but utilizing the Auto or Program mode, which will not compensate correctly for the background. The resulting photo resembles a person floating in a sea of black, as the camera exposes for the flash, but sets a default shutter speed, probably 1/60, that does not create enough exposure for the background. Often this mode will also compensate for the "hot pixels" that show up in some long exposures. Caused by the heat buildup in the chip that a long exposure creates, these hot pixels will look like specks of light in your image. The camera will actually make a "second" exposure, equal to the first, but only recording black, and use this to reduce or remove the effects of the long exposure. Pretty cool.

- **Landscape and Portrait** mode, not pictured, is usually indicated by a mountain and a variation of a face. This will keep both foreground and background in focus, so the person in the foreground will be sharp, as will the scene behind. Again, this is done by closing down the aperture to create a greater depth of field.

- **WB indicator** may be shown as a small icon, like a cloud, or a light bulb, indicating the white balance setting the camera is set to or if it is in Auto mode. Much more on this a little later.

- **File type indicator** Wonder what that SHQ, or HQ, or TIFF means? That tells you the type of file the camera is saving. Most point-and-shoots provide JPEG (Joint Photographic Experts Group), a universally accepted format that is a compressed image. Cameras will also generally provide TIFFs (Tagged Image File Format), and some will shoot raw files. Each of these type files will be different in size and in its capabilities. Read more about these formats in Chapter 11.

I hear a lot of amateurs talk about reducing the quality to get more photos on a card. Why did you purchase a 5-mega-pixel camera if you are not going to take advantage of the big beautiful chip? The cost of CompactFlash cards and other media is dropping, and you'll never be able to increase the quality of that small file you shot to squeeze out a few more photographs. What if it is that once-in-a lifetime photo you happen upon, and the camera is set to shoot a 640 × 480 image? You'll never be able to print anything larger than a wallet-size print.

Image Sizes, Exact Scene

5MB Camera	
SQ	946KB
HQ	1.2MB
SHQ	3.3MB
RAW	10.1MB
TIFF	15.3MB

Shooting the same image with different file types, the size differences are quite significant.

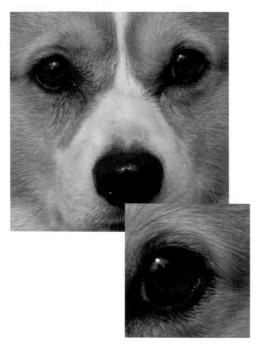

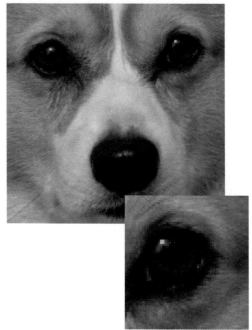

This photo is a cropped section of a full frame, shot at maximum SHQ resolution of 2560 × 1920. The inset is a further enlargement of the eye of the dog, showing almost no pixilation.

The same dog, the same cropped area, and the same enlarged section of that photo shows a lot of image degradation caused by the poor image quality of the 640 × 480 SQ image.

As a general rule of thumb, unless you are shooting for very high quality reproduction or printing needs, a SHQ file (a super-high quality JPEG) will suffice. TIFFs are usually about 4–5 times the size of a JPEG, but there are not the compression problems with a TIFF that there are with a JPEG. Every time you open a JPEG, make any change, and save that change, the quality of the file deteriorates, and information is thrown away, which is not true with a TIFF. A raw file is essentially pure data. The camera white balance settings, sharpness, and other camera processing issues do not apply to this type of file. The raw format is closest to an undeveloped color negative, one that can be developed over and over again, until satisfaction is arrived at, giving you the most control over the image.

CHOOSING a FILE TYPE

Within the controls of the digital camera, the photographer is given a choice of file types ranging from the very low quality SQ to the

very large TIFF to the color negative of the digital world, raw. The choice made here will forever impact the ability to edit, print, and manage the image. Much of this is covered in depth in Chapter 11.

- **HQ or SQ** If you are shooting for web use, and the images will *always* remain small or web only, this is the time I'd consider using this file type. Limited by its small (640 × 480 or a bit larger) file size, a 4 × 6" photo is about as large as one can print this file. Also, any work done to this in photo editing software will further deteriorate the quality of the file. Generally these will be under 1MB in size, which is a good size for sending as email attachments or for web gallery display.

- **JPEG** A great, all-around file type to shoot, JPEG has been available since 1986. Compressible in varying degrees, this file will take far less space on your hard drive than a TIFF and will print quite well. However, remember to always do your editing/tweaking to a duplicate, not the original. On the *A Day in the Life of Africa* book project, we all shot JPEGs. These images were reproduced in a large coffee table book, and they looked beautiful. On a 5-megapixel camera, these files are about 3MB.

- **Raw** Think of this file type as closest to a color negative. This is pure data, meaning that no in-camera processing (sharpness, white balance, saturation, contrast) will be imposed on this file.

The image, as it is seen, is what will be recorded. Many pros shoot only this file type, as it gives them the greatest control over the image. However, you must convert the raw files in either the proprietary software that comes with the camera or with Photoshop CS2. This can slow down the editing process as each image has to be opened and then saved as either a JPEG or TIFF. A side benefit to this is that if anyone claims a photo has been altered or manipulated, the photographer can show the raw file, which is unalterable. *National Geographic* has decided to handle the controversial manipulation issue by requiring that all digital shoots for the magazine be done in raw.

The raw algorithms written by each manufacturer are a closely guarded secret. Conversion in anything but the proprietary converter does not take full advantage of the raw file. This can be seen in shadow detail and noise. This is being challenged by Adobe Camera Raw, as it is suggesting that proprietary development of raw is unnecessary and that Adobe can do as well or better. The Adobe DNG (Digital Negative) was developed by Adobe to address the lack of an open standard for raw files created for each digital camera. DNG was invented to allow photographers the ability to archive their raw camera files to a single format (DNG) for easy access and cataloging of those files.

Upon opening raw files in a raw converter, the photographer has the choice of an 8-bit or 16-bit file. This is very important as a 16-bit file provides a much larger well of color to draw on. This allows the photographer to perform critical adjustments such as levels and curves with far less deterioration of the image file.

Again, if you really want to function within the "digital darkroom," you should consider using the raw format for its absolute control ability.

■ **TIFF** TIFFs will be the largest file to reside in your media card or hard drive. About five times bigger than a JPEG, a great advantage of this file is that it will not lose data when it is opened, tweaked, and saved, regardless of how many times this is done. There is a "lossless" compression for this, so it can take up less space. This is a good file format to shoot for large prints, as the artifacts (tiny, jagged edges as the file is enlarged) that inhabit JPEGs will not be evident in a TIFF.

TIFFs and JPEGs invoke a density remap by the camera which is tantamount to developing the image. TIFF and JPEGs are often 8-bit files, while a raw file will allow the creation of a 16-bit file, giving the photographer far more color information to draw on when working on the file.

The Dawning of the Digital Age

A Day in the Life of Africa was one of the first all digitally produced coffee table books published. I shot for this 2002 project as a newbie in the digital realm, as did the majority of the photographers working on this project. Many went on assignment hesitant and questioning this technology, and most came back digital converts. All assigned photographers were required to shoot SHQ files on all images. The book, with open spreads measuring 20 × 12.5", is a testament to the unbelievably high quality of the file. Take a look.

Flash Modes

The flash is one of the most underused, underappreciated, and conversely, one of the most overused tools on the camera. In national parks, I often see tourists visiting the sights at the worst time of day, noon, and shooting photos like crazy. Invariably, they are disappointed with the washed-out colors and harsh shadows that result. A simple yet highly effective trick in those situations: turn on your flash. Also, move a bit closer. The flash, even on the point-and-shoots, will fill the shadows in eye sockets created by the sun directly overhead. This results in a kinder, gentler photo that will make your significant other much happier to pose for your endless photos next time. Moving closer fills the frame and brings the center of attention, the main subject, closer to the viewer of the photo. The simple trick here is to "force on" the flash, turning the setting on your controls so

the lightning bolt shows in the display. This makes the flash fire with every exposure, and it is a great tool for very bright and high-contrast days.

I also see people shooting photos with a flash at night, usually in Program mode, and then wondering why the picture of Uncle Joe looks like he's floating in a black universe. Again, utilizing the Night mode, or slowing down the shutter speed so the exposure on the background is correct, will place the subject in the environment, giving the viewer a sense of place. This is why we shot this photo in the first place, to communicate that idea.

- **No flash** This is for those scenic shots, very wide shots, and photos where the subject is too far to be lit by the flash. Remember, digital cameras are power-hungry beasts, so the energy savings here may keep you shooting at the end of the day. Be wise, don't energize (when you don't need to).

- **Flash** This may be represented by a lightning bolt. This setting tells the camera to fire the flash with every exposure, regardless of other settings.

- **Auto-flash** This is indicated by a lightning bolt with the letter A beside it. Again, you are turning over control to the camera to decide when you need the flash. The downside to this is that you may be taking an "available light" photo, wanting to capture the ambience of the scene, and the flash fires. This not only possibly disrupts the scene, but the camera (in

the Auto mode or Program mode where this function is applicable) may not go to a slow-enough exposure to capture the image.

- **Red–eye flash** We've all seen this: a group is ready to have their photo taken, and several pulses of light are emitted from the photographer's flash. The purpose of this is to force the pupils in the subjects' eyes to close down, by a series of weak rapid flashes, so the back of the eye with its many blood vessels won't bounce back a red that would work well in a Dracula movie. You may want to tell your subjects that the camera will do this; often the group will start to walk away after the first flash!

- **Rear-curtain sync** When a photographer is shooting in the dark or near dark, and there are moving items with lights (a car is a perfect example), there are inherent problems using normal flash. The headlights become streaks of light moving through the body of the car, which looks very unnatural. The desired effect is to have the lights following behind the vehicle, in a more natural looking scene. This is accomplished by using rear-curtain sync, a technical sounding term meaning that the camera is instructing the flash to fire at the end of the exposure, instead of the normal flash at the start of a longer exposure.

Working with White Balance

One of the magic tools of digital photography, white balance enables the photographer to control the filtering of the light with a button set on the camera. This is one area where shooting digital is vastly superior to film.

I did a job for a national business magazine a couple of years ago, using film to photograph the president of a major railroad. I scouted the location as usual and found the conditions abysmal, to be polite. The main light source was faded-out sodium vapor lights. This required several gel filters over the camera lens to bring the source at least close to daylight, which reduced the exposure by several stops. Attempting to shoot on a slower speed film wasn't possible, because of the loss of light the gels created, so I had to use a higher speed film, with its inherent quality sacrifice. Plus, I had to shoot Polaroids to check how he looked, and a lot of these folks give you a minimum of time. Now, if this had been on digital, I could have walked in, done a white balance by pointing the camera at a white card and pressing the WB button, and the camera would have neutralized the heavy off-coloring of the sodium lights. Plus, I could have checked the image with the actual photographs I was taking, not a Polaroid simulation.

White Balance Can Be a Creative Tool

White balance is a very powerful child of digital technology that you can use as a creative tool, as well. In the film days, I always had an 81A filter mounted on the front of all my lenses. This filter creates a slight warming effect, making many scenes more pleasant in their ambience. Now, if I'm shooting digital, I put my white balance setting on 6000 Kelvin, which is also shown on most cameras as a setting to use on cloudy days. Thus, the little cloud that appears in my monitor tells me I've got the white balance set to a bit of a warming "filter." Settings in the white balance area will also neutralize the greenish cast from fluorescent lighting or the very orange cast from tungsten lighting, the most common lighting used in homes. The little icons for these settings are—guess—a fluorescent bulb and a regular light bulb. These manufacturers are on to something!

Note Kelvin, simply put, is the measurement standard for the temperature of light. The higher the temperature, the cooler or more blue the light. The lower the temperature, the warmer or more orange/yellow the light. Sometimes I like to shoot a daylight white balance under tungsten light because it imparts a warm, snuggly cast, like being at home. Or I might shoot outdoors at dusk with the camera set on a lower Kelvin setting to emphasis the coldness of the evening with the extra blue this WB setting will provide.

White Balance Tips

White balance is our bag of filters in one simple button. I am always aware of the WB setting and have utilized it often for control or effect. The following tips will illustrate how

Temperature	Ambient Lighting Conditions
20,000+K	High mountain open shade
9000–18,000K	A blue sky (the higher your altitude, the higher the temperature)
6500–7500K	An overcast sky
5300–5650K	Electronic flash
5500K	Daylight, around noon on a sunny day
5000–4500K	Xenon lamp
3400-3600K	"Golden hour," one hour pre-sunset or post-sunrise
4000K	Warm white fluorescent bulbs
2750–3000K	A tungsten lamp, found in most homes (the lower the wattage, the lower the temperature)
3000K	Early sunrise or late sunset
1500K	Candlelight

Color temperature measured in Kelvin (K)

you can capture more compelling images no matter what actual light you have.

- Don't use the "Auto" white balance. This may provide an uneven response from frame to frame, as the camera—with even a slight shift of perspective—may establish its white balance from a different "white" it finds in the frame. Also, since the purpose of white balance is to bring white back to white, the beautiful "golden hour" hue may be removed from the photo!

- Carry a white card or piece of cloth (or make sure you always wear a clean t-shirt), so you always have a white sample available to take the reading from. If your white shirt has an optical brightener in it, it will fluoresce under the strobe's UV illumination. Just like in a funhouse, the white shirt will glow bluish, but you may not notice it if you're not in a funhouse dark environment (although it can balance your scene oddly). Consider pre-testing your shirts under a UV source. I find that a folded piece of white typing paper is a practical thing to include in a camera bag. Use it folded to make it opaque and photograph at least one image of this paper, shot in the illumination you'll ultimately shoot your primary captures in.

These two photos, shot within seconds of each other, illustrate how the photographer can use the Kelvin setting as a filter. The photo at top was shot at a white balance setting of 3000 Kelvin, usually thought of as a tungsten setting. I wanted the intense blue cast, normally used to balance out the extreme warmth of tungsten, to create a mood. In the photo at bottom, I shot at the white balance setting of 6000 Kelvin to warm the photo slightly. 50–200mm lens, 1/125 second at f4

- As mentioned before, use the white balance as a warming filter or a slight cooling filter by dialing in appropriate Kelvin degrees.

- Do use the custom settings on your camera, if you intend to go back to an area that required an unusual white balance. This way, a twist of the dial will ready your camera immediately, so you can come in from outdoors and resume shooting in that room that used fluorescent lighting.

- Get your white balance (and exposure) correct while shooting! Photoshop is a powerful tool, but the more you have to tweak the photo file, the more you will negatively impact the quality of the final image. The old saying "garbage in, garbage out" still holds true.

Achieving Sharpness

Digital cameras often come with a setting to control the sharpness of the JPEG or TIFF image. This setting is actually an algorithm that the computer in the camera applies to the image. Be careful in setting the sharpness too high, as you will produce artificial looking edges in the photograph. Many, if not most professional photographers do their sharpening in Photoshop, preferring to keep the camera on a medium setting while shooting. In the raw file mode, sharpening will *not* be applied to the image.

Nothing is nicer than a well-focused, sharp image, and it is one of the first things a photographer checks when looking at photos.

Like brightness, the eye also seeks the area in a photo that is sharp. There are many factors impacting sharpness: unwanted movement, or shake, of the camera, improper focus, and depth of field. Often, a precise use of focus that intentionally causes an out-of-focus area is desired.

Sharpening Tips

Another area new to the digital world is the ability to heighten the apparent sharpness of the image, either in the camera or during post-processing in Photoshop. Some manufacturers provide a default file from the camera that upon initial viewing may not appear as razor sharp. Many pros want to do their sharpening in post-processing, in the computer, feeling that the microprocessor in the camera will not do as good a job as a full-blown computer. Remember these tips when sharpening your images:

- Don't do the sharpening in camera; leave that to Unsharp Mask or Smart Sharpen in Photoshop or a third-party sharpener.

- Never, *never* sharpen the original. Always work on duplicates, so you always have the original file to go back to.

Note For a more in-depth discussion of sharpening, see Chapter 15.

Contrast and Saturation

Back in the old days of film, the photographer had various emulsions to choose from, so a specific look could be achieved. Kodachrome was the standard by which all others were

judged for years; its accuracy was unparalleled. Velvia, the supersaturated transparency film, is a favorite of mine, though too saturated for some. I always thought it replicated how your memory remembered the scene, slightly exaggerated across its palette.

Now we have the ability to "dial in" the contrast and saturation we require. This, too, is a function of the algorithms in the software.

Use the Histogram to Get Brighter Whites

The histogram is another powerful informational tool of the digital realm. It displays the distribution of tones in the digital image and resembles a cross-section of a mountain range. It can be displayed on your camera monitor, either separately or superimposed over the image just shot. The breadth of the range the histogram displays, from left to right, represents 256 levels of brightness, from pure black at 0 to pure white at 255. The mountain peaks tell you the number of pixels that are being used, or stacked, in that particular brightness level. The higher the peak, the more saturated that color or tone.

It's impossible to say there is a perfect or normal histogram, as it depends on what you are trying to accomplish in your photograph. A histogram heavily weighted to the left, toward black, may be an image of a side-lit orchid in a sea of darkness. An Arctic explorer's face in the snow may be heavily peaked toward the right, the bright end of things. Often you'll have to decide if the image works, regardless of what the histogram tells you.

As a camera setting, the histogram may be displayed immediately after shooting a photo or it can be called up via menu or button pushes at the monitor.

This is a good example (on facing page) of not reading the histogram literally. The orchid is lit well, and the background appears as it should. This image would not produce a "classic" histogram of the evenly spaced mountain range. Again, the histogram is *information*, not creative genius. As a tool, the histogram will tell you, with a fairly straightforward image, if the exposure is over or under, by indicating where the "peak" of the range is. Adjustment to the exposure can be made at that point.

When you've gone into Photoshop and made Level or Curves corrections, the histogram displayed will be more evenly distributed.

The histogram's power is that the photographer can check the exposure immediately, determining if the photo is within the range the chip can handle.

You'll often see "blinkies" in one form of the histogram—that is, a warning that the camera senses an overexposed area. This will literally be a small patch of white, overexposed area blinking to black on your camera monitor. The blinkies tell you that the chip cannot hold any detail in the blinking area when viewed or printed. Personally, I don't give the blinkies much attention, as I like to concentrate on the image at hand. However, if you are photographing a static

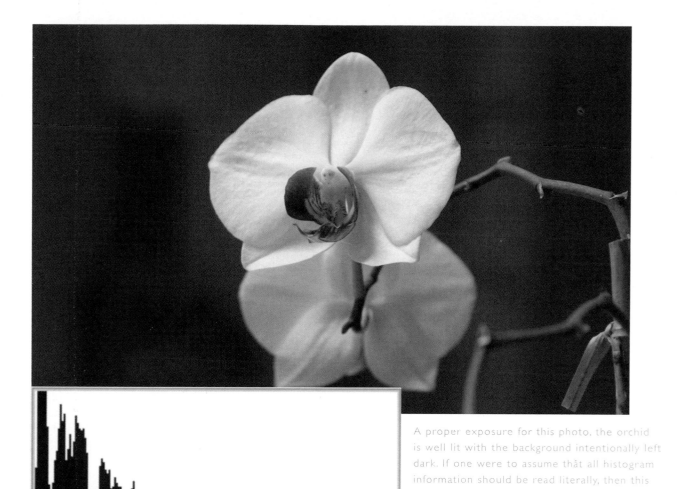

A proper exposure for this photo, the orchid is well lit with the background intentionally left dark. If one were to assume that all histogram information should be read literally, then this histogram would indicate the photo is exposed heavily towards the dark area, because of the large "mountain range" seen on the left of the graph. 50mm lens, 1/60 second at f4

scene, and not an event, this warning can be of tremendous benefit, as lighting and exposure can be adjusted or changed to eliminate the overexposed area.

UNDERSTANDING STORAGE MEDIA

Heading out on a *Geographic* shoot, I used to carry two bags on the plane: one with all my cameras, a full set of gear (discussed in depth in Chapter 2) that I needed to get the shoot done, a couple of camera bodies, necessary lenses, and a strobe. The other bag contained film. Lots and lots of film. If I was to be gone a month, this probably meant around 250 rolls of slow emulsions and fast, possibly a bit of tungsten balance film for indoor photography. It was a nice balance between the bags resting on either shoulder, about 25 pounds each. Added to the mix was having

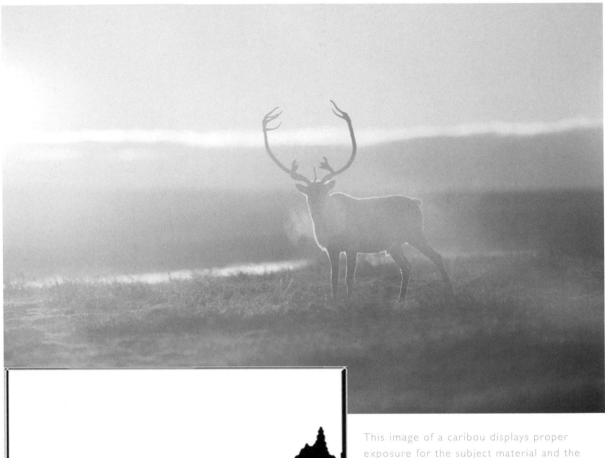

This image of a caribou displays proper exposure for the subject material and the histogram is heavily weighted toward the highlight end. 300mm lens, 1/500 second at f4.5

to get to the airport early to request a "hand check" on this mass of rolls, making sure the film never got too hot, and captioning each and every roll. Plus, I would regularly have to ship film in, partly to make sure there were no equipment problems that would require a reshoot.

These days, I still arrive early, but there's no need to request a hand check on my digital media, as it will not be impacted by the x-rays used at the security check.

Caution Do not ship digital media by U.S. Mail, as the security screening used can damage the data.

There are several types of media available to photographers now: CompactFlash (the professionals' choice) and Microdrives, xD cards (developed jointly between Olympus and Fujifilm), Sony's Memory Stick (MS), secure digital (SD) cards, multimedia cards (MMC),

and smart media (SM) cards. All these cards serve the same purpose in photography: to store images.

Flash Cards

- **CompactFlash (CF)** Most professional cameras use this old-timer of the digital realm. The early version of CompactFlash cards is Type 1, the next and current version is Type 2. The Type 2 cards are thicker than the Type 1 cards. Be aware that the Type 2 holder in your camera can handle a Type 1 card, but a Type 1 slot cannot hold a Type 2. CompactFlash cards are currently available in sizes ranging from 16MB all the way up to a 12GB monster, and these cards also are available in different write speeds, which dictate the speed the image is written to the card. The faster write speed, the better.

Note Cards 2GB or larger have to be FAT-32 compatible. FAT-32 is the File Allocation Table. It supports large drives along with an improved disk space efficiency better than the older FAT technology, which used 16 bits to address each cluster, up to a maximum card

size of 512 versus the 8GB capability of FAT-32. Your camera must be compatible with the newer FAT-32 system to be able to use those larger cards. Check out "Steve's Digicams" site at www.steves-digicams.com/high-capacity_storage.html for a more thorough discussion and reference to other great sites. Steve's site has links to Rob Galbraith's excellent site on CompactFlash, as well as manufacturers' compatibility sites.

- **Microdrives** While these cards have the same dimensions and physical look as a CompactFlash card, they are actually a mini-hard drive and are used to store images. These cards will fit in a camera that is capable of holding a Type 2 CompactFlash card.

Note While you'll save considerable money if you buy a 4GB Microdrive versus a 4GB CompactFlash card, the Microdrives do have an Achilles' heel. The drives are somewhat fragile, due to the moving parts enclosed, and are sensitive to hard bumps, drops, or other physical mishandlings. However, I do know photographers who do the same kind of work I do who have had no problems with their Microdrives.

- **Secure digital (SD) or multimedia card (MMC)** These two cards are identical physically, but do vary internally. SD and MMC cards may be used interchangeably in some cameras, while others will only recognize the SD cards. This card may be the wave of the future, offering connectivity between many devices, fast speed, and potential huge capacity.

- **Memory Stick (MS)** This Sony product is a card used primarily in Sony cameras and videocams. These are available in sizes up to 4GB. The Memory Stick Select card allowed older Sony cameras to use a 256MB Memory Stick card by using a switch on the back of the card. Memory Stick PRO cards are the latest version, with capacities up to 4GB. However, unless you are using the CyberShot F717 that can utilize both types of MS cards, the Memory Stick PRO will not work in cameras that were manufactured before 2003.

- **xD Cards** A joint effort between Olympus and Fuji Photo Film. These cards are very compact (about the size of a postage stamp) and have capacities of up to 512MB with a (projected) potential of 8GB.

Note When using an Olympus camera, writing to an xD card is the only way to utilize the panoramic function.

Media Card Tips

A few of years ago I was photographing my son, Matt, working through his Eagle Scout project as part of an assignment for *Boys' Life* magazine. This was early in my conversion to digital, and I hadn't had the opportunity to make the big mistakes and learn from those ugly processes. Sure enough, I had a major hard disk crash, with no retrievable files left of a number of images of Matt and his project— and I had not backed those files up. Learn from my mistake so you don't lose invaluable photos! The following are some storage tips

I've learned and tips I've picked up from talking to other pros.

- If you've bought a camera with 4, 5, or 6 megapixel potential, make sure you use it! I hear amateurs say they are going to shoot smaller files on their cameras, SQs (super quality) or HQs (high quality), which will allow more images per card. But those space-saving 640 × 480 size photos won't have the quality to print that once-in-a-lifetime photo large. Camera media is relatively cheap; buy as large as you can afford. I always carry at least two additional cards as a minimum. Presently, I'm using 4GB cards in each camera.

- After you have downloaded images to your computer and to a separate CD or DVD (as part of that redundant storage), and you are ready to erase the card to shoot more, don't do a simple erase. Instead, do a format after reinserting the card. There are specific data files your camera model will write to the card, and it's better to start clean with a card formatted for your camera. An erase leaves the data from prior uses on the card. Also, when placing a new card in the camera, do the same—format it immediately.

- Don't send your card through the mail. With the heightened security practices that the U.S. Postal Service has put into place since 9/11, your mail may be irradiated, and this can damage the card.

- Carry a "digital wallet" that is used to store extra cards, both empty and full. Get

into the habit of marking cards that have been shot as well as those that are empty. Lexar makes a great media wallet with mesh pockets that have a red or green flag atop that pocket. The flag with the red side showing indicates a used card, and the empty ones are flagged with green.

- Your camera purchase should be influenced by the card type. Is the card technology going to be around in five years? CF is a very safe bet at this point.

- This sounds obvious, but write your name on whatever kind of media card you're using. I've seen photographers working together on projects and inevitably media cards will be brought out for downloading. When there are five Lexar 1GB cards on the table, it's a lot of effort to have to load, open, and determine whose card belongs to whom.

The following definitions are applicable to both film and digital, and should be fully understood by the photographer.

Depth of Field (DOF)

You will hear "depth of field" tossed around by photographers in discussing their images. Simply put, depth of field is that zone of focus, from foreground to background, that is sharp. This zone of focus increases if you close the lens down to a larger aperture number (toward f22), and the DOF zone will become shallower the wider open you have the lens (f4, f2.8, or a smaller number). The focal length of the lens you are shooting adds other dimensions as well. A wide-angle lens, 35mm or wider, will have a greater depth of field than a longer lens.

As a rule, the wider the angle of your lens, the more DOF you will have. Conversely, a longer lens, from 50mm to 85mm to 120mm and so on, will give you shallower zones of focus or DOF. And this DOF will become shallower and shallower with longer and longer lenses. A long lens with a shallow DOF is very often used for creative effect, and there is usually a button on the front of the camera or lens that will close the lens down to the predetermined aperture, so the DOF can be previewed through the viewfinder.

How Aperture and Shutter Speed Affect Exposure

Your camera lens has internal blades that open or close, allowing light in, or decreasing the amount of light. These are f-stops, represented by the numbers f1.4, f2, f2.8, f4, f5.6, f8, f11, f16, f22, and so on. Moving from one f-stop to the next doubles or halves the amount of light striking the chip. These numbers represent the ratio of the aperture's opening created by the blades to the focal length of the lens. The f-stops work interactively with the shutter speed to control exposure. In other words, the two factors that affect exposure are shutter speed and aperture. These are interrelated; to maintain the same exposure, the shutter speed is moved up accordingly, and the aperture is changed in the other direction. If the exposure is 1/125 at f4, and you want to increase the shutter speed to stop the action more effectively, then you could go to 1/250 at f2.8, or 1/500 at f2.

If you wanted to change the aperture to get greater or less depth of field, and your exposure was 1/125 at f4, you could move the aperture to f5.6, and the shutter speed would then drop to 1/60, to maintain the same exposure.

Shutter Speed

I used to shoot NFL football, and the rule of thumb was that you needed a shutter speed of 1/500 of a second to really stop the action. If you went to 1/250, a bit of blur would start to appear in moving feet and arms. Remember, the longer the shutter stays open, the more movement will be recorded.

Shutter speed can also be used for creative effect, using a long exposure—say, 1/2 second—to really capture the effect of a lot of movement in the frame of people moving on the street. Another example would be opening the shutter in a long exposure to capture the rotation of the earth shown by the stars streaking across the frame in a two-hour exposure.

THE GRAND MANTRA of PHOTOGRAPHY: "THERE ARE NO RULES"

I've seen phenomenal photos taken with $7 disposable cameras, and—at the other end of the photographic spectrum—we've all seen the beauty of Ansel Adams's exquisite environmental images. Modern "edgy" photography, the catchword of editors requesting the latest look, has created wonderful images. I really think the bottom line in photography is, "Does it work?" Does the photo convey the message the photographer is trying to say? Photography is a totally subjective craft; what I think is great, you may think stinks, and vice versa.

As I said earlier, the camera is a tool. The better we know our tools, the easier our work is—and the more we can focus on our craft and not the mechanics.

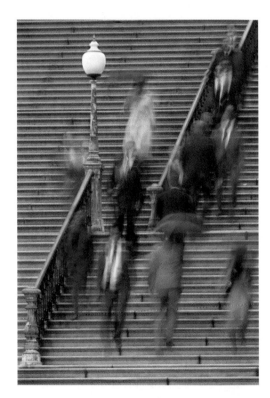

On a corporate shoot for EDS Corporation, the edict from the client was to capture energy and motion in the photographs. We were in Washington, DC, on this round-the-world shoot, where this photo of people moving up and down the Capitol stairs was made. 600mm lens, 1/4 second at f8

HOW TO: CREATING a CUSTOM WHITE BALANCE

Digital is such a powerful tool, and the more you understand your equipment, the more control you'll have over the final product. The automatic features of today's camera are very sophisticated, yet turning all control over to the onboard computer takes away some or all of the artistic control that's available. Auto white balance is often an overly efficient tool that can rob your photos of the "golden hour" hue that you've scheduled your day around. Honestly, auto white balance is a setting you should not use. Going from auto to manual is a good step toward better photography.

Here is an easy way to set your white balance. The following will work for a camera that has a WB setting button.

Step 1
Get a white card, about 4 × 6 inches, large enough to fill a fair amount of your camera's viewfinder when held at arm's length. If this is not available, find someone with a white shirt, or a piece of plain white paper will work fine.

Step 2
When you're in the environment you plan to shoot in, hold the card up, allowing the light to fall on it as if it were the subject you are photographing.

Step 3
Press the WB button while pointing at the white card.

The monitor will display a screen in the monitor similar to the illustration at right:

Step 4
When you press OK, the camera will store the correct white balance, which will balance the light so the white paper is white. Once that color is determined, all other colors will fall into place.

Step 5
Many upper-end cameras will allow you to store this setting and retrieve it at the turn of a dial to the custom setting number. This makes it very easy to be shooting in a room that is a fluorescent light source, move outdoors and shoot, and come back in to shoot in the fluorescent setting again by turning the custom dial to that setting.

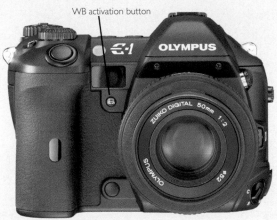

WB activation button

The WB setting button is placed at a convenient spot for your finger to find.

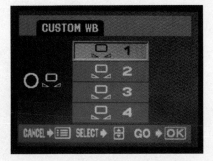

Using a custom setting as displayed in the monitor

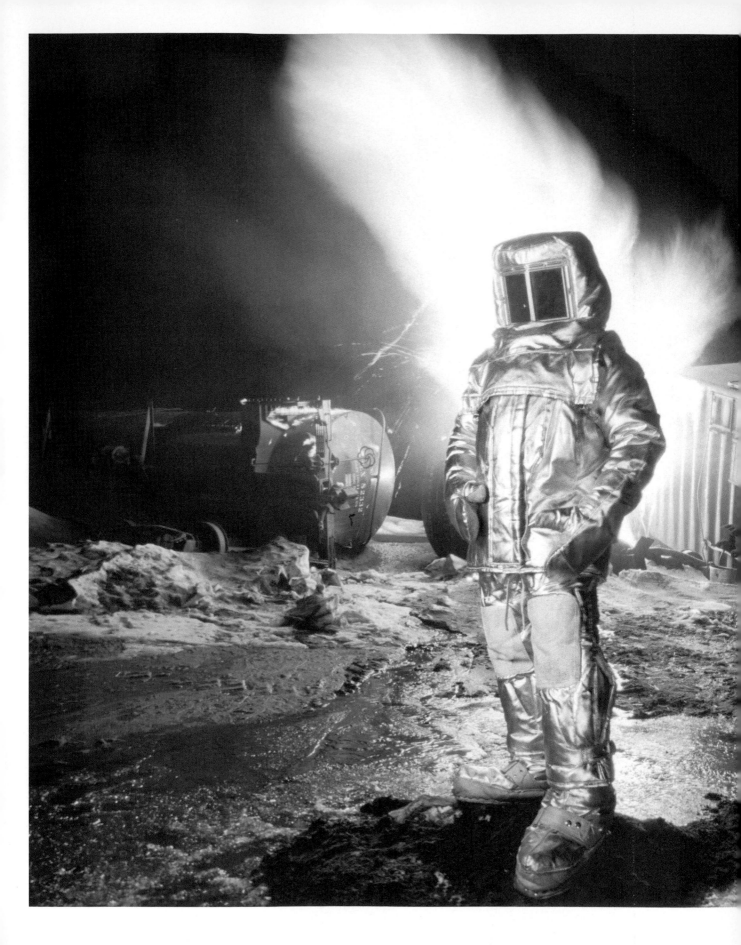

UNDERSTANDING LIGHT

Light is good from whatever lamp it shines.

—Chinese proverb

On a late July afternoon near Lake Myvatn, in northern Iceland, I was watching the sunset. As I stood on the sunburnt edge of a geothermal vent, the arctic light painted everything in clear radiance. The sun dropped close to the horizon on its nearly flat parabola, prolonging the amazing sunset, literally forcing me to shoot and shoot until the sun was gone.

The Transportation Test Center in Colorado trains hazmat crews in handling various spills and accidents, including train derailments. This was a photo mixing both ambient light and my lighting on the man in the silver suit. 24mm lens, 1/2 second at f4.5

In the evening hour in Papua New Guinea, I photographed Bahinemo tribesmen spearfishing in an unexplored part of the country. A shaft of light cut through the thick rainforest, painting the sides of their faces, helping to create a layering effect in the photograph. The shadows became a deeper and more saturated purple.

Without light, we wouldn't have much to work with, so in this chapter we'll deal with different types of light and the issues of controlling and/or creating light. Too much light and the image is washed out, too little light and the image is too dark to see. The correct amount of light is the correct exposure.

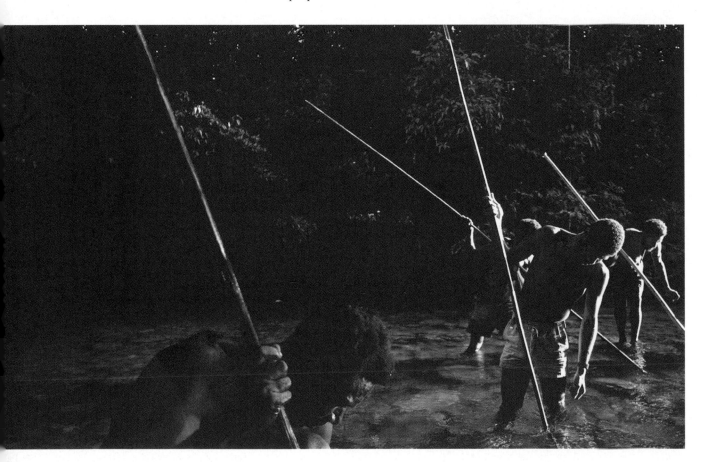

Working with very strong sidelighting in the rainforests of Papua New Guinea, I photographed these Bahinemo tribesmen spearfishing on the Hunstein River as part of a *National Geographic* story. I wanted to use the rim lighting created by the late sun to barely light the sides of these men, "painting" them in the beautiful shaft of light. 24mm lens, 1/125 second at f5.6

Vatnajokull is the largest glacier in Europe, located in the interior of Iceland. Watching the sun bathe the icecap on a late afternoon, I was struck how the scene almost looked like a sea of clouds as seen from an aircraft. 20mm lens, 1/250 second at f4

THE VIEWFINDER IS OUR CANVAS and LIGHT IS OUR PAINT

The most common form of lighting photographers use is available light. If we're outdoors, it is the daylight we're shooting in. Indoors, it's the light provided by lights that are there. Using the light to your benefit is the key.

We have at our disposal six "flavors" of available light:

- **Frontlight** This is the light coming over your shoulder and falling on the subject. This creates a flat, often dull light. If you want to shoot in this, try moving around the subject, so the light falls more from behind, and using a strobe to fill the shadowed underexposed area.

- **Sidelight** As the name implies, this is light coming directly from the side. Great for landscapes and scenic shots, this light is pretty severe for people pictures, unless you're trying to emphasize character in a face (such as lines and crags). Be kind here—you want to be remembered in Aunt Betty's will. This being such perfect light for landscapes, as it gives a dimension in your photos, try including a person for a sense of scale, placing them on the edge of the canyon and shooting wide, just establishing the human presence.

- **Toplight** Noon, when the sun falls directly down on the subject, is not a favorable light to photograph people, as it creates harsh shadows and tends to be colorless. This is a great time of day to scout areas, choosing when to come back. If you have to shoot now, try a graduated filter, which will help saturate the sky's color, creating a bit more interest.

- **Backlight** This light, which comes directly from behind, can create a ethereal look, emphasizing the spray in ocean waves, giving depth and magic to smoke, and creating halos when used in portraits. This is wonderful light, but it does weaken the saturation of color. Again, try popping in a little strobe to bring up the light on the backlit side, strengthening the colors.

- **Overcast/shade** This is one of the kindest types of light for photographing people. Clouds create a giant "soft box," softening the light and smoothing out the skin. This also helps out the exposure, as the dynamic range of light that the chip can capture is within range. Side-, front-, and toplighting will often have an exposure range greater than the chip can capture in the frame.

- **Twilight** This, too, can be a "magic hour." Just as the sun goes down, the ambient (available) light starts moving more toward the blue range. Shooting on a daylight setting will emphasis this effect. Do not use auto white balance, as it will take out this cool/cold effect. Try manually setting the camera to the correct exposure for the scene, then use a strobe to fill flash the subject. This will create a wonderful dichotomy between the warm strobe light and the cool ambient light.

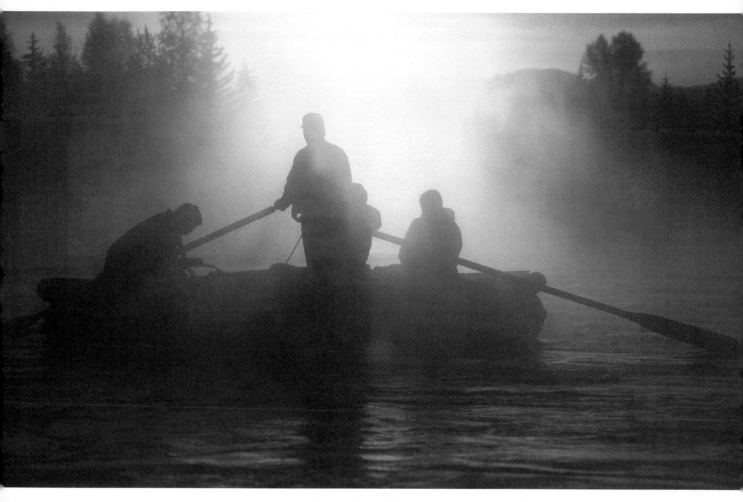

On the Snake River early one morning, the raft ahead was heading downstream and positioned directly beneath the rising sun. 180mm lens, 1/250 second at f4

The Golden Hour

It's noon at the Grand Canyon. Everyone is standing in herds on the south rim, photographing the giant expanse of canyon. The noon light is sterile, having no character of its own, yet this is the most common time that the tourists turn out. Inevitably the images are a disappointment; horribly bright and with a lot of contrast, almost a monochromatic image.

The preceding scenario is a perfect intro into the discussion of "the Golden Hour." This magical time, generally defined as the hour before sunset, produces a gigantic warming filter, and it's almost difficult *not* to take a good photograph in this environment.

One benefit of pollution is that it creates so much crud in the air that the light passing through is softened and warmed, creating that beautiful glow.

I'll often arrange shoots so I can benefit from this great light—not only the later afternoon, but the early morning as well. Either of these times will benefit your photos, but I prefer the afternoon, and not only because I don't have to get up at the crack of dawn. As evening approaches, the light keeps getting better and better, reaching its crescendo in the final minutes before the sun touches the horizon. The photographer working in the afternoon light has the opportunity to work the subject, moving around to find the best place to be when the light reaches its peak. Early morning light is also beautiful, but you have to be in place as the sun crests the horizon, and the quality of light does deteriorate the longer you work into the morning, away from the crescendo, which occurred at the moment of sunrise.

Back to that scene at the Grand Canyon… When I go out to those scenic vistas and other photo-op spots in the late afternoon or early morning, I'll usually be alone or with little company, save for other serious photographers. The tourists are filling the restaurants or sleeping in (which *is* hard to pass up on vacation). Just a little rearranging of their schedule could allow them to capture the Golden Hour.

Tips for Golden Hour Photography

- Take the tiny strobe atop many consumer and prosumer cameras, add this to the mix of Golden Hour light, and you have the recipe for successful people pictures.

- Plan your day accordingly. Use the middle of the day to scout and reconnoiter the area, to see where you want to be during the late afternoon.

- Use a compass! I always carry one in my photo vest, along with a printed page from this great website that tells you, for a specific domestic or international location, the exact time for sunrise and sunset:

 - U.S. Naval Observatory, Sun or Moon Rise/Set Table for One Year: aa.usno.navy.mil/data/docs/RS_OneYear.html

- These are a couple of other websites that offer custom information on sunrise/sunset; in fact if you Google search under "sunrise sunset charts", you'll find many states and countries offer charts specific to those areas.

 - Penguin Central-Sunset and Sunrise around the world: penguincentral.com/sunchart/sunchart.html
 - Custom Sunrise Sunset Calendar: www.sunrisesunset.com800

- Tissot, Casio, and Timex produce watches that are a combination of compass, thermometer, barometer, altimeter, alarm, and stopwatch. Compass-containing

watches are becoming more common, and are affordable and practical for shooters.

- Along with a compass, a number of websites will offer exact compass points for the exact location of sunrise and sunset from your present or projected location. These along with a compass can help you pick your spot where the solunar event will occur! (Sunrise or sunset, I mean.) Try these sites:

 - susdesign.com/sunangle/
 - www.locationworks.com/sunrise/ssr .html

- To quote the Boy Scouts, "Be prepared"— take a tripod. You may want to extend your shooting into the evening hours, and nothing is more frustrating than not having a simple piece of gear that can make such a difference.

- A graduated filter can be the difference between a successful shoot and one that is almost there. A scene where the sky is brighter than the foreground is the perfect situation calling for this type of filter. These filters are dark at the top, graduating either sharply or in a soft change to clear at the bottom. This will allow the photographer to capture the bright sky and the darker foreground in the frame. Without a filter this would be impossible, due to the great difference in exposure in those two areas. Singh-Ray makes some very good ones; I like them because they are rectangular and can be moved up and down in front of the lens, giving you far more control on where the

impacted area will be (www.singh-ray .com/grndgrads.html). The Singh-Ray filters shown here can be purchased in varying degrees of density, from one stop all the way to five full stops. Also, the filters can be had with different colorations for different effects.

Note: Filters should be oriented with darkest edge at top.
Singh-Ray Galen Rowell Graduated Neutral Density - (L) 2-stop soft-step. (R) 3-stop hard-step

Singh-Ray graduated filters, seen in both hard step and soft step. The hard step is for an exact horizon line, the soft step is for a more subtle change.

- In many photographers' bags you'll find a neutral density (ND) filter, shown on the next page. The purpose of this filter is to reduce the overall amount of light coming through the lens. Why not just stop the lens down? If you want to use a low ISO setting and shoot a slow exposure, perhaps a waterfall at midday, this is where the ND filter would work. NDs

can be purchased in one, two, or more stops. Singh-Ray sells a Vari-ND filter that allows the photographer to dial in the amount of reduction infinitely from one to eight stops.

The same neutral density filter, Singh-Ray Vari-ND, seen in three phases of its controllability

Sometimes the Simplest Light Is the Best

I always carry flashlights with me for lighting purposes—just a small one, either a standard bulb or a halogen, with an adjustable beam. I was on the Yukon River for *National Geographic*, photographing a story about the river. The day was cold and dark, and the village, Kotlik, was nearly empty. This was an important village in that it was the last

outpost of man on this mighty river. An old man walked by and I started a conversation with him. Turns out he was the oldest man in the village, and I felt that he warranted a photograph. I wanted to maintain the cold, blue look of the scene, so instead of using a warming filter, or white balancing the blue out of the frame, I shot it "as is," a daylight balance, and lit the man's face with my flashlight. The exposure was about 1/15 of a second, and I had to make sure and move the light slightly, so it would smooth out the light. The effect is seen on the facing page, just the look I was hoping to accomplish. His face is very warm, tending toward an orange-gold, because the flashlight bulb is a tungsten light source, and I knew that it produced that warmth when recorded on a daylight-based setting. The background, the village, came out with a bluish cast, again the desired look.

Cloudy days can provide a beautiful softness that is ideal for close-ups of people. The light is very kind to human complexions, and eyes won't be squinting, as they do when facing the subject into the sun.

Tom Prince, oldest fellow in Kotlik, Alaska, the last village on the Yukon. I used a small flashlight to illuminate his face. 20–35mm lens, 1/15 second at f3.5

Dynamic Range

The human eye is amazing in its adaptability. We look over a scene, and our eyes are able to see the full range of light, from shadowed areas to the parts lit by full sun. The eye has the ability to see a dynamic range, or ratio of dark to light, of about 800 to 1, while the camera is able to "see" a range of about 100 to 1. Photographers are often surprised when they look at their images and the shadows are totally black or the highlights are completely washed out. The histogram on the back of the camera can display the five-stop range that the chip can cover.

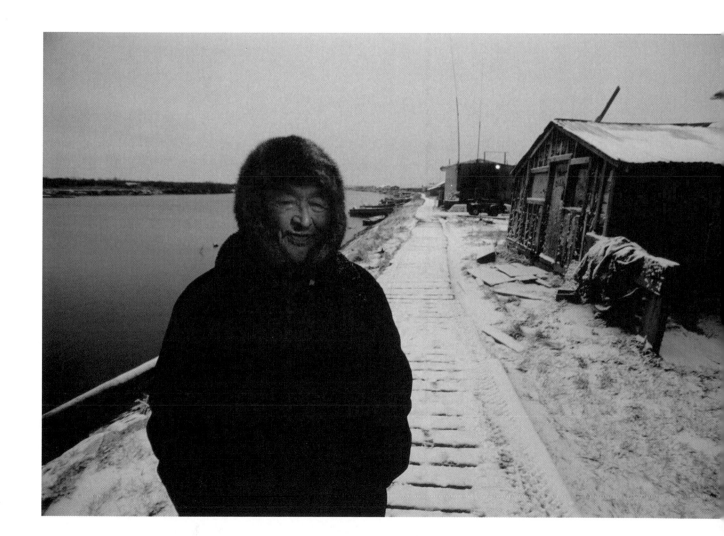

REFLECTORS

Reflectors are an easy way to add a little light to a face in shadow that will bring interest to the subject. This is another tool I always travel with and use often. All it takes sometimes is just a little bit of extra light thrown in somewhere to make that picture work. You want your photos to be noticed for the image content, not have someone look at it and comment, "Too much/too hard/too unflattering light." Often this is a case for simplification of the lighting, adding just a little strobe fill or a little reflector fill.

Reflectors can be as simple as a piece of paper used to redirect light into the desired area. When photographing flowers in a field, try using the paper to bounce light into a shadowed area of the scene. This simple trick can take a photo from ordinary to exquisite.

As a mentor for American Photo Mentor Series Trek, I was at Belgium's Ruins de Montaigle for an early morning private visit. I wanted to show the Trekkers how much impact a reflector could have on a photo. This photo is shot without any additional light, either flash or reflector. It's a nice photo, nothing special.

The same scene as before, but with the addition of a reflector bouncing light into the shadowed area of the face and on the falcon as well. This really opens the photo up, making it much more interesting. 17–35mm lens, 1/125 second at f5.6

Reflectors come in a lot of styles and sizes, from one small enough for your pocket to models requiring an assistant or two. In my car I carry four reflectors, all of which fold to a smaller size and are very portable. Here is my short list of reflectors that you may want to make a permanent part of your shooting kit:

- **Large** A 54-inch reflector is large enough to bounce back light that can cover a standing person or can be utilized for portraits. The benefit of the 54-inch size is the softness of the light that is reflected from such a large area. Move the reflector in for the softest light. Seems like a contradiction? It's not—the closer a light source, the softer the light will be. Think of moving away from the subject with the reflector, until it's about

the size of a flashlight from the subject's perspective. The light will be very focused, from a very small point. There are five ways you can use this type of reflector. One side is a solid gold color, which will reflect a very, very warm light. The solid gold side will reflect about 85 percent of the light, which can be too warm for photos of people. The other side available will often be a gold/silver mixed surface. This is not as warm as the solid gold and is a bit more efficient, about 90 percent, in the amount of light it reflects. The solid silver side reflects about 95 percent of the light, but can be a little too hard or harsh. This is a matter of taste. The other side may be black, which can be used to reduce light. If you wanted a portrait that had a bit of shadow on one side, the black side could be placed to the side of the subject to cut down on the light.

- **Medium** The medium-size reflector is used where a little harder light is desired. Say you were photographing your black Labrador. The large reflector is such soft light that the dog's black coat will absorb a lot of the light. This is an ideal situation for a smaller reflector creating a more direct light source, effectively brightening the coat.

- **Very small** A small reflector is easy to always keep with you, as it fits in a vest pocket or in the pocket of a camera bag. I was on a shoot photographing scientists collecting bugs on the Amazon, and wanted a simple light source to use for shooting the bugs they collected. A small reflector (about 12 inches across, unfolded) worked perfectly. I could get it in close, and it could be pivoted to create the exact light I wanted.

- **Scrims** These are a Hollywood favorite, as their purpose is to soften a direct light source, which is very nice for portraits on a sunny day. Open the scrim, have your assistant (read: spouse, traveling companion, innocent bystander) hold it in between the light source, such as the sun, and the subject. Very pretty light. I often use a scrim to soften the direct overhead sun, and I'll use another reflector or strobe as my main light. It's all about controlling your environment.

Understanding light does not always mean working with an abundance of light. There are times you'll want to use the selective ray of light coming through a window to partially light the subject's face and create an air of mystery. This is seeing and thinking outside the box. Watch a professional work a scene: they will work harder at getting the lighting right than just about any other aspect of the picture-taking process. Light is everything.

Often, simply using your flash in midday light will make all the difference in a photo being a disappointment, as shown here, or...

...a success, as shown here. Balancing the foreground and back-ground is necessary, which can simply mean pointing the camera at the general scene in the background, and holding the shutter button halfway down to lock in the exposure. Then, with the flash set to the TTL setting, point the camera back toward your subject and press the shutter. 11–22mm lens, 1/60 second at f5.6

On an American Photo Mentor Series Trek, I was with a group of Trekkers at an amusement park, when I saw pyrotechnic artist Melinda Rivers eating fire. Only a couple of frames were made, and the only light available was from the flame above her face. 85mm lens, 1/60 second at f1.4

STROBES and ON-CAMERA FLASH

These can be either the most overused tool or the most underappreciated feature of our cameras. Properly used, a strobe can fill in harsh shadows, turning a ghastly lit noonday photo into a pleasing portrait. Here are some tips for using your in-camera flash or accessory flash:

- If shooting at midday, turn on the flash, and allow it to fill the shadows, creating an evenly lit image. You can use your Program mode for this—go into your flash control and turn it on, usually indicated by the lightning bolt icon. In Manual mode, turn on the strobe and set the exposure to the ambient light.

- If you're using an off-camera strobe, consider purchasing a remote cord so the flash can really be used off-camera. This enables you to move the flash off to the side, and this trick alone will either eliminate or dramatically lessen the effect of red-eye. This is less of an issue today with Photoshop's Redeye

command, which will effectively remove this unsightly byproduct of direct flash photography.

- Try bouncing the light—if you are inside with a light-colored ceiling at a normal height, you can point the strobe toward the ceiling during shooting. This disperses the light, flooding the scene with it. It creates a much more natural look than direct flash, producing a more even light across the frame. This technique can create a color crossover if the color temperature is 200K different from the main light's color. Making a white balance exposure frame will correct the off color.

- Use a "bounce card," which can be as simple as a piece of white paper taped to the strobe (make sure the paper is on the backside of the flash, from the perspective of the subject). This will still utilize the flash bouncing off of the ceiling, but it will aim a wee bit of light directly on the closest subject. This creates a nice fill light, but still takes advantage of the light illuminating the area for a much more natural look. LumiQuest also makes different bounce devices, as well as mini-lightboxes that fit on the flash. One I carry always is the ProMax 80-20. This is a reflector that will attach to your strobe with Velcro, and allows 80 percent of the light to hit the ceiling, while allowing 20 percent to fill in the subject.

- Now we're going to get creative, by using the strobe with a reflector. Have your

The LumiQuest ProMax 80-20 card attaches to your external flash with hook and loop fasteners, allowing the reflector to be attached quickly or pulled off at a moment's notice.

fabled assistant hold the reflector, to direct the light just on the side of the subject's head or torso. Then use the flash as the main light. With this, you are creating a more dimensional lighting. Try not to go overboard with the reflector; just bring up the level of light or use it to light a shadowed side of your subject.

- In the old days of film, many pros using handheld strobes would tape a filter over the business end of the flash. I kept a very soft gold colored gel attached at

all times. This would "warm up" the light just a bit, which helped quite a lot with skin tones, by making them look more natural. Inherently, flash tends to be a bit blue. These little sample packs of filters are available from theatrical lighting companies, and some top photo shops carry them. Roscolux offers many different samples of their full range of lighting filters. Conveniently, these fit perfectly on many popular strobes, no cutting necessary. Don't limit your experimentation to one.

- In the digital era, the effect of this filtering trick can be white balanced out if the camera is left on auto white balance.

However, if you are shooting in raw format, this will work. Remember, raw is how the scene really looks. White balance will not impact the file, so the effect of filters on the lens of the camera, or on the strobe, will be recorded.

A Bit of Control from the Menu

Within a digital camera's menu are white balance settings, which can be used as a virtual "filter pack". These white balance settings are actually for different K settings (K meaning Kelvin degrees, the standard by which we measure the temperature of light), or the color of the ambient light. These often are shown as icons representing a standard light bulb, or 3000K, and three different types of fluorescent lighting—4000K, 4500K, and 6600K—determined by the type of fluorescent bulb. Also shown will be various daylight settings. 5300K is considered standard daylight, 6000K is the setting for cloudy daylight, and 7500K, the setting for high altitude sunlight found around noon.

This inexpensive pack of theatrical filter samples makes a perfect warming/cooling/ softening filter that will fit over the business end of an external flash. Use a little electrician's or gaffer's tape to secure it. Don't use duct tape, as it will leave sticky residue. Gaffer's tape (available at the same theatrical supply or pro photo store) will not leave a mess, even under heat.

How is this a filter pack? On a cold and rainy day, the photographer may want to emphasis the cold feeling by pumping up the blue setting. Press the WB button, and set the camera to 3000K, which is a tungsten light setting. Tungsten light, common in house lamps, produces a very warm coloration, and the 3000K white balance setting neutralizes that by adding blue. So, if you use the 3000K setting in an outdoor scene, you add blue or a mood to the image.

Conversely, we can put the WB setting to 6000K, adding a lot of warmth to the photo. Remember, this setting is a default for shooting in open shade, which is a very blue lighting condition, and the camera is actually using a mathematical algorithm to correct that color cast, by pumping up the warmth.

Tips for Using White Balance

- When shooting in an area with tungsten lighting, set the white balance to 5300K, the setting for outdoors. This will record the light from those lamps in very warm mode, which in a home setting, creates a warm and toasty mood.

- It's a rainy, cloudy afternoon. You can emphasize the cold feeling by setting the WB to 3600K, which is a setting for indoor light and will create a cooler environment in the photograph.

- Don't use the auto white balance. This takes away much of your control, as the function of this setting is to take the predominant white area in a photo and make it white. If you are shooting in a beautiful Golden Hour situation, the WB auto setting will often "correct" the golden hue out of the photo. If the light is a very strong gold, use a 5300K daylight setting or 6000K cloudy setting.

- Shoot one frame that includes a "gray card," something with a neutral reflectance. Having one of these frames to use for balancing in Curves or Levels can be of tremendous value, as making a known neutral subject neutral will color correct essentially everything else exposed in the same illuminant.

INDOOR LIGHTING

Generally speaking, our homes are not quite as bright as outdoors, so when the photographer moves indoors, ISO is one way to deal with the lesser amounts of light. The ISO setting increases the speed or sensitivity of the chip to light. The higher the ISO, the more sensitive to light the chip is—or to be more accurate, the camera uses algorithms to increase the sensitivity. This allows you to photograph in darker environments at higher shutter speeds. ISO 100 will not work if you're trying to photograph an indoor sporting event and capture frozen action. The beauty of digital is that you can specify exactly which frames you want to have an increased ISO.

The downside of increasing ISO is that the image becomes more noisy, which is very similar to the grain that happens when "pushing" the film speed up to higher areas. This ISO setting is dependent on the amount of light, not the quality. Photographers will often use a higher ISO setting to create an ethereal look or ambience, which is a result of that speed increase.

Situations that may require a boost in the ISO:

- **Indoor sports photography** When photographing inside a gym, increase the ISO to 1600. This will often provide a high enough shutter speed to freeze the action. Try combining this with flash fill, so the environment of the arena is included, not just a flash-lit subject rising out of a sea of black. Take an exposure reading of something in the gym that is a mid-tone or gray, use this to establish the manual exposure, and turn the strobe to a TTL setting. The strobe, along with the higher shutter speed, will help freeze the action.

- **Indoor events** Increase the ISO setting at birthday parties or other indoor events where you would prefer to photograph without a flash.

- **Special effects** There are times when the photographer may want the increased noise in a higher ISO image, to impart a special look or feeling to the photo.

Too often, the photographer shoots moments like this with a direct flash, eliminating all warmth in the photo. Here, I increased the ISO to 800 and exposed the photo for the candlelight on the face. 85mm lens, 1/30 second at f2

The power of light is the essence of photography, and photography is what we do and what we love. The mind thinks in terms of images, and those images are awash with light, or they wouldn't exist. Our jobs, as photographers, is to use that light, studying it ever so carefully, painting with it in our viewfinder. Watch the light. See how it moves across the land, how it paints and illuminates and creates our reality.

The moments after the sun sets can provide
some of the most dramatic, peaceful, and
invigorating light the photographer can find. In
Costa Rica, two kids (they're mine!) walk on
a beach on the Osa Peninsula. 20–35mm lens,
1/60 second at f2.8

UNDERSTANDING FRONTLIGHT, SIDELIGHT, AND BACKLIGHT

An understanding of the three basic styles of lighting is essential if you intend on taking more control in the lighting process.

Frontlight, as described in this chapter, is the light coming from behind the photographer and striking the subject. Depending on the time of day, using the sun as your main lighting source can be harsh (if shot around midday) or can be beautiful and soft (if using late afternoon light).

Shooting in the late afternoon light can be the only light source the photographer needs. Turning the subject ever so slightly from the light falling directly upon their face can provide enough shadowing to help create depth in the portrait.

A fatal flaw many aspiring photographers make is trying to shoot a nice portrait in midday sun. The light is too harsh, creating hard and unappealing shadows, and the light has no warmth to it.

Artificial Light

Sidelight can be from an artificial light source such as a lamp or flash, or it can be from the sun. Using sidelight effectively can add depth to the photo by turning the subject into or away from the light to control the amount of light striking the face. Here, I've shot a photo with full sidelight as well as from a three-quarter angle.

Using artificial lighting, such as a strobe in a "soft box" (which emulates late daylight—beautiful light—from a source the size of a window) by placing the unit immediately behind the camera, we create a very flat light as the light is striking the face equally from the camera's angle.

Now, if we move the light box off to the right of the side of the subject, we create a sidelit photo. By itself, it's not terribly appealing.

Here, the soft box was moved to the right of the subject, making a strong shadow across the face. I find this lighting unflattering due to its harshness.

Now, using the soft box from the side lighting position and using a reflector to "fill"

the harshly shadowed area, we create a very nicely lit portrait. The beauty of this system is that only one light is required; our backlight can be created by the sun, or the ambient light. In this portrait, I used a general manual exposure for the wall in the background, thereby making it a part of the composition.

Keeping lighting to a minimum can often produce great results. A main light source, an exposure for the ambient light, and a reflector to fill the shadowed area creates a nicely lit photo.

By doing this, we are using the ambient available light as our backlighting and the reflector fill light as our key light (a key light is the main light source, be it sun, flash, or a table lamp—whatever creates the main light on the subject). This method provides a multi-light setup with no lights, just a reflector. But the results look like a photo shot under very controlled lighting conditions.

Now you see why many photographers carry a reflector with them. Adding, controlling, or changing light gives the photographer more options when photographing people.

HOW TO: UNDERSTANDING LIGHT

by Joe McNally

Joe McNally shoots assignments for magazines, ad agencies, and graphic design firms. Clients include Sports Illustrated, ESPN Magazine, National Geographic, LIFE, Time, Fortune, New York Magazine, Business Week, Rolling Stone, *New York Stock Exchange, Target, Sony, GE, Nikon, Lehman Brothers, and PNC Bank. In addition to having been a recipient of the Alfred Eisenstaedt Award for outstanding magazine photography, McNally has been honored for his images by* Pictures of the Year, The World Press Photo Foundation, The Art Directors' Club, Photo District News, American Photo, Communication Arts, Applied Arts Magazine, *and* Graphis. *Joe's teaching credentials include: the Eddie Adams Workshop, the National Geographic Masters of Contemporary Photography, the Smithsonian Institute Masters of Photography, Rochester Institute of Technology, Maine Photo Workshops, Department of Defense Worldwide Military Workshops, Santa Fe Workshops, and the Disney Institute. He has also worked on numerous "Day in the Life" projects. One of McNally's most notable large scale projects, "Faces of Ground Zero—Giant Polaroid Collection," has become known as one of the most primary and significant artistic responses to the tragedy at the World Trade Center. Joe was described by American Photo magazine as "perhaps the most versatile photojournalist working today" and was listed as one of the 100 most important people in photography. In January 1999, Kodak and Photo District News honored Joe by inducting him into their Legends Online archive. In 2001, Nikon Inc. bestowed upon him a similar honor when he was placed on their website's prestigious list of photographers noted as "Legends Behind the Lens."*

I have always thought of light as language. I ascribe to light the same qualities and characteristics one could generally apply to the spoken or written word. Light has color and tone, range, emotion, inflection, and timbre. It can sharpen or soften a picture. It can change the meaning of a photo. Like language, when used effectively, it has the power to move people, viscerally and emotionally, and inform them. The use of light in our pictures harkens back to the original descriptive term we use to define this beloved endeavor of making pictures: Photography, from the Greek *phot-graphos*, meaning "to write with light."

Writing with light! As a photographer, it is very important to know how to do this. So why are so many of us illiterate? Or rather, selectively illiterate. I have seen photographers with an acutely beautiful sense of natural light, indeed a passion for it, start to vibrate like a tuning fork when a strobe is placed in their hands. Some photographers will wait for hours for the right time of

day. Some will quite literally chase a swatch of photons reflecting off the sideview mirror of a slow-moving bus down the block at dawn just to see if it will momentarily hit the wizened face of the elderly gentleman reading the paper at the window of the corner coffee shop. These very same shooters will look hesitantly, quizzically, even fearfully at a source of artificial light as if they are auditioning for a part in *Quest for Fire* and had never seen such magic before.

I was blessed early in my career by having my self-esteem and photographic efforts subjected to assessment by old-school wire service photo editors who, when they were on the street as photographers, started their day by placing yesterday's cigar between their teeth, hitching up a pair of pants you could fit a zeppelin into, and looping a 500-volt wet cell battery pack through their belts and snug against their ample hips. Armed with a potato masher and a speed graphic (which most likely had the f-stop ring

taped down at f8), they went about their day, indoors and out, making flash pictures. What we refer to now as fill flash, they called "synchro sun." Like an umbrella on a rainy day or their car keys, they wouldn't think of leaving the house without their strobe.

They brought that ethic to their judgment of film as editors. During the 1978 NY-KC baseball playoffs I returned to the UPI temporary darkroom in Yankee Stadium with what I thought was a terrific ISO 1600 available-fluorescence photo of one of the losing Royal players slumped against the wall surrounded by discarded jerseys. Larry Desantis, the news picture editor, never took his eye from his Agfa-loup while whipping through my film as he croaked in his best Brooklynese, "Nice picture, kid. Never shoot locker room without a strobe. I give this advice to you for free."

That advice was pretty much an absolute, but I have survived long enough in this nutty business to know there are no real absolutes. Sometimes the best frames are made from broken rules and bad exposures. But one thing that Larry was addressing—albeit through the prism of his no frills, big city, down and dirty get-it-on-the-wire point of view—was the use of light. What sticks with us, always, is light. It is the wand in the conductor's hand. We watch it, follow it, respond to it, and yearn to ring every nuance of substance, meaning, and emotion out of it. It leads us, and we shoot and move to its rhythm.

I could wax eloquently about how, in a moment of photographic epiphany, I discovered and became conversant with the magic of strobe light. But I would be lying. Any degree of proficiency and acquaintance I have with the use of light of any kind has been a matter of hard work, repeated failures, basic curiosity, and a simple instinct for survival. I realized very early in my career that I was not possessed of the brilliance required to dictate to my clients that I would only shoot available-light black and white film with a Leica. My destiny was to be a general-assignment magazine photographer, by and

large, and, to that end, I rapidly converted to the school of available light being "any ***damn light that's available."

Because light is just light. It's not magic, but a very real thing, and we need to be able to use it, adjust it, and bend it to our advantage. At my lighting workshops I always tell students that light is like a basketball. It bounces off the floor, hits the wall, and comes back to you. It is pretty basic, in many ways.

Given the simple nature of light, I offer some equivalently simple tips for using it effectively in your photographs. Mind you, I offer these tips—dos and don'ts if you will—with the caveat that all rules are meant to be broken, and there is no unifying, earth-encompassing credo any photographer can employ in all situations he or she will encounter. All photo assignments are situational, and require improvisational, spontaneous responses. At this point in my career, the only absolute I would offer to anyone is to not do this at all professionally, chuck the photo/art school curricula you're taking that offers academic credit for courses called "Finding Your Zen Central," and get an MBA. (However, if you're reading this, it is probably too late.)

Joe's Lighting Tips, or things to remember when you are on location and the flying fecal matter is hitting the rotating blades of the air-circulating device:

Step 1

Always start with one light. Multiple lights all at once can create multiple problems, which can be difficult to sort out. Put up one light. See what it does. You may have to go no further. (The obvious corollary to this: Look at the nature of the existing light. You just might be able to leave the strobes in the trunk of your car.)

Step 2

Generally, warm is better than cool. When lighting portraits, a small bit of warming gel is often very effective in obtaining a pleasing result. Face it, people look better slightly warm, as if they are sitting with a bunch of swells in the glow of the table lights at Le Cirque, rather than

sort of cold, as if they are the extras on *The Sopranos* who end up on a hook in a meat locker.

Step 3
During location assessment—those crucial first few minutes when you are trying to determine how awful your day is about to get—look at where the light is coming from already. From the ceiling? Through the windows or the door? Am I going for a natural environmental look and therefore merely have to tweak what exists, or do I have to control the whole scene by overpowering existing light with my own lights? What does my editor or publication want? How much time do I have? Will my subject have the patience to wait while I set up for two hours, or do I have to throw up a light and get this done? (Lots and lots of practical questions should race through your head immediately, because your initial assessment process will determine where you will place your camera. Given the strictures of location work, deadlines, and subject availability, this first shot may be the only shot you get, so this initial set of internal queries is extremely important.)

Step 4
When wrapped up in the euphoria (or agony) of the shoot, do a mental check on yourself. If you are working with a long lens, try to imagine the scene with a wide lens from the other side of the room. Or think about a high or low angle. Always remember the last thing most editors want to see is a couple hundred frames shot from exactly the same position and attitude. Move around. Think outside of the lens and light you are currently using. This can be summed up by the nagging question that lurks in the back of my mind when I'm on location: "Hey, why don't I do my re-shoot now?"

Step 5
Never shoot locker room without a strobe. (Just kidding!)

Step 6
Remember as an assignment photographer that one "aw s***" wipes out three "attaboys."

Step 7
Remember that the hardest thing about lighting is not lighting, but the control of light. Any idiot can put up an umbrella. It takes effort and expertise to speak with the light, and bring different qualities of shadow, color, and tone to different areas of the photo. Flags, cutters, honeycomb grids, barn doors, gels, or the dining room tablecloth gaffer taped to your light source will help you

control and wrangle the explosion of photons that occurs when you trip a strobe. If you work with all these elements and practice with them, you will soon see that in the context of the same photo, you can light Jimmy differently from Sally. (A handy tip: If you want something to look interesting, don't light all of it.)

Step 8

A white wall can be your friend or your enemy. White walls are great if you are looking for bounce and fill, and open, airy results. They are deadly if you are trying to light someone in a dramatic or shadowy way. I carry in my grip bags some cutup rolls of what I call black flocking paper (it goes by different names in the industry) that, when taped to walls, turns your average office into a black hole, allowing the light to be expressed in exactly the manner you intended.

Step 9

Experiment! You should have a written or mental Rolodex of what you have tried and what looks good. That is not to say you should do the same thing all the time, quite the contrary. But when you have to move fast, you must have the nuts and bolts and f-stops of your process down cold, so that your vision of the shot can dominate your thinking.

All the fancy strobe heads and packs and c-stands and soft boxes you drag along with you should never interfere with your clarity of thought. All that stuff (and it is just stuff) is in service to how you want the photograph to feel, and what you are trying to say, picture-wise.

Step 10

A follow up to Step 9: Don't light everything the same way! Boring! Clint Eastwood's face requires a different lighting approach than, say, Pamela Anderson's.

Step 11

If you're getting assignments to shoot people like Clint and Pamela, you don't need my advice.

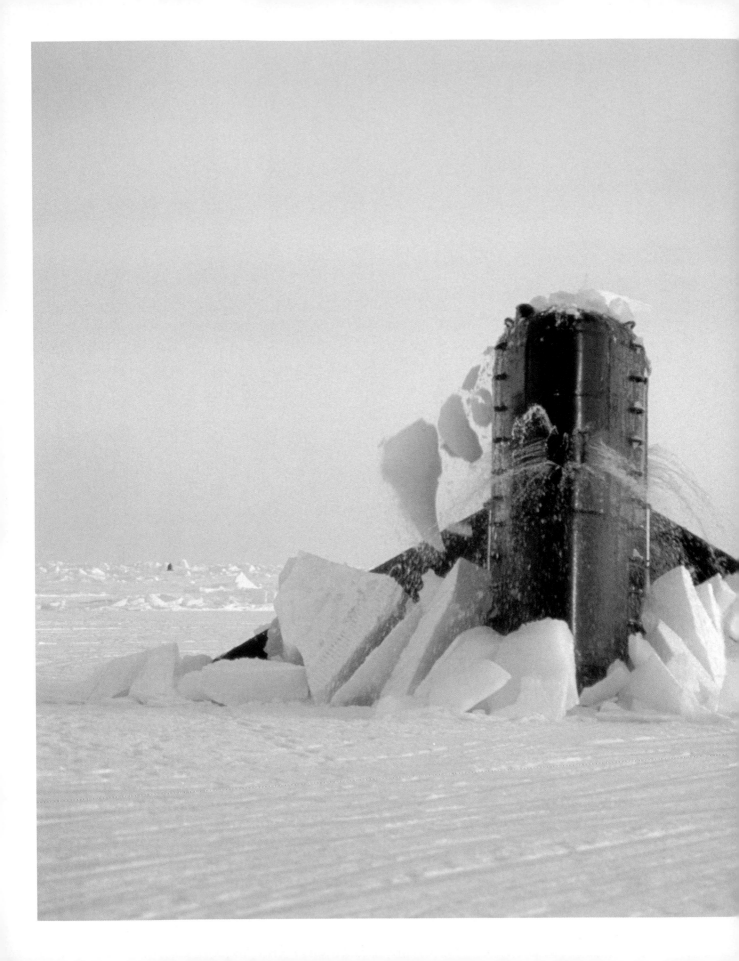

CREATIVE EXPOSURES

Does not the very word "creative" mean to build, to initiate, to give out,

to act—rather than to be acted upon, to be subjective? Living photography

is positive in its approach, it sings a song of life—not death.

—Berenice Abbott

Photography has been around since 1826, and the digital

realm has been in existence for around 15 years—still in its

technological infancy. The most common question I get these

days when someone is watching me shoot is, "Is that digital?"

Accompanying that question is the attitude among many

The USS *Hawkbill* surfaces from beneath the Arctic ice. Part
of a *National Geographic* assignment on the SCICEX program,
a five-year look at the world under the Arctic ice. 80–200mm
lens, 1/250 second at f4.5

amateurs that with the advent of digital photography and the ability to alter images in Photoshop, composition, good exposure, and creativity are no longer required. What needs to be remembered is this: a digital camera is simply another tool.

Many concepts of photography also exist in painting, such as tension, composition, and freezing a moment so we can study it at our leisure. Until 1872, painters had only mental images of how a horse appeared as it ran. Leland Stanford, ex-governor of California and owner of the Great Palo Alto Breeding Ranch, hired photographer Eadweard Muybridge, the most famous cameraman in the American West, to photograph a racing horse in his stable. Racing enthusiasts had long argued the position of the legs of a running horse, and Muybridge's images proved that at one point all four feet were actually off the ground at once. This proved to be one of the first collaborations of photography and painting, as painters used these photographs for an accurate representation of a running horse.

Just as with a painting, a photo has to work on its own—it should not require a lot of dialogue to convey the sense of what is happening. Some photos are good for the time at which they were shot, perhaps a record of an event, or the family portrait that is legitimate strictly because of its content. Great photos will be as good to view ten years from now as they are today. And what makes them great is content, moment, and composition—and how we use the controls on the camera to achieve creative elements.

What we'll talk about in this chapter is how we can use creative elements to improve our photography. This creative exploration takes photography beyond mere snapshot. Creative control over the shutter speed and aperture allows you to move beyond capturing normal scenes and begin to use your camera to explore and record your creative visions.

CAMERA CONTROLS

The assignment was for CH2M Hill, the official environmental advisors to the Atlanta Olympics. My goal was to convey the power of American athletes as they practiced for the Games. I felt that incorporating motion into my photographs would best convey the world of the athlete. Controlling the shutter speed and aperture can be used to either stop motion or accent it, and to increase or decrease the zone of focus. On this particular shoot I was going to use the shutter speed control as my creative tool.

As a contributing editor to *American Way* magazine, I shot a story on the Miskito Indians of Nicaragua. Using a very long exposure in the photo at right, the light from a very small brush fire illuminated the lower section of the trees and allowed the clouds to become a stream of texture. 20mm lens, 20 minutes at f4.5.

To control the action in an image, we can choose a slower than normal shutter speed, allowing the motion to blur. This can result in a painterly and slightly abstract rendition of the scene. Another technique is to freeze the action with a very fast shutter speed. This hyper-realistic view of the action is the most common type of sports photography, allowing us to capture the athlete at the decisive moment with their eyes focused and muscles taut at the peak of concentration and exertion.

Examples of Shutter Speed Control

Stopping motion or accentuating motion is a control at your command. An old rule of thumb in sports photography: to stop a player in motion requires a shutter speed of at least 1/500 of a second. Anything less would start showing some blur. If you're photographing a waterfall, you could slow the shutter speed down to 1/15 of a second to really emphasize the motion of the water.

In this corporate shoot for CH2M Hill, the official environmental advisors to the Atlanta Olympic Games, I was photographing the U.S. C2 kayak team practicing. Criteria for the shoot were motion and power. 80–200mm lens, 1/15 second at f5.6

The photo of the Olympic kayakers is an example of slowing the shutter speed down, here to about 1/15 of a second, and adjusting the aperture accordingly. So, instead of the boat stopped in the wave, and the motion of the paddlers arms frozen, we see a fluid-looking image. The power of the stroke can almost be felt in the photo. The detail of the water is softened and muted by the long exposure, focusing attention on the two boatsmen. I use this technique when I want to convey a sense of motion in the image and create a more "painted" look.

This slowing down or "dragging" the shutter can work creatively in a number of scenarios. Photographing lightning by using a shutter speed of 1/2 second to several seconds at dusk can capture several bolts of lightning. I've photographed freeways at night with a long exposure, the taillights and headlights of the vehicles becoming streaks of light in the frame as the long exposure captured the movement of the vehicles.

John Knaur, the digital product manager for Olympus U.S., approached me about shooting advertising photos using the 300mm 2.8 lens. This is equivalent to a 600mm 2.8 in 35mm world. John and I discussed the idea of shooting motocross riders, and I found a group of them through a local motorcycle shop. 300mm 2.8 lens, 1/500 second at f2.8

Long exposures open an entire world of possibilities that just require a tripod—the major requirement for long exposures. Another rule of thumb from the pro side of photography: when shooting wide angles, the slowest speed that can be comfortably used without a tripod is equal to the focal length of the lens. A 24mm lens could be hand-held at 1/30 of a second. I've found, with practice, that I can go a couple of shutter speed settings slower by using techniques previously described. Spread your feet apart and hold the camera up, shooting as you slowly exhale. It works!

Using a high shutter speed with a large aperture allowed me to stop the motion in the photo of the motocross rider and to blur the background. Shot at a shutter speed of 1/500 of a second, the motion of the bike is stopped. Due to the high shutter speed, a large aperture of f2.8 is needed for correct exposure, which caused the background to be out of focus. Choosing a large aperture is a creative technique that I discuss in Chapter 3.

Another fairly accurate old saw is to let the length of your lens determine the minimum shutter speed at which the camera can be hand-held. If you are shooting with a 105mm lens, the minimum shutter speed you could generally use would be about 1/125 of a second, so as not to show camera shake in the photo. The longer the lens, the more pronounced movement will be in the exposure. With really long lenses, 500mm plus, even the motion from your heartbeat can be a factor in sharpness if shooting slow exposures without a

tripod. So, if you're shooting a 500mm, then the minimum shutter speed would be 1/500 by this rule. If you don't have a tripod, try resting the camera and lens against a tree, or try shooting in a prone position resting the camera on a rock or tree stump.

Examples of Aperture Control

Think of the aperture as a window shade, increasing or decreasing the amount of light coming through the window. The aperture in a camera does the same in controlling the amount of light coming through the lens.

A Few Hints Regarding Stability and Holding the Camera

One classic flaw I notice among amateur photographers is the tendency when holding the camera to "hang" the lens from the fingers instead of supporting the lens with the hand used for focusing. This may sound silly, but try stretching your arm out and hanging a baseball-sized rock from your fingertips. Now try the same thing by cradling the rock in your palm, face up. You'll find that your arm muscles are much more comfortable supporting the weight versus hanging the weight. I've always told classes that the telltale sign of the amateur is watching how one holds a long lens.

In this same spirit, another trick of the trade when shooting slower exposures is to use your body as a camera stand more efficiently, creating a more stable platform. Spreading

your feet apart is the first step in this simple trick, and if there is a tree or wall to lean against, you are closer to performing the role of a tripod.

Okay, so you're cradling the camera lens in one hand, and the other hand is holding the camera body. Feet are spread about shoulders' width apart and you are leaning against a convenient tree or other support. Now add controlled breathing and you have increased your ability to shoot at a slower shutter speed,

sometimes up to two or three speeds slower. Controlled breathing means taking a deep breath, exhaling slowly, and pressing the shutter while exhaling.

If It Isn't Good Enough, You're Probably Not Close Enough

The fatal flaw of many aspiring photographers' work is not being close enough. As discussed in Chapter 3, we need to learn to use the viewfinder like a painter's canvas, filling the

Using the light reflected off of bodybuilders in the Baltic States, the viewer gets more of a feeling of people than if the faces were included. 300mm lens, 1/125 second at f4

frame so everything going on in the photo is relevant to the image. Moving in close is often the essential key here.

Using this theory and taking it a step further, use a portion of your subject to tell the story. Try shooting very close on someone's hands or face. This will work when the viewer knows what the subject is; otherwise it can be a meaningless abstraction.

Bringing the subject closer to the camera forces the viewer to interact with the photograph. Unless a carefully composed image uses the dead or empty space as part of the composition, a subject that is very small in the frame will not engage the viewer. Remember that your finished piece will often be a 4 × 6-inch card. A small detail in the image may be lost in a small print. Sometimes your composition needs to shout to get your message across.

ACHIEVING IMPACT in YOUR PHOTOGRAPHY

We've all seen the *Sports Illustrated* photo of the wide receiver, hands outstretched, fingertips reaching for the ball. This is a great example of impact in a photo. Impact is also about the decisive moment. The power of the athlete is conveyed in the image in an unmistakable way. Generally shot with a long telephoto lens that helps to compress the image, this forces the background out of focus because of the very shallow depth of field. Utilizing a high shutter speed freezes the action, emphasizing the instant of the catch.

A high shutter speed can freeze the runner in mid-step, the dancer in flight, or the Frisbee just outside the reach of the dog's jaws. The impact of this style of photography has defined how we think about athletes.

Adjusting Aperture for Maximum Impact

This is where long lenses shine. Try using a lens in the 200mm-plus length. The inherent nature of these lenses in compressing the field of view is amplified the longer the length of the lens. When shooting, try a shallow depth of field, f4 or f2.8. This will force the background out of focus, creating a greater zone of interest on the main subject, being the only area that is sharp.

Shooting fast-moving subjects can be intimidating at first, especially when trying to use a long lens. Try pre-focusing on a spot on the field where the runner is going to pass, such as a piece of dirt, grass, or anything that marks the spot. Then wait until they are charging toward you and press the shutter at

It's a style of photography that isn't exclusive to sports photography. On assignment for *National Geographic* photographing the Yukon River, I was out for almost nine days with the Yupik people, who fish and hunt the river using traditional methods. This photo was of a young Yupik man throwing a harpoon at a seal. The effectiveness of the photo is in its simplicity… and its power. In other words, it works by impact. 300mm lens, 1/500 second at f4

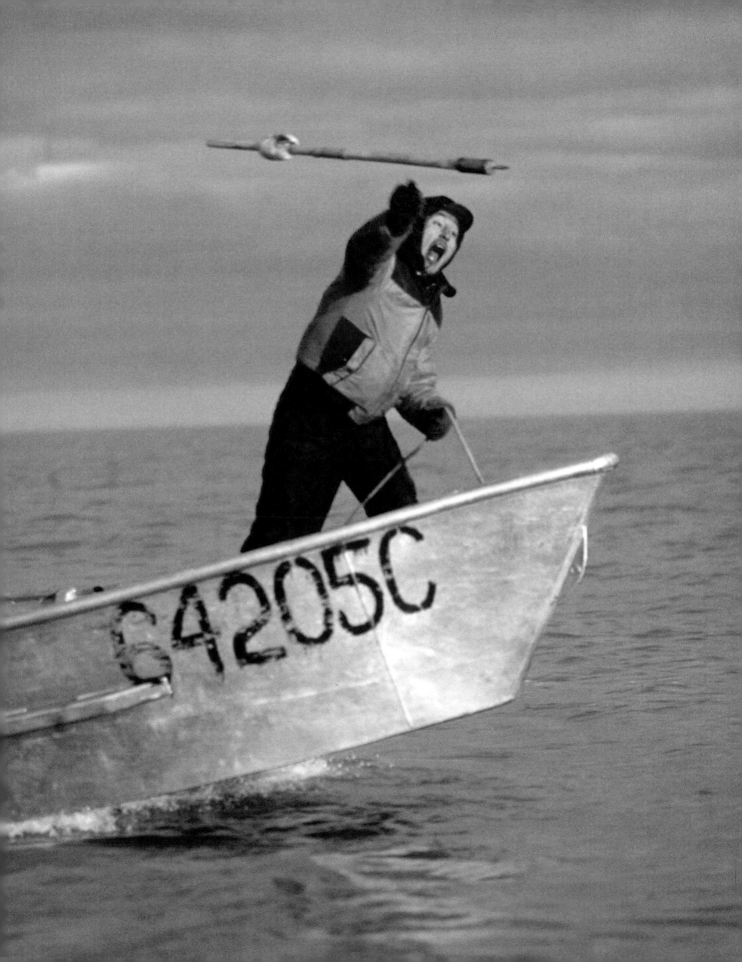

the moment they hit that spot. The more you do this, the more comfortable you'll become with shooting moving targets.

If possible, shoot with the sun or main light source at your back. Not only will this provide better light, it will be easier to track the subject. Watch for the key moment—the third baseman throwing the ball or scooping up the grounder.

The Magic of Long Lenses, the Breadth of Wide Lenses

Within our camera bags are mechanical tools we carry: telephoto lenses, wide-angle lenses, macro lenses. Each lens serves a specific purpose, enabling us to compress our photos, expand horizons, or capture the tiny details of the macro world that exist all around us. The first "long" lens I bought was an 85mm for my 35mm film camera, many years ago. I remember looking through it the first time and marveling at how the slight compression of this short telephoto lens dramatized an otherwise normal portrait. Shooting wide open, the background dropped slightly out of focus, yet the range of focus encompassed the nose to the ears. I thought it was magical.

Large apertures are used interchangeably with the term "wide open" in the photographic world. These refer to the diaphragm in the lens being open to allow the most amount of light to pass through the lens to the chip. Wide open in an 85mm f2 lens would be f2.

Short lenses and long lenses: you'll hear photographers use these terms in talking about their images and equipment. Short lenses is another term for wide angle—anywhere from 14mm up to about 40mm. Long lenses covers lenses from about 85mm up to the super telephotos of 600mm and beyond.

I was fortunate to work in a camera store when I bought my first telephoto lens. I had the opportunity to use or at least "try on" many lenses before purchasing. Because of the sheer number of lenses I could try, my choice was made simple. Looking through a macro lens for the first time, seeing through the viewfinder the life-size rendering of a tiny flower or small bug, opened up another world to me. This was such an exciting visual awakening. At the same time I was absorbing the visual lessons of *National Geographic*, *LIFE* magazine, and other photographically powerful publications. What I learned was that photographs made with a long or short lens did not rely strictly on the lens's compression or expansion effect, but that the photographer was using the physical traits of the lens along with shutter or aperture to create these wonderful moments.

The first time I looked through a 24mm was another visual epiphany. The world literally opened up, bringing a wide, new world into that tiny viewfinder. The lessons came quickly, and I learned to use a wide lens very carefully. The dramatic reduction in size of the subject as it moved away from the camera could reduce or eliminate the impact of the photo. Using wide lenses effectively takes practice. Another benefit of digital is that you can shoot and check while you are in the moment.

The start of the Ironman Triathlon is bedlam. As the sun breaks on the
horizon, hundreds of swimmers explode into the surf for the two-mile
ocean swim. I wanted to convey the huge numbers of swimmers, so I
shot this with a 24mm wide-angle lens, allowing the sea of arms to carry
the eye from foreground to background. 24mm lens, 1/250 second at f5.6

Using a wide lens, placing the subject
close to the camera, and shooting wide open
creates a very different look than shooting
with the lens closed down for a greater depth
of field. Many photographers prefer using
a wide lens stopped down to f11 or f16, to
obtain maximum depth of field so the image
is tack-sharp, front to back. This exaggerates
the feeling of distance between subject and
background.

Use leading lines with a wide-angle lens
to give a dynamic perspective. Train tracks
leading from foreground to background,
either vertically or on a diagonal, force the
eye to move through the photo, following
the direction of the lines.

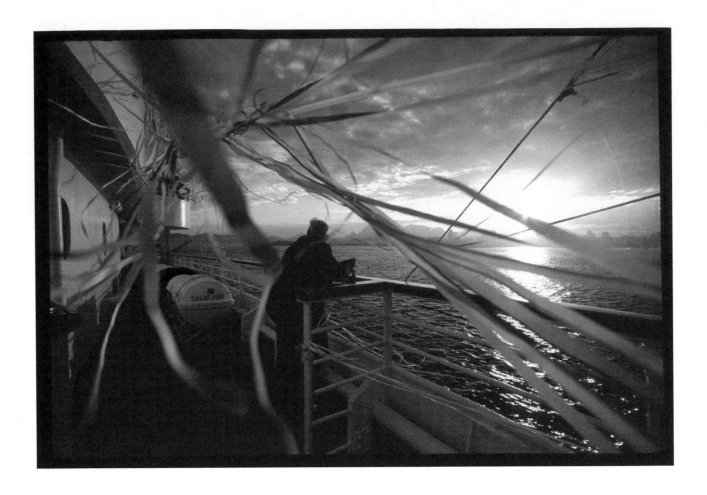

The opportunity to witness a full solar eclipse is not a common occurrence. *American Way* magazine sent me to Rio de Janeiro to meet the cruise ship *Sagafjord*, on which we were to steam 600 miles along the coast of Brazil to position ourselves in the middle of the path of totality—over four minutes' worth. This photo is an example of leading lines, the streamers, pulling your eye into the photo. Telephotos create their own "look" through the natural compression the lens creates. With the telephoto set at f2.8 or f4, the zone of focus is restricted to the subject and the background drops out of focus. If you shoot with a telephoto and the lens closed down to f11 or f16, the background will appear more in focus, which can be either a distraction or a benefit to the photo. 20–35mm lens, 1/125 second at f4

We have so many options, both within our camera bags and within our thinking process, to control creativity in our photos. Learning about your equipment and understanding the traits of particular lenses will enable you to use that knowledge to your own photographic advantage. Remember, the photographer makes the image, not the lens or equipment. This is a key point of this or any other photo book. The photographer's vision makes the photo, and the camera and lenses are creative tools we have to work with, similar to the painter being able to choose from different brushes.

Digital is the perfect tool for growth as a creative artist. The ability to check your photographic endeavors in "real time" versus looking at them as a historical artifact, as with film, is invaluable in the growth process of a photographer. Experimentation without the costs of film and processing is an obvious benefit. The EXIF file, which is attached to every photo, contains information on the shutter, ISO, aperture, and white balance as well as the date the photo was shot. This EXIF file information, found through File | File Info | Camera Data 1 & 2 in Photoshop, can provide answers for your photographic experimentation. Say you shot photos of your child's soccer game, and the photos were blurred. Look at the EXIF file to determine the exposure used, then increase the shutter speed for the next game. Your photographic experimentation is documented with digital.

Note The new Photoshop CS2 has seemingly changed the old EXIF moniker to Camera Data 1 and Camera Data 2.

HOW TO: CREATIVE SHUTTER CONTROL

Since the invention of photography, two constants in the world of the photographer have been shutter and aperture. The equipment may become more and more technically sophisticated, but these two compatriots of the camera are still the core of the mechanical side of the camera. Here are a few ideas on using the shutter as your creative tool.

■ If you are using your camera in the Program mode, you still have control over the shutter in most cameras. Moving the control dial while in the P mode will allow you to change the shutter speed and the aperture in sync. You will notice that the mode indicator will change from P to Ps or some other indicator that you are using as the Program mode, but you are changing the default shutter speed. In the P, S, or A mode, the camera will automatically adjust the aperture to match the new shutter speed you've chosen. A flashing exposure number or exposure warning means that

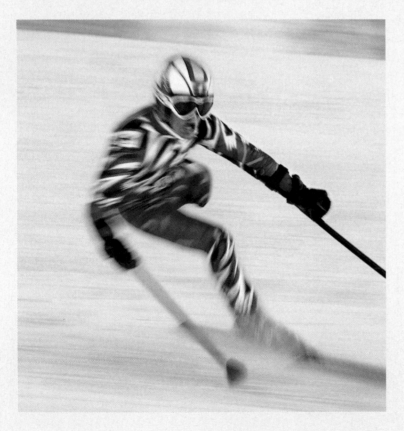

Working with designer Mike Sukle in Denver to photograph an ad campaign for the National Sports Center for the Disabled and that organization's skiing program, I shot this world-class skier running a grand slalom course. Shooting with a slow exposure to create the feeling of speed, I also used a powerful battery-powered strobe to illuminate the side of his body as it passed, freezing some of the detail on his outfit. 80–200mm lens, 1/4 second at f4.5

you have either too little or too much light available for that particular shutter speed. If necessary, adjust the ISO to compensate. Moving it to a slower speed will set the aperture correctly.

- If you're photographing a moving object, try "panning" with the subject as it passes. Panning is the trick of following the motion of the passing subject with the camera. When combined with a slower shutter speed, in the 1/30 of a second or less range, panning will make the background blur with the motion, but the subject will retain some sharpness—creating a feeling of speed in the still photo.

- Along with the previous method, try using either the pop-up flash or a supplemental flash for fill-in light. Setting the flash to the TTL (through the lens) mode provides the most accurate flash setting as the camera meter is reading the flash as the lens sees it. As the subject moves by you, the flash will help freeze the subject while the background exposure is maintained. I do this in Manual mode, often underexposing the background by about a half stop. This makes the moving subject become more the visual center of the image as the background becomes a little less prominent. I've also found that the camera/flash combination needs to be tested to achieve the perfect balance. For my tastes, the flash is also set about two-thirds of a stop underexposed, creating a more natural looking light.

- Many modern strobes provide an ability to use much higher sync speeds than normal but only if using the proprietary strobe for that camera. The Olympus E1 with an FL50 strobe allows a shutter speed of up to 1/4000 of a second sync in Special mode versus the maximum 1/180 of a second in Normal mode. The effective guide number is greatly reduced, meaning the power of the strobe is limited to very close subjects. But this can work well in brightly lit situations where you may want to use the strobe for fill light, such as a midday portrait with the subject near the camera and the vista in the background, or an environmental portrait where you want the background to be totally out of focus.

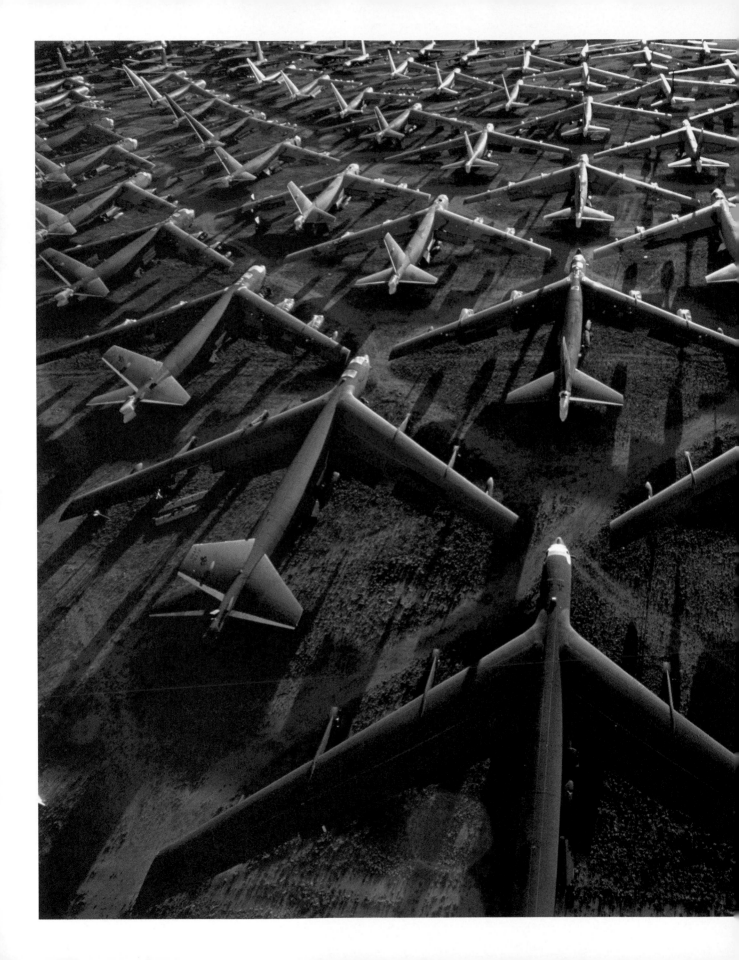

COMPOSITION

Every other artist begins with a blank canvas, a piece of paper…the photographer begins with the finished product.

—Edward Steichen

In the craft of photography, we work with a small canvas, the viewfinder, just as the painter works with their canvas. The photographer and the painter construct their images using moment, content, and composition. One of the main components of a good photograph, the composition of an image is often the engine that drives the photo.

Davis-Monthan Air Force Base is the retirement home for many U.S. military aircraft. These giant B52s, with a wingspan of 300 feet, look like a field of toys, and their repeating pattern is what makes this photo work. 20mm lens, 1/125 second at f8

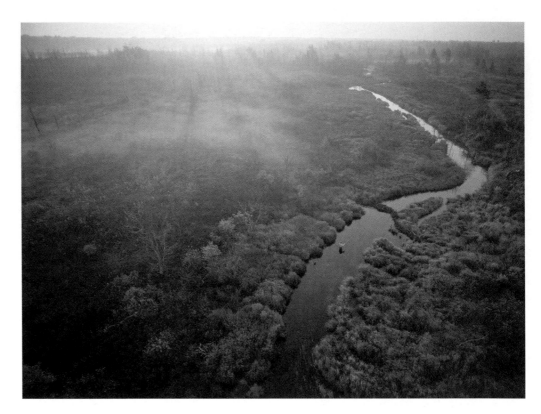

The "S-curve" and offset horizon are two classic compositional tools used to make this photo successful. Shot as part of a story for *National Geographic*, I photographed this fly-fisherman at dawn on the Fox River in the upper Michigan peninsula. 20–35mm lens, 1/60 second at f4

By following a few rules of composition you can create even better photos. What are the rules of composition and how do you apply them in your photography? This chapter will be a discussion of various rules and guidelines, always remembering that these are not written in stone, as composition is a subjective issue. Part of the joy of this craft is using the rules as well as bending them or totally ignoring them. As with painting, we decide if we think the image is successful.

RULES of CLASSIC COMPOSITION

For centuries, painters have followed several rules of composition that are applicable to the world of photography. These include the rule of thirds, leading lines, and tension.

The Rule of Thirds

One of the classic compositional theories is the "rule of thirds." This is a simple but quite effective way of constructing your image so

the viewer's eye is drawn to one of several key spots. Applicable in both the art and photographic worlds, this helps create images that are nicely balanced and pleasing to the eye.

The intersection points on the horizontal and vertical lines are the spots where you should place your subject or point of visual interest.

To visualize the rule, take your viewfinder and divide it equally into thirds, both horizontally and vertically. The photo is then composed allowing the subject or center of interest to fall on one of the four intersection points.

S-Curves

The eye is also attracted to the gentle sweep of an S-curve (see the following page). Be it a road or river leading from the foreground into the distance, this curve will draw the viewer's eye along the path where your main subject can be placed.

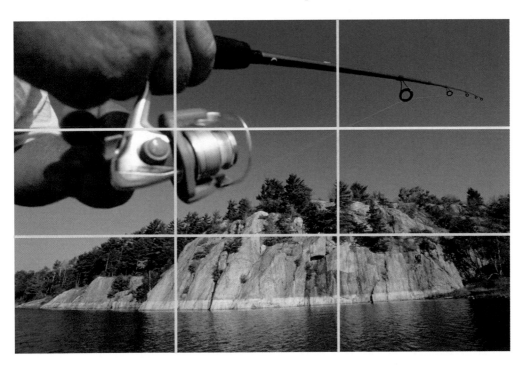

Photographing the dynamics of the rise and fall of water levels in the Great Lakes for *National Geographic*, I wanted to illustrate the high-water mark on the rock face in the background. Using the "rule of thirds," I photographed a fisherman as he worked the waters on Georgian Bay on Lake Huron. I placed the reel and hands at one of the intersection points in a "rule of thirds" grid, drawing the viewer's eye to the reel. 20–35mm lens, 1/60 second at f11.

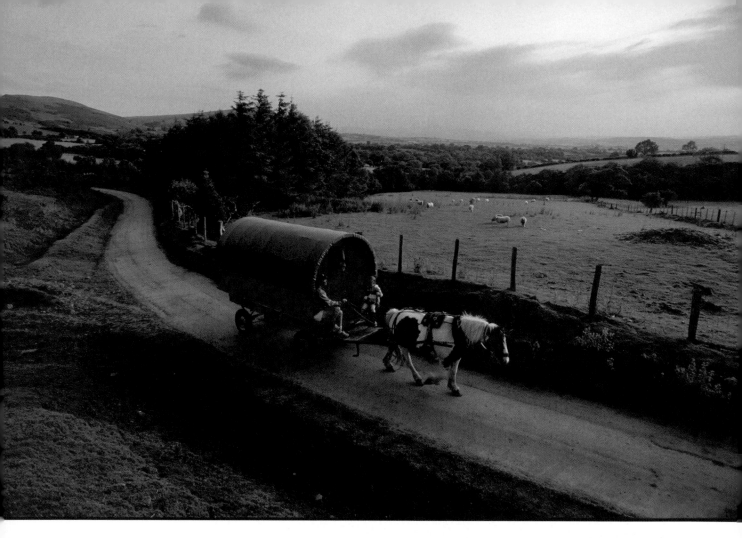

As a contributing editor with *American Way* magazine, the in-flight journal of American Airlines, I shot this assignment of a horse-drawn gypsy wagon in Wales as part of a story. The S-curve of the road pulls the eye into the photo, adding to the gentle feel of the image. 24mm lens, 1/60 second at f4

Rhythm and Repeating Patterns

As shown in the opening photo of the B52 planes, another compositional theme is repeating patterns or rhythm. Seen in the redundant pattern of the aircraft, this theme carries the eye from the foreground to the background of the photo.

Using Horizon Lines

Horizon lines are best not placed across the dead center of the photo. When centered, the photo is divided into two distinct frames in the viewer's mind. Both parts are given equal importance and no tension is introduced into the frame. It's better to have the horizon line

high in the frame, emphasizing the foreground or, conversely, placing the horizon line low and emphasizing the sky.

This photo (below) places the horizon at the top of the frame and uses the lines of the river to pull the eye into the heart of the image.

Leading Lines

Leading lines, such as a fence going from foreground to background, draw the eye into the photo and along the course of those lines. This is a powerful way of using an element in the environment to pull the eye along a given path.

Layering

I was shooting an assignment for *Geographic* on the dynamics of the Great Lakes, how the lake levels rise and fall cyclically. The latest lowering of the lakes levels has been the greatest in the shortest period of time, and my job was to illustrate that fact. I used "layering" in the composition of the photo on the following page. This is the creating of different layers of interest: the beach chairs form the foreground layer, the beach the middle layer, and the shore and hotel form the background layer. This forces the viewer to absorb the content of each layer and combine

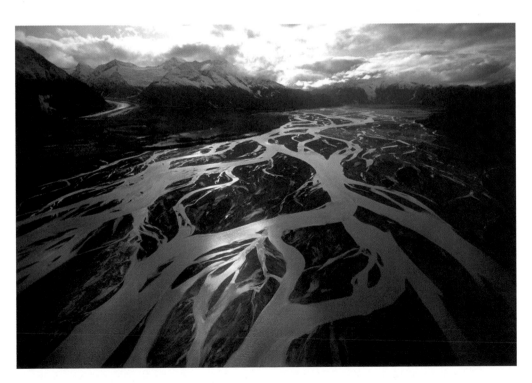

A horizon line placed high in the frame creates a more interesting photo of the confluence of the Tatshenshini and Alsek rivers in Alaska. If the horizon had cut across the center of the image, it would have been too symmetric to be interesting. 24mm lens, 1/250 second at f4.5

The normal lake levels are far up the beach; here a hotel had set beach chairs at the new shoreline. 17–35mm lens, 1/125 second at f5.6

the information for the photo's message. Here I was showing the effects of the lowered water with those three different components.

Look at the classic documentary work of Larry Frank, Danny Lyons, and Henri Cartier-Bresson to see how these photographers used the different layers of the photo to create entire dialogues within each.

Scale

By simply adding a familiar element to the photograph, such as a human, car, or animal, we create an instant indicator of the size of the landscape or subject. This is a great way to inform the viewer of the scale of the photo.

Tension

This is what we take aspirin for, right? In our real lives, perhaps. But in the world of graphic arts, tension is a tool we can use in our photography to convey a feeling in the photo. Two-time Pulitzer Prize–winning photographer (and friend) Larry Price provides this definition of tension:

"The idea of 'tension' in a photograph or other two-dimensional image—as in a painting or collage, for instance—can be interpreted as a manner of composition that excites the visual senses apart from the generally accepted 'rules' of composition. For instance, classical composition such as the 'rule of thirds' usually results in a pleasing arrangement regardless of the subject matter. But if the artist breaks all the rules and uses extreme compositional techniques, the resulting visual 'tension' sometimes results in a more engaging image. For instance, if the photographer severely tilts the camera frame, visual tension is induced because the viewer isn't accustomed to viewing the real world from a skewed perspective. These techniques sometimes work because they stimulate the visual senses to accept the information as a new and different way of looking at the world. The best photographers and artists constantly challenge the basic rules of composition to find ways to infuse this tension. If successful, the results yield energetic and vibrant visual statements."

This photo of the village of Wagu in Papua New Guinea was shot on assignment for *National Geographic*, as part of "Return to the Hunstein," a story dealing with an unexplored area of the country. I wanted to illustrate what this village looked like in a visually interesting way. I had a villager walk through Wagu with a lantern, having taken an exposure reading of the light that the lantern cast on the huts, and waiting until that exposure matched the exposure of the light in the sky. The line created by the lantern's light, and the lines on the walls of the building, act as leading lines, pulling the viewer's eye into the photo. 20mm lens, 20 seconds at f5.6

Using scale as well as filling the frame, this very simple photo works in conveying the size of this black-sand desert dune in Iceland, one of my favorite places on earth. Including the car and person provides the viewer with an immediate idea of the size of the landscape. 180mm lens, 1/250 second at f4.5

KEEP IT SIMPLE

When my kids were younger, one of their favorite books was *Simple Pictures Are Best* (by Nancy Willard). That title is a good motto for photographic success. By eliminating distracting and unimportant material in the photo, we force the viewer to interact with the subject.

In our visually sophisticated society, I'm surprised that one of the common problems I see in many photographs is there's too much going on in the frame. The photographer is often so excited by what is happening in front of the lens that they don't remember that the camera is capturing everything in the field of

In 1994 Rick Smolan organized a group of photographers to document the "reopening" of Vietnam. From this shoot, the book *Passage to Vietnam* was published. My assignment for this was the small H'mong village of Sapa, ten hours by train from Hanoi and another few hours in a four-wheel-drive military vehicle to this small village in the "Tonkinese Alps" on the Chinese border. Sapa was the cultural center of the H'mong and frequently for the Tai and Red Dzao hill tribes as well. This photo was shot late one night in the village center during a downpour. I wanted the umbrellas to be the identifiable objects and the core of the composition. Although it violates several rules in terms of straight horizon lines, sharpness, and focus, I think the photo is still successful in conveying a feeling for the time and place. 20–35mm lens, 1/2 second at f4

focus. A frequent comment when viewing photos in print form or on the computer monitor is, "I didn't realize that was going to be in the photo."

Move close and fill the frame, remembering that the viewfinder is your world, and everything in the frame should be relevant to the image. Don't hesitate to physically move closer or farther back to frame the subject. Many photographs suffer from the photographer allowing their eye to become the zoom lens, never changing their physical perspective by moving closer to the subject.

Another often-prescribed rule in photography: Don't place your subject in the middle of the frame. This habit is like kids learning to kick soccer balls—the natural tendency is to kick to the center of the goal where the goalie is. The tendency for the new photographer is to center everything. Photographically this can create boring images.

A few thoughts on keeping your photos simple and graphically appealing:

- Use one center of attention in the image. Too many areas requiring the attention of the viewer will create a confusing image.
- Move in close to fill the frame or farther back to capture more of the environment.
- Move high and low to change your perspective.
- Use fence lines or other leading lines to draw the viewer to the subject.
- Be aware of what's in the frame. Sounds simple, but too many photos suffer from being way too busy.

- Use the viewfinder as a painter uses a canvas, making certain that everything in the frame is relevant to what the photo is saying.

BREAKING the RULES

Now we'll go in the other direction and discuss breaking the rules I've described. Photography is an art form—and a subjective art form at that. Our criteria for what makes a great photo is personal. The photo I love, someone else might find uninspiring. I enjoy looking at some of the photography found in many publications such as *Condé Nast Traveler*. The out-of-focus, weirdly cropped, strangely composed pictures may succeed because they draw the viewer into the image and create a sense of place.

These work on a different level, speaking to emotion instead of a literal translation of the subject. Many photographers are flaunting the rules of focus and composition and are succeeding in producing powerful images. The point once again: does the photo work or not?

What Makes Your Photo Work

A photo can work on several levels. Compositionally the photo can be well constructed—following the rules of composition—and it may not work. Bert Fox, a *National Geographic* photo editor, sits at a lightbox or in front of a computer monitor all day, looking through thousands of photos and deciding during the

Kayaking in Glacier Bay National Preserve was a great assignment for *Condé Nast Traveler*, and I wanted to create a different looking photo. The camera is in an Ewa bag, a waterproof and flexible housing that I held just above the water's surface. 20mm lens, 1/125 second at f5.6

edit which images to keep. Bert has to make a very fast, instinctual decision on what photos are "working." What is it that makes the photo succeed?

One of the greatest powers of photography is the ability to capture reality. We are photographing moments in our lives, and these images can become a testament to that time. Is it art? If the photo is strictly a document of a moment with no intent of composing or using elements to convey a message, that photo probably does not qualify as art.

But if the photo creates an emotion in the viewer, whether it's nostalgia, melancholy, outrage, or humor, and if it also has craftsmanship, then perhaps it becomes

art. The photographer has the ability to use compositional elements to construct at least a visually interesting photo. But to take that photo to the next level requires the photographer to combine composition, the sense of the moment, and historical or emotional content.

We're taught from early on that first impressions are important. This is true in photography as well. How well the viewer reacts initially is how that photo may be remembered. The reader of a magazine will linger on a photo for less than a second. The photographer has to create a first impression that will force the viewer to linger. The photograph has to succeed on deeper layers of meaning.

HOW TO: USING a MULTITUDE of TOOLS in YOUR COMPOSITION

As we've seen from this chapter, there are a number of tools the photographer has at hand to empower their photographic composition.

Use your wide angle lens to create a sense of space and emphasize the vastness of an area. In many workshops I teach, I find many amateurs are hesitant to use a wide lens, thinking that the only purpose of this lens is to get more in the photo when space is limited. The wide lens is a common and irreplaceable tool in almost every pro's bag. Dynamic structure and leading lines are a couple of the strengths of this tool.

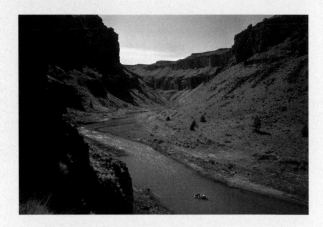

When using a wide lens, try using something in the foreground to "frame" the subject. This will establish more interest in the photo by creating a layered effect of foreground to background.

This image of Sydney, Australia, is more interesting due to the tree leaves framing the photograph.

The repeating pattern of the mountains and the clouds in this valley are enhanced by using a long lens to shoot this photo of Great Smoky Mountains National Park. Use a long lens, 200mm or longer, to compress the image. Longer lenses require more stability as any movement with the camera will be emphasized.

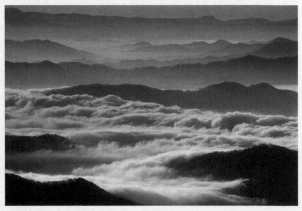

Using leading lines with a wide angle pulls the viewer's eye along that line and can help make an interesting composition. When shooting wide, use roads, fences, and architectural features, i.e. any strong vertical or diagonal lines, to draw the eye through the photo.

Using a long lens with its natural compression in addition to using a palette helped create the composition in this photo from a *National Geographic* story on the Fox River. Everything in the photo appears to be on the same plane of interest. With a long lens, keep your foreground simple and uncluttered, and have a main area of interest in the photo that the image is built around. The compression of the long lens will then bring more attention to the subject.

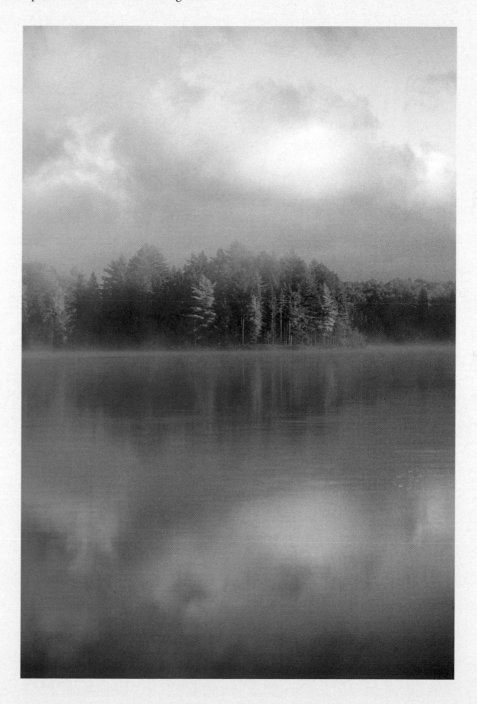

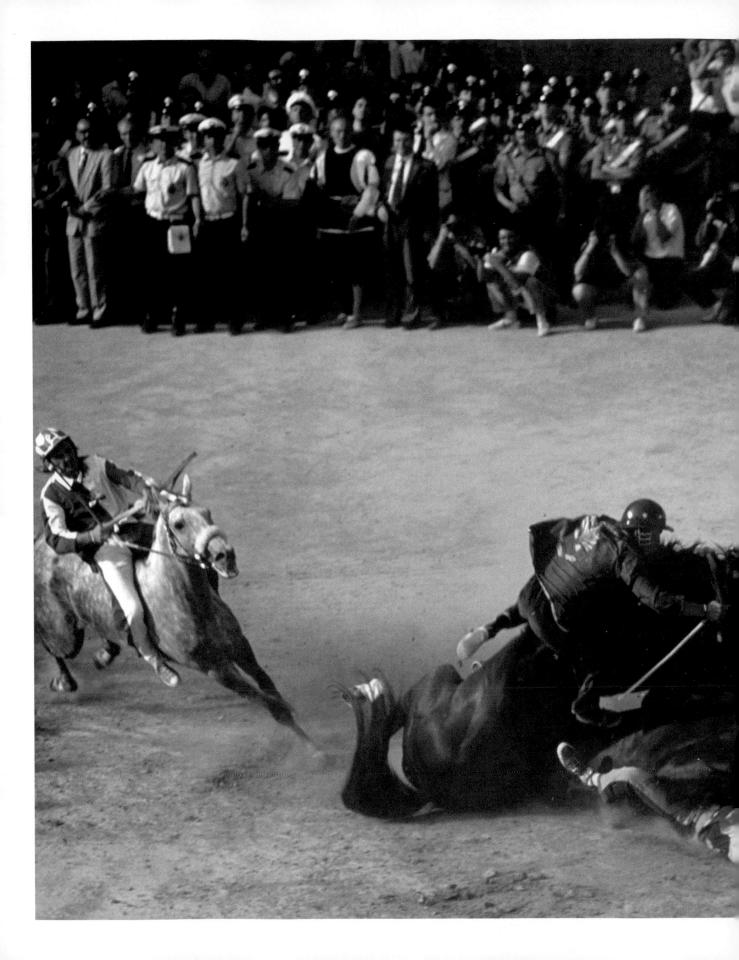

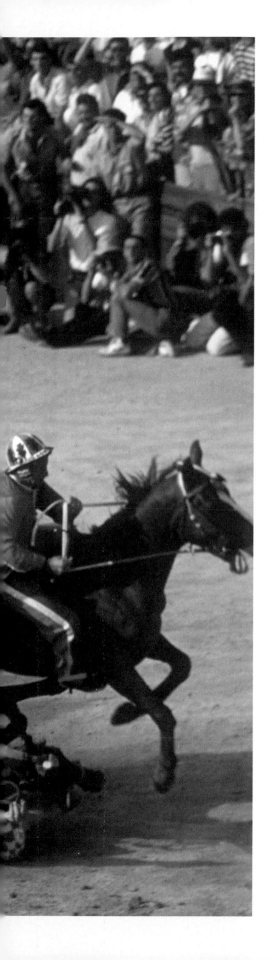

TELLING the STORY

Photography is a way of feeling, of touching, of loving. What you have caught on film is captured forever…it remembers little things, long after you have forgotten everything.

—Aaron Siskind

We all love a good story. From Steinbeck's *Cannery Row* to Mark Helprin's *A Soldier of the Great War*—these works form powerful mental images. As a kid in school, I remember reading *Cannery Row*. Steinbeck's ability to create imagery in my mind while telling a great story has always stayed with me. I think the role of a photographer as storyteller is fairly similar, pulling the viewer

Rounding the corner on the most dangerous turn of the Palio, held twice annually in Siena, Italy, a couple of the horses start to crash. Part of a photo essay I shot on the famous centuries-old race for *American Way* magazine. 80-200mm lens, 1/500 second at f4

into the story and using your photography to create a narrative for the viewer. This chapter will deal with the process of telling a story in photos.

Whether it's shooting for the family album or shooting for *National Geographic*, constructing a story and providing the viewer with key elements gives the photo story life and generates interest in the viewer. A story should have several key components: an establishing shot, a close-up to explain what is going on, a photo or photos with a key moment that creates an interest, an image that can finalize the story, and a visual style that ties these together.

Part of the process of shooting a story for *National Geographic* involves a story conference involving the writer and photographer team working on the particular story. This conference occurs at the outset of a project to make certain everyone is on the same page. The photographer and writer both bring their own narrative to the story. In this chapter we explore that process of finding and weaving a story together.

THE COMPONENTS of a STORY

Many aspiring photographers want to know how to find a story to shoot. They are thinking that the story needs to be some grand work, instead of finding what is important to them. What could be better to photograph and construct as a photo piece than a subject near to you? Too often the individual is thinking

on too large a scale, ignoring what is in their backyard or neighborhood. Look at the people around you. Try photographing your son or daughter during their soccer or swim practices. Try shooting a story on a local Fourth of July celebration or your family vacation. These are naturals and are easy to work with because we immediately eliminate the intimidation factor that so many find a very large hurdle.

A photographer assembles a story much the same way a writer does, with an introduction that includes an overview of the subject, a main body of work addressing details, and a closer. A successful photo story contains its own narrative, carrying the viewer through the different parts of the piece.

Set the Scene

As the photojournalist—and this is truly what you've become, since you will be creating a visual narrative—you need to create an image to establish where you are and how the subject fits into that environment. This opening shot will bring the viewer into the world of the subject and give them a sense of place.

Photographing one of those simple moments can produce a nice photograph. Here, my daughter Maggie pets Wally, a draft horse. The interaction between Maggie and Wally is what makes this photo work. Her expression as well as her hand touching his nose are the necessary gestures that add to the photo's success.

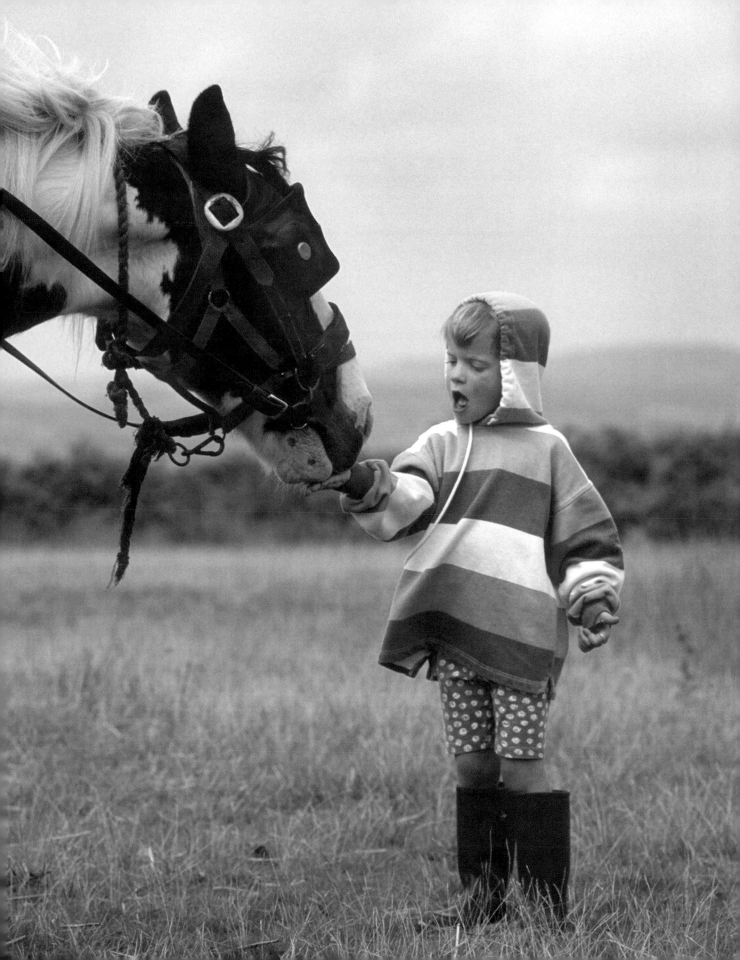

Back in the days when I was a newspaper photographer, an unwritten rule of covering a news story was to shoot an initial overview of the scene as you approached the story. This still holds true in magazine photography or in sharing your vacation photos with relatives: open the story with a scene-setter.

What is a scene-setter? It's a photo that visually describes the location in which you are shooting. Whether it's Dubrovnik or Disneyland, this establishing photo can be very simple in its construction. A well-composed image of the gates of Disneyland or an over-view of the city of Dubrovnik shows why this place is different from home. It introduces the location to the viewer.

The Magic Can Be in the Details

Once you have an initial opening photo, you can work on several photos to create the story of the trip to Disneyland or Dubrovnik. Shooting the entrance tickets clutched in a tiny hand says a lot about where you are. A close-up of the lavender flowers that Croatia is famous for introduces that fact to the viewer. These detail photos can provide much information about your location and can be a way of creating a more personal interaction with the story. Moving in close for detail forces the viewer into a more intimate relationship with the photo story.

Here is where research on your subject really pays off, as it allows you to capture what you find interesting about this subject or place. The photographer's personal perspective is

unique and should be considered central to the telling of the story (somewhat like the three blind guys describing the elephant).

The photographer's job is to stop the viewer and draw them into the story, bringing them information that they may not have been aware of or conveying a sense of place that is fresh.

Bring Life into the Story with Portraits

Effective portraiture can bring life to a story as it obviously conveys a sense of whom we are photographing. People love seeing and understanding other people, and a strong portrait is a very inviting way to draw someone into your story.

An area that aspiring photographers may have difficulty with is shooting close portraits of strangers. This is discussed in detail in Chapter 8, but here are a few important points regarding portraits in a photo story.

An opening photo often will be one that conveys a sense of place, providing the viewer with a feeling of the area they're seeing. This photo of Auyan Tepui, in southern Venezuela, works because of the large granitic formation of the Tepui (Angel Falls cascades from atop Auyan), the river in the foreground, and the clouds topping off the scene. 80–200mm lens, 1/250 second at f4

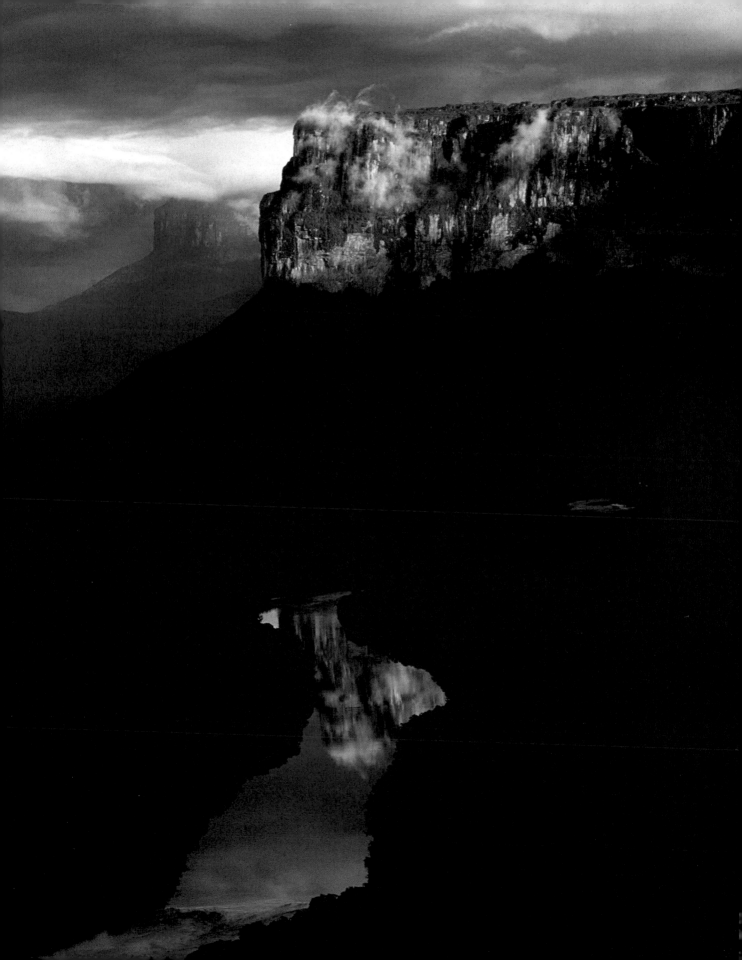

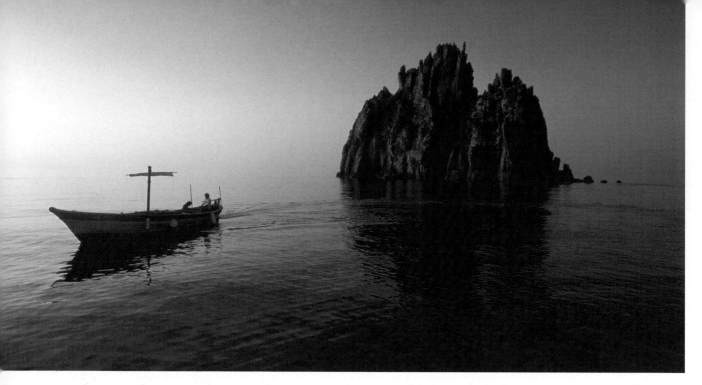

Part of the magic of photography is using composition or creative elements to set the scene. Here, on a shoot for *National Geographic* in the Aeolian Islands, I shot this fishing boat working the waters around the amazing rock formations off of Panarea. The light allowed the boat to become almost a silhouette, but enough detail remains in the water and people aboard to give them definition and help set the scene. 20–35mm lens, 1/250 second at f4

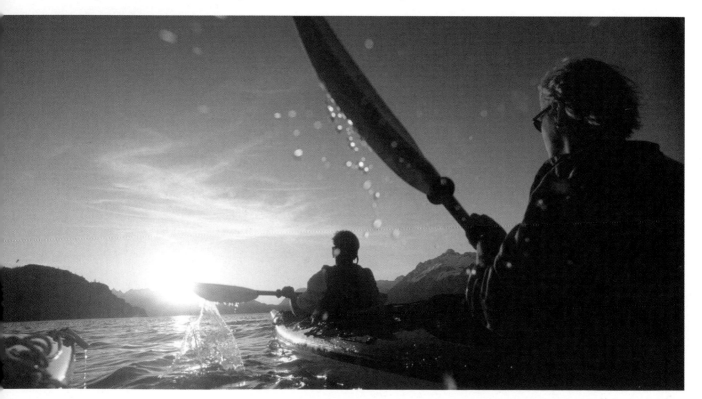

Using this photo of sea-kayakers in Glacier Bay National Park, part of a story I shot for *Condé Nast Traveler*, I wanted to force the viewer to be part of the experience of kayaking, so I shot the photo from a very low angle, the camera in a waterproof housing, to place them in the scene. 20mm lens, 1/125 second at f4

■ Approaching a stranger on the street can be intimidating at first. However, a bit of confidence along with a compelling reason why you want to photograph that person can go a long way. You're shooting a series of portraits on the craftsmen in the flea market, or fishermen in a small village. Most potential photographic subjects will comply with your request if it sounds legitimate. The first few times are the toughest, and it does get easier.

■ Show an interest in what that person is doing. That's what appealed to you photographically in the first place, right? I've found that if I am sincere in my interest, more often than not I am allowed to photograph that individual. Here's where asking some questions about what they're doing can be of some value as it allows the would-be subject to be the expert. Genuine interest is often a ticket to making a good photograph. When you take the time to be interested, you're an interesting person to the subject.

■ Photographing that person doing what attracted you in the first place is essential. This takes time as the first few minutes they probably will be staring at your camera waiting for you to take the photo. Explain that you would like them to do what they were doing when you approached, then give it time. I'll often spend an hour or so (if it feels like I'm not intruding) watching and waiting for that one moment.

■ That bears repeating: photography takes time. This makes budgeting your time important, especially if you're not at home.

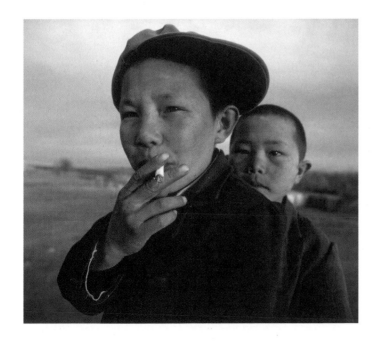

Stories involving people usually benefit from a tight, close-up portrait. This makes the photos much more personal by forcing the viewer to visually confront the subject. This photo of a couple of kids was shot for *A Day in the Life of China*. Typical of any son anywhere in the world, the 12-year-old on the left was scared his mother would see him smoking. 35–70mm lens, 1/125 second at f4

Key Moments Are Essential

This is a natural extension of our last point, as working the situation for key moments also takes time. A key moment is, as Henri Cartier Bresson described, existent in every situation in life. The dynamics of two people conversing on the street will build to a "decisive moment" where the gestures of the individuals reflect the peak of energy in their discussion. It doesn't have to be a dramatic over-the-top photo to be powerful. An example of a key moment could be the second a woman touches her new grandchild's face, how her face lights up as her hand is extended to touch the baby. Or when the Little Leaguer leaps in the air after touching home base with his team around him—now, *that* is a loud key moment.

These key moment photos will bring life and energy to your story, and can be the fabric that not only connects the images, but also helps the viewer understand how those moments felt.

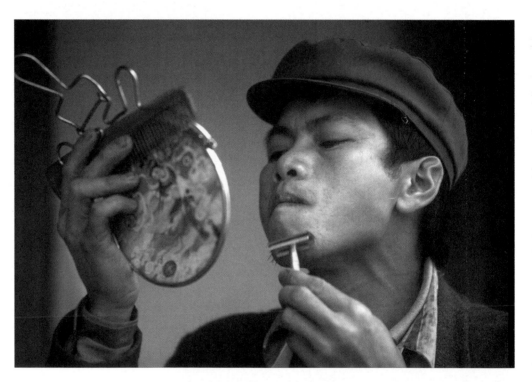

A key moment does not always have to be a super-dramatic, wide receiver flying through the air with the ball on fingertips photo. Some key moments can be much more gentle. This photo of a young H'mong man shaving before visiting his girlfriend is an example of such a moment. The facial expression, the razor on chin, the mirror held at just the right angle, all reflect the instant he was most focused in this simple task. This was shot for *Passage to Vietnam*. 80–200mm lens, 1/60 second at f4

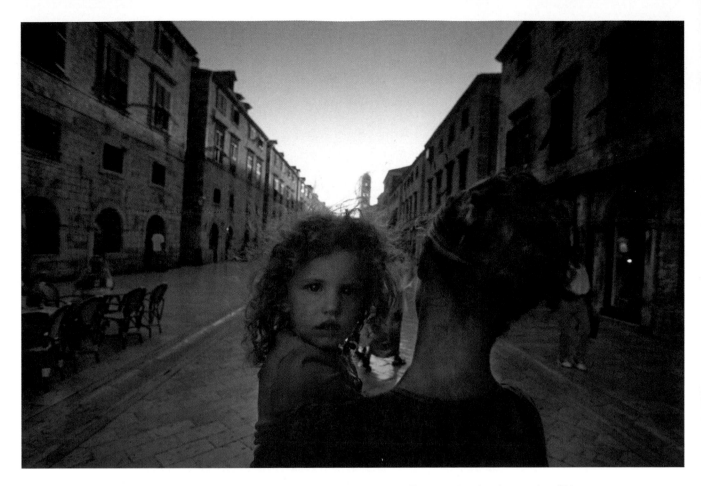

When shooting a story, the photographer has to produce an image that will close the visual narrative. This young girl being carried by her mother as they walk down the main street in Dubrovnik, Croatia, was a natural end to the story. Her direct gaze into the camera and the diagonal features of the building tops make the photo more compelling, and their walking away is almost saying "goodbye" to the viewer. 17–35mm lens, 1/125 second at f4

Anticipating human response allows the shooter to be ready when the "decisive moment" arrives. This is a skill that will develop the more the photographer shoots. Knowing when to shoot is made easier by staying focused, literally and figuratively, on your subject.

Bringing Closure to the Story

You've got a good opener, a photo that introduces the viewer to your subject and explains a bit of the character of the place or people. Your story then contains a detail or portrait, or both, that makes the story more intimate. You've introduced the viewer to a specific person or aspect of the story. Next you've worked the situation for those wonderful explosive or quiet moments that bring energy to the story.

Bill Allen, retired editor of *National Geographic,* says that the reader is coming into the story through *their* door, and you want them to leave through *your* door. That door is the closing photo.

Backlit and with the subject in the middle of the frame (which disputes one of the tenets of photography), this photo of a single tree in Shenandoah National Park was photographed for a *National Geographic* book and has sold multiple times as stock. 20mm lens. 1/125 second at f8

The closer can be as obvious as the sun setting over the kids walking down the beach on the last day of the vacation. It can be as gentle as a flower left in the church aisle as the bridal couple is walking away in the background. The closer wraps up the story, and can direct the emotional feeling the viewer will be left with.

Looking at photo essays—not just any old photo essays, but really good ones—is of definite benefit to anyone aspiring to shoot one. Eugene Smith's famous essay on the country doctor for *LIFE* magazine is one such essay, and there are scores of others to help guide the aspiring shooter.

Less Can Be More

In your vacation story presentation or in a *National Geographic* layout session, one rule holds true: less is more. Six photos of kids kicking soccer balls will be good for the season-end dinner presentation, but in a story those redundant images will bore the viewer. One really strong action photo will speak volumes compared to several weak photos.

HOW TO: CREATING a PHOTO STORY

As a contributing editor for *American Way*, the in-flight magazine of American Airlines, I was asked to come up with story ideas for the magazine. I would research story ideas in or near cities to which the airlines flew. One story I proposed to the editors was on the Palio in Siena, Italy. This twice-annual horse race has been run since the 11th century and was an event I'd always wanted to see. A race track is created in the village square, the Piazza del Campo, with tons of dirt being trucked in to cover the ancient brickwork. The 17 *contrade*—neighborhoods or city wards—are each represented by a horse and rider who will tear around the Piazza at breakneck speed. The winning horse can even be riderless. It is utter and wonderful mayhem.

I'd contacted the tourist office in Siena and arranged a meeting with the director. He in turn put me in contact with a few *contrade* directors, whom I made sure I at least introduced myself to prior to the weeklong events leading up to the July race.

This is an overview of how I shot the story and how it was constructed as a finished piece.

Step 1
Needing an opening photo that introduces the Palio to the reader, we want to use a strong dynamic photo with enough photographic tension (see Chapter 6 for a discussion of tension) to stop the viewer and draw them into the image.

Step 2
Having made a graphic entrance into the story with the opening photo, we then immediately bring in the main element, the horse, and the flag theme, continued from the first photo, that is also carried to the next image. This creates a visual narrative by establishing a palette of colors and shapes.

Step 3

With this photo, we continue the visual narrative of the palette, but bring the human element into the story. I like the idea of the *contrade* colors being common to the first three photos.

Step 4

A photographer friend, Jeffrey Aaronson, told me once that if something makes us laugh or go "Oh, wow!", we should be photographing that subject. Historically in the Palio, each *contrada*'s horse is taken into the neighborhood church to be blessed. You don't see that every day in Topeka. It's always nice to be able to introduce humor into the piece.

Step 5

We've teased the viewer with some very nice images of specific things going on in Siena; now we want to bring a view of the town, the track, the race, and the crowd. There's a lot going on in this photo, but it actually is quite simple—and necessary to show the reader where you are. That detail does not always have to be up front in the story.

Step 6

Providing more continuity, as we did with the palette theme, we use the crowd from the previous photo in this image. But we bring the human element into it with the beautiful young lady.

Step 7

As with the opening three photos, we are using three crowd photos, but each has a totally different feeling and place in the narrative. Here the main focus of this photo is the two kids watching the race; the crowd is the supporting cast.

Step 8

Another repeating theme, this is what the event is all about: the race itself. In the magazine layout, we actually use these four photos as a series. This corner of the track is notorious for horrendous crashes, and it happens during this race. I'd had to purchase a very, very narrow seat with an overview of this spot—it was not cheap but, as you can see, still well worth it.

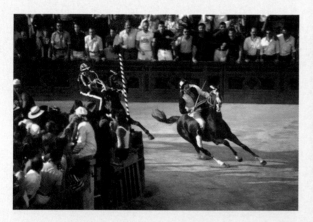

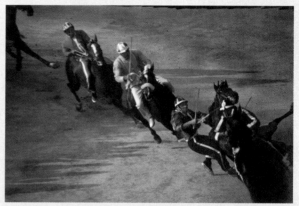

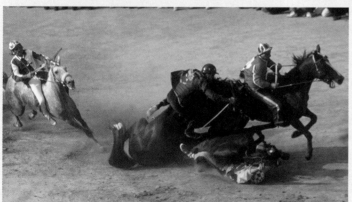

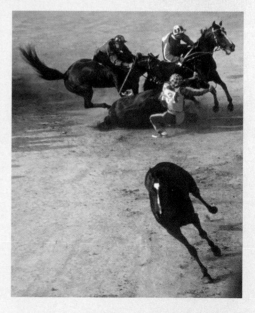

Step 9
This *contrada* had not won the Palio for a number of years, so it is an emotional event to the neighborhood members. Following them back to their church where the winners have historically gone, I find this woman emotionally celebrating the win.

Step 10
After giving thanks in the church, the *contrada* carries the winning jockey through the streets of Siena. This is purposely shot at a slow shutter speed with a flash to get the movement, yet freezing the jockey's face.

Step 11
This is our closing photograph. Small fires are lit atop a few buildings to celebrate the race, and I talk my way atop a hotel nearby to get this important overview. Is working on a story tiring? Yes. Is it exhausting? Yes. Is it worth it? Yes!

PHOTOGRAPHING PEOPLE

Like the people you shoot and let them know it.

—Robert Capa

We love photographing each other—it is part of the fabric of being human. Becoming comfortable with this task takes a little time and initially a little nerve. But the power of being able to photograph people well is one of the most satisfying areas of photography.

Passage to Vietnam was the brainchild of Rick Smolan, who assembled a group of photographers to enter the country in 1994. I'd taken a train on a ten-hour trip from Hanoi to Lao Cai, where a four-wheel-drive Soviet-era jeep drove us on the four-hour bone-jarring trip to the H'mong village of Sapa. I was wandering the mountain trails around Sapa when I found this family working on one of thousands of rice paddies dug into the mountainside. 35mm lens, 1/60 second at f4

Perhaps you've turned to this chapter first, as people are one of the most intimidating and frustrating areas of photography. How the heck does a *National Geographic*, *Condé Nast Traveler*, or *TIME* photographer go into those situations where he or she may not speak a word of the language and come out with those magical and involved photos?

In many ways it really is a simple combination of confidence and interest. The confidence is gained by having approached strangers many times, as well as knowing your equipment. Taking real interest in another person and who they are is the other part of the equation. This is the heart of what we'll talk about in this chapter.

IS THERE an EASY FORMULA to PHOTOGRAPHING PEOPLE?

Yes, there is! I've mentored on several American Photo Mentor Treks, and one of the most-asked questions is how to approach people on the street. I've found the best answer for this question is a demonstration. I'll be with a group of Trekkers and we'll find someone on the streets we want to photograph. Eye contact with a friendly

While shooting for the *A Day in the Life of China* book project, I was wandering through Tiananmen Square early one morning when I found this Communist Youth group at attention. The layers of the handsome faces pull the eye through the photo. 180mm lens, 1/125 second at f4.5

look is the starter, followed by an explanation of what I'm doing. And here's a major hint: give yourself an assignment so your photographic mission has a reason to exist.

Your photographic mission can be as simple as, "I'm shooting portraits for a photographic series I'm assembling" or "I'm shooting a photo project on the streets of your town." What you'll often find is an interest and a willingness of the subject to help you in your endeavor.

A Few Lessons on Approaching Subjects

- **Don't travel in a group.** This can seem to your intended subject like you're part of a gang of camera-wielding attackers. Work solo or with as small a group as you can. If you're out shooting with a spouse or friend, that person can help hold reflectors and carry equipment.

- **Make eye contact** with your potential subject. We're all humans here, and the small task of looking someone in the eye shows that you acknowledge them. A smile can go a long way.

- **Show interest** in what they are doing. We all like to feel that what we do is of interest or has a degree of importance to someone else. Spend a few minutes watching or listening to your intended subject, and talk about their craft or work. Even if you don't speak the language, you can visually interpret quite a bit by watching.

- **Ask permission** to take their photo. Believe me, after 35 years of creating relationships, however brief, with intended subjects, the times I've been turned down for photos is a tiny

percentage of the times I've received willing permission to photograph total strangers.

Throughout the rest of this chapter, I'll share with you some examples of photographs I've taken around the world and also share the stories of how I got permission.

Hail Cannons Near Turin, Italy

Near Turin, Italy, I was looking for "hail cannons" as part of a story I was shooting for *National Geographic*. I had the luxury of an interpreter/fixer, Marisa Montibeller, who was traveling with me. These "fixers" are individuals located in countries around the globe who provide research-gathering services, assisting, and interpreting. The hail cannon is a bit of eccentric and arguable science/technology that is used by farmers here and elsewhere in the world. It looks like a huge steel drainpipe pointed skyward, and we knew there were some in the Turin area. The basic idea is that when a potential hail-storm is approaching, the hail cannons are set off. The sound waves from the detonation and the ionic waves pulsed into the air are supposed to break up hail before it damages crops. Driving through the vineyards of the area, we saw several on a nearby farm. As I've often done—and as many other photographers do regularly—I pulled into the drive of the farm and up to the house.

Stepping out of our vehicle, we introduced ourselves and explained what I was doing. An initial bit of trepidation disappeared quickly into an enthusiastic tour of the

vineyards and a full story of the hail cannons, and how there were many nearby farms that hated the barrage that started from their multiple cannons when a storm approached. This was followed by a full history on the production of balsamic vinegars (we were a few miles from Modena, heart of the balsamic industry) and a special trip to the vats of the family's personal balsamic stash, which ages for 22 years. We were invited in for dinner with the extended families of the husband and wife who owned the farm, and invited to visit any time in the future. As we left, we were given a small bottle of the 22-year-old balsamic vinegar. Willing subjects? Yes, absolutely.

This is what I love about this business and how a simple piece of gear, the camera, can be an entrée into someone's life. I have a standing invitation to return to the farm with my family, and I have new friends in another part of the world. In return, the family had the opportunity to share with a foreigner a bit of their history, and they too have a new friend in the United States.

On a *National Geographic* assignment story about weather forecasting, I'd traveled to Italy to photograph hail cannons. These controversial devices are fired into the air when atmospheric conditions are ripe for producing hail, with the intent of breaking up the hail before it forms. In a beautiful Italian vineyard near Modena, I photographed the farm owner's son, six-year-old Enrico Nascimbeni, holding a hailstone that was part of a storm that devastated their vineyard when they had not fired up the cannon. I used a reflector and flash-fill to illuminate Enrico. 17–35mm lens, 1/125 second at f5.6

Breaking the Language Barrier

What if language is a barrier to communicating with your intended subject? It's likely that those three years of high school Spanish are a foggy memory, or perhaps your next trip is to a country that speaks a language you've never had the opportunity to learn. If you have the luxury of a couple of months before you leave on your adventure, try your local community college for a crash-course in the language of your destination. Or go online and buy a Berlitz (www.berlitz.us) or Pimsleur (www.languagetapes.com) short course in the language. Your standard travel guidebook will help you learn at least a few words of the language: "Thanks"; "May I take your photo?"; "Has anyone told you your eyes are the color of liquid?" Well, the last one may not go over.

The point is, if you show the locals of the place you're visiting that you've at least attempted to learn a few phrases, it will go a long way toward making that essential connection.

Once You're on Location, Now What?

You've found your subject and you've made the approach. You've spent a few minutes talking with them to convey your legitimate interest in photographing them. Now what? How do you get the best photograph possible?

Shooting Fish in a Smokehouse

Yukon Territory is larger than the state of Texas, and I was in a small village photographing an older villager I'd found hanging fish in a smokehouse. He knew *National Geographic* and this prompted a discussion of the magazine. During this time his hands constantly worked with the fish he was hanging. I was shooting wide and shooting close, stepping back to photograph his environment. I'd look up sometimes to see his eyes watching me work. If I had fumbled with my camera, and if I'd not continued talking to him, the dynamics would have been totally different.

Second-nature familiarity with your equipment is crucial. Part of being successful in photographing people is the comfort range and knowledge of your equipment that you display as you work. If someone has allowed you into their world to share who they are with you, it is your responsibility to know your craft so well that the process of taking photos does not get in the way of the relationship you've created. The camera should not be an intrusion in this process.

Understanding exposure, what you want, what your camera is capable of, and what the situation can accommodate must also be second nature. Back in the Yukon, had I fumbled with my camera, or looked uncertain or confused, the photo of that villager would not have happened. The focus in that environment would have turned to my lack of experience.

Anticipate the Decisive Moment of Your Scene

Give a situation time to develop. Henri Cartier-Bresson, the great French

The Tatshenshini River starts in Canada's Yukon Territory. Shooting a story on the river for *National Geographic*, I was in a small Klukshu First Nations village when I photographed Ronald Salmon hanging salmon to smoke. I like the warm palette Ronald was in, the same hue as the salmon. 50mm lens, 1/60 second at f4.5

photojournalist, said that every situation has its "decisive moment." That is the moment when everything comes together in the photo. Whether it's a guy hanging fish or kids on the soccer field, the responsibility of the photographer is to capture that peak moment.

I was explaining to one of my students in a photo workshop this theory of the decisive

moment and that we have to take the time to allow a situation to develop. I pointed out that the photographer has to "work" the scene, exploring it from every angle, seeing both wide and tight, trying to find that unique look and the perfect moment. The next day the student brought his CompactFlash card in for review. Instead of working the subject by photographing the many ways we'd discussed,

this person shot two frames and called it a day, never getting the decisive photo.

This is a common problem with new photographers—not working a situation. You've spent the time searching for the subject material, you've made the approach and created a relationship of trust, now stay with it until you feel you've really gotten the moment. This may take 3 frames, it may take 75 frames. This is irrelevant. The bottom line is: Does this image work? Does it capture that decisive moment?

So how *do* you capture the decisive moment?

■ First, find subject material that interests you. Do a little research if necessary and figure out why this is a good subject.

■ Next, create a story line for your assignment. This could be portraits of Spain or a day at the soccer match.

■ Then approach the situation, identify the potential subjects, and repeat the process described previously: make eye contact, state your mission, and express interest in what the subject is doing.

■ Give it time. Stay with the subject and really watch for the small gesture they make or the laugh between two friends sharing a story. That will be the moment that produces a nice image. Stay with it until your presence is no longer alien. You want to disappear like a wallflower so the camera's presence is not driving the situation.

■ Don't be hesitant to shoot multiple frames of a situation or person. One or two frames may not get that moment, and by working on getting that moment you'll become more proficient in the craft.

■ I can't emphasize enough that you must be technically proficient, and know your equipment like the back of your hand. Also, stay with your subject material until you've exhausted every possible way to see it. I don't want to seem like a broken record, but the last sentence bears repeating. Pushing yourself here is what will make you grow as a photographer.

Don't Overstay Your Welcome

Remember that you need to know when it is time to back out or leave. Many situations call for sensitivity. In some countries, women do not want attention called to them. That street vendor you are photographing may not want you in their face for too long. Learn how to read signals from your subjects, and make a graceful exit.

PHOTOGRAPHING CHILDREN

Children are an easy subject and such great material. Kids are naturals when it comes to posing, and without much exception love having their photos taken. Rarely do you find a kid who is self-conscious in front of a photographer, and most will willingly strut, mug, and perform for the camera. However, there are some hard-and-fast rules that must be addressed.

Covering the war in El Salvador in the early 1980s, I photographed this young girl in a Honduran refugee camp. This photo was part of a 13-picture series for which I won the Pulitzer Prize. The story was very somber and dark, and I wanted to end the series on an upbeat note. I'd seen this shy little girl when we first arrived in the camp the previous evening. The next morning I made my way through the camp until I found her family's tent. I sat for a while without shooting, so she'd become used to my presence. Speaking in the little Spanish I knew, I talked to her as I moved closer, kneeling down to her level, and took just a couple of frames. I wanted the explosion of the sun's rays, so I moved the camera up and down until I found the effect that looked best. 24mm lens, 1/60 second at f2.8

First and foremost, *always* ask permission from a parent or guardian first. This is not always easy, as the parents may not be around, but if a parent isn't around, you have to weigh whether the photo is worth possible police involvement. This is an unfortunate truth that must be adhered to.

Once you have obtained permission, and you've explained why you'd like to photograph this person's child, the kids will usually go back to doing what drew your eye in the first place. Again, give this situation time to develop.

I've always found with children that the first few minutes of the process involves their mugging and acting for the camera. The trick here is to either put your camera down when they fight/mug/act up for the camera or to turn it in other directions. This will quickly

Part of the fun of working with *American Way* magazine was their openness to story ideas. I'd suggested they do a story on kid-friendly Costa Rica, and I happened to know a family we could do the story on (my own). The photo of my kids running on the beach on the Osa Peninsula illustrates another idea when photographing people: you don't always have to have the person immediately in front of the camera. This photo gives a sense of place in addition to making a statement of the closeness of the pair. 80–200mm lens, 1/250 second at f5.6

get the idea across that this silliness is not what you are trying to shoot. Again, give the situation time to become natural.

Be prepared to even walk away from the scene you're trying to capture, a short distance or altogether if it gets out of hand. Like a news event, you do not want your presence and camera to be what drives the situation.

The best photos will happen when they have gotten bored with your presence and go back to doing what attracted you in the first place. This takes time and patience on your part and can be worth the extra effort.

A Few Rules and Tips Regarding Photographing Children

- Get permission. In parts of Europe, it is actually illegal to photograph kids in a school, so be aware of local regulations. Look for the Chamber of Commerce in the area you're going to and see if they can

Sometimes the simpler the image, the more it works. This young lady with her pet monkey was in a small indigenous Indian village on one of the tributaries of the Amazon River in Peru. No distracting background makes it a very direct image. 105mm lens, 1/60 second at f11/8

help with this important aspect. You can also check with the local school.

- Get down to the kids' level. Too many pictures of children are shot from adult eye level, which creates a superior feeling. When you kneel down to shoot your photo, you are creating a feeling of being on their level. You'll also find that kids react to you more readily if you're willing to kneel down and shoot from that level.

- The beauty of digital is being able to show the child (and the parents) their own photo. This will also help them understand what you are trying to photograph.

- If a person has gone out of their way for you, be sure to send a print to them. Too often, photographers walk away from a session where someone has gone to extra effort and never send prints.

- Above all, remember: give it time and work the situation. Don't be content with taking a couple of frames and departing. This is a craft that requires time.

POSING YOUR SUBJECT

The re-creation of the battle of Little Bighorn is done twice a year, once by the Hardin, Montana, Chamber of Commerce and again by the Crow Nation. They tell a slightly different story, but both have General George Armstrong Custer as one of the key figures. As a contributing editor for *American Way*, I was assigned a story to photograph both these events. An obvious necessity for the story was a photo of General Custer, who was admirably and believably portrayed by actor Steve Alexander. I'd contacted Steve and asked if we could take his photo out on the hill where Custer had died.

Posing is an issue in all photos of people. Do you want the photo to look natural or staged? One is not better than the other and both can work beautifully.

I wanted this image to look like it was really the general at Last Stand Hill, and decided on a late afternoon session so we could utilize the beautiful light on the gently rolling hills of Little Bighorn. I had Steve stand in the grassland and had my assistant (this time, my wife) hold a gold and silver reflector (more about these in the equipment and lighting chapters, Chapters 2 and 4) to fill in some of the shadows on the shadowed side of Steve's body. This is a simple trick used by photographers, but it can enhance a photo by eliminating some of the hard light caused by direct sunlight.

A postscript: When I called Steve to obtain a release to use his photo in this book, I hadn't spoken to him since the picture was made several years ago. I tracked him down in Monroe, Michigan, where he had bought the house George Custer lived in. His wife, Sandy, answered the phone and I explained that I needed Steve to sign a release. She said there should be no problem, and asked if she could tell me a story. When she was single, Sandy had been flying home from a vacation. Prior to the flight, she had said a little prayer that

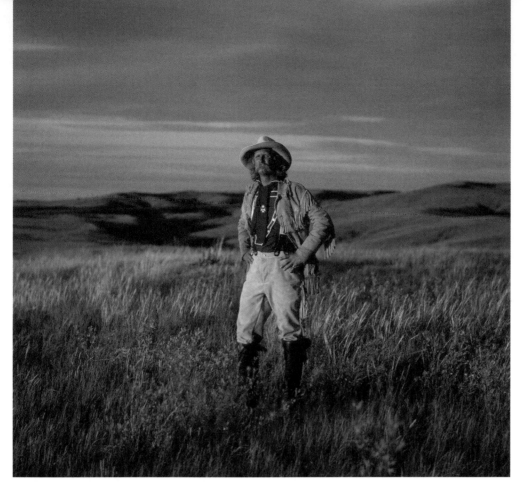

General Custer's lookalike, Steve Alexander, standing on Last Stand Hill, where Custer died. 80mm lens, 1/60 second at f8

a sign be given to her as to who her lifemate might be. She opened up the *American Way* magazine during her flight to the page where this photo of Steve appeared. There and then she knew he was that person. Kinda nice, huh?

Whether you're photographing on assignment or for friends, start thinking of different ways of posing your subjects even while you're shooting the initial photos. Think of these as warmups. The subject may be a bit nervous at first, and this is a great opportunity for them to become comfortable and for you to have the time to think of other ways to pose them.

Don't be static—move in and step back. Fill the viewfinder with the person, and then move back so the environment is incorporated. Don't only center the person in the viewfinder; try placing them off to one side in some frames. The viewfinder is your canvas, so make certain that everything going on in the frame is relevant to the image.

The entire time you're shooting, try talking to the subject—even stupid jokes can help relax the situation. Or you could impersonate the actor David Hemmings from *Blow-Up* and get into the "Yeah baby…" talk.

Probably better not to, though—they may confuse you with Austin Powers.

Keeping eye contact is important as well. This will make your subject more comfortable and create a feeling of confidence. And the confidence you exude will be reflected in the trust the subject will give you, resulting in better photos.

CHOOSING EQUIPMENT to GET the BEST SHOT

Within our camera bags we carry various lenses for different looks and effects. Long and short lenses have their own look, wide lenses exaggerating perspectives and long lenses compressing the field of view. Photographing people can call on all the tools in your bag.

Head and shoulder portraits are extremely direct and force the viewer to look directly at the subject. A medium to long telephoto is often the lens of choice, ranging from 85mm to 200mm. This medium length does not compress the subject too much, which would have the tendency to flatten someone's face out of proportion.

Photographing for the book *A Day in the Life of the United States Armed Forces*, I was on a mountain in the rainforest to the east of Hanoi, in Vietnam. I was photographing Joint Task Force Full Accounting, a long-term project involving all branches of the U.S. military to collect the remains of U.S. service people lost in World War II, the Korean War, the Cold War, the Vietnam War, and the Gulf War. A former North Vietnamese soldier had

discovered the remains of a U.S. Navy A6 Intruder aircraft on the hillside where it had crashed in 1972. The carrier-based plane had been on a mission near Hanoi and was heading back to the Gulf of Tonkin.

The photo I took of this soldier was shot with an 85mm f1.4 lens, shot wide open. I wanted the background to be out of focus as well as the sides of his head. The desired effect was to build the photo around his eyes with the very select focus created by the extremely shallow depth of field of this fast short telephoto lens.

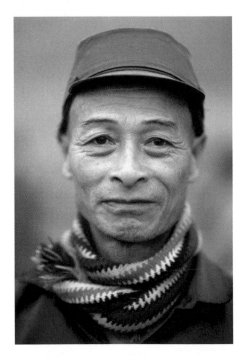

Ly Thien, who fought with the Viet Cong. I shot this with an 85mm f1.4 lens, wide open, to create a plane of interest of the very shallow depth of field this lens produces when shot at maximum aperture.

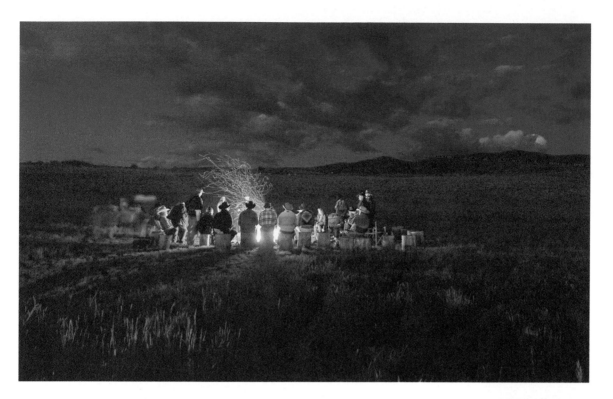

On a late afternoon in remote northern Colorado, I photographed these cowboys relaxing around the campfire, which I think says a lot about their lifestyle. 11–22mm lens, ½ second at f2.8

Sometimes a photo of a person does not have to be literal—that is, we do not always have to see the face of the person or people in the photo to get a feeling for their character. While photographing the Cowboy Artists of America trail ride in northern Colorado, I decided a photo of all the cowboy artists gathered around the campfire would say a lot more about the lifestyle of these people than a straight portrait. Shot for *Western Interiors and Design*, the simplicity of the image, with the one cowboy hat silhouetted against the fire, evokes a romantic image of this life.

You can also use different types of light to emphasize specific components of an image you're trying to capture. In this photo of the old man, I used a strong sidelight to emphasize the character of the subject. You need to make sure the exposure is set for the main light; types of meters are discussed in Chapter 2.

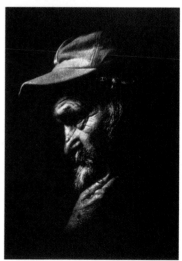

Way back when I worked for a newspaper (a great learning ground), I photographed this old guy I'd found walking by our building. A single, strong sidelight was used to fill his face, which directed toward the main light. 105mm lens, 1/60 second at f11

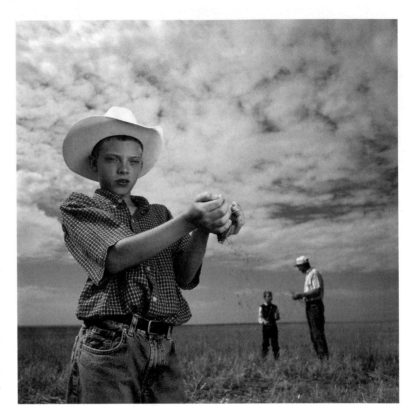

TIME for Kids was doing a story on the drought in the American West, and gave me the assignment to photograph this young man and his dad and brother on some of their sun-parched acreage. I shot this with a strobe bounced in an umbrella, along with a reflector just off to the side to fill in the shadows on the side of his face. 80mm lens, 1/250 second at f8.5

Using Strobe Lighting with the Ambient Light

Colorado had been through several continuous years of a drought, and the assignment for *TIME for Kids* magazine was to shoot a cover using this youngster as my subject. Shooting in the harsh midday light in the drought-stricken eastern plains of Colorado, I wanted to create a fairly stark lighting effect. I used a single "soft box" with a strobe inside it as my main light. This is fairly common, mixing available light (the sunlight) and artificial light. As you can see, the effect is one of a balanced and even light across the subject, making the viewer respond to the photo and not the lighting.

ENVIRONMENTAL PORTRAITS

Many assignments for *TIME* call for an environmental portrait. This is a photo that will capture the essence of the person as well as telling the viewer something about that person's environment or world.

Environmental portraits are generally shot with the subject in the near foreground, while the background contains elements relating to the subject. Often shot with a wide-angle lens, these added elements in the background can contain a powerful narrative about the person.

The nice thing about environmental photos is that they can be accomplished with

This environmental portrait for TIME is of David Parish of Omnitech Robotics, who manufactures remote controls for full-size military vehicles. Talk about a great toy.

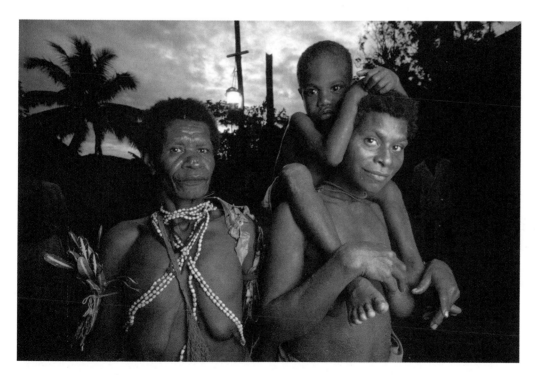

Blending the ambient light of late afternoon with the lantern and adding my own lighting provided by a strobe and umbrella, this compelling portrait of two Bahinemo women in a Stone Age–like village in Papua New Guinea ran as a two-page spread in *National Geographic*. 35mm lens, ¼ second at f5.6

a minimum amount of equipment and hassle. Try using a wide to normal length lens and a strobe and/or reflector to add a slight amount of light on the subject, helping to create a little more visual interest. Place your photo subject thoughtfully—for example, your neighbor in the foreground with his Harley-Davidson in the near background. The strobe will work on-camera for this, or you can use an extension cord for the strobe so the light it casts will not be so flat. Moving the light slightly out and above the camera will create more interesting shadows. For the next step up in complexity, try using a photographic umbrella, or your own bumbershoot with white paper

Riding backwards in the bow of a raft through class-V whitewater provided the "point of view" photo of this paddler being doused by a wave. Facing the back of the raft, at least I didn't have to worry about what was coming! Camera: Olympus 8080 in an Olympus waterproof housing. 1/15 second at f11 with a fill flash set to two-thirds of a stop exposure

or aluminum foil placed inside the dome. Pointing the strobe into the umbrella will create a softer and less obtrusive light.

A reflector can also work nicely in this scenario, but it can cause a subject to squint if the light is too bright. I've almost fried eggs with the amount of energy bounced off of a silver reflector on a bright day, so be kind to your subject! A combination of the two works very well, placing the strobe as the "key" light—lighting the main part of the subject's face—and using the bounced light off the reflector to fill shadows on the side of the head.

Exposure in this scenario would be for the general scene in the background. Make the exposure using no additional lighting to ascertain the correct exposure for the background, and then introduce the lighting in the foreground. This really is building a photo, the monitor on the digital camera being the perfect place to check the accuracy of each step.

PHOTOGRAPHING PEOPLE in ACTION

Combining available light and on-camera flash on the Futalefeu River in Patagonian Chile made this image work. The assignment was for Steve Connatser's *Traveler Overseas* magazine as part of a story on this world-class whitewater river.

With the shutter speed set to 1/15 of a second, I set the aperture to the correct exposure, to get movement in the background and to create a sense of speed. I had the camera and strobe in an Ewa marine bag,

which made it waterproof. The strobe was set on TTL exposure, about one-third of a stop underexposed. This is personal preference; I like the flash fill slightly understated. I think this makes for a more believable photo.

Light is what this business is all about, and the photographer decides what form of light they will use in creating a portrait. As simple as a light ray pouring through a window creating a feeling of mystery, to a fully controlled environment with multiple lights, the choices are as great as the potential.

Photographing people is such a natural and wonderful part of photography, and using some of the simple tricks we discussed here will give your photographs more power and visual interest. A comfort level with your approach and with your equipment skill will give you that much more control over the finished photo.

LIGHTING a PORTRAIT

Find your willing subject, someone who is ready to put up with a bit of an extended shooting session. Find a location that has an interesting background, perhaps a flowerbed in your backyard or the neighborhood park.

Have a strobe handy and something to bounce the light into—this could be a white piece of artboard, say a minimum of 20 inches square, or a photographic umbrella. You can create a makeshift photo umbrella with a normal umbrella lined with some aluminum or gold-colored foil. A reflector is a great tool to have in your bag; these are discussed in some detail in Chapter 4.

Bring your subject close to the camera with their back to the sunlight and frame the photo so it makes a simple composition, such as the person in the foreground off to one side of the frame and the garden in the background. Take a meter reading on the background; this will be your main exposure. I usually underexpose the background one-third to two-thirds of a stop.

The strobe can be set to TTL, Auto, or Manual—your choice. Manual exposure will give you the most consistent results and the output can be controlled exactly in this mode. But the accuracy of today's TTL exposure systems is so good, it can be depended on.

Shoot a test exposure with the strobe pointed and bounced into the umbrella or card. The light bouncing off of the reflective surface is dispersed over a greater area creating a softer effect. Using the strobe pointed directly at the subject will create a very harsh light.

When the exposure looks good, have your assistant hold the reflector just out of the frame so it reflects some of the light from the strobe onto the side of the face that is most heavily shadowed. Generally, I like to have the reflector just out of range of the viewfinder as it is more efficient in bouncing light in to soften the shadows the closer it is to the subject.

In this process, the strobe is your key light and the reflector is providing fill light, which is not as powerful as the main light, but just enough to bring up the light levels in the shadowed area.

HOW TO: PHOTOGRAPHING PEOPLE with the LIGHT YOU HAVE—A SOMETIMES MINIMALIST'S GUIDE

The very nature of a photojournalist/traveling photographer dictates that equipment is kept to a minimum. Most of my lighting is in response to the needs of the moment; rarely do I go out with a specific lighting scheme in mind. Adding light when photographing people can bring life as well as attention to your subject, especially if not overdone.

I will use whatever is at hand to accomplish my lighting needs, with the overriding idea of creating a strong image that works on the merits of a good photograph, not a photo that the viewer looks at thinking: "Is that photo overlit?" Keeping it natural and understated works for me.

With that in mind, this "How To" will be an overview of several methods I've used in the past, and a brief description of how to use these styles of lighting in your own work.

One tool I always carry is a flashlight…not only for seeing where I'm going so I don't crash and drop expensive equipment, but as a subtle way to add light in exact areas to make the photo more interesting. (See the section "Sometimes the Simplest Light Is the Best" in Chapter 4 for the photo of Tom Prince, lit with a flashlight.)

Using available light can literally mean using the only light available at that moment. This photo of a couple of square dancers was shot in Dubois, Wyoming. Walking out of the event, I spotted Kevin Christopher and thought he'd look great for a photo, so I asked him if I could photograph him. My wife then saw Gretchen, Kevin's wife, and grabbed her to add to the photo. The only available light was the neon window sign for the bar, so I placed both of them with the light coming slightly from the side. Balanced with the deep purple sky and the neon light for the bar, it makes a nice portrait of some Dubois cowpersons!!

I was shooting a story on the Yukon River for *National Geographic* and my subject here was the *Ruby*, one of the barges that deliver goods on the 2,000-mile-long river. I wanted to illustrate the barge making the last trip of the year, so I positioned myself on about 3000 cases of beer that were being delivered on the bow of the barge. I exposed my camera (tripod-mounted) at ½ second at f5.6, while "painting" the truck in the

lower foreground with a pretty strong spotlight. Again, I was moving the light constantly and lit or painted this area so the light would be smoother than if I were to have held it steady. This brought up the light value (the brightness) on the side of the truck, which would have been totally dark otherwise. The captain in the cabin of the barge is lit with a strobe that I taped up in the upper-right corner and is actually being fired by the captain of the *Ruby*. I had the strobe connected to a camera by a remote cord, and the camera was placed within reach of the captain. I asked him to press the shutter of the camera when I signaled him with a small penlight I held in my teeth. The interior of the cabin is lit, the side of the truck is lit, and the overall scene is correctly exposed…three lighting sources for a multiple-light situation: flashlight, strobe, and ambient.

This photo took a bit of work, but it was shot with equipment that is common to a lot of photographers…a couple of strobes and cameras that were placed in the police car with the sheriff triggering the shutters on both cameras. The strobes were taped above the visors, the remote cords stretched along the side of the window. The tricky part…I was riding in the open trunk of an old Cadillac that was immediately in front of the sheriff's vehicle. It did turn a few heads of drivers passing us on this photo shot for *LIFE* magazine…a police car in slow-speed pursuit of an old Caddie with a guy standing in the trunk taking photos. The only way this photo would work was to shoot at a slow shutter speed, here ½ second at f5.6, so the sheriff could trip the shutter on my command and I could capture the flash during the exposure. This situation works when you can shoot several images, since coordinating flash and shutter is an inexact science.

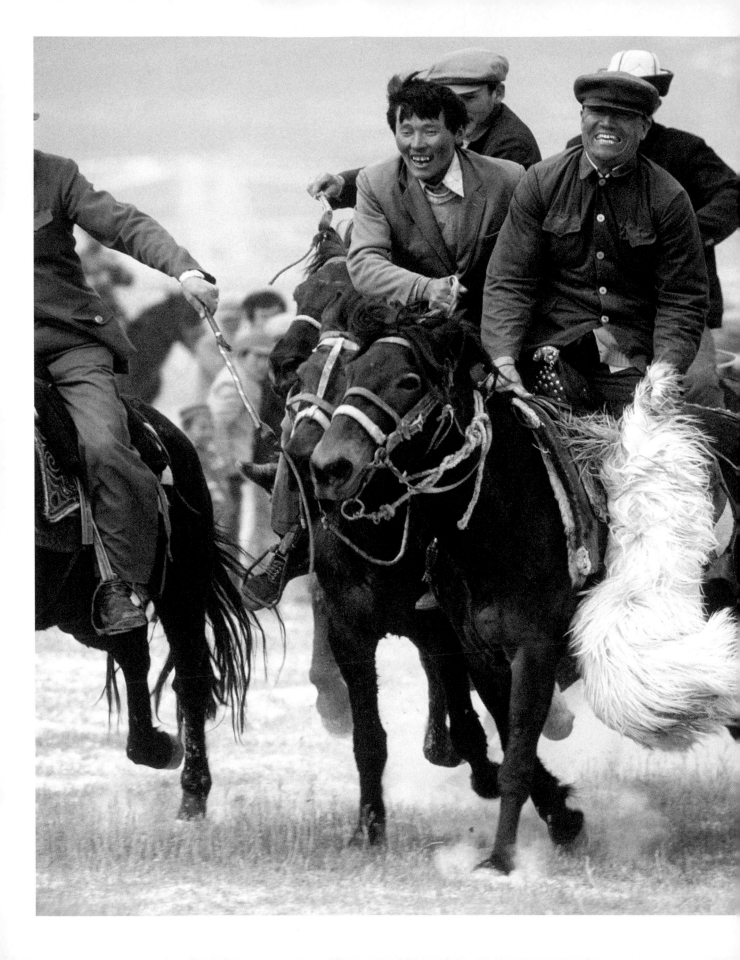

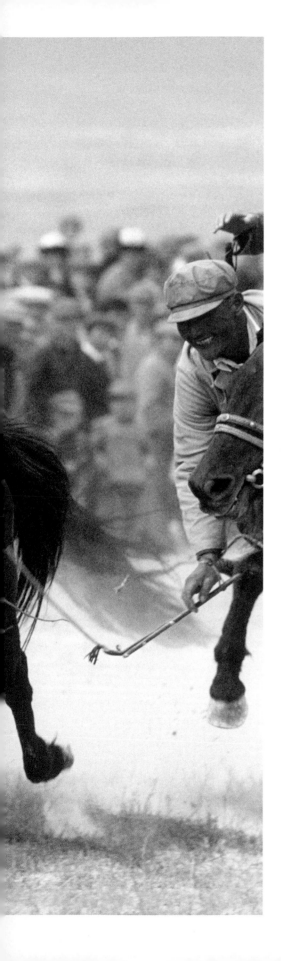

TRAVEL and DOCUMENTARY PHOTOGRAPHY

I have to be as much a diplomat as a photographer.

—Alfred Eisenstaedt

The first time I set foot outside of the United States was as a child growing up in Texas. For our annual family vacation, my mom and dad opted for south Texas, and Mexico was close enough for a day trip. I remember the moment of crossing into a foreign country, and the feeling of adventure and excitement in finally moving out of my comfortable realm. I still vaguely recall the sights and sounds of that initial foray, but I don't have a single photo from that trip.

In far western China near the town of Yining, Kazakh horsemen play their traditional sport known as Capture the Carcass. Using a sheep of recent demise, the horsemen fight each other over the carcass. The rider holding the largest piece at day's end is declared the winner. 300mm f4 lens, 1/500 second at f4

Now, many years and many visa stamps later, my travels are well documented with photographs. When I go back through those photos I am instantly brought back to the sights, smells, and experiences from the trip. This is one of the huge benefits of photography—the ability to record our travels and experiences for our future, both personally and for our family's history.

The baby boom generation has come of age and along with it is a longing to travel to the far-flung corners of the earth. Rarely do you see a traveler without a camera and the desire to gather more than simple snapshots from a trip. We want to document our travels and times, and this chapter will explore the dynamics of photography in the extended world and how digital is a perfect medium for that. This chapter provides tips for traveling as a photographer, including how to photograph safely in foreign lands, protecting camera gear on the road, and respecting local customs.

GO LIGHT! MINIMIZE EQUIPMENT for TRAVEL PHOTOGRAPHY

Late one night in Haines, Alaska, I watched a group of photographers unloading their equipment from their bus, one individual moving case upon case of gear. The next morning I ran into the same group out at the Chilkat Eagle Preserve and I watched that same individual struggling with his mountain of equipment, all while missing images of the hundreds of bald eagles in the beautiful morning light. The group leader, on the other hand, was moving quickly from vantage point to vantage point, using one camera with a long lens and a second camera with a shorter lens. His streamlined approach meant that he got the shots the less experienced photographer missed while wrestling with his gear.

Traveling light is traveling smart. We travel to immerse ourselves in another culture and to have new experiences, not to feel like globe-trotting baggage handlers. I prefer to keep my focus on shooting, not on thinking what particular piece of equipment I need to use in order to justify the hassle of bringing that gear along.

Tips for Traveling Light

- Stick with one brand of equipment. I often see photographers traveling with two entirely different brands of cameras, necessitating specific lenses for each body. I always carry two cameras, a wide zoom on one body, and a medium telephoto zoom on the other. This way, I'm ready to shoot most anything that appears, and if I manage to fill one of my CompactFlash cards on one body, I still have the other I can use any of my lenses on. Also, one type of camera uses one type of battery; no need to carry different chargers and batteries.

- The amount of gear you carry when shooting should be what you need and little more. Nothing is more daunting than digging frantically through a heavy camera bag hanging from your shoulder

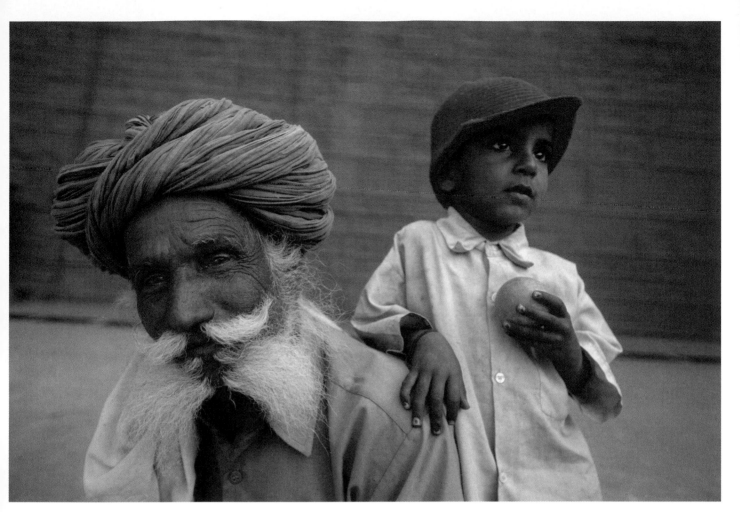

On the edges of the Red Fort in Agra, India, this father and son were just too great a photographic subject to pass up. 20–35mm lens, 1/60 second at f4

while a "moment" is occurring. Further along in this chapter you'll find a list of what I carry.

- Be familiar with your gear so operating the camera is second nature. What's important to you is the image, not fumbling with the camera. The camera is the tool to capture the photo.

- Decide whether you prefer a camera bag or a photo vest. Each offers benefits, as well as problems. The bag is bulky, but can be put down quickly. The vest is a bit more noticeable, but more fluid to work from. This is a matter of choice.

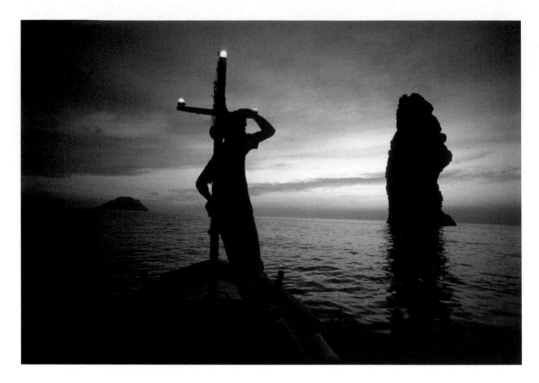

If I'd been burdened down with equipment, this shot would not have been possible, as there was very limited space in the open fishing boat in the ocean. On a shoot for *National Geographic* books, I was in the Aeolian Islands of Italy photographing "Islands Lost in Time." This small fishing boat was working the beautiful rock formations around Filicudi Island, including La Canna, the 302-foot remnant of a volcanic core. In the left background is Alicudi, considered the most remote spot in Europe. 20mm lens, 1/30 second at f2.8

THE ADVANTAGE of DIGITAL in TRAVEL PHOTOGRAPHY

Digital is the perfect photography medium for travel. You'll not only eliminate the hassles of traveling with film (carrying it to and from, protecting it, changing it, processing on site if needed), but you can also instantly share your photos with your subjects. I used to carry a Polaroid to be able to hand my subject an image of themselves, which obviously required extra space for the camera as well as packs of Polaroid film. Now, by using the monitor on the camera I can instantly share the actual image I shot with the subject.

Say "So long" to the shoulder bag containing the required rolls of film to get the shoot done—this can number in the hundreds on long shoots—and "Hello" to the 4 × 4-inch media wallet containing several CF cards.

Usually I will take my laptop, which allows me the opportunity of editing and cataloging my photos. (For peace of mind I *always* copy the files to a second, independent location, either a DVD/CD or an external hard drive.) This allows me to reformat my CF cards after download so I always have fresh cards at the start of the day.

Since the events of 9/11, traveling has become more of a hassle for everyone, and the photographer is no exception. More often than not, a camera bag will be marked at the security gates for further screening, primarily because an X-ray of the camera's electronics can look suspicious. Eliminating film from your camera bag makes the trip through security less stressful. No longer do we panic when approaching security at the airport, frantically trying to remember the number of times our film has been through the X-ray—multiple passes through airport X-rays can negatively impact the film.

And the number one reason in the growing list of advantages of digital over film: the ability to confirm the image. Content, composition, and exposure can be judged in a heartbeat.

HOW to FIND PHOTO POSSIBILITIES

One of the most common questions I hear from dedicated amateurs is, "What is there to shoot?" We all love putting the camera to eye and capturing that moment, but how do we find that event that will create our moment?

I teach a series of international photography workshops in locations from France to Scotland to the U.S. We provide the assignments for our participants, prearranged and checked out by myself prior to the workshop. These workshops are unique in that we actually publish a magazine of our participants' work.

A significant part of the time spent on a *National Geographic* assignment is for research. The photographer is right there in the middle of the mix, researching a story and gathering information on what to photograph. What does the photographer look for while doing this research that sets off the "Photo Opportunity" buzzers?

Once you leave your hotel to wander the streets of a city, be prepared to stay out for longer than expected. On a shoot in Krakow, Poland, I'd gone to the beautiful Stare Miasto, the Old Town, with its central square, the Rynek Glowny. The massive square was a feast for the eye, and I ended up staying all afternoon. Toward a rainy dusk, hundreds of people started pouring into the square with umbrellas. Turns out it was a celebration in advance of the Pope's upcoming visit and the anniversary of an assassination attempt against him. Having my usual gear—with a small travel tripod—and umbrella allowed me to stay with this event until I had the photos I needed.

The faithful turn out in Krakow, Poland, in honor of a visit by the Pope. 20mm lens, 1/4 second at f2.8

Check the local calendar of events for the times you are traveling, and don't hesitate to call the U.S. office of the tourist board for any other ideas or hints. Often an event that the locals consider mundane may be that sparkling photo op you were looking for. An event might be noted with no particulars, and a phone call can provide exact dates and times, in addition to the "Oh, yeah, you may want to check this out…." ideas that will surface during a conversation. Festivals, celebrations, annual events commemorating special holidays—all these are potentially ripe for photographic opportunities. I will plan an entire trip around a festival, as this can provide wonderful photos. And for the shy photographer, it is an ideal situation since many people involved in the celebration may enjoy being photographed.

The Internet can also provide access to local newspapers, which can offer information on events going on in the area. Many search engines even provide a translation option, though the translation is often very rudimentary.

Traveling Abroad Contact Information

What if you don't have the grandeur of the Yukon or the access that *National Geographic* may give you? Do some reading and research about the country or area you are planning on traveling to. Google is a powerful tool for speeding up this research process. Chambers of commerce offer calendars of events for U.S. locations. Tourist boards are helpful for those international locations.

Here's a list of some popular destinations and their accompanying websites:

- **Africa** www.travelafricamag.com (not the tourist board, but a very knowledgeable magazine about Africa)

- **Australia** www.syd.australia.com

- **Caribbean** www.caribbeanconsulting .com/touristboards.htm

- **China** www.cnto.org

- **France** www.franceguide.com

- **Germany** www.germany-tourism.de

- **India** www.tourisminindia.com

- **Ireland** www.ireland.ie

- **Italy** www.italiantourism.com

- **New Zealand** www.newzealand.com/travel/

- **South America** touri.st/southamerica/

- **Spain** www.spain.info

- **United Kingdom** www.visitbritain.com

- And a great all-around website that will lead you to many countries' tourist boards: http://intltravelnews.com/Tourist__offices.htm.

The idea of "self-assigning" works very well in the world of travel photography. As you head out for a day's shooting, assign yourself certain images to obtain that day. Portraits of the locals, kids in parks, sporting events, the wedding of the day. The beauty of shooting specifics is that it allows you to really focus on the photos within those ideas. Portraits can reveal so much about the people and world you are visiting. Try to create "environmental portraits," positioning the subject in the foreground, possibly putting them slightly to the side of the frame and layering the photo so the background contains a feeling for what that person is about.

In many countries you'll find that Saturdays are a good day for weddings. Shooting an assignment for *Travelocity Magazine*, I was in the beautiful city of Dubrovnik, along the Dalmatian Coast. Walking the walled city on a Saturday afternoon I came upon a wedding party jubilantly parading down the main cobbled street. Not able to speak Croatian, I used sign language to ask permission of the family as they sang and danced along their way. Instead of a tourist on the outside, I was quickly assimilated into the group and accompanied the bride and groom as they were married and was invited to the wedding party afterwards. Isn't this why we travel?

On a shoot in Croatia, I'd gone back to utilize a location I'd found almost 20 years earlier. These cityscapes work when shot at dusk, when there is just enough ambient light in the sky to give a little separation to the horizon and the city. You'll notice the greenish cast of the predominant fluorescent lighting. 35–70mm lens, 3 seconds at f2.8

SO YOU'VE ARRIVED, NOW WHAT?

Late day into evening is a great time to mix flash with slower exposure. Using 1/4 of a second exposure slower than the normal shutter speed used with flash (which can be 1/125 or 1/250) allows the image to have motion, while the high-speed flash will "freeze" the subject near the camera. This will give a feeling of motion and energy.

Shooting a story on the rebirth of the Dalmatian Coast, previously part of Yugoslavia, I had walked up a path I'd scouted years before on a trip, to an overview of the beautiful city of Split. I had planned my foray toward dusk, wanting to utilize the evening light, as the port city faced west. Having headed out hours earlier, I took along a tripod

since I knew I was going to shoot into early evening, when the city lights had come on but there was still enough ambient light in the sky to give it some definition. Mixing these two light sources can produce a beautiful palette in the photo—the warm glow of tungsten light fixtures and the increasingly blue-purple of the twilight sky. Being prepared and doing my research translated into a beautiful photograph.

I will often go out wearing a photo vest with many pockets. This allows me to carry one or two lenses, a strobe, and filters, as well as an umbrella and very compressible jacket, such as a waterproof windbreaker. Vests come in all styles and colors. I've found that if I keep the color low-key, my presence is less obvious. The nice thing about a vest compared to a bag is that the photographer has less stuff hanging off his shoulders, and a vest is more difficult for someone to snatch gear from.

WHERE to FIND INSPIRATION

Here are a few resources I use to get inspired before embarking on a journey.

- **Photography magazines** The myriad of photo magazines on the newsstand can and should be a source of inspiration to all of us. I look forward to each month's *National Geographic*, not to steal the ideas of the artists, but to add to my own visual database how each photographer approached his or her subject. The inspiration includes not only examining how they worked the subject aesthetically, but perhaps how that person approached an event that at first glance was not visually rich. Every situation has its best picture.

- **Books** In the early 1980s, Rick Smolan and David Cohen started publishing their iconic and famous series, *A Day in the Life of…*, which included America, Australia, Japan, Hawaii, Spain, Italy, Ireland, the USSR, China, and Africa. As a photographer, I was privileged to work on this series; as someone who loves to look at great photography, I believe these books can be a source of inspiration for ideas for future travels.

Learn Something About the Area You're Visiting

In the pre-Internet days, a *National Geographic* article took a huge amount of research on the part of the photographer. One would spend hours on the phone in the initial stages of setting the story up, in addition to hours spent in a library poring over tomes and text. Now, Google, Yahoo!, and other search engines make the research stage easier. The Internet puts so much more power in the hands of the photographer. One fact can lead to an avenue of discovery that eventually leads to a great photo.

For the photographers shooting for themselves, this power is equally important. In the past, trying to figure out a location demanded on-the-ground time and research, often not easy or possible with a limited

amount of time in a place. The Internet provides information and direction that can take you to an area of rich photographic possibility. Do a web search on "the Palio," the biannual horse race in Italy, and you will find not only the dates of the race but also information on the best shooting locations.

TAKING THOSE FIRST FEW TRAVEL SHOTS

The research is done, airline tickets are in hand, and you have several photo ops lined up. You know a bit about the place you are traveling to. Now what?

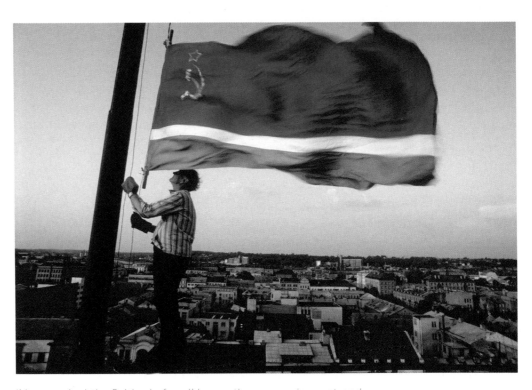

I'd researched the Baltics before I'd gone there on assignment, and knew the state flag was hoisted above the city hall every morning at dawn. The city office was more than happy to allow me access to the flag raising. I think it gives a sense of place to the photo. I used a slow exposure to make certain I got the flapping motion of the flag. 20mm lens, 1/15 second at f8

This is an area that concerns many aspiring photographers. How do I approach a subject I've never met before, especially if I don't speak the language? On a shoot in India, I watched a tour bus disgorge its load of camera-toting travelers. In the field of fire was an old beggar squatting by a red door. The pack of tourists moved as one, kicking up a trail of dust as they marched in lock-step toward the old guy. All cameras came up as if by signal, and the shooting began. The poor guy never had a chance. Never once did I see one of the visitors approach him to ask permission or even make eye contact—he was simply an involuntary photo op. The photo most of the ten or so photogs took home was of the old guy, hands up to deflect their invasion of his privacy. Nice photo.

A few days earlier, on a similar tour bus event, I watched several of the traveling photographers move out on their own. I followed one woman to watch how she worked. She walked down a small street off of the main drag, where there were merchants selling psychedelically colored spices in baskets. She moved slowly, making eye contact with the storeowners until a particular scene stood out. Instead of firing away from a distance, she approached the merchant and gestured toward her camera. She smiled, he smiled, and a tacit okay was given. The photographer stayed for probably 15 minutes, waiting for that nice photo to materialize. She went home with a beautiful photograph from her efforts. This is a great case study on how to work in a foreign country: as a traveling photographer,

the "foreign" part is you. We are guests in these people's lives. Treat them with respect. See Chapter 8 for information on simple tricks and hints for shooting in a new place.

How to Deal with People and Your Own Shyness

One of the most difficult subjects to photograph is people. A natural shyness and hesitation to approach perfect strangers is a natural obstacle to making good photos. Often I will literally take a breath and a step toward someone I'd like to photograph. Most of the time that person will be okay with having their photo taken. You'll find the curmudgeon every now and then, but we also find them in our backyards. Let it roll off your back and try again. I was shooting in Spain in a small village and asked in broken Spanish if I could photograph an old cobbler working in front of his shop. A curt dismissal sent me on my way and within a few shops there was a baker hanging out his breads. He was quite friendly and I photographed him for probably an hour. Finished shooting, I was walking away from his shop with a loaf of bread under my arm. I immediately ran into the cobbler, who had seen me photographing the baker and wanted to know if I'd shoot his photo now.

Showing interest in the person you want to photograph is a great icebreaker. Everyone wants to feel that what they do is important, and the camera can be a perfect validator of that importance.

A Day in the Life of China took me to far western China, where my assignment was to photograph the Kazakh herdsmen moving their sheep from the valleys to the mountains. I shot wide in this frame to convey a sense of place to the viewer. 24mm lens, 1/250 second at f4

Another door opener is to take along a small "book" of your work. This too can work wonders, and adds to the idea that photographers are not always taking, taking, taking. An inkjet printer is perfect for producing these images, and your local office supply store can add an inexpensive spiral binding to keep it together. Sharing your work will also show the potential subject what you have in mind photographically.

One item I take with me is a battery- or AC-powered Olympus P200 printer. This adds a negligible bit of weight, but its benefits far outweigh the hassle. I'm able to provide 3 × 5-inch prints to those I've photographed on the spot, or at least within a reasonable couple of hours. And you are acting as a goodwill ambassador for the next photographer who enters your subject's life. Be forewarned: once you give a photo to one person, everyone is going to want their photo taken.

Moving in close to your subject can make your photos feel more personal. This beautiful Kazakh woman was in the midst of a traditional wedding ceremony when I had the opportunity to photograph her. 24mm lens, 1/60 second at f5.6

PHOTOGRAPHY as a PASSPORT, the PHOTOGRAPHER as AMBASSADOR

Photography forms a common language in the world. Everyone loves seeing images of themselves. This "passport" to the world should be seen as an introduction between people, not a barrier.

What caught your eye in the first place? If it made you stop and smile, or feel awe, or created an emotion, it very well may be worth a photograph. These often gentle moments, or rambunctious celebrations, will create those images that your friends and family, and perhaps editors, will enthuse over.

In addition to being travelers and tourists, we are ambassadors with our cameras. Many people in foreign countries will form their impressions of Americans by their interactions with you. Understanding the cultural mores of the country you visit is invaluable.

The ability to speak a few words of the local language, as much a no-brainer as it seems, can work wonders. I'll learn the basics—thanks, no thanks, yes, may I take your photo—for every country I visit. I've found that my clumsy attempts at their language usually elicit friendly smiles and make it easier for me to take their pictures.

DOCUMENTARY PHOTOGRAPHY

Photojournalism and documentary photography are often seen as overlapping fields of art. The term came into existence during the Great Depression, when President Franklin Roosevelt appointed Rexford Guy Tugwell, a Columbia University economics professor,

Tabacon Hot Springs in Costa Rica is heated by the geothermal
activity of Arenal Volcano. Tourists flock to the springs to soak in
the near-boiling waters. 80–200mm lens, 1/30 second at f4

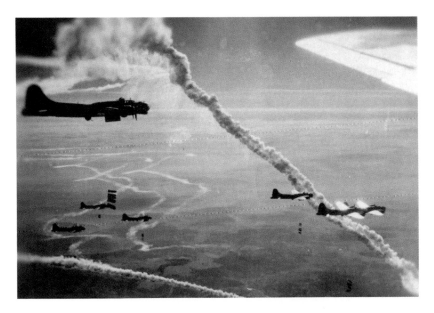

My wife's father, Harris Skelton,
was a bombardier in World War
II. Sitting in the nose cone of
a B17, his moment came over
the bomb site, where he would
take control of the aircraft.
In the seconds leading up to
this moment, Harris shot this
photo out the canopy of the
bomber, a perfect illustration of
a photo becoming a document
versus a simple snapshot: the
bomb "sticks" dropping from
the aircraft, the diagonal line
of smoke from a direct hit, and
the explosion of one of the
bombers.

as Assistant Secretary of Agriculture. Tugwell instituted controversial and expensive reforms that included low-interest loans and interest-free subsidies to America's struggling farmers. This was a potentially volatile act in those economically depressed times. Tugwell had the foresight to realize that photographs documenting the farmers' conditions could be a tool for change: documenting both the problem and the cure. He brought Roy Stryker into the department to direct the photographic mission.

Stryker, another former Columbia economics professor, had used photography in his lectures to illustrate the economic plight of farmers. He brought this photographic documentary approach to his new job with the Farm Securities Administration (FSA). Stryker appointed a small group of highly talented photographers, including Walker Evans, Carl Mydans, Dorothea Lange, and others, to travel and photograph the plight of America's farmers and the heartland. These artists were not only photographers, but anthropologists and historians. Documentary photography was defined by this project.

The body of work produced by the FSA stands today as not only a remarkable group of photographs, but a set of images that had a profound effect on society. An earlier example of the power of documentary photography—even before this style of photography had a name—was the work of Danish immigrant Jacob Riis, a reporter for the *New York Tribune*, whose main beat focused on the immigrant-jammed slums of New York in the late 1880s. Riis had complained to the city health officials about the horrible overcrowding and high death rates in this area. Nothing was done. Riis decided to utilize the newly invented flashlight powder that allowed photographs to be taken indoors. The resulting book he produced from this work, *How the Other Half Lives*, shocked everyone who saw the photos, including a rising young politician, Teddy Roosevelt, who sent Riis a note saying: "I have read your book and I have come to help." Roosevelt soon became New York Police Commissioner, and help he did. *How the Other Half Lives* resulted in a reform movement that improved conditions in the slums of New York. Riis's work proved what documentary photography could do.

The documentary photograph, upon first viewing, may be little more than a snapshot. But interlaced in the image are psychological layers of meaning and importance to the photographer. The camera shows things as they are, and this is the power of the good documentary photograph.

The family photographer is a documentary photographer in his or her own right. The photos we take of our families contain visual hints of that time period, and the successful photograph will elicit a reaction of recognition, joy, or many emotions all at once. Photographs are one of the most powerful records of history.

HOW TO: WHAT'S INSIDE the CAMERA BAG

Since the invention of photography, two constants in the world of the photographer have been shutter and aperture. The equipment may become more and more technically sophisticated, but these two compatriots of the camera are still the core of the mechanical side of the camera. Here are a few ideas on using the shutter as your creative tool.

Photographic equipment is the hammers and wrenches of the photographer's toolbox. The lighter and more efficient the toolbox, the easier it is for us to work. Plan ahead for your photo outing, whether it is a Little League game down the block or a month-long trip to Nepal. Take only what is necessary to get the job done. Don't load yourself down with so much gear that it gets in the way of making photos.

My camera bag is pretty well defined by years of travel and getting caught with too much or not having brought the correct equipment. On the plane or in the car, one medium-sized Domke bag, with two camera bodies and three or four lenses—depending on the shoot—will usually suffice for almost all conditions.

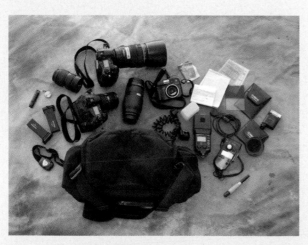

Camera bag and contents

I carry two Olympus E1 bodies, along with an Olympus 5060 as a backup. The 5060 can go in a pocket and can work in some situations where the larger bodies and lenses would broadcast "photographer." There are areas where someone shooting seriously may not be well received, and for those times the 5060 looks more like a tourist's camera. But the quality from a camera like this is top-notch and able to provide high quality files for printing.

Your camera choice may be a Nikon D100 with a second body, a D70, or a Canon 20D and a Canon 1Ds. Having two bodies really makes the shooting process easier. I'll carry a wide-zoom on one body, a medium-long zoom on the other. This way, I'm ready to shoot anything almost instantly.

Lens choice is specific to the type of photography you are doing. In my bag I'll carry a 7–14mm (which, in the 35mm film world, is equivalent to a 14–28mm), a 14–54 (28–108mm equivalent), and a 50–200 (100–400mm equivalent). On shoots that require high-speed lenses, a 150mm f2 (equivalent to a 300mm f2, extremely fast), and for wildlife or sports photography, a 300 2.8 (a 600mm f2.8 equivalent) is invaluable. These lenses, along with a 1.4 converter, which multiplies the focal length of lenses by a 1.4 factor, really gives me just about all the lens power I need.

Always found in my bag is a TTL flash and a remote cord for that strobe so I can shoot off camera with the flash. The cord allows me to hold the flash away from the camera so I can bounce or reflect the flash off of a ceiling or wall for a softer and more natural light.

A Lexar wallet carries my assortment of Lexar CompactFlash cards, usually a couple of 4GB cards that reside in-camera, a 2GB and 1GB card goes in the wallet along with a couple of older 512MB and 256MB cards.

In a second bag, I carry a 60GB LaCie Pocketdrive in addition to my laptop. Packed in that bag are enough CDs or DVDs to burn the number of images I feel I may shoot on the particular assignment. *Before I erase/reformat a card, I make sure the files are in a minimum of two independent places.* This is a cardinal rule.

If you don't want to lug a laptop to Lithuania, several manufacturers make small and very portable hard drive/ viewing units. Epson makes the P2000, Apple the photo-capable iPod. Both these units will hold a huge number of images and allow the photographer to view and share the images. The one downside: will this be the only backup for your photos? This could be reason enough to carry a laptop or a portable CD or DVD burner.

In the bits and pieces category: I carry a Sharpie black marker wrapped with about two feet of gaffer's tape

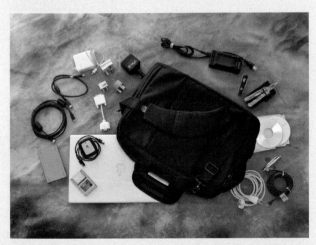

This is my computer bag and contents with which I travel, give or take a few items based on the shoot and location.

(gaffer's tape differs from duct tape as it can be used on lights and other hot items without leaving behind a sticky residue), a small headlamp (I carry a very lightweight model made by Petzl), a pen, and my ubiquitous reflector, discussed in Chapter 4.

Power Management and the Traveling Photographer

One of the great benefits of digital is the elimination of film and the problems of transporting the number of rolls needed for a trip. Now, we carry a few CF cards to equal many rolls of film. One of the big issues with digital is power. We now have a technology that is 100 percent power dependent. Gone are the days of carrying a fully mechanical 35mm body as a backup. When I turn the lights off in my hotel room, it looks like the approach of the mother ship in *Close Encounters of the Third Kind* due to all the power chargers running.

Here are some power necessities for the road:

- As I mentioned earlier, use a camera system that uses the same battery and charger.

- Always carry extra batteries. Nothing, and I mean nothing, is worse than running out of power with no backup in the middle of a great photo event. This includes rechargeable and nonrechargeable types. In addition to two or three extra camera batteries, I also carry a small bag with extra AA and AAA batteries.

- I always carry an extra charger, well worth the minimal weight increase since this provides 100 percent faster battery charging because you are charging two at once. It also provides a backup if one breaks. Not likely, but don't tempt Murphy's Law!

- I carry a small 12-volt power inverter (Nexxtech Power Inverter model 221-8075), which can be found

at Radio Shack. It's a 75-watt model that is small and light and provides charging time while on the road.

- Keep appropriate adaptor plugs for the area you are traveling in. I'll stop for lunch and ask to sit at a table by a plug, so I can use my charger to top off the batteries. This website (www.kropla.com/electric2.htm) not only lists the voltage availability worldwide, it also tells you the type of adaptor plug you'll need for that country. Take at least three adaptors.

- Solar battery chargers are now small and cheap (about $15) and can charge AA and AAA batteries.

Perhaps worth trying if you're going remote? Here's one source: www.siliconsolar.com/small_solar_battery_charger.htm.

Travel and digital photography are natural and necessary partners, as we love to document our world and our travels. Taking that step and moving from shooting passable images to memorable showstoppers is our aim, and creating a moment that defines our memory is our task. We photographers can reap the benefit of our exposure to the world. Isn't this what travel is about, experiencing a moment in time that transcends our daily routines?

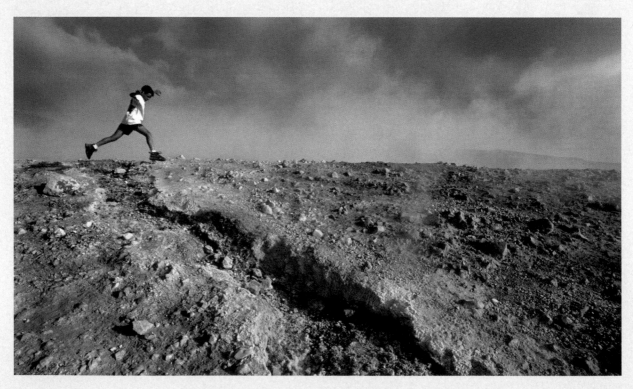

We travel to find the mystery and intrigue of foreign lands. Photographing the Aeolian Island of Vulcano in Italy for a *National Geographic* book, *Beyond the Horizon*, I found this young man leaping a sulfurous vent on the side of the still-breathing volcano. 20–35mm lens, 1/250 second at f8

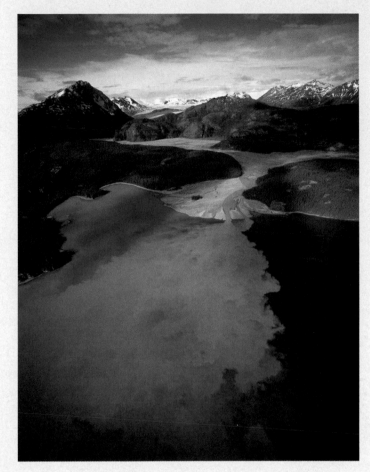

The 2,000-mile long Yukon River is "born" at these headwaters. Created from the melt of Llewellyn Glacier in the background, the river is most visible as it pours into Atlin Lake, in British Columbia, Canada. 17–35mm lens, 1/250 second at f4.5

Scouting ahead can pay off handsomely. My assignment was to photograph the posh Royal Scotsman train on the six-day route around Scotland. I had read that at one point, the diesel engine is exchanged for a traditional steam engine when the train goes from Fort William to Mallaigh in the Western Highlands, crossing this amazing trestle bridge, as seen in the *Harry Potter* movies. I'd gotten off the train in Fort William and hired a taxi to take me to the trestle bridge, clambering through the heather to this overlook of the tracks. 35–70mm lens, 1/60 second at f4

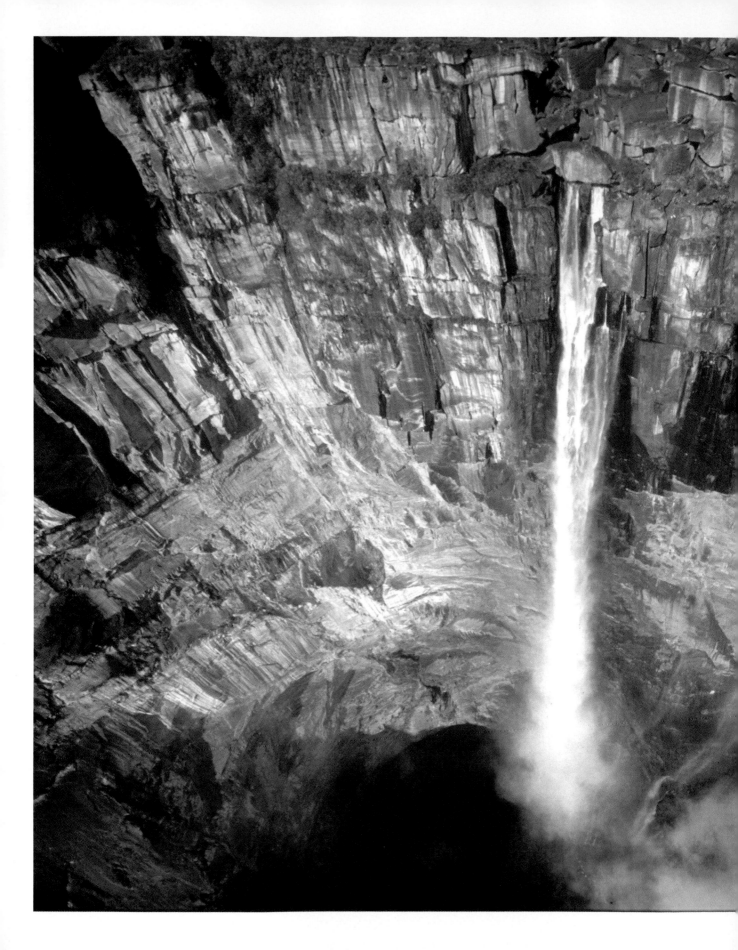

PHOTOGRAPHING the NATURAL WORLD

For me photography is a form of prayer.

—Don Doll

As evidenced by the explosion in popularity of *Outside* magazine, *National Geographic Adventure*, and the ubiquitousness of Patagonia outdoor clothing, more and more people are exploring the great outdoors. As long as photography has been in existence, the natural landscape has been a prominent subject in photographs. The subtle contours of rolling hillsides, the grandeur of precipitous and craggy cliffs, and the ever-changing sky provide an infinite array of photographic potential. This

Angel Falls, the world's tallest waterfall, shot from a "bird's-eye view" while I was on assignment for a National Geographic book, *Beyond the Horizon*. I spent several weeks photographing the tepuis in southern Venezuela. 20mm lens, 1/500 second at f3.5

chapter will help you improve your outdoor photographs and give you invaluable tips on photographing wildlife and protecting your camera equipment in unpredictable environs.

WE ALL WANT to BE ANSEL ADAMS

It was early in the morning when we set the helicopter down on Roraima-tepui in southeast Venezuela. These giant and ancient granite monoliths rise straight from the rainforest floor to heights of 5,000–6,000 feet above the surrounding forests. Roraima, the largest, is almost 15 miles long by several miles wide. The tepuis are protected by the Venezuelan government as part of their national parks. *National Geographic* had

obtained permission for me and a writer, Tom Melham, to escort a mountain rescue team as they practiced for a month on several of the nearly 100 tepuis.

We had the luxury of air support (two helicopters) on this assignment, which allowed us to visit Roraima-, Auyan- (the home of Angel Falls, the tallest waterfall in the world), and Cuquenan-tepuis. Normally this is a hike of several days from small villages that are themselves very remote. Wandering about the vast geological wonderland of Roraima's surface, I saw a couple of people standing perilously close to the near-vertical edge of Roraima's 4,000-foot drop. I thought perhaps they were two Indians from a nearby village. Two local tribes had recently been

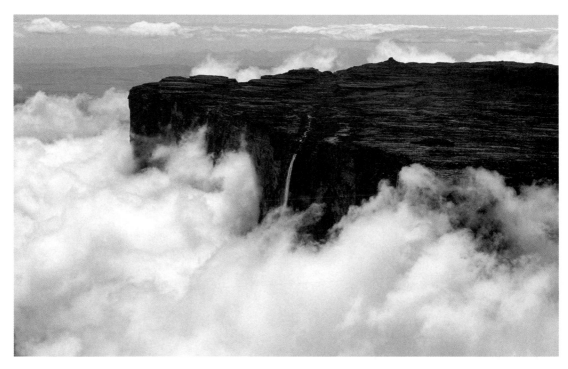

Looking like it is transforming water into clouds, Cuquenan Falls tumbles from atop Cuquenan-tepui. Some of the oldest formations on the earth's surface, the tepuis is one of my favorite areas in the world. 80–200mm lens, 1/500 second at f5.6.

warring and I didn't want to be mistaken for an adversary, so I moved with as much noise as I could to give them plenty of warning that I was in the vicinity. I cautiously approached the people, and as I drew closer I realized that their huge size was due to their backpacks and camera bags. They were photographing the amazing view of the jungle canopy afforded them by days of hiking. I'd found the local Ansel Adamses.

Cameras have given us glimpses into the most remote and untraveled corners of the earth. When we can see and share the images of the rainforests in Brazil, it creates a greater understanding of the importance of these areas instead of just reading a description. Through photographers such as Eliot Porter and Frans Lanting, the photograph has helped generate support for the preservation of wild places.

Photographers and travelers (almost synonymous) want to record their travels into the natural world. Let's talk about the various components of photography in the outdoor world and what a perfect fit digital is with the great outdoors.

THE COMPONENTS of OUTDOOR PHOTOGRAPHY

Successful landscape and outdoor photography have several components that are key in making them successful. Each of these brings power to the photograph by providing the viewer with a sense of scale, place, or magic.

Creating a Sense of Scale

Who isn't overwhelmed by the scale of the Grand Canyon? Or the size of the redwoods in northern California? If you've seen Yosemite, the view from Glacier Point can hold you for hours. Unfortunately, most aspiring photographers are underwhelmed when they view their photos of these places. One of the reasons this happens is that they fail to convey a sense of place in their images. This is critical, as you have to translate an immense physical location into a 4 × 6 or 8 × 10 print.

One of the simplest solutions is to add a person to your landscape. This creates an instant sense of scale if that person can be used to gauge the size of the cliff, waterfall, or whatever natural feature you're photographing.

Here are some tips for effectively communicating a sense of scale:

- Don't have the subject too close to the camera. This does not put the person in a place that creates scale. Put them back in an area where the size of the natural feature can be judged against the size of the person.

- Use a clean background. If the person in the photo is lost in the trees, the sense of scale will not exist. Place that person against a solid bar of color or against the sky. This will make your photo stronger by making the subject stand out, and utilizes scale as another dimension of the photo.

The interior of Iceland is one of the most phenomenal places I've had the fortune to visit. Equally portioned between stunning and breathtaking, these four photos convey my sense of this amazing place.

A late-afternoon snowmobile foray to the middle of Vatnajökull Glacier in Iceland, the largest glacier in Europe, I looked back to see another member of our party rushing to catch up with us, under the rising moon. 180mm lens, 1/30 second at f2.8

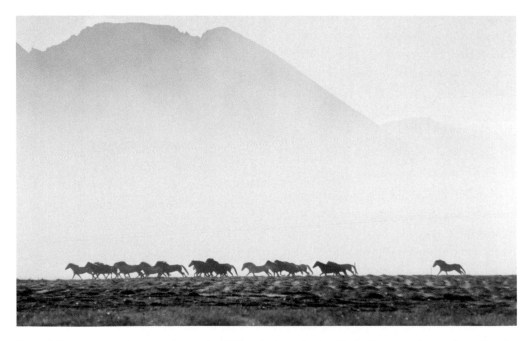

Part of the assignment was a three-day, 100-mile horseback ride in the mountains of southeast Iceland. This photo was shot the morning our farmers were gathering the Icelandic ponies for the trek. 300mm lens, 1/500 second at f5.6

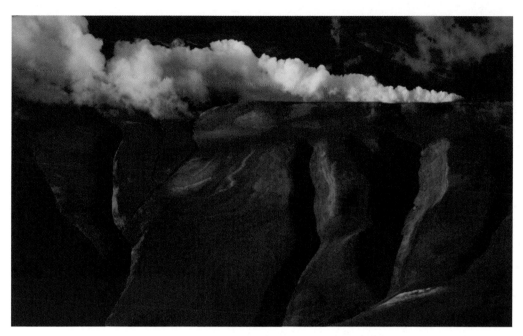

Iceland gets a majority of its power from geothermal sources; I saw this natural geothermal vent one late afternoon as the sun was setting. 180mm lens, 1/125 second at f2.8

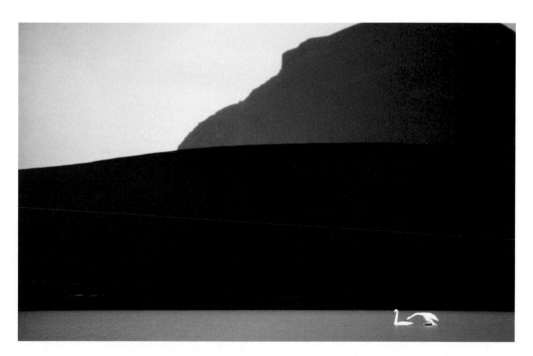

A pair of white swans perform a mating ritual in the volcanic fissure lakes in the interior of Iceland. 80–200mm lens, 1/125 second at f4

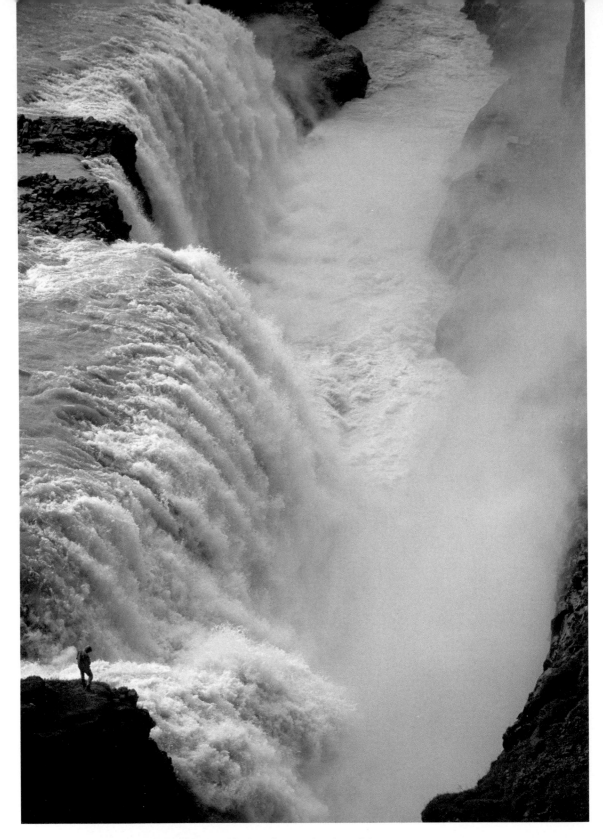

A visitor to Gullfoss waterfalls in Iceland is dwarfed by the size of the formation. 180mm lens, 1/500 second at f2.8

- Incorporate subject elements that are familiar to the viewer. A barn, a lone house, a fence post, or a windmill helps us to tell the story of the area and provides a tangible point of reference for the landscape.

- You don't always have to use a person for sense of scale. Shooting an assignment for *National Geographic Traveler*, I parked my rental car on a road on the west side of Gila National Wilderness in New Mexico, so I could illustrate the solitude and grandeur of this area.

Finding Your Subject

Within those Big Places, your subject can be the focal point of the photo, whether that subject is a person, bird, or bear. What your subject is doing helps create a more interesting photo. When the subject is centered in the frame staring into the camera, our eyes gravitate toward the center and little else. Conversely, when you have your subject interacting in the scene, the overall photo becomes the message.

Adding a subject to your photographs of Big Places not only adds a sense of scale, but heightens your personal interest in the photo. Photographs are most successful when you have a subject interacting with the environment, as the interaction tells a story and engages the viewer.

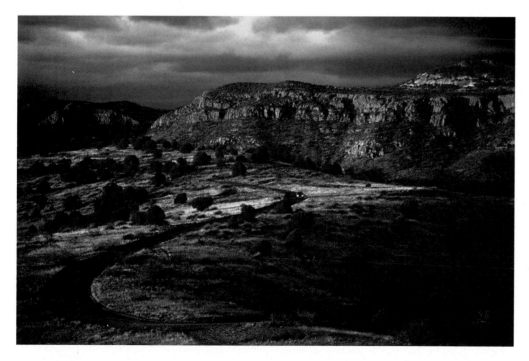

On a shoot for *National Geographic Traveler,* I was on a loop drive around the Gila Wilderness area in New Mexico. This back road ran up against the area, and I waited hours for the sun to peek out for only a moment. 80–200mm lens, 1/125 second at f4

Creating Interest: Make Your Audience Want More

Flipping through a stack of prints from your friend's latest vacation can be an exhilarating experience or an exercise in frustration, depending on the content of those photos. How do you make your photos command the attention of the viewer and make your audience want more?

- Keep things simple in the frame. One common mistake is having too much going on in the frame. Strive for simple, elegant compositions.

- Have your subject interact with the scene, not stare into the camera. Stay with the subject until something interesting happens. If you are photographing prairie dogs in a field, wait until two dogs interact, or one stretches its head toward the sky. Often it's that simple gesture that creates a spark of interest in what could have been a boring photo.

- Use contrasting colors to create interest. An expanse of blue sky with a strategically placed person in a red sweater creates a contrast in palette that draws the attention of the viewer.

- Shoot during a time of day that can utilize the light. Good afternoon or morning light against the wall of the cliff may not only produce a nicer quality light, but also create a more even light that helps the photograph succeed.

Creating a Sense of Place

One of the old rules of thumb when covering a story as a newspaper photographer was to shoot wide as you started your coverage. This anchors the story within the environment. It could be the zoo, the middle of the Sahara, or a village in Scotland. Next time you pick up a photo-driven magazine like *National Geographic*, look for the establishing photo that explains to the viewer where you are. A photo that works well in this sense works on several layers. The first and most obvious is to introduce the viewer to what the subject's world looks like. Secondly, it gives clues to the character of the subject as we are heavily influenced by where we live.

You've traveled far and wide to get to the place of your dreams and you want your photos to convey that feeling of being there. You want the viewer to understand the magic of what attracted you to the locale in the first place. Remember, if something makes you say "wow", then it's worth a photograph. What is the single element in the environment that compels you to pick up your camera? Isolate it and make that element the subject of your photograph. It's easy for landscape images to become cluttered. By composing your photo around a central element, your landscapes will be easier to "read" and will convey the essence of the environment.

Creating a Sense of Magic

Veteran photographers have the uncanny ability to consistently be at the right place at the right time—almost like a sixth sense. Your "spider" sense may not tingle when a stunning opportunity is near, but your pictures can benefit by using some of the tricks employed by professional landscape photographers.

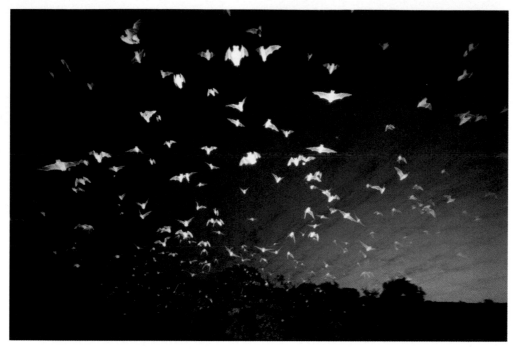

More than 20 million bats make Bracken Cave near San Antonio, Texas, their home. The nightly occurrence of the bats' emergence on their feeding flight takes a couple of hours to complete. I was on a cherry picker over the cave's entrance when I caught the flow of these amazing creatures. 17–35mm lens, 1/2 second at f4

A polarizing filter is one of the most essential filters to reside in your camera bag. What makes it indispensable is its ability to control glare, deepen colors, and eliminate reflections. All photographers should have a basic understanding of how the polarizer works to take full advantage of this uber-filter.

The photographer is constantly struggling with glare, scattered light, and reflections that degrade the quality of the photograph. These can dilute the light or obscure subjects in the photograph. The extended dynamic range of a scene may be beyond the ability for the chip to capture the full range of bright to dark in the image. The polarizer, when used correctly, can assist in mitigating these problems.

Some shooters leave polarizers on their cameras permanently, which can result in images that look obviously polarized. Also, be wary of wearing polarized sunglasses—you might miss a good picture because you couldn't see a reflectance that the polarized glasses absorbed.

A Quick Polarizer Tutorial

Almost all outdoor photography is accomplished with primary light sources such as the sun or moon. The light from these sources can be described, very simply, as a flow of particles moving perpendicular from the source. These light sources are *unpolarized*, and the job of the polarizer is to allow passage of the

light rays that are directed in the polarizing direction, effectively "selecting" which light rays may enter your lens.

Polarizers work when the lens is pointed at a 90-degree angle to the light source (sometimes we may want to polarize a source or reflectance that isn't related to the sun). One easy trick: use your hand to make an "L" with thumb and index finger. With your index finger, point at the sun and extend your thumb at a 90-degree angle to your index finger. That will be the direction you'll want to point your lens for maximum polarizer effect.

The bezel, or rotating front glass element of the polarizer, is turned while looking through the camera. You watch through the viewfinder or on the monitor to ascertain when the desired effect is reached. Wide-angle lenses can create problems with landscapes that include a lot of sky. Since the wide lens takes in such a large expanse of horizon, the ideal 90-degree positioning of the camera to the sun is changed on the extreme sides of the wide-angle image. The lens takes in so much of the horizon that the effective angle of the edges of the frame to the sun will not be 90 degrees, but closer to 45 to 75 degrees. This causes the polarizer to not darken the sky equally in the corners, but proportionally as to the relative angle. You will notice a darkening of the sky in the middle of the frame and lighter sky at the edges. One way to deal with this is to use a graduated filter (see the section "Another Necessity: The Graduated Filter"). This will provide an even darkening of the sky. Polarizing filters also affect the exposure as

they are essentially a neutral density filter that absorbs about two stops of light. Your camera's TTL metering will adjust for this, but if you are using an external meter, adjust the camera's aperture by opening it two stops. If the external meter reads 1/250 of a second at f8, the correct exposure with the polarizer would be 1/250 of a second at f4.

Two types of polarizing filters are available:

- **Linear polarizers** are considered standard and can actually cause problems with auto-focus and/or auto-exposure, contributing to inaccurate exposure and focus problems. Also, they may play havoc with your TTL light meter.

- **Circular polarizers** can be used on all cameras without any of the problems associated with the linear polarizer. A circular polarizer is preferred for digital photography as it will provide the best results with auto-focus lenses.

Polarizers in Action

The Owyhee River, in a remote corner of Idaho, is navigable by kayak or raft for just a few weeks every year, dictated by spring runoff. An assignment for *National Geographic Adventure* had me paddling an inflatable kayak for the week-long assignment. Fed by several very beautiful tributaries cutting through the desert landscape, the Owyhee (pronounced "Hawaii" because the first western explorers to travel the river thought it was so beautiful, it must be like the tropical paradise) is a classic whitewater river. Climbing up one afternoon to an overview of the river, I felt this was a

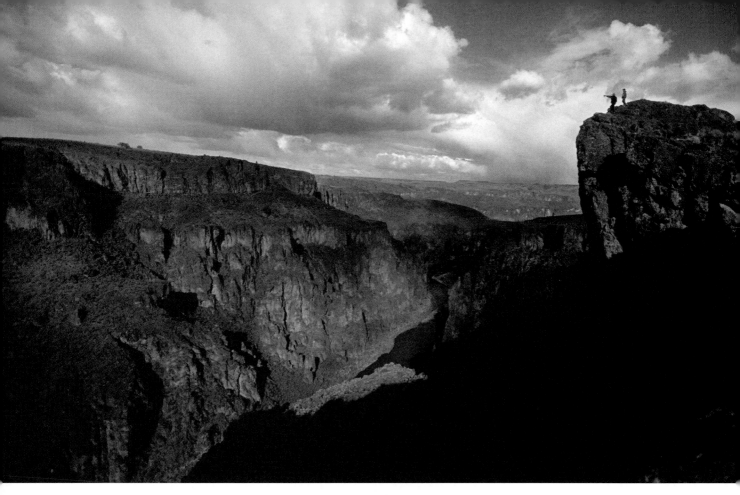

The Owyhee River cuts through a very remote section of Idaho. I shot this assignment for *National Geographic Adventure* on a six-day shoot kayaking down this river. I wanted the humans in this photo to be secondary to the amazing landscape. 20-35mm lens, 1/250 second at f5.6

great scene-setter. The problem here was the sky was a bit too "hot" for the rest of the image. The clouds and sky were out of the exposure range if I exposed for the river and peak with the climbers. Since my intended scene was at a perfect 90-degree angle to the setting sun, a polarizer made the sky and clouds come alive.

Another Necessity: The Graduated Filter

Photographers use many tools in our business. Some are to deal with the natural inability of digital to capture the dynamic range of the scene as our eyes can see it. The human eye can look at a scene and readily capture the full range of light, while the camera is limited by its ability to capture only a slice of that full brightness range.

Another life-saver that is a close second to the polarizer is the graduated neutral density filter. A graduated neutral density filter helps to compress a scene's brightness range into a range that can be captured by film or digital.

This rectangular filter is half-neutral density, half clear with a split in the middle. Used for situations where the sky is significantly brighter than the rest of the image, the filter is placed over the lens so that the split section of the lens aligns with the horizon and the neutral density portion of the filter covers the sky. This balances the brightness values so you can correctly expose for both the sky and the foreground.

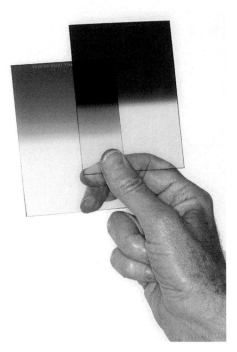

Two Singh-Ray graduated filters that are *always* in my bag. The version at left is a 2-stop filter, the version at right a 3-stop graduated filter.

When we look at a beach scene, our eyes capture the deep blue sky, the aquamarine of the water, and the soft umber color of the sand—all in the full blaze of the midday sunlight. The chip (or film) does not have the dynamic range of the eye and thus the unfiltered photo of that scene will suffer. If the exposure for the sky is correct, more than likely the sand will be blown out. Or if we expose for the sand, the sky will be almost black. The graduated neutral density filters give you the ability to more nearly capture the scene as you see it. Filters are the method by which we control the light and the exposure range.

Toward the end of the trip on the Owyhee, several of the kayakers walked up one of the most spectacular side canyons. Watching each member of the crew cross the small stream, the scene was perfect for a photograph. The problem was that the sky and the foreground were too far apart in exposure. The solution: use a graduated filter to reduce the exposure in the sky by three stops while leaving the foreground untouched. This filter now lives in my bag as it has saved the day in many landscape and scenic photos on bright, sunny days.

Shot for *National Geographic Adventure*, shooting into a fairly bright sky with a shadowed canyon in the foreground, the only way I could maintain the exposure was to use a neutral density filter, reducing the exposure of the sky by three stops, while leaving the foreground untouched. 17-35mm lens, 1/125 second at f8

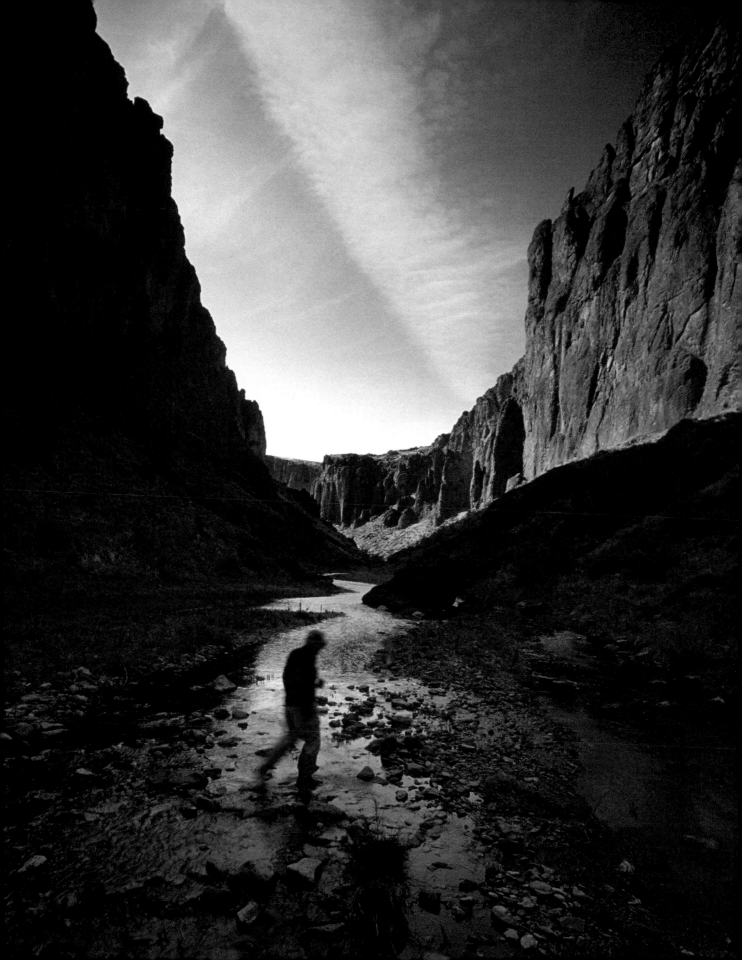

Neutral Density Filter

A graduated neutral density filter, as used in the preceding photo, has half the filter darkened, as to enable the photographer to reduce half the image's exposure. A neutral density filter is 100 percent darkened.

The sole purpose of this filter is to evenly reduce light going through the lens. This can be used for those times the ambient exposure requires too high a shutter speed. These filters come in one-stop, two-stop, or three-stop levels of reduction. Say you want to shoot a blurred image of runners to accentuate the movement and the slowest exposure you can achieve is 1/60 of a second at f16. Pop on a two-stop neutral density filter and you immediately alter the exposure to 1/15 of a second by the two-stops light loss the filter creates.

Skylight/UV/81A Filters

These are the filters to leave on the lens at all times. With no light loss and a very minimal amount of impact on the image, these filters will be a cheap insurance policy against having to replace an unprotected front element if something whacks the front of your lens. And believe me, after replacing a few front elements over the years, I have learned that keeping a filter on the lens is a lot cheaper way to go. I use B+W or Heliopan as my filters of choice as I've seen the results a cheap filter can create on optical benches in measuring the distortion.

As a photographer who grew up shooting film, I always kept an 81A filter on the lens,

for protection and for the slight warming effect the filter imposed. 81 filters come in three strengths: 81A, 81B, and 81C. I have all the filters listed on the back of a Minolta color meter, which includes 81D and 81EF. The A filter has a very slight warming effect, just enough to add a warm (gold-orange) feeling to the photo. The B filter goes further, as does the C, both of these being too strong for everyday shooting. Digital does present a bit of a problem with the 81A, B, and C filters. The white balance setting on your camera will see that warmer light, which has been enhanced by the filter, and will pump up the blue channel in the camera's software, thereby neutralizing the filter's effect. The problem here is that the blue channel is where the main body of noise comes from. A skylight or UV filter is the best choice for a permanent filter on your lens.

Software Filter Packages

In the not-so-long-ago past, all filtration was done in the obvious place, in front of the lens. Understanding filter packs, light loss, and mixed light sources all were part of that knowledge, which years in school or in the business would provide you. With the advent of digital, the photographer now has some filtration that can be introduced in the computer.

Unfortunately, the most common uses of photographic filters can't be introduced in the digital darkroom. Filtering a scattered light source with a polarizer or compressing the brightness range of the scene can't be done on the computer. Digital filters are nice tools for

slightly enhancing or modifying photographs, but they are not a substitute for filtration done on the lens.

There is some value in keeping a warming and cooling filter capture on the computer. If you have a Macbeth ColorChecker shot with all the warming and cooling filters (for landscapes, I'd use noon sun for illumination), you can "apply" warming filters by applying a balance of the complimentary cooling filter. For example, to apply an 81B, use the balance information of an 82B on the image you want to warm. When the balance removes the 82B's coolness, it warms to neutral; apply that to a nonfiltered image to replicate Wratten filters without having to apply the filters on the lens, at the shoot. The ColorChecker images can be stored, or the Curves/Levels balance info can be stored.

PHOTOGRAPHING WILDLIFE

Animals, animals, animals require patience, patience, patience. Wildlife photography is a wildly popular area of photography that does not necessarily demand that you travel to the four corners of the earth. This section will discuss where you can go to obtain great wildlife photographs without breaking the bank. We'll also discuss some ideas regarding photographing critters.

I spent some time in the Dry Bay area of the enormous Glacier Bay National Park, a very remote section only accessible by bush plane or boat via the Gulf of Alaska. I was photographing a story for *National*

Geographic on the Tatshenshini-Alsek River and needed to photograph grizzlies for the story. Greg Dudgeon, a National Park Service ranger for the northern extremes of the park, had suggested the area, which has one of the highest densities of the bears in the world. Access to Greg's location had required an all-terrain vehicle (a four-wheeled motorcycle) trek followed by a short hike to the banks of the East Alsek River. We took off early and made it to the river before dawn. A shallow rapid was a natural ladder for the salmon swimming upstream to spawn, and we were right in the middle of the spawning season. Moving as quietly as we could so we would not scare off any bears, we tiptoed past dozens of bear-mauled salmon carcasses.

Greg chose a spot on the riverbank, thinking that we could make our presence known to the grizzlies, and not surprise them, which could initiate an attack. We sat that first morning for two or three hours, with several predators moving past in the distance. A gray wolf and a grizzly were out this morning, but not close enough to photograph. We decided to try again the next morning, and headed back to the same place. A super-telephoto 600mm lens was mounted on my tripod with a second camera carrying an 80–200mm zoom. I hoped I would be ready for anything.

Within a few minutes a large coastal grizzly (so named because these bears stay close to the ocean for the abundance of fish) appeared out of the willow brush along the far shore, about 200 yards away, thus a little too far to photograph. Still, the grizzly's arrival

caused an immediate increase in my pulse rate and focused my attention—these bears are generally larger than their mountain brethren and this one was no exception. Greg, armed with a shotgun, was talking softly so the bear would not be alarmed by our presence.

The initial rush of seeing this huge critter so close soon gave way to our relaxing a bit as the bear just moved around in a small area. Twenty minutes passed and my attention was starting to drift. Something, a sound or motion, triggered the bear's next reaction. Turning toward us, he lit out in a full sprint directly at our exposed position. I started shooting with my camera and Greg brought his weapon up. The charging bear stopped in the water immediately in front of us. Sizing us up, he looked at us, then looked into the water, back at us, and back at the water. He then dunked his enormous head into the rapids, bringing up a large salmon. I've always thought he was deciding, "Hmmm, surf or turf?"

Animal Encounters Close to Home

The Serengeti, the Arctic Circle, the rainforest…traveling to these exotic locales will provide amazing photo opportunities. However, it will also expose you to hungry lions, ornery polar bears, and a host of creepy crawlers that you'd probably rather not have scurrying around your camera bag. Practicing your techniques at your local zoo provides access to animals from around the world, but without the risk of becoming lunch for a hungry carnivore.

Encounters like my grizzly adventure are rare and require time—a lot of time. I've always hugely admired the wildlife photography of Frans Lanting and John Shaw and wished I had the same patience their craft requires. If you are short on time, or don't want an unexpected encounter with a giant bear, the zoo can provide a wonderful environment for capturing wildlife. In your bag, be sure and carry a long lens for close-up portraits of the animals and to help compress the photo enough that the distracting background is a blur.

- A 300mm lens is a great choice for shooting in a zoo, long enough to reach out but not so long that any tiny bit of motion is amplified because of the long reach. This long lens will also help to blur the bars of the cage between you and the animal you're photographing.

- Find out from the zoo when feeding takes place. This is a time when you'll get action from the animals instead of a series of portraits of sleeping bears.

- Take your time. Hang out at a cage or pen that has an interesting animal and give it time for something to develop. Remember, wildlife photographers may be hunkered down in a cold blind for hours waiting for the moment the eagle swoops down for a fish. This is good training for the time you are in the field and have to practice patience.

- Think early and late when deciding when to visit. Often, these are the times when it

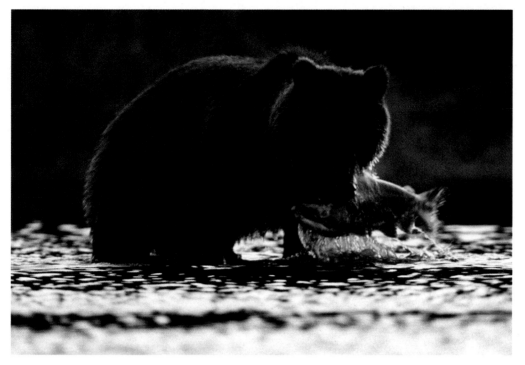

On the East Alsek River near Dry Bay, Alaska, this bear had stayed just out of camera range for quite a while before he decided to run for a salmon. 600mm lens, 1/250 second at f4

is least crowded and the animals may be up and moving.

- Approach the zoo and ask if they ever need photos for possible publicity, archiving, and so on. Most larger zoos have their own photographic staff, but smaller zoos may be quite interested in working out an arrangement. This relationship may pay off by them contacting you the next time they have an animal birth or special event happening.

- Bring a flash so you can fill in the shadows on a harshly lit or backlit photo.

- Zoos are more than pleased to have amateur photographers on the premises as long as they are not shooting for commercial gain. This means any selling of the images, for publication or for any monetary gain. This is a strict policy with large zoos, and you should ask for a copy of the zoo's policy on commercial photography if that is your intent.

SPECIALIZED EQUIPMENT

The world of outdoor photography can demand a lot of photographers and their equipment. Weather conditions are not always ideal, traveling to and from a location can be arduous if not hazardous, and trying to combine good light with the perfect moment can be frustrating. In this section, we'll talk about how to improve your odds and make life a bit easier.

Camera Equipment and Such

We'd hiked across the tundra in the Eskers country of the Northwest Territories for hours, trying to find the den of arctic wolves that Terry had seen earlier. I was on assignment for *Condé Nast Traveler* to photograph this unspoiled and largely uninhabited area of Canada. Terry was not only a guide; he was an accomplished photographer as well. He'd whittled his equipment down to two bodies—one in a LowePro TLZ Pro AW chest case and the other a body with a long (400mm) lens attached to a monopod (imagine using one leg of a tripod with a ballhead attached and you get the picture: fast and stable). This was no country for a camera bag. I had my vest loaded with the minimum amount of gear to get the job done: a total of two cameras and three lenses. I used a wide zoom on one body, a medium length zoom (80–200mm) in my vest pocket, and a 600mm on the other body, also on a monopod.

The outdoors will teach you quickly what works and what doesn't. What does

work well are cases such as the LowePro bag that attach firmly to your torso so there is no bouncing of the camera against your chest. Providing a snug fit for a camera with up to an 80–200mm lens attached, the bag also affords weatherproofing and is well padded against shock and accidental knocks.

When you don't need them, they are a pain to carry, but when the conditions require the use of a tripod, they are utterly invaluable. Those conditions include long exposures, and shooting with longer lenses where holding 15 pounds of lens and camera would be unrealistic. I carry a Gitzo 1228 carbon fiber tripod with an Arca Swiss ballhead. This light combination works very well for me in the outdoors and has taken and shaken off quite a bit of abuse.

Another piece of equipment that is always in my outdoors bag is a macro lens. This extreme close-up lens opens worlds to the outdoor photographer. I've spent hours in a ten-square-yard area working on shooting close-ups. It is another world that some photographers even specialize in. Here are a few tips for macro work:

- A small strobe can be helpful, or try a "ring light." These strobes are circular in design and fit around the lens. The light produced by a ring light is very even across the photo.

- A reflector is a must for the macro photographer, often to reflect a bit of light to fill in the shadow caused by the camera and photographer or to warm up

the image. To improvise, I'll carry small pieces of paper and aluminum foil to create mini-reflectors that can be fitted into very small spaces yet reflect just enough light to fill in shadowed areas of a flower or insect. The foil that wraps Wratten filters can sometimes be the right size.

- A small tripod is a necessity as the zone of focus of a macro lens can be very shallow, and working close in lower light amplifies any movement of the camera.

- A shutter release cord should also be in your macro kit. When you are working with extreme close-ups in low light, any movement of the camera can affect the sharpness, and the shutter release cord removes your shaky hands from the camera. If you've forgotten your shutter release cord, try using the self-timer on the camera. Set it for a couple of seconds, compose your photo, then remove your hands as soon as you press the shutter. This allows any movement of the camera to settle out, ensuring a very stable platform. Mirror lockup can be used to help steady the camera further when shooting long exposures, but focusing must be done pre-lockup as this trick eliminates the ability to see through the camera.

- A small spray bottle of water can be used to moisten leaves, petals, flowers, and so on to give a bit more life to them.

- If shooting insects, bugs, birds, and such for possible sales, obtain the scientific name. Any serious biological journal will want to know that you've photographed an *Euchromus giganteus* and not a "funky kinda green and gold huge critter."

The Amazon basin has a dizzyingly large array of insects. On assignment for *Condé Nast Traveler*, my photographic subjects, who happened to be biologists, found this beautiful beetle, *Euchromus giganteus*, probably 2.5 inches long. I used a reflector to fill in the light on the insect's wings, producing a visual "pop" to heighten the attention on the colorful creature. 60mm macro lens, 1/60 second at f5.6

Various and Sundry Other Gear to Contemplate

In my years of working as a photographer, I've accumulated my own set of specialized outdoor gear as well as stuff I find helps me in my photographic mission. Keep a list of what you take, and at the end of the shoot note what was used and what wasn't. Over time you will have your own list addressing your shooting style and needs.

Here are a few other bits of specialized gear I'll take on outdoor shoots:

- I always carry one or two chamois cloths in my bag/vest. These are invaluable as camera wipes and rain covers. Check your local auto parts store or grocery store for a chamois.

- A "camera raincoat" is a specific rain cover for the camera and lens. Several different brands are available, including Photo Fax Camera Raincoat, which is one of the most serious looking covers, and raincovers made by FotoSharp and Kata Kata. If you're serious about shooting in the great outdoors, a good rain cover is an absolute necessity.

- In addition to my camera raincoat, I always take an umbrella. Either a small portable one that fits in a pocket of my vest or a golf umbrella—cumbersome, but it provides great protection, as long as the wind is not blowing!

- Desiccants and ziplock baggies are also permanent residents of my travel/outdoor kit. At the end of a day shooting in a rainforest or other high-humidity situation, the camera and lens go in a baggie along with a small container of desiccant. Desiccants are the little bags of moisture-absorbing silica gel we're not supposed to eat that are included in almost every bit of electronic/photographic gear that we purchase. Drierite Corporation makes a small cylindrical container that once saturated with moisture can be regenerated by baking in the oven (www.drierite.com/default.cfm). The container on page 9 of Drierite's 32-page catalog is one of the most functional units as it is small and portable.

- One unfortunate byproduct of the "Golden Hour," that perfect time near sunset when the light is ethereal, is that it is also the time mosquitoes call lunch hour. To deal with these little devils, I always wear a long-sleeve light-colored shirt, sprayed with Permethrin. When sprayed on clothing, this product repels ticks, mosquitoes, chiggers, and mites. I've never had a reaction of any sort to this product and it works wonderfully. Find it online at www.sawyerproducts.com/sawyer_products/pages/insect_repellent/. Several clothing manufacturers now offer clothing that is pretreated with Permethrin. These include Exofficio's "Buzz Off" line of clothing.

- I also keep a lens pen and batteries specific to my camera in my vest.

THE BENEFITS of DIGITAL in NATURE PHOTOGRAPHY

On a three-month assignment in Papua New Guinea, I was so remote I did not have the opportunity to ship my ever-growing pile of film to *National Geographic* for processing. Every day I'd check the case where the rolls resided and worry about exposure, camera problems, if the moment was captured, and so on. Beyond frustrated, I found myself shooting more than normal with different cameras on the same situation. I wanted to cover my tail and protect against losing an important image due to camera malfunction.

Fast-forward to the digital era. I shoot, I confirm, I move on. At night, I back up my cards to my laptop and burn them to CD. The advantages of digital in this particular area of photography are legion. The ability to check out the image immediately for composition and exposure actually empowers the photographer in this craft. (And don't forget, it also allows you to spend countless hours poring over your laptop when you could be sleeping!) Instead of covering your tail by shooting and shooting, you can move on to the next image when you see the fruition of the moment or situation on the monitor. If possible I shoot test exposures based on my metering and make adjustment prior to the real deal. Then I know I don't have to bracket, shooting additional exposures a third of a stop or so on either side of the correct exposure to cover myself… and I can work on the moment.

On an assignment for *National Geographic* in an almost prehistoric area of Papua New Guinea, I went hunting for wild pigs and cassowaries with a couple of local hunters. The cassowary is the most feared animal in the rainforest there, as the ostrich-sized bird is armed with a huge claw on the back of each foot and will come after you if it sees you first with an intent to disembowel. 20mm lens, 1/125 second at f4

One of the most spectacular settings on earth, the interior of Iceland is as varied a terrain as I've seen. I shot a slow exposure here to allow the movement of the water to be exaggerated, creating the "molten silver" look. 180mm lens, 1/4 second at f8

HOW TO: CREATING a SENSE of PLACE in YOUR OUTDOOR PHOTOGRAPHY

When photographing on assignment for an outdoor publication, the photographer is responsible for capturing a "sense of place." The viewer has to feel that photo resonate. Here are some tips for effectively conveying that sense of place:

- This may take more than one photo. Start with a wide shot creating an overall scene. Again, use your light as a key factor by shooting at good times of the day. Supporting photos can be details and moments that help create that sense of grandeur.

- What attracted you to this area? This could be the key element to your photos. If it's Old Faithful, then use it as an element in your photo, even if it is only in part of the frame—perhaps your child in the foreground taking a photo of the geyser.

- The above tip goes hand in hand with this one: don't be literal. A photo of Old Faithful by itself will not be as interesting as a photo that includes a human. Try shooting from different levels, up high, down low. Look around. An image of Old Faithful reflected in a tourist's sunglasses tells a lot about the crowds that eagerly await its eruptions.

- Include scale if the scene is grand. This will give the viewer a sense of the majesty of the place.

- Don't stop working the scene after the sun sets. This can be a wonderful time to bring out the tripod for long exposures, which opens up another world of photography and a fresh look and palette.

- As an aside, here's a website that I recommend to students: www.artphotogallery.org. This website has a Masters section with important images from some of the most legendary photographers ever: Ansel Adams, Edward Weston, Arnold Newman, Joel Meyerowitz, Walker Evans, Yosuf Karsh, Irving Penn, Richard Avedon—62 artists are catalogued here. This is a nice, free access photo library for anyone interested in seeing accomplished work.

THE DIGITAL DARKROOM

© Jay Kinghorn

INTRODUCTION to the DIGITAL DARKROOM

Good photographs are seen in the mind's eye before the shutter is tripped, but they are made in the darkroom. For it is the final stage of photography—in the production of negative and print—that the creative vision is realized in a picture meant to be looked at, admired, perhaps honored.

—Anonymous, *The Print (The Life Library of Photography)* by Time-Life Books

Photography is in its greatest period of evolution since the transition from glass plate negatives of the 1800s to the roll of film we are familiar with today. It's not simply a change in tools, but also of technique and vision. Photographers are relearning some fundamental concepts of photography to capitalize on the new tools, techniques, and potential that digital has to offer.

Clear sailing at Rai-Lai Beach, Southern Thailand.

At the nexus of this revolution is Adobe Photoshop. It has become *the* essential tool for the digital photographer, incorporating the key elements of the traditional darkroom, but now with the ability to process and refine your images with greater dexterity and ease.

This is not to say that Photoshop is without a steep learning curve. Fortunately, as photographers, we can narrow the scope of our learning to incorporate only the techniques most essential to our day-to-day work. Photoshop has applications broader than that of just digital photography. It is also used in graphic design, web design, and illustration. While the program may seem daunting initially, this book will simplify the core techniques you need and help you become adept at manipulating your digital images.

PHOTOSHOP AS A CREATIVE TOOL

At the core of our photography training lies the maxim, "Technical proficiency opens doors for creative exploration." Photography has always been a technical art. Shutter speeds, apertures, development times, darkroom chemistry, and print contrast ratios have always challenged traditional photographers. Digital photography is no different. The art and craft of digital photography demands that photographers learn to use the new tools—to understand what they are capable of, and to use that knowledge to capture and arrange light in a manner that communicates your message to the viewer. *Photoshop doesn't replace the need for proper exposure, brilliant light, and fabulous composition.* It merely enhances those elements, and allows a skilled practitioner to further refine the messages contained in the digital original—imparting your images' subtler experiences with clarity and power. Photoshop allows for a great degree of latitude to correct mistakes in exposure or color balance, but it is never a substitute for skill and artistry behind the camera. Up until this point, this book has concentrated on capturing a brilliant digital negative. Now we turn our attention to distilling the content in that digital image through a series of adjustments, preparing it for print or the Web, and finally, archiving the image for posterity.

A Tour of the Digital Darkroom

Sitting under the blue and white plastic awning of the food bazaar in the town of Trang, in Southern Thailand, I watched a woman make the cherished noodle dish pad thai for a line of hungry Thais. Watching her work, I was struck by the fluidity and grace of her movements. From the angle at which she held the wok over the gas flame to the way she cracked the egg and mixed it with the noodles, it was apparent she had made thousands of plates of pad thai over many years. At one point in her life, she had to learn how much water was needed in the wok to soften and cook the noodles, when to crack the egg into the wok, and how much lime to add for just the right amount of citrus zing. Through practice, patience, and time, the technical aspects of her craft transformed into rote muscle movements and the artistry of her cooking developed.

Working in Photoshop is very similar. At first, the location of the menu commands and palettes may seem to be an impediment to your pursuit of photography. However, with moderate practice and time, Photoshop's organization will become a natural extension of your photography. Although it may seem elementary, it is worth spending the time to learn how Photoshop is organized, to learn the basic imaging fundamentals, so that in time you will know exactly how much contrast to add to images and be able to mix it with just a pinch of saturation to give your photos that added bit of zing.

Elements of the Digital Darkroom

In a traditional darkroom, one would expect to find enlargers, chemicals for development, wash and rinse basins, and an array of papers for printing. What would you expect to see in a digital darkroom? Since this term is frequently used, we felt it would be a good idea to provide an overview of a digital darkroom—to give you the 30,000-foot view of its key components.

Image Input Images are either captured on a digital camera or scans are created from negative or positive film. The better part of the first half of this book has concentrated on making the best images from your digital camera, and Chapter 12 is devoted to the process of creating the best scans from your film. Digital files are temporarily stored on CompactFlash (CF) cards, Microdrives, or other types of digital media, while scans are generally burned to CD or archived directly onto a hard drive prior to processing.

Image Processing The image-processing stage consists of several important hardware and software elements:

- **Computer** Technology evolves at a blistering pace. Sage advice is to buy the fastest processor you can afford and load up the computer with as much RAM as it can hold. There is less of a difference between Macintosh and Windows platforms than in years past. I recommend that you use whatever platform you are most comfortable with.

■ **Monitor** The question I am most commonly asked about monitors is whether the new LCD displays meet the requirements of digital photographers or whether photographers should stick with the tried and true CRT monitors. Budget, expectations, and size of workspace are important elements in this equation. Whether you purchase an LCD or CRT monitor, you get what you pay for—and the addendum to that old saw is that you should expect to pay a lot more for a high-quality LCD. For someone new to digital photography and constrained by a tight budget, I would suggest getting a medium-quality 17-inch to 21-inch LCD. For maximum color accuracy, or if I wanted something sexy on my desk, I would buy an Apple Cinema Display or Eizo ColorEdge LCD display.

■ **Monitor calibration package** No serious digital photographer should be without a software and hardware package designed to calibrate and profile your monitor. Calibrating a monitor saves a tremendous amount of ink and paper ordinarily wasted on proof prints and ensures that the colors you see on your screen are accurate to the colors contained in your images. Monitor calibration will be discussed in the "Color Management" section later in this chapter.

■ **Raw image converter (optional)** Some form of raw image converter is necessary for converting the proprietary raw camera files (NEF, CRW, ORF, and so on) into a format more conducive to image editing and printing (TIFF, JPEG, PSD). I predom-inantly use the Adobe Camera Raw plug-in included in the most recent versions of Photoshop; however, there are occasions that require the use of a different raw image converter for best results. Raw image converters will be discussed in Chapter 14.

■ **Photoshop** The modern equivalent of the traditional darkroom, Photoshop is the processing chemistry, contrast filters, color

correction filters, and enlargers compacted into a tidy package on your hard drive. For those on a limited budget or not technically inclined, Photoshop Elements is a good starter program offering many of the same features as its big brother at a greatly reduced price. You can perform many of the techniques contained in this book with Photoshop Elements.

Output Viewing images on screen is nice, but it is difficult to hang a monitor on the wall or send your laptop to a friend for a gift. The output stage of the workflow is focused on translating pixels into prints and is often seen as the culmination of the digital photography process. We will cover printing in great detail in Chapter 17.

- **Inkjet printer (optional)** Almost everyone today has an inexpensive inkjet printer touted as "photo-quality." The output from these printers can be quite good, but the vast majority of them use dye-based inks, which fade quickly, and the printers are limited to 8 by 10 inch prints. The Epson line of printers currently owns the lion's share of the photography market with a wide range of printers including moderately priced desktop ink-jets and wide format machines geared to a high-end photo studio. Most of Epson's printers geared toward discriminating photographers use archival inks and print on a wide range of glossy, matte, and rag papers.

Image courtesy of Epson America, Inc.

- **Digital photo lab (optional)** The digital darkroom extends beyond the walls of your home or office. Professional photo labs offer medium- to high-quality prints made on photographic paper from digital files. Printers like the Fuji Frontier and the Océ LightJet use lasers to expose photosensitive paper to light. Because they do not require the same chemistry as traditional color printing, the prints have a long archival life, brilliant color palette, and very high quality.

Essentials of Digital Photography

Pixels are to a digital photographer what marble is to a sculptor, canvas is to a painter, and notes are to a composer—the raw material to be shaped and refined by the hand of a craftsman. Before learning how to exaggerate contrast, sharpen an image, or create a brilliant print, you must first understand the basic ingredients of the digital image. After all, a digital photo is nothing more than an elaborate string of ones and zeros cleverly arranged in such a manner so as to fool our eye into thinking that we are looking at a piece of reality. Let's roll up our sleeves and dive into the nitty-gritty of digital images: pixels.

Pixels, File Size, Image Size, and Image Resolution

When viewing a digital photograph onscreen, what you are really looking at is a collection of digital sample points called pixels. When grouped closely together, pixels trick our eyes into thinking that we are looking at a continuous tone photograph. Digital photographs are somewhat akin to an incredibly fine pointillist painting with finely nuanced variations in tone and color, giving us the illusion of detail. The number of pixels an image contains is determined by the size of the sensor on a digital camera (usually measured in megapixels) or a combination of the scanning resolution (measured in pixels per inch) multiplied by the physical dimensions of the film.

Tip When you trip the shutter on a digital camera or press Scan in your scanning software you've created a file with a fixed size. The number of pixels that file contains determines how large a print you can create from that file. For the best results, always capture the largest file size possible.

The *file size* of the image, in its simplest form, refers to how much disk space is needed to store the image data. Let's say our sample file requires just shy of 21MB of disk space. This tells us how much hard drive space is needed, but doesn't give us a tangible description of how large a print we could make with the file. A better piece of information is the *image size*, described in pixels. This tells us how many points of information (pixels) the file contains. Using the Image Size dialog box (Image | Image Size), we can see how many pixels the image

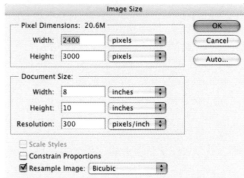

contains. In the case of our sample image, it is 2400 pixels wide and 3000 pixels tall.

We are still missing an important piece of information to determine how large a print we can make from this file: the *image resolution*. Returning to the analogy of a pointillist painting, imagine that we have a fixed number of paint strokes we can use for the painting. If we arrange those paint strokes over a very large canvas, there will be more space between

Mastering the Lingo: ppi vs. dpi

Want to sound like a digital cognoscente? Whenever you speak of digital images, use the abbreviation ppi or pixels per inch instead of dpi or dots per inch. Using dpi to describe image resolution is technically incorrect. The information contained in the file consists of pixels, not dots, although the abbreviation dpi is commonly used. If you were so inclined, you could print out a file, then use a magnifying glass to count the number of dots along a single row on an inch of paper. The quickest way to remember which abbreviation to use is to consider the medium. If it is viewed on the monitor, use pixels per inch; if it is a printed piece, use dots per inch.

file open and make sure the Resample Image checkbox is unchecked. Notice that when the Resample Image checkbox is unchecked, the ability to adjust the number of pixels disappears. Photoshop will not allow you to add or subtract pixels from the file, only to adjust the resolution or print size. Do just that: enter different values for the image resolution and document size to get a feel for how adjusting the document size affects image resolution and vice versa.

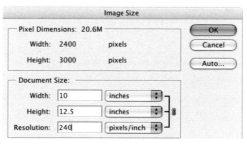

the dots, resulting in a more impressionistic painting with less detail and realism. However, if we cluster those paint strokes together on a smaller canvas, the tight spacing between strokes results in our eye perceiving the painting not as a collection of strokes but as a realistic photographic image with fine detail. The image's resolution allows us to adapt the number of pixels in the image to the needs of our output, stretching or compressing the grid the pixels are contained on to match the desired output size. The larger we scale the grid, the fewer pixels per inch (ppi) and the less detailed the print. The smaller the grid, the higher the ppi, and the more detailed the print becomes.

To get a feel of how image size and image resolution affect each other, open the Image Size dialog box (Image | Image Size) with a

It is a fact of life. In digital photography we regularly have to throw pixels away, or *downsample* an image, to create smaller print files or prepare images for the Web. On very rare occasions, we have to add pixels to our images to make a larger print. Adding pixels or *upsampling* will be discussed in Chapter 16, but for now, understand that there is no such thing as a free lunch. Upsampling usually results in a loss of image quality.

The *interpolation method* is the mathematical equation Photoshop uses to intelligently add or remove pixels from the image. The three most commonly used interpolation methods are

- **Bicubic** The default interpolation method, achieves satisfactory results for both upsampling and downsampling images
- **Bicubic Smoother** Designed for upsampling images
- **Bicubic Sharper** Used for downsampling images

Color Modes

Every digital image is associated with a color mode used by Photoshop and other imaging programs to translate the ones and zeros of an image into colors. Of the many color modes available in Photoshop, we will use only three, RGB, CMYK, and Grayscale. These modes store color and tone information numerically either as values along a scale from 0–255 (RGB or Grayscale) or as ink percentages (CMYK).

Grayscale is the simplest color mode to understand. Tonal information is stored as values ranging from 0 (black) to 255 (white). Fifty percent gray lands at 128 on this scale.

Red, green, and blue (RGB) are the three primary constituents of light. Numeric RGB values from 0–255 are given for each color to describe both the saturation of the individual primaries and the composite pixel color. Fully saturated values of red, green, and blue add up to white and are thus called additive

colors. RGB mode is used for files associated with light-based devices (scanners, cameras, or a monitor in the case of the Web). As photographers accustomed to working with light, we will work almost exclusively in RGB mode in this book.

Swatch with RGB values of 244, 204, and 136 with corresponding red, green, and blue values.

A few important points about RGB color:

Equal values of RGB correspond to a neutral shade of gray.

The greater the difference between the primary colors, the more saturated the individual color.

200, 180, 180 240, 180, 180

RGB values affect not only color, but tone as well. Low RGB values equate to darker tones, higher RGB values equate to brighter tones.

15,12,40 75, 85,130 150, 210, 240

Adding any of the three primary colors makes both the color more saturated and the tone brighter.

150,128,128 220,128,128

CMYK mode is the complement to RGB. Cyan, magenta, and yellow are called subtractive colors and are used for reflective print rendering, such as traditional color printing filters, printing presses, inkjet inks,

dye sublimation pigments, and color laser toners. Since ink absorbs light, fully saturated values of cyan, magenta, and yellow equal black. In the real world, the pigments we use to create cyan, magenta, and yellow inks aren't perfect, so we add black (K) to the mix to get truer, richer blacks on an inkjet printer or printing press.

Additive

Subtractive

RGB and CMYK color modes are complementary methods of describing color.

Histograms

Histograms are like topographic maps for the digital image, giving us a feel for the "lay of the land." The histogram is a graphic representation of how the tonal values and/or colors in the image are distributed. Learning to read a histogram is essential for maximizing the potential of your digital images. The histogram displays the RGB data (0–255) graphically, with 0 on the far left of the histogram and 255 on the far right of the histogram. The peaks and valleys indicate the number of pixels with that color value in the image.

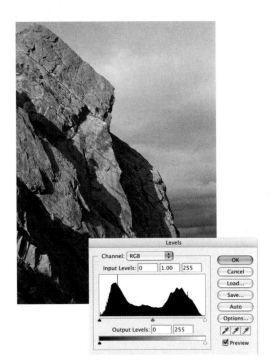

A healthy histogram has a small gap between either end point on the histogram and a distribution of values in between. There is no "magic" value to look for as each image

will have a unique histogram, though it is important to check the histogram for clipping (image information pressed against either side of the tonal range) and combing (indicates excessive image adjustment and potential posterization).

Jargon Guide

Posterization An abrupt and unnatural transition in tonal values, usually from under-exposure or overcorrecting in Photoshop, that spoils the illusion of a continuous-tone image. Most commonly seen in the shadows or very saturated areas of an image.

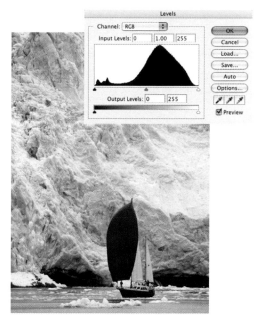

Notice that the image information is lumped into the highlight (right) end of the histogram. The abrupt cliff at the maximum highlight range of the histogram indicates that valuable image data has been lost from overexposure of the image. Hopefully, you took several exposures when shooting and have a better exposure to work with.

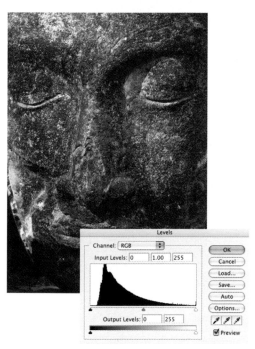

Notice that even though each histogram has a unique distribution of tones along the graph, all share a small space between the end of the pixel data and the maximum end points on the graph.

A histogram from an overexposed image

In this underexposed image, the terminus of the image data lies at the shadow end. Again, the steep cliff means that important shadow detail has been lost. No amount of manipulation can bring it back.

A histogram from an underexposed image

Exceptions to the Rules　A spike in either the shadows or the highlights in a histogram isn't always a cause for concern. Specular highlights—the shiny patches on water, chrome, or other highly reflective surfaces—aren't supposed to have any detail in them. If they did, they would ruin the rest of the image. It is usually desirable to let these highlights blow out to paper white.

Conversely, there are times when you want a shadow without any detail. Primarily, this occurs when you have a subject silhouetted against a sunset. Here, the histogram would give the appearance of an underexposed image, but in this case it happens to be exactly what we want.

Bit Depth　The bit depth of an image indicates how much information is used by Photoshop to store the RGB, grayscale, or CMYK data. The tonal range from black to white is divided up into a number of different slivers for encoding and processing purposes. Most images are stored in 8-bit mode, meaning that this range from black to

High Dynamic Range Images

Photographers have always been challenged by the fact that our eyes are able to perceive a wider brightness range than film or digital is able to capture. As you may remember, the average person is capable of perceiving detail across a 16-stop range, while most digital cameras can only record detail across a 6-stop range.

A high dynamic range (HDR) image can capture and preserve detail across an 18-stop range. This allows a photographer to create an image that more closely resem-bles the original scene as he saw it. By com-positing several exposures, HDR images preserve detail in bright highlights and deep shadows that would be lost in standard photographs.

Photoshop has begun to provide support for HDR images through the Merge To HDR command. The process of creating an HDR image requires multiple exposures taken with a tripod. Photoshop blends these exposures into a single 32 bits per channel HDR image. Upon converting from 32 bits per channel to 8 or 16 bits per channel, Photoshop gives you several options for compressing the high-contrast image into an image more appropriate for printing. HDR images contain such a high-contrast range that Photoshop provides a slider that allows you to view separate areas of the color range, as there is no way for a monitor to display both the highlights and the shadows simultaneously!

The drawback to HDR images at this point is the limited support and large file size. Since the images are limited by a low-dynamic range output device like a printer or monitor, extensive tonal mapping is needed to preserve the tonal differences between the elements of the photo. This can result in a loss of contrast throughout the image, or posterization in the extreme shadows or highlights. A comparison of the exposure ranges of important photographic elements is shown here.

I expect HDR to improve rapidly and in a few short years gain much wider acceptance. Certainly, photographers will be eager to break free of the 5–7 f-stop exposure range and experiment with photographing scenes that would have been impossible to capture using traditional photographic techniques.

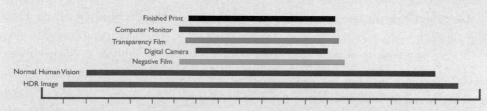

Approximate exposure ranges of photographic capture and storage media

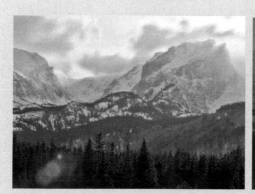 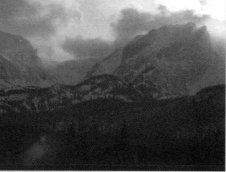

A high-contrast scene photographed normally (left) and as an HDR image (right)

white is chopped up into 256 different slivers. In 16-bit mode, we have the same range from black to white, but instead of using 256 levels of gray, we describe the levels of gray with a much higher degree of precision by breaking the tonal range into thousands of subtle increments. While this doesn't give you brighter colors or increased tonal range, it does give you a larger degree of latitude for correcting exposure errors without sacrificing image quality. Having this extra latitude is often desirable when correcting raw scans, but be forewarned, file sizes for 16-bit images are double those of 8-bit images and can get even larger when extra layers are added. For consistency and convenience, Photoshop continues to use the conventional 0–255 scale for displaying RGB values and uses the additional information for computing image adjustments.

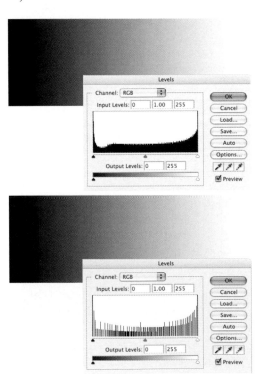

PIXEL POWER: AN INTRODUCTION to PHOTOSHOP

I still remember launching Photoshop for the first time and being perplexed by the multitude of pull-down menus, tools, and palettes. It was like being a stranger in a strange land. In this section, I'll guide you through the world of Photoshop and point out some important landmarks along the way. Think of this as the nickel tour to Photoshop, geared mostly toward those who are new to the program, but with valuable information for more experienced users. You may find it most effective to read through the rest of this chapter once, then revisit it after you become more acquainted with the program to pick up on several important time-saving tips you may have missed on the first read. For a more detailed overview of all Photoshop's tools and palettes, check out *How to Do Everything with Adobe Photoshop CS2*, by Colin Smith (McGraw-Hill/Osborne, 2005).

A. Menu Bar Along the top margin of the main window lies the menu bar, which provides access to the pull-down menus arranged left to right from global changes (opening and closing files) to localized changes (adjusting selections).

- **File** Opens, closes, and saves files. Most of the menu commands contained here are identical to most of the other applications on your computer.

- **Edit** Primarily used for rotating, transforming, or scaling images. Also the repository for Photoshop's color management commands.

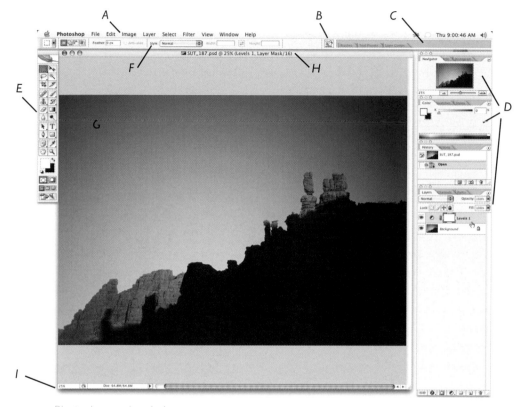

Photoshop main window

- **Image** Contains tools for adjusting tone, color, and overall size of the image.

- **Select** Menu commands for working with and adjusting localized selections within an image.

- **Filter** Contains a bevy of filters for creating abstract effects that are not used often for photography (colored pencil, warp, plastic wrap) and practical filters a photographer uses every day (Unsharp Mask, Smart Sharpen, Gaussian Blur, Lens Blur).

- **View** Allows you to zoom in to look at fine detail or zoom out for an overview

of the image. Also provides the ability to show or hide layout elements like rulers and guides.

- **Window** Used to show/hide Photoshop's palettes to balance an efficient workspace with maximum screen real estate.

- **Help** Accesses Photoshop's help menu.

B. Bridge Icon Delivers quick access to the Bridge, a retooled version of the File Browser. Formerly a module of Photoshop, the Bridge has become its own program and serves as a centralized focal point for all of the Creative Suite applications for organizing, editing, and sorting images.

C. Palette Well Storage for the many palettes Photoshop offers. I use this to store the palettes I use on an infrequent basis, like the Actions and Brushes palettes.

D. Palettes Each of the palettes provides functionality to a particular aspect of the program, such as layers or type. Many of the palettes are not used in a typical photographer's workflow. I will show you how to maximize your screen real estate with a custom workspace later in this chapter.

- **Actions** Truly harnessing the power of Photoshop requires that you make the computer perform a lot of the grunt work involved with image processing. The Actions palette allows you to automate many of the laborious tasks needed to process a large number of images. See Chapter 18 for more information.

- **Animation** You know those quirky, looping ads you see on the banner ads of websites? If you wanted to make them, the Animation palette would be helpful to you. Since we're photographers and not web designers, we'll bypass this palette in favor of something more useful to us.

- **Brushes** Want to create a custom brush in the shape of an eyeball? Me neither. The Brushes palette allows you to customize brush sizes and brush behavior to mimic painting styles. We will use this palette infrequently for retouching and little else.

- **Channels** Perhaps the most maligned and misunderstood palette in Photoshop. The Channels palette is a repository for the tone and color information in your files. Occasionally, the perfect selection or Layer Mask can be found lurking in one of the color channels.

- **Character** No, you don't get to choose a different persona in Photoshop; instead, the Character palette is used for selecting fonts and letter characteristics when working with type.

- **Color** Another palette used primarily for painting, design, and illustration. We'll hide it to save space.

- **Bridge** Absolutely essential to the photographer. It serves as the digital equivalent to the venerable lightbox. We will devote a significant portion of Chapter 13 to its use.

- **Histogram** Graphs the tonal characteristics of your files. I glance at it as I'm making corrections to a file about as often as I check my speedometer while driving.

- **History** Ever wish you could go back in time to correct a tragic mistake you've made? Photoshop, being the wondrous program it is, allows you to do just that. We'll cover its use in Chapter 15.

- **Info** Essential for color correction, the Info palette combined with the Histogram palette allows you to monitor your file's vital signs. See Chapter 14 for an explanation of how the Info palette makes color correction easy.

- **Layer comps** Primarily a design feature, the layer comps allow a designer or artist to save several variations of a composite or layout within a single file.

- **Layers** Probably the most valuable palette to the photographer. We will use it constantly as a repository for our corrections and image adjustments.

- **Navigator** Useful for learning how to navigate through Photoshop, but we will learn a few simple shortcuts that make this palette redundant.

- **Options** Displays the options for the current tool chosen. We'll leave this palette open.

- **Paragraph** Sister to the Character palette, the Paragraph palette is home to the features that apply to more than one line of type.

- **Paths** Another palette used frequently by designers and infrequently by photographers, paths are primarily used by illustrators or designers needing to drop out a background in an image destined for QuarkXPress.

- **Styles** Layer styles let you make type look like it was stamped from chrome or copper and copy that effect to text in other documents. While it is a very cool feature, it is not of great use for most photographers.

- **Swatches** Think of it as a Photoshop artist's box of crayons. Nice, but why choose from a box of 102 crayons when we have access to millions of crayons through the color picker in the toolbox?

- **Tool presets** Many photographers like to create a series of presets for the crop tool at standard print sizes like 4×6, 5×7, and so forth.

E. Toolbox Also known as the Tool palette, the toolbox is the one centralized location for all the tools used in Photoshop. The small black triangle in the lower-right corner of the tool icon indicates additional tools that are accessed by clicking and holding on the tool icon. A small fly-out menu appears displaying the hidden tools.

F. Options Bar The options bar allows you to adjust the behavior of the currently selected tool. For example, when the brush tool is selected, the options bar provides quick access to different brush sizes, brush presets, and the ability to adjust the opacity and quality of the paint stroke.

G. Image Window The image window contains, quite obviously, the image. Not so obvious, however, are the three screen modes: the standard screen mode for viewing multiple images simultaneously; the full screen mode, which surrounds the image with a neutral gray background; and the display mode, which hides the menu bar and surrounds the image with a black background. All three screen modes are accessed from icons in the toolbox located between the Quick Mask and Jump To Image Ready icons. To quickly scroll through the screen modes, press F on your keyboard.

H. Title Bar The title bar allows you to quickly access the most pertinent information about your file, including, from left to right:

- **Copyright status** Images that have a copyright embedded in the file will display a copyright symbol on the far left of the title bar.

- **File name** Displayed along with the file type (.jpg, .tif, or .psd).

- **Zoom percentage** The zoom percentage tells you what percentage of the pixels in the file is currently displayed on the monitor. At 100% zoom, every pixel in the file is being displayed on screen, which is invaluable for fine detail work such as retouching or sharpening. Commonly, though, you will make the majority of your adjustments at a zoom percentage that allows you to see the entire image.

- **Color mode** RGB, CMYK, or Grayscale. A pound symbol or an asterisk indicates that the image is untagged or contains a different color space than the working space for color management purposes (see "Color Management," later in this chapter).

- **Bit depth** Indicates the current bit depth of the active file, 8 or 16 bits per channel.

© SUT_187.tif @ 25% (RGB/16)

I. Status Bar The status bar, located in the lower-left corner of the image window, provides information about the active file. The left corner displays the zoom percentage, while the black triangle to the right offers access to additional information, including:

- **Version Cue** Used by designers and art houses to track multiple versions of images for a project.

- **Document Sizes** The default option list provides an estimate of the current file size in both flattened (left of the slash) and layered (right of the slash) states.

- **Document Profile** Displays the current color profile associated with the image.

- **Document Dimensions** Gives an estimated print size based on the current file size and image resolution.

- **Scratch Sizes** When Photoshop requires more memory than is installed as RAM in your computer, it temporarily writes a portion of the file to a portion of your hard drive called the scratch disk. The scratch sizes indicate the amount of memory being used by Photoshop and the amount of memory available to Photoshop.

- **Efficiency** During memory-intensive processes, the efficiency may drop below 100%, indicating that Photoshop is utilizing your scratch disk for additional memory. If the efficiency indicator drops below 100% routinely, it may be wise to purchase additional RAM for your computer.

- **Timing** Shows how long it took to complete the last computation.
- **Current Tool** Displays the currently selected tool.
- **32-bit Exposure** A slider used to adjust the portion of the tonal range displayed when working with HDR images.

Customizing Your Workspace

Some people like to have a desk that is neat and tidy. Me, I think that's a sign of neurosis. My workspace in Photoshop, however, I make as clean as possible to maximize the work area. I do this by creating a custom workspace, hiding most of Photoshop's palettes except for the few I use most frequently. A few palettes that I use on a semi-regular basis, like the Channels and Histogram palettes, I've nested with the Layers and Info palettes for quick but not immediate access. Use my workspace example as a jumping-off point. As you begin to feel more comfortable in Photoshop, feel free to tinker with my recommendations to find the workspace that works best for you.

To Create Jay's Custom Workspace

Step 1 Go to the Window pull-down menu at the top of the screen, go to the Workspace heading, and follow the arrow

to the right to Reset Palette Locations. This brings all the palettes back to the default settings.

Step 2 Close the Color/Swatches/Styles palette by clicking on the small red circle at the top left of the palette.

Step 3 Make the Actions palette visible by choosing it from the Window menu. Drag it to the palette well by clicking and holding on the top of the Actions tab. Release the mouse when the thin black outline appears around the palette well.

Step 4 Separate the Paths palette from the Layers and Channels by clicking on the Paths title and dragging it to the center of the screen. Close it.

Step 5 Dock the History palette with the Layers and Channels by clicking on the palette title and then drag it onto the Layers palette. Release the mouse when the thin black line appears around the palette.

Step 6 Bring the Layers and Info palettes to the front by clicking once on their palette title.

Step 7 From the Window pull-down menu, follow the Workspace arrow to the right, and this time choose Save Workspace. In the resulting dialog box, type **Jay's workspace** and choose OK.

Step 8 Should your workspace once again become cluttered, simply choose the custom workspace you created here from the Window | Workspace menu.

Step 9 Photoshop CS2 allows you to customize both your keyboard shortcuts and your menu items to show only the commands you use most often and hide the rest. Unless you are an advanced user, I recommend that you leave the menu items and the keyboard shortcuts at their default setting so that the tutorials and screenshots in this book match what you see on your screen. If you've already adjusted your menu items or

keyboard shortcuts, simply choose Window |
Workspace | Reset Menus, or Key-board
Shortcuts to return to Photoshop's defaults.

Layers

Central to compositing and essential to tone
and color correction, layers give Photoshop
a great deal of its flexibility and power. Once
you learn to use layers effectively, you'll have a
hard time imagining how you managed to get
along without them.

In the screenshots shown on the following
page, an image is shown along with the Layers
palette. The types of layers and key layer
features that are combined in this image are

A. Background Digital images in Photoshop
have at least one layer called the background
layer containing image information in the
form of pixels. Additional image layers can be
created or brought from other documents for
compositing, retouching, or special effects.

The image information contained on a layer is
generally opaque and hides the image on the
layer below it. In this image, the background
layer is not currently visible because there are
two opaque layers above it.

B. Smart Objects Smart objects appear in
the Layers palette and stack like normal layers,
but they are actually other images that have
been cleverly placed into Photoshop. A smart
object is actually a link to another file opening
up a number of creative possibilities. This
image contains two versions of the original
raw file that have been placed as smart objects.
The corrected image layer is the original raw
capture adjusted for better shadow detail
and image balance. The layer immediately
above it is the same raw file adjusted for the
highlights. The Layer Mask immediately to the
right of the Highlight SO thumbnail shows
a thumbnail of the Layer Mask. All of this
layer has been masked (hidden) except a small
portion of the brightest highlight area.

C. Adjustment Layers These layers are like
transparent sheets of acetate containing your
image corrections and adjustments. Think
of them as similar to a warming or a neutral
density filter for your camera lens. This part-
icular image contains levels and curves layers
used to correct the color and tone of the entire
image along with a second curves layer that
is specifically targeting the shadows in the
foreground. All three layers have been grouped
into a layer set to keep the Layers palette
organized.

D. *Type Layers* Type layers are used to add type to an image. These two type layers containing a short caption and my copyright information are linked, meaning that they will move in tandem if I choose to reposition them anywhere in the image.

E. *Specialty Layers* Shape, pattern, and fill layers are used commonly in creating artwork and illustration, but infrequently in photography. About the only time I use shape layers is to add a copyright symbol as a watermark. I've reduced the opacity of the layer to make it less obtrusive in the image and have added an embossed effect to give the copyright symbol the appearance of being three-dimensional.

F. *Layer Visibility Icons* The eyeballs along the left margin of the palette indicate that the layer is currently visible. I toggle these frequently as a quick before-and-after preview to verify that my adjustments have had the desired effect.

G. *Layer Blending Mode* Controls the inter-action between the currently highlighted layer and the layers below it. We'll experiment with the layer blending modes in Chapter 15 when we mimic traditional burning and dodging techniques.

H. *Layer Opacity Slider* Controls how opaque a given layer is. I use the opacity slider frequently to make slight adjustments to color and tone corrections.

A layered image

The corresponding
Layers palette

File Types Used for Digital Imaging

Photoshop is able to read and write in a large number of file formats, only a fraction of which are commonly used for digital photography. Choosing the appropriate file format for the task at hand is an essential skill. This section offers a brief description of the most commonly used file formats along with pros and cons, and a recommendation of when each format should be used.

JPEG

Fast, nimble, and read by almost every imaging program on the planet, JPEGs (Joint Photographic Experts Group) are a good choice when you want images to take up the least amount of space or move very quickly through an image processing workflow. Internet forums are rife with arguments as to whether a JPEG workflow is superior to raw files for digital photography. We prefer to leave our cameras on Raw mode to take advantage of the superior flexibility of raw camera files and use JPEGs only when we are shooting in a controlled environment like a studio, or when we need our images processed immediately. JPEGS make images small by compressing or "averaging" data into smaller bites, such as "these 9 pixels of sky have roughly the same values." This results in a small file, but can also result in a loss of subtle image detail. Opening and resaving a JPEG with a different compression setting causes the file to be compressed (averaged) a second time, which is a bit like making a copy of a cassette tape, then making a copy of the copy and so on. Each

subsequent generation loses quality compared to the original. JPEGs can't store layers and do not support 16-bit data. JPEGs are adept for the Internet and for quick processing or emailing, but I don't use them much for image archiving or processing.

TIFF

TIFF (Tag Image File Format) could be called the "other universal image format," but that would be giving TIFF short service. Unlike JPEG, TIFF doesn't average or lose data when it is saved, making it an ideal format for archiving. TIFF is also the format your service bureau or minilab will request. TIFF can store layers and works with 16-bit data, but beware, your minilab's machine will likely choke on layered or high-bit data, so some caution is required with TIFF files. Some cameras can shoot in TIFF mode, but we don't recommend it, as it essentially gives you the worst of both worlds, a large file that takes up a lot of space on your CF card, and none of the flexibility of a raw file. TIFF is an excellent format for long-term archiving because TIFFs can be read by many different imaging programs, and offers zip compression, a lossless form of image compression to save hard drive space.

PSD

As you would expect, just about everything you can do in Photoshop, you can save in a PSD (Photoshop Document), the native file format for Photoshop documents. Layers, yup, 16-bit data, yup, type layers, shape layers and alpha channels, yup, yup and yup. This has

traditionally been the archive format of choice for most photographers as it ensured all of the characteristics of a layered Photoshop file would be retained. For a long time, photographers used PSD to indicate whether the file was their layered master file, or TIFF for a flattened print-ready file. With TIFF now able to store layered and high-bit files, this distinction has become less cut and dried. For the sake of simplicity, I still recommend using PSD to denote layered master files, but if you decide that you would rather use TIFF, by all means, go for it.

Raw Camera Format

Not really one particular format, this is the term used to describe unprocessed camera files. They come in a variety of flavors like NEF (Nikon), ORF (Olympus), CRW (Canon), and RAF (Fuji). These files contain the unprocessed data from the digital camera along with an instruction set as to how the data should be processed. The raw file format is comparable to having a grocery sack full of flour, eggs, sugar, and chocolate chips along with a recipe for making chocolate chip cookies. The other file formats—JPEG, TIFF, PSD, and so forth—are like having a bag of finished cookies. While it is possible to make the finished cookies sweeter, it is much easier and more effective to sweeten them by adjusting the original recipe. The Adobe Camera Raw plug-in allows you to manipulate the recipes of almost all the most common raw camera formats, which makes shooting raw our preferred option.

DNG

In 2004, Adobe introduced DNG (Digital Negative Format), which aims to unify the multitude of camera raw formats into an open source, non-proprietary raw-file format. It remains to be seen whether camera manufacturers will make cameras that support the DNG format as Adobe has hoped. At the time of writing, third-party editing programs such as iView MediaPro and Capture One DSLR provide support for the DNG format. Photoshop allows you to convert your camera's raw files to the DNG raw file format and to edit and adjust DNG files as you would any other raw file.

Color Management

Anyone printing digital photos, either on a desktop printer or from a professional lab, has looked at their print and mused, "Why doesn't my print match my monitor?" The short answer to this question is that proper color management procedures weren't in place. Each piece of equipment used in digital imaging has its own set of color characteristics with a finite range of colors it is capable of reproducing, called the *color gamut*. These characteristics are described in a software file called an *ICC profile* that allows applications such as Photoshop to interpret colors from input devices and translate the colors for an output device like a desktop printer.

Fortunately, when color management is set up correctly, the entire process is very easy to use and is nearly seamless to you, the user. You already have most of the necessary

software installed on your computer to begin using color management, and I will walk you through the steps needed to configure Photoshop's color settings.

Governing Bodies

The ICC (International Color Consortium) and the CIE (Commission Internationale de l'Eclairage or International Commission on Illumination) have made great contributions to the science and standards behind color management. The CIE has conducted several studies over the last century to study the way that humans perceive color. The ICC oversees and develops the standards for the color management models we use in this book.

What Color Management Does

Proper use of color management in a digital photography workflow brings consistency to your color and tone corrections and predictability to your printing. A calibrated monitor allows you to trust what you see on the monitor and print with confidence.

Jargon Guide

The Jargon-English Guide to Color Management

- *Color space* The mathematical description or lookup table used by Photoshop to ascertain what the file's RGB, grayscale, and CMYK numbers should look like. Additionally, the color space contains information on the color characteristics of a device, such as a scanner, printer, or monitor.

- *Color gamut* The colors reproducible by a particular device or color space.

- *ICC profile* A metadata file, usually embedded in the image, used to give Photoshop

and other color-savvy imaging programs the necessary information to display the image correctly and to convert the image between color spaces.

- *Display profile* An ICC profile that describes the color reproduction characteristics of a display such as a CRT or LCD (flat panel).

- *Editing space* In an RGB workflow, the color space is used as the primary color space for tone and color corrections. RGB editing spaces do not represent the color behavior of a physical device, making them ideal as an intermediate space, between input and output, for conducting tone and color corrections. In Photoshop, editing spaces are selected as Working Spaces in the Color Management settings.

Color Management: Why Bother?

Really astute readers might be asking themselves right now why we need to bother with color management at all. The short answer to this complicated question is that we do not live in a perfect world. Remember when we discussed the RGB color mode and suggested that RGB values are in essence "saturation percentages"? In RGB, 255,0,0 is the equivalent of 100 percent saturated red. The need for color management arises from the fact that 100 percent red on my scanner is different than 100 percent red on my monitor and is very different from 100 percent red on my printer even though each color is denoted as 255,0,0. For digital photography to work, we need to make sure the RGB values are converted from the scanner's color space to the editing space inPhoto-shop in such a manner that the RGB combinations change, but the color appearance does not.

How Color Management Works in a Digital Photography Workflow

To achieve consistent color throughout the input, editing, and printing stages of a digital workflow, an ICC profile embedded in the image tells the software programs what the colors in the image should look like. As the image file moves from one device to another (for instance, from scanner to computer), the color numbers are converted from one color space to another to preserve as accurately as possible the color appearance of the file. A common workflow is shown here:

Step 1 RGB information is captured by the scanner or digital camera. The scanner software allows the use of an ICC profile to describe the scanner's color behavior. Raw digital camera files generally begin their color management process during the processing of the raw files.

Step 2 The information is then converted from the input space into an editing space used for tone and color correction.

Step 3 During the editing process, the information is converted from the editing space to the monitor profile instantaneously, ensuring that the image displayed on your monitor is as accurate as possible. This process is referred to as *display compensation*.

Step 4 After the necessary adjustments are made to the file, the color values in the file are translated to the printer's color space and the information is sent to the printer.

Calibrating Your Display

Calibrating your display is a quick and relatively painless procedure that allows you to trust what you see on the screen and make tone and color corrections visually. As photographers, we are visual people. It makes sense to invest a little time and money to work on a calibrated display to achieve the best results from our digital photographs. Effective display calibration requires the purchase of a hardware and software package consisting of a colorimeter or spectrophotometer to read the output of your display and software to drive the hardware and create the profile. Visual calibration packages such as the Adobe Gamma Utility or the Apple Display Calibrator Assistant are not accurate enough for a demanding photography workflow. The money spent on the appropriate display calibration equipment will be quickly recovered in ink and paper savings as far fewer test prints and proof prints will be needed to achieve a satisfactory print.

Caution It is very important that you don't use the suction cups on your colorimeter to attach the device to your flat panel display. The suction may separate and damage the delicate layers in the monitor, rendering it useless for anything other than an expensive paperweight. Follow the directions contained in your profiling package for attaching the device to an LCD display. Most use a counterweight system to position the colorimeter against the face of the LCD panel.

The term *display calibration* actually refers to a two-part process, calibration and profiling. During the calibration stage, adjustments are made to the controls of the monitor (brightness, contrast) to achieve a brightness level approximating print viewing conditions. In the profiling stage, a series of colored patches are displayed on the screen and measured by the colorimeter. The known values of the colors are compared to the measured values of the colors and a lookup table is created to describe the unique characteristics of your display. The software writes out this table as an ICC profile and makes this profile available to color-savvy applications like Photoshop to compensate for any deficiencies in the monitor's output. This process of display compensation is done entirely behind the scenes and requires no intervention on your part other than 1) the creation of an accurate profile and 2) verification that the monitor profile is being used by Photoshop. Since the color characteristics of your monitor will change over time, it is recommended that you recalibrate at least every month, and even more often if your display is newer than six months or older than two years.

The steps involved in monitor calibration differ based on the software and hardware you are using, but there are a few common points to aim for:

Step 1 Set the brightness/luminosity between 85–95 candelas (cd). LCD monitors in particular have the ability to reach very high brightness levels. A display

that is too bright will mean that you won't achieve density matches with prints and will likely shorten the usable life of your display, particularly flat panel displays.

Step 2 Set the white point to 6500 K and the gamma to 2.2 for both CRT and LCD monitors on both Mac and Windows machines.

Step 3 To verify that the profile was stored in the correct location to be used by Photoshop, open Photoshop's color settings (Edit | Color Settings). Click once on the RGB working space tab and look to see that the profile you just created is listed next to the "Monitor RGB" tab. Don't choose your monitor profile for the working space, simply verify that it is listed correctly. If it is not, quit, then relaunch Photoshop. Sometimes, the color settings are not updated unless the program is relaunched.

Configuring Photoshop's Color Settings

Color settings affect Photoshop's color behavior, and configuring them properly can be the difference between joy and misery. Often, when photographers complain about poor prints from their printer, an error in their

color management settings or a lack of an accurate monitor profile is to blame.

I recommend that photographers change the color settings to the North America Prepress 2.

Tip Opinions differ as to which editing space is ideal for digital photography as there are several valid color spaces to choose from, each with their own set of pros and cons. These include: Pro Photo RGB, sRGB, ECI-RGB, and Color Match RGB. In general, I suggest that you not stray too far from the flock until you comfortably understand the pros and cons of choosing a particular working space. In addition, I strongly suggest that you not use your monitor profile for your editing space.

Profile Mismatch and Missing Profile Warnings

Once you've set your color settings correctly, you may encounter two important dialog boxes when opening files: Embedded Profile Mismatch and Missing Profile.

The Embedded Profile Mismatch dialog box informs you that the color space associated with the image is different than the color space designated in your Color Settings preferences. You are presented with three options:

- **Use the embedded profile (instead of the working space)** This is the preferred option and is listed first because it best preserves the color fidelity of the image. Read the "Converting Profiles" section that follows to correctly convert your document to the working space to minimize the number of times you have to go through this step.

- **Convert document's colors to the working space** This might seem like the best option, but you may unintentionally throw away important color information.

- **Discard the embedded profile (don't color manage)** This is not a good idea. Without an embedded profile Photoshop doesn't know how to correctly display the colors in your file. The result of this is that your tone and color corrections will not be accurate and you will have a difficult time achieving a satisfactory print.

The Missing Profile warning is more important than the Profile Mismatch dialog box. Photoshop is telling you that it doesn't know how to correctly display the information in the file, so it has to guess. Photoshop can do a number of things incredibly well, but guessing isn't one of them. The tone, color, and saturation of your images will most likely not match your expectations. A workflow without the use of embedded profiles is not recommended. As with the Profile Mismatch dialog box, you have three options to choose from:

- **Leave as is (don't color manage)** It may sound counterintuitive based on the last paragraph, but this is the best option to choose in this case. You don't want to arbitrarily assign a profile to an image without being able to see it. I will walk you through the process of assigning the correct profile in the next section.

- **Assign working RGB** It might be a good guess. Then again it might not. Stick with the previous option.

- **Assign profile** This option gives you a pull-down menu with a list of all the possible profiles for the document. Kind of like speed dating, you might find a perfect match, but the odds are against it.

Assigning Profiles

If you are confronted with the ominous Missing Profile dialog box, the best option is to choose "Leave as is (don't color manage)," then assign an appropriate profile using the Assign Profile option. Assigning a profile doesn't change the RGB color values, it simply provides a slightly different interpretation of the RGB values. This is somewhat akin to a Londoner, a southern belle, and a mechanic named Sal from the Bronx reading the same paragraph of text. Although the words are the same, they sound very different.

Step 1 With the image open, choose Edit | Assign Profile from the menu bar. A pull-down menu at the bottom of the dialog box allows you to choose different profiles and visually assess whether or not the profile is a match for the file. Make sure the

Preview box is checked, otherwise you will be flying blind.

Step 2 Try sRGB as your first guess, followed by ColorMatch RGB and Adobe 1998.

Step 3 When you find a match, choose OK. If the profile you assigned is different than your working space, read on. For this particular image, sRGB gave the best skin tones, so I chose sRGB in the Assign Profile dialog box.

Converting Profiles

Whenever an image travels from one device to another—say, from the computer to the printer—you need to convert from your editing space to a printing space. Converting between two profiles is similar to translating a text between two languages that share a common alphabet, like French and Spanish. Translating a paragraph from French to Spanish requires that you change the French words to their Spanish counterparts in such a manner that the essential meaning of the paragraph is unchanged. Converting between color spaces works the same way. The RGB values of one color space are converted to the corresponding values of another color space so that the color remains unchanged.

To convert between color profiles:

Step 1 With an image open, choose Edit | Convert To Profile from the menu bar. Your source space (where you are converting from) is displayed along with a pull-down menu that lets you choose your destination space (what you are converting to).

Step 2 For your rendering intent, choose Relative Colorimetric and make sure Use Black Point Compensation is checked. The only time you want to

change your rendering intent is when your image contains very saturated colors with fine detail, like a closeup of a red rose. I recommend using Relative Colorimetric for the most accurate color on the vast majority of images.

Step 3 Toggle the Preview checkbox on and off. Can you see a difference between the unconverted (preview off) and converted (preview on) images? If not, choose OK. If you can, try using the perceptual rendering intent and pick the results you like best.

The time you spend learning the basics of color management will pay great dividends in your ability to trust your monitor when making tone and color corrections and will improve the quality and consistency of your finished prints.

For more information on color management, I highly recommend the excellent book *Real World Color Management, Second Edition,* by Bruce Fraser, Chris Murphy, and Fred Bunting (Peachpit Press, 2004).

HOW TO: FINDING BALANCE in the DIGITAL DARKROOM

Any art form can be distilled into a handful of simple rules that form the fundamental essence of the craft. For the visual arts—photography, painting, illustration—we commonly use the rule of thirds for composing our subject. To pair wine with food, the simple rule is to choose a wine from the region matching the origin of the food. When learning to cook, I was flummoxed in my early attempts to create simple, Asian-style marinades until I learned that the art of Chinese cooking is to strike a simple balance between each of the five flavors: sweet, sour, salty, bitter, and pungent. Suddenly, the perfect marinade became a snap. I combine elements of each of the five flavors and fine-tune my recipe until I've achieved a balance among them.

I've found that creating the master image is much like creating the perfect marinade. You must first seek to find a balance among the flavors in the image such that each flavor enhances the others. What are the flavors of a digital image, you ask?

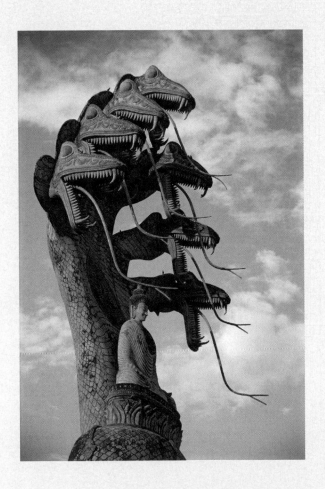

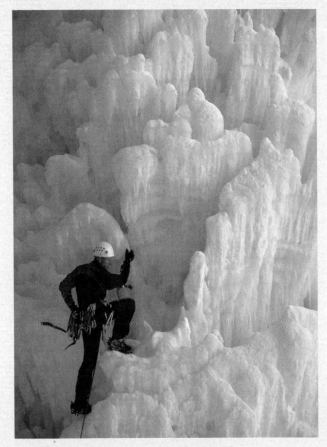

Tone Our eyes are accustomed to seeing snow as white, not gray. The tires on our cars are dark, not light. A photograph should generally reflect how we see the world, and tonality is a significant portion of making a digital image "fit." Tone also sets the mood of a photograph. Dark tones are somber, mysterious, and sinister, while lighter tones are open, airy, and pure.

Color *I see skies of blue and I see clouds of white*. The colors that make up "A Wonderful World" exist in your wonderful world as well. Our eyes are particularly sensitive to these "memory colors." If we can get these colors right, the rest of the image will fall into place. We can communicate with color by enhancing or reducing the visual weight of certain colors. Red stimulates our senses and our appetites, connoting sensuality and high energy. Blues tend to relax and soothe, while black can be clean and elegant.

Contrast The difference between tones, contrast makes details appear sharper and images more vibrant. Sometimes a good image just needs a little extra "snap" to become a great image. It's like adding a little bit of spice to a dish; be wary of adding too much.

Saturation Another ingredient best used in small doses. A heavy hand results in garish colors that look phony, though the right touch adds a bit of brilliance to a blue sky or makes red lipstick that much more enticing.

Focus Imagine two photographs. The first is an expansive landscape taken from a high point in the desert. As you look at it, your eye roams from the scraggly sage in the foreground across the rolling mesas and sandstone buttes and travels across the horizon along a bank of puffy, white clouds. The second image is an intimate portrait of a pair of emerald eyes taken with a long lens. Your gaze is riveted on those captivating eyes. Focus is a powerful ingredient in a digital photograph. As we learned earlier, we can control the depth of field in a photograph by our choice of lenses and our aperture setting. In Photoshop, we can refine the depth of field even further by selectively sharpening and blurring key elements in our composition.

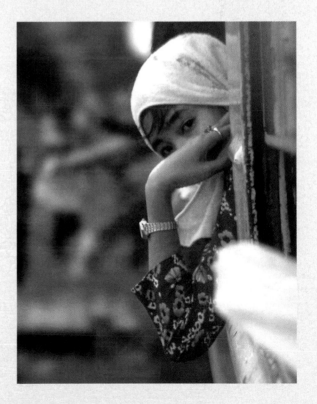

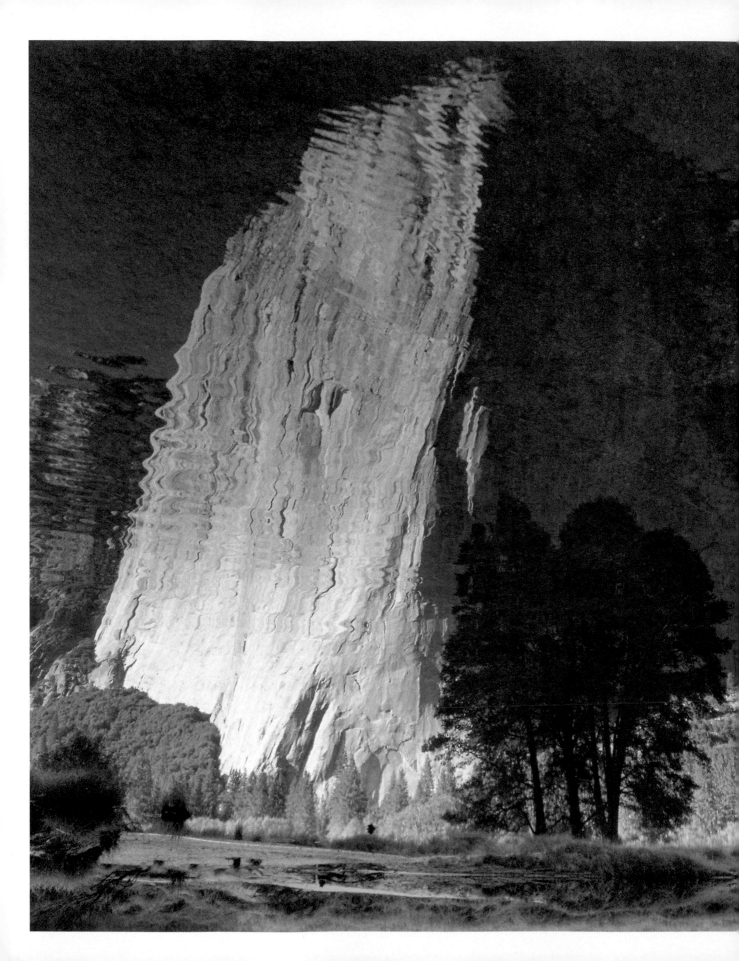

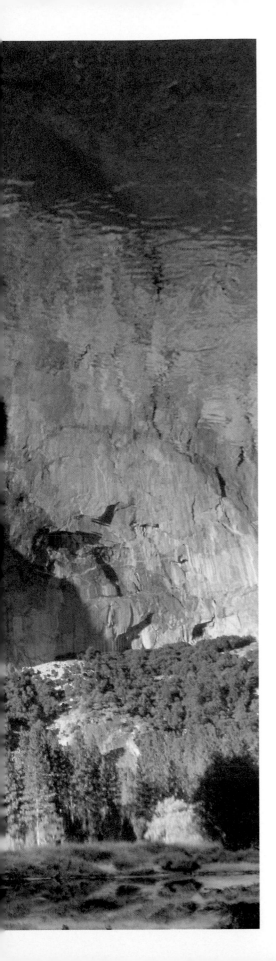

SCANNING ESSENTIALS

Only within the last few years have digital cameras begun to gain acceptance among discerning amateur and professional photographers. Most of us have collected a lifetime of images recorded on film, but we are reticent to banish them to the attic with other forgotten heirlooms simply because digital cameras have arrived on the scene. Well, at least one good reason to incorporate digital technology into photography is that film scanners and digital printers are able to breathe new life into your legacy images. It is, in fact, quite exciting to digitize treasured slides and black-and-white negatives.

Liquid Reality, El Capitan, Yosemite National Park, California

Film still has an important place in a digital workflow. Not only do you have entire collections of film images, but on some occasions shooting film, and scanning those images later, will give you better results. Both JD and I actively shoot slides or black-and-white film when we feel the situation requires it.

In this chapter, we'll survey the range of scanners available to photographers, listing their pros and cons and offering guidelines for anyone in the market for a film scanner. We'll also navigate the quagmire of technical terms surrounding scanners. Finally, the How To section at the end of the chapter, "Creating the Master Scan," will walk you through the steps needed to capture the most information possible from your original slides or negatives.

Jargon Guide
Scanners

- $D_{max} - D_{min}$ *and dynamic range* D_{max} and D_{min} are the maximum and minimum densities at which the scanner is capable of discerning discrete differences in transmitted light. The *dynamic range* is calculated by subtracting the D_{min} from the D_{max}. This range provides a quick tool for assessing the quality of the scanner. A scanner with a higher dynamic range will more effectively capture the broad range of tones found in slide film.

- *Digital ICE* A software plug-in from ASF included in many scanning programs that uses infrared light to remove dust and surface scratches from the finished scan.

- *Drum scan* A high-quality scan done at a professional digital lab. The film or transparency is oil-mounted and taped to a clear plastic drum that spins at high speeds inside a drum scanner. Drum scanners, when operated by a skilled technician, deliver the highest quality scans possible.

- *Optical resolution vs. interpolated resolution* The *optical resolution* of a scanner is the resolution at which the scanning software is not adding or subtracting pixels to the finished scan. Scanning at the optical resolution generally results in the highest quality scan. An *interpolated resolution* scan has been upsampled or downsampled by the scanning software to achieve a desired file size or image resolution.

- *Bit depth* The number of data bits used to store pixel data. 8-bit or 24-bit (8 bits × 3 color channels) scanners are fairly scarce these days, as they have been surpassed by high-bit scanners capable of capturing 16 bits of information per channel. The additional bit depth gives more flexibility in the editing process.

- *CCD* A charge-coupled device to transform light intensities into the voltage signals that eventually result in RGB data.

- *A/D converter* The element in your scanner or digital camera that converts analog voltage from the CCD to the digital signals read by your scanning or imaging software. A high-bit A/D converter can increase the quality of your high-bit scans because the scanning software is receiving "true" high-bit data.

■ *Newton's rings* Colored interference fringes occurring when a piece of film is pressed flat against a piece of glass or plastic, as in the case of a flatbed or drum scan, and scanned at high resolutions. Wet-mounting or oil-mounting the film usually resolves this problem.

HOW DO SCANNERS WORK?

For most film scanners, the CCD travels the length of the film measuring the light passing through the film. This information is then converted from analog voltage signals to ones and zeros by the A/D converter. These ones and zeroes are then translated to RGB values by the scanning software. For a drum scan, a piece of film is taped to a cylindrical drum mounted in the scanner. The drum revolves inside the scanner at very high speeds while the light source travels the length of the drum in very fine increments. A series of mirrors refract the light to three separate photo-multiplier tubes that convert the analog signal into red, green, and blue data. Flatbed scanners work in a similar fashion to a photocopier. Light is directed onto the film or print and the light bouncing back to the data from the CCD is then converted from analog to digital, before being interpreted by the software.

TYPES of SCANNERS (CHARACTERISTICS and USES)

Flatbed Scanners

Inexpensive and common, flatbed scanners are used for scanning art or prints and for digitizing documents. A few scanners are capable of scanning film, which make them an enticing option for budding photographers. Most flatbed scanners are designed to scan letter-size objects (or larger). As such, these models are not well suited for producing high-quality scans from small pieces of film. (The glass mounting plate is a haven for dust and fingerprints.) That said, some high-end flatbeds are capable of producing high-quality film scans, but at very high resolutions, film needs to be oil-mounted to reduce the visibility of Newton's rings.

Dedicated Film Scanners

Exemplified by the Nikon CoolScan series scanners, these desktop film scanners deliver a high-quality scan for a reasonable price. The resolution race of past years has plateaued with most film scanners achieving an optical resolution of 4000 ppi. Current advancements in scanning technology emphasize the capture of quality information, as opposed to more information. While the most economical models are dedicated to the 35mm format, many of the more expensive scanners offer a variety of adapters for 35mm, 2 1/4, and 4 × 5 film formats. Almost all film scanners have the ability to scan transparency film and ship with holders for negative film. Bridging the gap between a desktop film scanner and a

production drum scanner is the FlexTight line of scanners from Imacon. FlexTight scanners produce a very clean scan—rivaling a drum scan in quality and image resolution.

Drum Scanners

Long considered the penultimate in scanning technology because of their high scanning resolution and fine optics, drum scanners are facing competition from the best desktop scanners. Typically found in digital photo labs and pre-press houses, drum scanners are designed to extract every last bit of information from a piece of film. To create the scan, a piece of film is oil-mounted and taped to the drum. The oil creates a wet seal between the film and the drum maximizing sharpness and minimizing Newton's rings.

The oil mount also has the ancillary benefit of reducing the appearance of dust and scratches on the film. Like any piece of complex machinery, the results from a drum scan are highly dependent upon the skill level of the technician. Scans from these machines can be expensive, because the scanner is also expensive and the process is labor intensive.

What Type of Scanner Is Best for Me?

Combining high quality, ease of use, and compact size, a dedicated film scanner best serves the needs of the majority of photographers. The performance of inexpensive flatbed scanners is acceptable for quick, low-resolution scans for the Internet or for smaller prints, but their performance falters

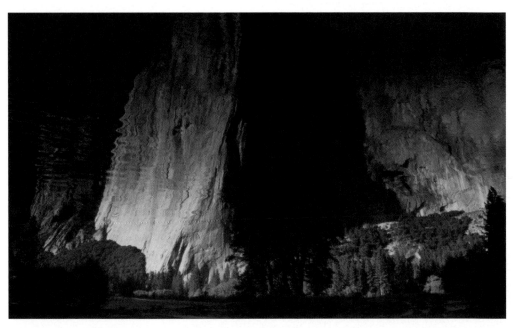

This scan from a flatbed is very dark and has lost a lot of the important shadow detail.

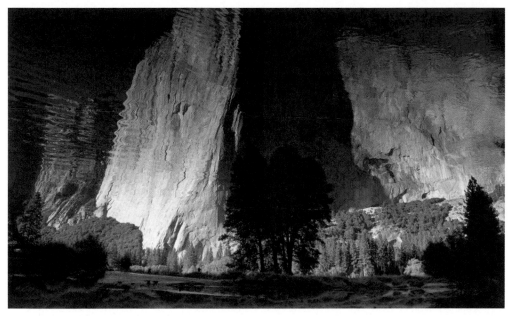

The dedicated film scanner captures better shadow detail, improved focus, and more accurate color than the flatbed.

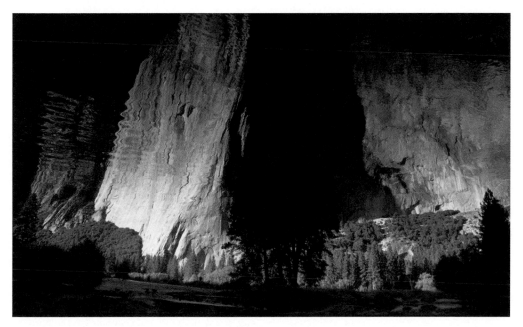

The drum scanner has the best image sharpness, shadow detail, and color fidelity.

at higher resolutions. This difference in quality was demonstrated by a test I did recently of two moderately priced flatbed scanners. I scanned a 35mm slide at the scanners' highest optical resolutions. The first scanner delivered an adequate scan from the transparency; however, the shadow detail had been entirely lost. The second model, a scanner/printer combination, exhibited pronounced banding across the scan because of the coarse movements of the stepper motor as it traveled across the slide. This banding would certainly be visible in a finished print.

WHAT SHOULD I LOOK for WHEN BUYING a SCANNER?

Choosing a scanner that matches your needs, quality expectations, and budget can be a daunting proposition. I've ranked six important issues by order of importance to consider when shopping for scanners. I highly recommend taking the scanner for a test drive, if possible, or soliciting advice from a trusted friend who has used the scanner.

1. **Film formats** A quick way to narrow the search is to look at your film collection. Do you have any 4×5 or medium format film? If not, then disregard any of the medium format scanners, as their price tag is much higher than a dedicated 35mm scanner. If medium and large format film constitutes a significant portion of your work, you'll have to purchase a more expensive machine. If you fall somewhere in between, look at the difference in price between the 35mm and large format models and find out if you can buy drum scans from your lab for the cost of the large format scanner.

2. **Price** Window shopping may be entertaining, but real life demands that we make hard choices with our money. Unfortunately, a good film scanner is not inexpensive. It is worthwhile to invest as much money as you can comfortably spend on your scanner. Trying to make do with a subpar scanner is an exercise in frustration. Speaking from experience, I purchased a "make do" scanner years ago but was so frustrated with it that I rarely used it. If budget is a major concern, I suggest buying scans from a professional lab or purchasing a used scanner from a reputable photographer. Last year's prosumer scanner will be a much better buy than this year's consumer scanner.

3. **Software** The best scanner in the world is nearly useless if the software controlling it drives you to tears. Look for software that allows you to override any auto-corrections, offers the ability to perform manual tone and color corrections, and has a sensible dust and scratch correction filter. I've listed a few of the most common software packages and my experiences with each. Don't take my words as gospel; software packages change frequently, and successive updates tend to correct past weaknesses. Try the programs for yourself. Standalone programs, like SilverFast and VueScan, offer demo

versions that allow you to test the full functionality of the programs.

- **Nikon Scan** With a sensible interface, gentle learning curve, and a wide range of palettes that put the scanner's controls at your fingertips, Nikon Scan (shown below) is a highly functional scanning program. I find the auto-corrections from Nikon Scan to be a bit too severe and the lack of support for external color management to be two of the program's few drawbacks. Nonetheless, Nikon Scan is an efficient, effective program.

- **SilverFast AI** SilverFast positions itself as a professional-level scanning application. A deep and complex program, SilverFast has so many options for customizing the scanning process that I've found the program's complexity interferes with its usability.

I find it very difficult to turn off the auto adjustments in the program, which impedes the creation of a master scan. If one manages to overcome the quirky interface and to disarm the auto features that threaten to hijack a well-intentioned scanner operator, I imagine that SilverFast can be a powerful and capable program.

- **VueScan** Like SilverFast, VueScan is a software program designed to work with a wide range of scanners. I really like VueScan's interface, and I applaud the company for providing access to advanced features in a manner that doesn't impinge on the functionality of the program. VueScan currently lacks a Histogram or Curves adjustment feature. The

default color profile associated with the program leaves a lot to be desired, but having the option to create a custom profile is helpful. VueScan is intuitive, inexpensive, and efficiently functional.

■ **FlexColor** The Flex Color software, designed for Imacon scanners, is an example of a scanning program done right. Like being in a luxury car, the controls are intelligently placed and

highly functional, and they deliver superb results. My only real criticisms of the program are that the color correction palette is clunky and that the program can't be used to enhance the capabilities of all scanners.

4. **Ability to capture clean shadow detail** You sweat over choosing the right exposure to balance the bright highlight areas with the essential shadow detail. You want your scanner to be capable of faithfully reproducing the fruits of your labor. Shadow areas that simply fill with black or, worse yet, turn into a mottled mess simply won't do. While the numbers for D_{max} and dynamic range listed in your scanner's specifications might help make a decision, they are very similar to the miles-per-gallon estimates on new cars. Your mileage may vary. A test drive or a sample scan is very helpful to assess a scanner's ability to capture the detail in the deep shadows. Inexpensive scanners, particularly flatbeds, tend to exhibit lackluster performance in this area. This is one of the reasons I don't feel they are well suited for discerning photographers.

5. **Scanning resolution** Most desktop film scanners are capable of creating a 4000 ppi true optical scan, making scanner resolution less of a factor for new buyers. Still, it is worth reading the specifications to verify that the scanner produces true optical scans of 4000 ppi. Resolution being equal, shift your attention to the quality of the data.

6. **Speed** Scanning is generally a background activity for me. I prepare the film, make the necessary adjustments, click Scan, and then go back to whatever it is that I was doing. This makes the speed of the scanner a low priority to me. You may have a very different set of priorities. On the Macintosh platform, FireWire is the way to go. On a PC, choose a USB-2 compatible scanner.

SHOULD YOU DO IT YOURSELF?

While I get a great deal of satisfaction from doing something myself, like troubleshooting my computer or fixing a leaky faucet, I'm more than happy to pay someone else to perform more onerous tasks, like changing the oil in my truck. Whether you decide to do your own scanning or pay someone else to do it for you depends on several factors:

- **Quantity of scans needed** A good-quality film scanner will set you back around a thousand dollars. I can get roughly 30 top-quality drum scans or 100 economy scans from my digital lab for the same price. If you are new to photography and only have a few treasured negatives, using a lab may be the best option. If you've been shooting for 30 years and have a venerable library of images on black-and-white, color negative, and slide film, you are probably better off investing the money into the best scanner you can afford and doing the job yourself.

- **Quality of scans needed** How rabid about quality are you? If you are a part-time enthusiast, you may find the reprograde scans from your digital lab to be perfect for printing 5 × 7s, 8 × 10s, and the occasional 11 × 14. If the highest image quality is paramount and you don't mind spending the time and money to achieve the best results, you will enjoy the fruits of the labor involved in learning how to create a master scan (described later in this chapter) and scanning your own originals. If images are destined for a very large print size, consider paying for a drum scan or a scan from an Imacon scanner for the oversize enlargements.

- **How you will use the images** If you intend to do nothing more than create a web gallery of images from Aunt Martha's barbeque for your family, you can probably get away with the cheapest scans offered at your digital minilab. However, if your last name is Adams or Weston and you are assembling a 20-year retrospective of images from Aunt Martha's barbeques for the San Francisco Museum of Modern Art, you'll need the best scans possible—which means either paying for a drum scan or purchasing the highest quality scanner money can buy.

■ **Your digital skill level** If you are just beginning to dip your toes into the digital waters and want the best results with a minimal amount of hassle, I highly recommend having someone else do your first few scans. As your experience grows, you will have a better idea of what you need from a scan with regard to image resolution, color space, and bit depth. If you are an intermediate to advanced digital photographer, you may find that you like the freedom that making your own scans offers. I know that I like having control over the shadow density and overall color of my images, but it took me a significant period of time before I really felt comfortable with the controls of the scanner and learned how a raw scan translates to a finished print.

WHAT to ASK for when BUYING SCANS

I can't say enough good things about the digital lab I use. I love the work they do for me. They've patiently explained the options available to me for scanning and printing and have always delivered superlative results. What has made my relationship with the lab so successful is that I've developed a rapport with them over the years by asking intelligent questions. The range of options available to you at your local lab may feel overwhelming, so I've designed a list of questions for you to ask yourself prior to your trip to the lab.

These questions will help clarify your needs and help you create a list of questions to ask the lab once you arrive to make sure those needs are met. Developing a strong bond with your local lab will make your life easier as a photographer, as they have a wealth of skill and experience to help make your photography the best it can be.

Questions to Ask Yourself Prior to Your Trip to the Lab

■ **How do I intend to use this scan?** Will the finished print be 4 × 6, 11 × 14, or larger? The larger the finished print size, the higher quality and higher resolution the scan needs to be.

■ **Which is more important, quality or price?** Most photo labs offer two or three quality levels of scanning. The lowest-quality and lowest-priced scans are usually done on a Fuji Frontier or other minilab at the time of processing. These scans are very cheap, but are only good enough for a 5 × 7 print. The medium tier balances price and quality. These scans, sometimes called "repro grade," are commonly made on a high-quality desktop scanner and may or may not include custom adjustments for color and tone. Depending on the quality of the scanner and the scanning resolution, these

scans are appropriate for 8×10 to 11×14 print sizes. A drum scan is the highest quality scan commercially available and is used for the most demanding reproductions or very large prints. Drum scanners run in the tens of thousands of dollars and require a highly trained technician for the best results. Expect to pay accordingly.

- **What output device do I intend to print this on?** It's perfectly okay not to have an answer to this question. However, if you know the lab doing the scanning will eventually create the prints in house, they can tailor the scan to best match the characteristics of their printer. If you are unsure, you want to make certain the scan is delivered in an RGB editing space to make your scan as versatile as possible. Some labs are willing to give you two copies of the file—one targeted for their printer, a second in an RGB editing space.

Questions to Ask Your Lab

- What device will the film or negative be scanned on?

- Will they make custom adjustments to tone and color, or are they making a quick "machine" scan where no adjustment is made?

- What resolution will they scan the image at and what will be the resulting file size in megabytes? Make sure the finished file size matches the resolution needed for your largest print.

- What color mode (RGB or CMYK) will they scan in and what color space will they scan into? Unless you plan to print your image on a printing press, you definitely don't want a scan in CMYK. Insist on receiving a scan in RGB. For repro or drum scans, ask for the scan to be delivered in a wide-gamut color space like ProPhoto RGB, or Adobe 1998 unless you are having the lab target the scan to a particular printing device like a LightJet.

HOW TO: CREATING the MASTER SCAN

I have to admit it. I'm lazy. Particularly when it comes to scanning. I don't ever want to have to scan an image more than once. When I scan an image, my goal is to never have to pull that slide off the shelf again. This means scanning film at the highest optical resolution available and exercising vigilance over the controls in the scanning software to ensure that I capture the entire range of tone and color contained in the original. I want my master scan to be of the highest resolution, but also rather dull in color and flat in contrast. Most of the tone and color correction in Photoshop adds contrast and saturation to the image. Starting out with a flat scan helps to prevent the image from becoming too saturated and the color too heavily saturated.

Here's how to do your master scan:

Step 1

Use compressed air to blow dust and other particles off the film. Taking the time to ensure the film is as clean as possible will minimize the time needed to remove dust and other debris in Photoshop. A great practice to adopt is to move the film, not the canister of air. If the compressed air is shaken too vigorously the liquid propellant will spray onto your film, possibly rendering it unusable. Be careful.

Step 2

Carefully place the film or slide in its appropriate holder. Be sure the negative strip or slide is straight in the film carrier, otherwise you will lose important information at the edges of the frame when you have to straighten the crop.

Step 3

Create a preview image. If possible, turn off any auto-corrections in the scanning software and reset all tone and color controls back to their default settings. You want to start with a clean slate for the new image.

Copy Curve Settings to Clipboard

Save Curve Settings...
Delete Curve Settings...

Import Curve Settings...
Export Curve Settings...

Reset to Default Curve Settings
Reset to User Curve Settings

Step 4

Draw the marquee around the image area. It is accept-able to include areas of the slide mount if necessary, though including the mount will affect the readings in the shadow area of the histogram.

Step 5

Loosely set the lightest and darkest points in the image using the histogram or levels adjustment. You want to leave some room on the endpoints to: (1) ensure you capture all the tonal information without clipping either the bright highlights or deep shadows and (2) leave room to set the

highlight and shadow points with greater precision in Photo-shop. I usually try to set my maximum highlight around 250

and my shadow point from 8–10. In this image, I brought the highlight slider in very slightly to set the lightest point in the center of the sky to 246–248. I left the shadow slider at the default setting since the deep shadows are already at a value of 10.

Step 6

Adjust the midtone or gamma value to balance the overall tone of the image. Remember, it is preferable at this stage to have the scan appear "flat," because it is easier to add contrast to a flat image in Photoshop than it is to reduce the contrast

of a contrasty scan. To brighten the midtones, I moved the gamma slider slightly toward the shadow end.

Step 7

Use the eyedropper feature or RGB info display to evaluate the color of the neutral areas of the image. Gray sidewalks, dark shadows, and white clothing can

make good visual guides. Obviously the color of the light in the image is important. You don't want to neutralize beautiful golden light, but you do want to minimize the blue or cyan cast that occurs on a bright, cloudless day. Areas of neutral color should have roughly equal RGB values. Let the RGB info reading give you clues for color correcting your image. The goal here is to achieve pleasing color throughout the image with the understanding that you will perform additional corrections after you bring the image into Photoshop. This image doesn't have many neutral areas, so I made a visual assessment of the scan and decided to pull out 4 points of blue and add 1 point of red. For this type of visual correction, a profiled display is essential!

Step 8

After making the necessary tone and color corrections to your image, set the scanning resolution and bit depth. Disregard the readings for output size, but check to see that your zoom or scaling percentage (if your software has one) is at 100%. You want your finished scan to contain information from the scanner's sensor without any additional software interpolation. I usually set the scan resolution to the highest optical resolution available.

For most high-quality desktop scanners this is 4000 ppi. I chose to scan this image at the maximum optical resolution of 4000 ppi with 16 bits of information per channel. This gives me a great deal of editing headroom for making tone and color corrections in Photoshop.

Step 9

I turned off any image sharpening, preferring instead to do this in Photoshop where I have more control. Finally, I activated Digital ICE or other dust and scratch filter, at a reasonable setting. Here, the bright red X is a great visual indicator that Unsharp Mask is turned off. I activated Digital ICE at the fine setting to minimize the time I have to spend in Photoshop cloning out dust specks from the scan. Additional options for minimizing the appearance of grain and restoring the color from a faded original aren't necessary for this image, so I turned them off.

Step 10

The very last step is to click Scan, give it a name and a destination, and choose the desired file type. I chose to save this file as a TIFF.

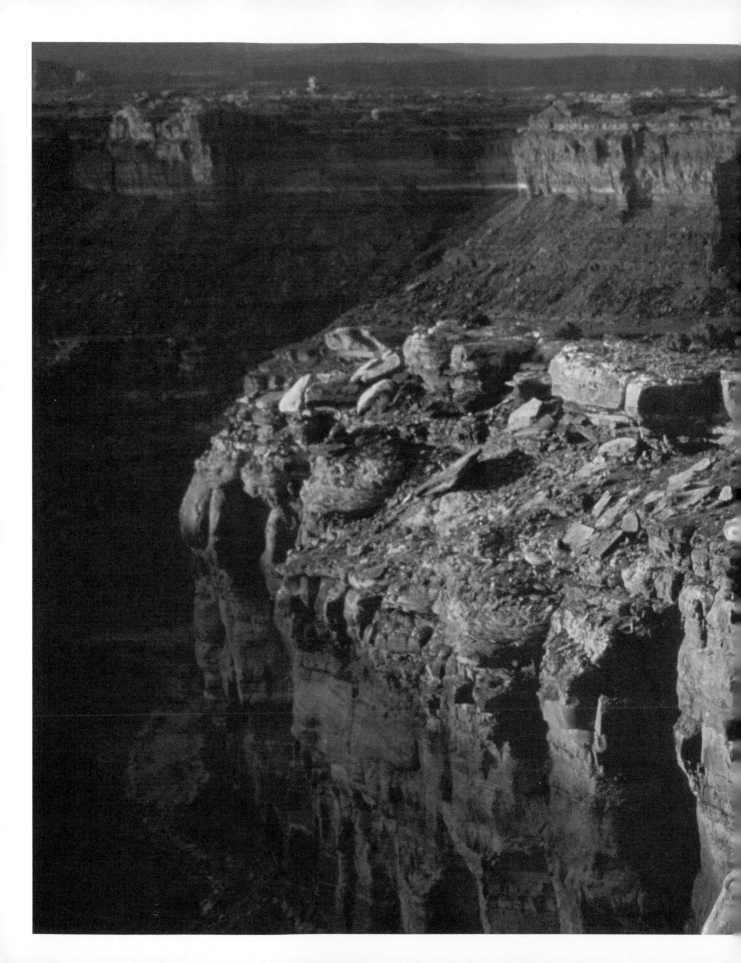

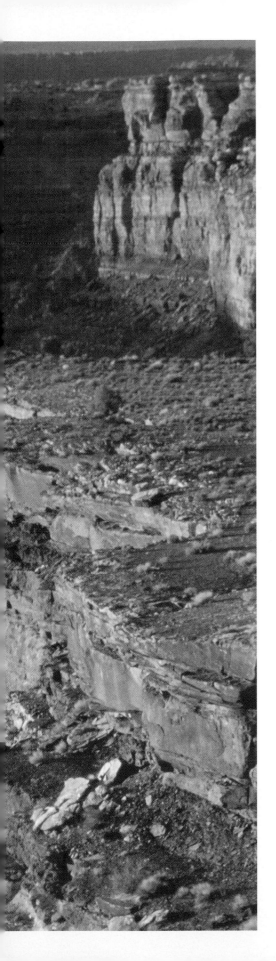

EDITING and ORGANIZING IMAGES

Amateur and professional photographers tend toward personality traits that reflect their creativity and individualism. These characteristics help to produce brilliant art but make it a challenge to keep those beautiful images organized. If you have a hard drive with neatly filed folders and perfectly renamed images and can find any image in less than a minute, you may want to skip this chapter. If you're like most photographers and your hard drives look as though a tornado whipped across their desktop, we'll toss you a lifeline and give you guidelines for organizing and filing images and show you how to make the

The Needles Canyonlands National Park, Utah

Bridge behave like the old light table you used to know and love. Finally, we will feature an essay by Bert Fox, the assistant photo editor at *National Geographic*, on how he culls through thousands of images while sorting and editing a shoot.

TRANSFERRING IMAGES from YOUR CAMERA to YOUR DESKTOP

The first step in editing digital camera files is to transfer the files from the CompactFlash card or Memory Stick to the computer. It is not advisable to edit images while they are still on the memory card as this can result in a corrupted card and lost images.

Insert your memory card into a FireWire or USB 2.0 card reader. Connecting the camera to the computer is painfully slow and can deplete the camera's battery unless it is connected to AC power. On a Macintosh computer, your card will appear as a removable drive on your desktop. On a PC, you'll need to access the drive from the Start menu and choose My Computer. The card should appear as a removable device, typically the E: drive.

Once you've located the drive, double-click on the drive icon. Often the images on the card are stored in a subfolder two levels deep on the card. Click on the DCIM folder to open it.

Step 1 Select all of the images on your card using CMD-A or CTRL-A.

Step 2 Create a new folder on your desktop to receive the images.

Step 3 Drag the selected images from the CF card to the newly created folder on your desktop.

Step 4 Relocate the folder with your new images to your photo archive.

You may not have created your photo archive at this point, or, if you have, it may not be very organized. Asset management programs like iView MediaPro or Extensis Portfolio allow you to keep your images scattered around your hard drive. However, storing all of your images in a central location will not only expedite your image editing, it will make it much easier to ensure that your images are safely backed up to a second drive.

Building Your Image Library

The image library is a series of folders containing your entire photo collection. Typically, this is a folder named Photos or Images with a series of subfolders inside the image folder to help sort the photos into logical categories. Imagine your hard drive as a file cabinet. In your file cabinet, you probably have a folder named Bills. Inside that folder you have additional folders labeled Phone, Electricity, Insurance, and Mortgage. You may even have a folder in your file cabinet labeled Credit Cards with several folders inside, each for a separate credit card company. Your image library will look very similar. My image library contains

folders describing the country where images were taken. In the folder labeled US I have several subfolders for each state I've visited. How you sort is up to you. The structure of the folders in your image library is much less important than actually having a folder structure in place.

The photos in my image library are stored in folders corresponding to the location where the photos were taken.

EDITING IMAGES

Once your images are on your hard drive, you need to separate the keepers from the rejects. Even the best photographers edit their shoots heavily, only keeping the very best images from a shoot. Learning to efficiently edit your shoot will allow you to quickly find your favorite images from any shoot. We'll look at the editing tools that Photoshop has to offer, then examine editing and asset management programs that can be used to supplement and support your image processing in Adobe Photoshop.

Take It to the Bridge

In Photoshop CS2, Adobe shows its commitment to helping you organize and quickly retrieve your files by expanding the File Browser from Photoshop CS into a program of its own—the Bridge. Serving as a central point for file organization, the File Browser and the Bridge blend folder-style organization with a digital version of a photographer's lightbox. This allows you to quickly preview, edit, rename, and batch process an entire shoot of images. Throughout the remainder of the book we access the Bridge frequently so it is worth spending time introducing you to its key features and providing an overview of how the Bridge will fit into your workflow. If you haven't worked with either the File Browser or the Bridge, this new method of opening and editing files may feel a little foreign at first. I encourage you to stick with it. You'll find that with a little practice it becomes the most efficient method of accessing the photos in your image library.

The Bridge: An Overview

This is one of many possible layouts of the Bridge's elements. One of the best new features in the Bridge is the ability to create custom workspaces for specific tasks like arranging, captioning, batch processing, or evaluating fine detail. We'll cover the nuts and bolts on creating custom workspaces in the Bridge shortly, but first let's take a tour of the important components of the Bridge.

A. Folders Panel Displays the folders on your computer's hard drive, external hard drives, and any servers you may be connected to. The Folders panel is used to locate files in your image library or to move files between different folders on your hard drive.

B. Shortcut Buttons Function similarly to the forward and backward buttons on your web browser to quickly return to recently viewed folders. A second set of buttons on the right side of the Bridge gives options for rotating and deleting files, creating new folders, and sorting images in the content area.

C. Favorites Panel Allows you to store a list of the folders you access frequently. A single click on the folder icon in the Favorites panel takes you to the images in that folder.

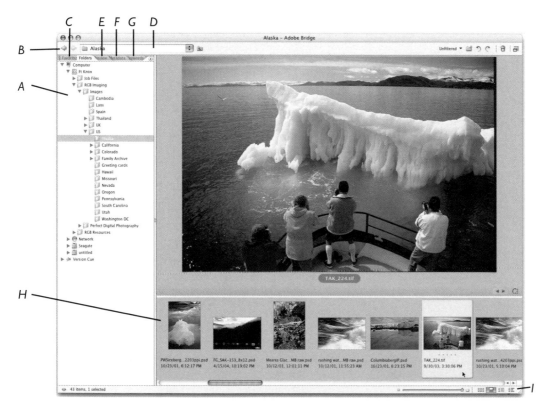

The Bridge panels can be configured to suit the specific needs of your editing workflow.

D. Look In Menu Maintains a list of the recently accessed folders, the folders from your Favorites menu, and a listing of the folder hierarchy of the currently selected folder.

E. Preview Panel Contains, as the name implies, a preview of the currently selected image. This preview window can be resized to balance the content area and the image preview. The Preview panel is commonly used to assess image sharpness and to facilitate choosing the image with the best expression or composition.

F. Metadata Panel Metadata is the information about the image, including the title, caption, and copyright along with the information embedded by the digital camera, such as f-stop, shutter speed, lens used, and camera mode. The Metadata panel is the central repository of this metadata.

G. Keywords Panel What if you wanted to find all of the images in your library of Bruno, your cat? You should first assign the keyword Bruno to the appropriate images. The Keywords panel allows you to do just that. Create a set of custom keywords—Bruno, Hawaii, Kids, and so forth—then apply the keywords to your images with a single mouse click.

H. Content Area Could also be called the thumbnails panel. You can reorder images by clicking and dragging them around the content area just as you would rearrange slides on a light table. In the content area you can also rotate, flag, and rank images.

I. Display Buttons Give you quick access to four predefined workspaces. The slider to the left of the display buttons allows you to adjust the size of the thumbnails to suit your editing style.

Using and Configuring the Bridge

Launch the Bridge by either clicking on the application icon or by clicking on the Bridge icon next to the Palette well in Photoshop.

Tip *For Macintosh OSX users:* A quick method of viewing a folder of images in the Bridge is to drag the folder onto the Bridge icon in the Dock. This launches the Bridge and displays your selected folder.

Arrange images in the content area by clicking and dragging the thumbnails into a custom order.

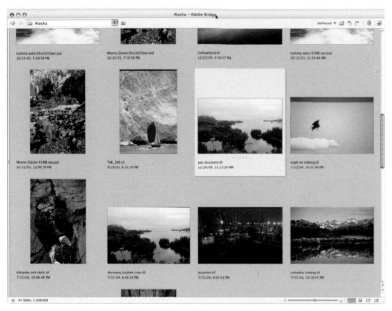

The Lightbox mode with the thumbnails enlarged for grouping and rearranging images from a shoot.

The File Navigator makes it quick to jump between folders using the Favorites and Folders panels.

Opening images from the Bridge is easy. Simply double-click on either the image thumbnail or the preview image. Raw camera files will automatically open in the Adobe Camera Raw plug-in. Other images will open directly into Photoshop for additional editing. Click and drag images around the content areas as you would arrange slides on a lightbox. Rotate images by clicking on the rotate image buttons or with the keyboard shortcuts CMD-[or CTRL-[and CMD-] or CTRL-] for counterclockwise and clockwise rotation respectively. The thumbnails are rotated in the Bridge, and the rotation is applied to the images when they are opened in Photoshop.

Creating Custom Workspaces in the Bridge

As mentioned earlier, the Bridge can be customized to perform a particular editing task most efficiently. Use Photoshop's predefined workspaces as a starting point for your own customization. These four figures (at left and far right) show the four workspace presets found under the Window | Workspace menu.

Customize the preset workspaces by clicking on the dividers between panels to expand or contract the space allocated to the panel. Dock panels by clicking on the panel name and dragging it on top of another panel just as you did with Photoshop's palettes.

Save your workspace by choosing Save Workspace from the Window menu (Window | Workspace | Save Workspace).

In the resulting dialog box, name your workspace and assign a keyboard shortcut to quickly switch between workspaces.

The new workspace will appear at the bottom of the Workspace menu, or access it by pressing the keyboard shortcut.

Playing Favorites

Adding folders to the Favorites panel in the Bridge is a fast way to jump directly to the folder you want to view. To add your currently selected folder to your Favorites, choose

The Metadata Focus provides easy access to the Metadata and Keywords panels for preparing images for your image database.

The Filmstrip mode is used for editing and ranking images. Use the arrow keys to advance through the thumbnails. The Filmstrip mode is great for evaluating the sharpness of an image and for judging a subject's expression.

File | Add To Favorites. Make sure you don't have any files currently selected, otherwise you will add the file instead of the folder.

Tip It is now possible to have more than one open window in the Bridge. This is particularly helpful if you have dual monitors. Open two separate windows side by side for comparing the sharpness of two images from the same take, or use one window for arranging images in Lightbox mode, and a second window for analyzing detail or applying metadata. To quickly create a new editing window in the Bridge, press CMD-N or CTRL-N.

If you have your Folder panel separate from your Favorites, simply drag folders from the Folders panel onto the Favorites panel. Don't drag folders onto another folder in the Favorites panel or Photoshop will begin copying files from the first folder into the folder listed in your Favorites.

Don't forget that you can access your favorites even if the Favorites panel isn't visible. The Look In menu stores a listing of all of your favorites along with the ten most recently visited folders.

Pull Rank

The Bridge has abandoned the flagging system used for ranking files in favor of a more flexible color-coding label and star-based ranking system. This opens up a range of workflow possibilities for editing images from a shoot.

Color Coding

The easiest method of separating the keepers from the outtakes is to color code the images using the Bridge's five colored labels: red, yellow, green, blue, and purple. The purple label lacks a keyboard shortcut, making it less useful than the others because you must use the pull-down menu to assign it to images. Even so, the labels offer four levels of ranking, allowing you to separate the best images of a shoot from the above average and the throwaway images. I typically arrange my workspace to give me two columns of thumbnails and a very large preview window. I use the following keyboard shortcuts to assign the blue label to the best images, green to the above-average images I want to keep, and yellow or red to images destined for the trash.

- **Red** CMD-6 or CTRL-6
- **Yellow** CMD-7 or CTRL-7
- **Green** CMD-8 or CTRL-8
- **Blue** CMD-9 or CTRL-9

Note It is possible to select a preference in the Bridge to assign the label without the CMD or CTRL modifier key. Go to the Bridge preferences, CMD-K, click on the Labels menu, and uncheck the Require Command Key To Apply Labels And Ratings box. I like using this for editing in Slideshow mode, discussed later.

After you've completed the initial edit of your shoot and want to throw away the outtakes, go to the Filter menu (see next page, top left) and select Show Yellow Label. The images you want to keep will be hidden from view, allowing you to select all (CMD-A or CTRL-A) and send the files to the trash by clicking on the trashcan icon in the Bridge. Bring the remaining items back into view by choosing Show All Items from the Filter menu.

Star Ranking

Also introduced in the Bridge is the ability to rank images by adding a series of stars to the file. Five stars might be a home-run image while one star might go straight to the trash. Both ranking systems can be quickly adapted to your personal workflow. There is really no right or wrong way to rank images in the Bridge. The keyboard shortcuts for ranking images in the Bridge are as follows:

- **No stars** CMD-0 or CTRL-0
- **1 star** CMD-1 or CTRL-1
- **2 stars** CMD-2 or CTRL-2
- **3 stars** CMD-3 or CTRL-3
- **4 stars** CMD-4 or CTRL-4
- **5 stars** CMD-5 or CTRL-5
- **1 star** CMD-' or CTRL-' (apostrophe)
- **Decrease star rating** CMD-, or CTRL-, (comma)
- **Increase star rating** CMD-. or CTRL-. (period)

It is also possible to click on the label area of the thumbnail above the filename to add or subtract stars. When the thumbnail is selected, you will notice five small dots corresponding to the star location. Click on the fourth dot to quickly add four stars. Caution should be used with the star system as I find I often inadvertently add stars to the images when I rearrange the thumbnails by clicking and moving them around the content area.

When you've finished, use the Filter menu to isolate images of a particular ranking in exactly the same fashion as with the color labels.

Slideshow

Perhaps the most interesting new editing method is to use the Slideshow view (CMD-L or CTRL-L) to view the images in a full-screen slideshow. The primary advantage of the Slideshow view is the large preview. The disadvantage of Slideshow is that it requires you to be versed in the keyboard shortcuts used for editing, and it makes it more difficult

to compare images that aren't adjacent to each other.

Using the Slideshow mode is easy. Once you've entered the Slideshow view, I suggest pressing H to view a list of the most important Slideshow commands. Use the right and left arrow keys to advance or review the slideshow or simply click the mouse key to advance to the next slide. Pressing C toggles between three different methods of displaying the image's caption information.

I use the Slideshow view for my initial edit to check focus and expression. For more refined edits I tend to favor a large preview window with two columns of thumbnails, which allows me to jump back and forth between images and rearrange their order. Experiment with a number of different editing layouts to find the system that works best for you.

Batch Renaming Images

The files from your digital camera aren't named in a way that gives you a clue as to the content of the files. Giving your images a more logical name aids in finding images more quickly down the road. The Batch Rename feature in Photoshop lets you apply a meaningful name to all the images and assigns a unique serial number to each image in the folder.

Some photographers rename their images immediately after transferring them from the card to the computer. I prefer to rename images after I've performed the initial edit, deleted the obvious outtakes, and rearranged the images in the order I want them to appear. Most asset management and editing programs order the images based on the filename. Renaming *after* I've rearranged and grouped like images together ensures that my preferred order will be maintained.

The Batch Rename command

To rename a folder of images:

Step 1 Select the images in the File Browser you wish to rename. If you wish to rename all of the images in the browser, you can leave them all unselected. The Bridge will then rename all files. Choose the Batch Rename command from the Tools menu (Tools | Batch Rename).

Step 2 In the Destination Folder area, specify whether you want the Bridge to rename the images in the same folder, move the images to another folder, or copy the images into another folder. If you chose either of the last two options, you will need to use the Browse button to specify a destination. Most of the time it is preferable to rename the files in their original location.

Step 3 Specify the new filenames. Typically, photographers enter text that describes the content of the images, like Skiing, followed by a number so that the finished filenames read Skiing001.tif, Skiing002.tif, and so forth. This is accomplished by entering your custom text in the Text field, clicking on the plus button to the right of the text field to create a second filename field, and adding a sequence number. Choose the correct number of digits to assign a unique number to each of the images in your folder. Use two digits

for folders of less than 100 images or three digits for folders containing less than 1,000 images. I always specify a zero before my first digit so the computer recognizes that the image order should be 01, 02, 03 instead of 1, 11, 12. This can help avert headaches when using the asset management programs described later in this chapter. If you are unsure of how many files you have selected, check the listing at the bottom of the Preview section where you'll find the number of files to be renamed.

Step 4 In the Options section you have the ability to preserve the current filename as part of the image's metadata. I suggest checking this as a safety measure in the unlikely event that the Batch Rename is set up incorrectly. The space it adds to a file is insignificant. Make sure the Windows and Macintosh OS Compatibility checkboxes are selected so that your images can be viewed on either platform.

Step 5 The Preview section gives you a final "flight check" before you rename your files and gives you a listing of the number of files that will be renamed. I always check the First New Filename listing to make sure that the new filenames are structured

correctly. I am particularly careful to check to make sure the file will keep its extension. In Photoshop 8, it was possible to rename files without an extension, which required you to manually type the extension back into the filename. This is much less likely in Photoshop CS2; however, I still check the extension before clicking Rename.

about a file? What if you want to know the exact date the photo was taken, or want a descriptive caption to help you remember that the image was taken in Waimanu Valley in Hawaii on June 7? The metadata contained within your digital images can help you find the date a photo was taken, its location, and a whole lot more.

Preview

First selected filename	First new filename
_2081560.ORF	Jessica01.ORF
138 files will be renamed	

Step 6 Click Rename. If you are renaming camera raw files, the Bridge will write the original filename to a sidecar file instead of embedding this information into the raw file. If you see this warning, you can safely check the Don't Show Again box.

Caution *Deselecting files in Bridge*: Photoshop's keyboard shortcut to deselect (CMD-D or CTRL-D) has a very different function in the Bridge. If you press CMD-D or CTRL-D you will be very surprised to find that instead of deselecting your thumbnails, you've duplicated the files. In order to maintain consistency with other Adobe applications like InDesign and Illustrator, the keyboard shortcut to deselect files in the Bridge is CMD-SHIFT-A or CTRL-SHIFT-A. Or you can simply click in the space on the content area.

Information at Your Fingertips

Now that the images on your hard drive have a sensible name, you are able to ascertain roughly what the content of the photo is. But what if you need more specific information

Keywords Metadata Preview Folders Favorites

▼ File Properties

Filename	: Scotland_O4_0283.orf
Document Kind	: Camera Raw
Application	: Version 1.3
Date Created	: 9/28/04, 7:23:13 AM
Date File Created	: --
Date File Modified	: 9/28/04, 7:23:12 AM
File Size	: 10.17 MB
Dimensions	: 2560 x 1920
Resolution	: 240 dpi
Bit Depth	: 16
Color Mode	: RGB Color
Color Profile	: sRGB IEC61966-2.1

▼ IPTC Core

Creator	: Jay Kinghorn
Creator: Job Title	:
Creator: Address	:
Creator: City	:
Creator: State/Province	:
Creator: Postal Code	:
Creator: Country	:
Creator: Phone(s)	:
Creator: Email(s)	:
Creator: Website(s)	:
Headline	:
Description	:
Keywords	: Scotland
IPTC Subject Code	:
Description Writer	:
Date Created	:
Intellectual Genre	:
IPTC Scene	:
Location	:
City	:
State/Province	:
Country	:
ISO Country Code	:
Title	:
Job Identifier	:
Instructions	:
Provider	: Jay Kinghorn
Source	:
Copyright Notice	: © 2005 Jay Kinghorn–All Rights Reserved
Rights Usage Terms	:

▼ Camera Data (Exif)

Exposure	: 1/320 s at f/4.5
Exposure Program	: Shutter priority
ISO Speed Ratings	: 100
Focal Length	: 147 mm
Max Aperture Value	: f/2.8
Software	: Version 1.3
Artist	: Jay Kinghorn
Date Time	: 9/28/04, 7:23:13 AM
Date Time Original	: 9/28/04, 7:23:13 AM
Flash	: Did not fire

The Metadata panel displays the vital statistics along with some basic information about the file at left.

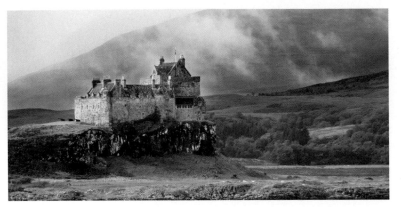

▼ IPTC Core		
Creator	: Jay Kinghorn	
Creator: Job Title	:	
Creator: Address	: 1705 14st #379	
Creator: City	: Boulder	
Creator: State/Province	: CO	
Creator: Postal Code	: 80302	
Creator: Country	: USA	
Creator: Phone(s)	: 303-474-4577	
Creator: Email(s)	: info@prorgb.com	
Creator: Website(s)	: www.prorgb.com	
Headline	:	
Description	: Duart Castle, Isle of Mull as seen from the	
Keywords	: Scotland	
IPTC Subject Code	:	
Description Writer	:	
Date Created	: 09/28/2004	
Intellectual Genre	:	
IPTC Scene	:	
Location	: Isle of Mull	
City	: Hebredean Islands	
State/Province	: Argyll region	
Country	: Scotland, UK	
ISO Country Code	:	
Title	:	
Job Identifier	:	
Instructions	:	
Provider	: Jay Kinghorn	
Source	:	
Copyright Notice	: © 2005 Jay Kinghorn-All Rights Reserved	
Rights Usage Terms	: All Rights Reserved	

The metadata for this image of a castle in western Scotland contains some bare-bones information about the image, including the shutter speed, f-stop, and camera's ISO setting along with a keyword entry for Scotland. That really isn't all that helpful to me four years from now when I want to know the name of the castle, where it is located, or what vantage the picture was taken from. Using the Metadata panel, I can enter important caption information along with keywords to help me find the image quickly using an asset management program like Extensis Portfolio, iView Multimedia, or Canto Cumulus.

The pencil icon in the metadata field means that I am able to manually enter information by clicking once in the field to activate it, then typing in the relevant information. In the IPTC Core section, I'll enter my contact information, phone number, email address, and so forth along with the description and location information for the image.

Now, I won't have to thumb through my trusty Rough Guide to remember that the photograph is of Duart Castle on the Isle of Mull in the Argyll region of Scotland, and the photo was taken on September 28, 2004. That information is now embedded in the file and is transferred to any TIFF, JPEG, or PSD file I make from that original.

Tip *Captioning Multiple Files:* To apply caption and location information for multiple files simultaneously, select the images before editing the metadata. Once you click the Apply Metadata checkbox, the information will be embedded in all of the selected files.

Another way to view and edit metadata in Photoshop and the Bridge is through the File Info panel (File | File Info), shown on the facing page, top left. This provides access to more detailed metadata listings and the ability to save specific metadata listings as templates, which can be applied to an entire folder of images.

The File Info panel, accessed through Photoshop or the Bridge, contains all of the photo's metadata.

The metadata we entered in the Metadata panel of the Bridge has been applied to the image and now appears in the File Info panel of the processed file. Here we can edit, add, or view the file's metadata in several different categories. Photoshop CS2 supports the new IPTC panels, which contain detailed information for photographers to better protect their copyrights, track image usage, and apply keywords. The fly-out window next to the Keywords window contains the list of keywords from the Keywords panel in the Bridge This makes it easy to create a common set of keywords between Photoshop, the Bridge, and an asset management program. The thrust of this effort is to make it easier to quickly locate one image in an image library of thousands of photographs.

Tip *File Info Templates:* Much of the information you need to enter into the metadata of your files is consistent from image to image. Your phone number, copyright information, and address are all standard. To create a File Info template, enter your base set of information into the appropriate fields and choose Save Metadata Template from the fly-out menu at the top-right corner of the File Info dialog. In the Bridge, select the images you want the template applied to. Click on the fly-out menu in the Metadata panel, select Append Metadata, and choose your template.

Metadata is literally data about data. The purpose of metadata is to help us organize, keep track of, and protect the rights to our digital images. Metadata replaces the handwritten notes on the slide mount describing the location the photo was taken, and the labels on the back of the binders denoting each binder's contents. Metadata helps keep track of the rightful owner of digital images.

The next stage in the editing workflow is to examine other programs that can be used for editing images and a few of the programs that can be used for managing large image libraries. We'll now have a cursory introduction to third-party editing and digital asset management (DAM) programs and their use.

Dedicated Editing Programs

When it comes to editing images from a shoot, Photoshop isn't the only game in town. Although Photoshop and the Bridge have come a long way toward making the editing process easier, many photographers and professional organizations who need to edit huge numbers of files still prefer to use dedicated editing programs like Photo Mechanic or iView MediPro for their speed and simplicity.

Photo Mechanic

Photo Mechanic by Camera Bits is the editing program of choice for many of the major newspapers and magazines where time is of the essence and deadlines are measured in hours instead of days. The keys to Photo Mechanic's success are its intuitive interface, blazing speed, and detail window for editing.

Photo Mechanic's editing window

The IPTC Stationery Pad feature allows you to quickly add your metadata to files. The pull-down menus remember past entries to expedite the addition of repetitive information.

is an incredible feature for comparing the focus of two images side by side. This is a feature that is next to impossible to replicate in the Bridge.

Selecting images is simple and intuitive as well. You can choose from either a simple checkbox yes/no-type selection, or use their Color Class labeling that is applied to images with a single keystroke. The Rename function shares the same, efficient functionality as the other features in Photo Mechanic that make it a top-flight image editing program.

Photo Mechanic uses a large, high-resolution preview window for checking focus and sharpness. One of the best features of Photo Mechanic is the Zoom checkbox that quickly jumps the zoom view to 100 percent so that you see every pixel in the image. This

iView MediaPro

iView is a hybrid between a dedicated image editing program like Photo Mechanic and a full-fledged DAM program like Extensis Portfolio. Fortunately for photographers, it fulfills both obligations well. While not quite as fast as Photo Mechanic for importing images into a catalog, it easily surpasses the DAM programs like Portfolio and Canto Cumulus for quickness. Don't let the simplicity of iView fool you. This is a powerful program, rich with features that have been thoughtfully designed and executed.

Note A light version of iView MediaPro, called iView Media, is considerably less expensive than its full-featured sibling. It shares a number of the same features as the Pro version, but doesn't catalog camera raw files and auto-watch folders or have the image editing capabilities. If you shoot JPEGs and want a quick program for editing and storing images, iView Media may be the tool for you.

The main editing window in iView MediaPro

The primary editing window in iView is the Thumbnail view, which displays the contents of the catalog. The default view may be too small for photographers, but it is very simple to change the size of the thumbnails and have iView regenerate larger thumbnails. The two other catalog views, List and Media, are used to view metadata and image attributes, while the media window acts as a large preview window. iView also uses a color-coded labeling system that is applied with a single keystroke.

The ability to customize iView is one of its greatest assets. All three of the catalog views can be tailored to show specific metadata like keywords, image size, and colorspace. Even the background color and fonts can be adjusted to your liking. iView's slideshow mode is an easy way to edit a shoot using the full-screen image previews and single-key labels. The slideshow can be saved as a QuickTime movie to post on the Internet, show friends, or send to prospective clients. Another neat feature is the ability to back up image files to a CD or DVD.

In addition to those mentioned, iView has a raft of features from batch renaming to HTML galleries with auto-watermarking. The asset management features of iView will be discussed in the next section. If you only intend to use iView for editing, you are missing out on a lot of the power this program has to offer and you'd probably be better served by the simpler, less expensive Photo Mechanic. If you would like to take advantage of the asset management features, I recommend giving iView MediaPro a test drive.

DIGITAL ASSET MANAGEMENT

In the film days, photographers had elaborate methods of finding a particular negative or transparency. Index cards, contact sheets, and even text listings in FileMaker Pro databases were used to let you know that the sunset image in Costa Rica you are looking for is in binder number 7. If the slide hadn't been filed correctly, you had to hunt through the stacks of transparencies on the lightbox to find it. The purpose of digital asset management is to eliminate the search for files scattered across hard drives and CDs, and centralize the images in one easy-to-use location. Efficient use of keywords and meta-data captions makes it easy to find that one sunset image in Costa Rica you are looking for.

This section explains the concept of keywording, a core component to the success of digital asset management (DAM) programs, and surveys the three most popular DAM programs for photographers. While it is not possible to give a comprehensive overview of digital asset management, it is important that photographers have an understanding of what asset management does and how it has the potential to make life a lot easier.

Using Keywords

Keywords have long been used to identify the content, subject, or genre of photographs, movies, and other digital content. You are probably already familiar with using keywords to find digital assets without even realizing it. If you've ever shopped online, you've used keywords to find the shirt, suitcase, or DVD you were looking for. Let's say that you were shopping online for the new David Byrne CD. You could scroll through their catalog alphabetically, but that would be too time consuming because this online store has hundreds of thousands of CDs. By the time you get to the B's, Mr. Byrne will have probably released another CD. You could also search in the Alternative genre, but that too would be time consuming due to the sheer number of titles in the category. More likely, if you were a savvy online shopper you typed *Byrne, David*, or the album title into the store's search field and the store quickly displays only the CDs by David Byrne. Using keywords you were quickly able to limit your search through hundreds of thousands of entries into the handful that were immediately pertinent.

Keywording images is designed to work in exactly the same fashion. Think about how many images you have in your image library. Then multiply that number by five years, ten years, and even twenty years. The number of images you will have on your hard

drives is staggering. Storing your images in a folder hierarchy as we did in the beginning of the chapter is a great start, but to really take advantage of your computer's ability to find information quickly, you need to keyword your images to make searching for images a breeze.

Keyword Lists

Before creating a keyword list, it is well worth taking the time to think about how you might look for images based on the content of your images. Ask yourself a few simple questions.

- **Do you think of images in terms of content, location, or activity?** Ideally, you will have a keyword list that encompasses all three, but for an initial list, you may want to limit your keyword list to the criteria that are most important to you. You can always add keywords later.

- **Can you restrict keywords in your files to a particular list?** Extensis Portfolio allows you to restrict your keyword use to only those keywords in a master keyword list. This means that you'll never miss files in searches for Mountain Biking because you abbreviated it Mtn. Biking.

- **Do you need to look for images based on a particular stage of editing?** Perhaps you want to assign a keyword for master images and another for web images. Assigning keywords to your editing stages means that you are always working on the correct version of a file. It is a simple task to look for Sailboat images and run a second search for master images as well to find your layered file.

Applying Keywords in the Bridge

Once you've established your keyword list, you should figure out where you want to assign keywords to your images. It makes a lot of sense to assign keywords in the Bridge during your initial edit, though it may not be the fastest approach if you have a large number of keywords.

Creating Your Keyword List

The default keywords in the Bridge's Keyword palette aren't suitable for most photographers, so you'll have to create one of your own. Start by creating a series of keyword sets by clicking on the New Keyword Set icon at the bottom of the Keywords panel. The keyword sets act as categories for storing the individual keywords.

Next, create a series of individual keywords within each of the keyword sets. This can be done by clicking on the New Keyword icon, but this has the unintended consequence of creating a new keyword set *unless* you highlight one keyword set before creating the new keyword. I find it simpler to click once to highlight a keyword set, then right-click (PC) or CTRL-click (Macintosh) to add a new keyword from the contextual menu.

Assigning Keywords

Assigning keywords to your images is easy. Highlight the files to be keyworded and click in the checkbox next to the keyword to be applied (see illustration at bottom). Be careful not to check the box next to a keyword set or you will apply all of the keywords from the set to your file. To remove a keyword from an image, uncheck the box next to the keyword in the Keywords panel. The Bridge and Photoshop are not able to write into the metadata of the original file, so this information is stored in a sidecar XMP file. This is a tiny, 8KB text file Photoshop uses to store the camera raw settings, metadata, and keywords. This information is embedded in the image when Adobe Camera Raw processes the raw file. Your keywords are now accessible in the file info, or in any of the asset management programs discussed in the next sections.

Industrial-Strength Organization: Digital Asset Management Programs

Digital asset management programs serve to give you quick access to any image in your

photo library. Like a library's card catalog for your digital images, DAM programs work by creating an image database based on the filename, image size, keywords, and metadata. The image library can be easily searched for images of orangutans, oceans, or even sunsets. For DAM software to work for you, it has to be easy enough that you will get into the habit of importing and keywording images, and it has to be quick enough to display the images you are looking for instantaneously. Currently, three programs serve the asset management needs of photographers.

iView MediaPro

In the last section, I sang the praises of iView as an editing tool. But to look at iView as

simply editing software is fundamentally one-sided. iView is a unique hybrid between a quick, efficient lightbox for sorting the keepers from the outtakes and a full-featured asset management program. The keywording and asset management search features are robust enough for a healthy image library and allow for multiple search fields and quick single-keyword searches. iView intelligently grabs the keywords from the files as they are imported into the catalog and drops them into the Keywords field of the catalog index, making it easy to import images that have been keyworded in Photoshop or Photo Mechanic. Assigning keywords within iView is a simple drag-and-drop operation. Clicking on a keyword in the list instantly brings up all of the files in the catalog containing the keyword.

The Auto-Update feature monitors selected folders on your hard drive and imports new images into the catalog when you add files to your hard drive. This minimizes the amount of time you have to spend updating your catalog since iView automatically keeps the catalog up to date.

iView serves as a unique bridge between an editing program and DAM software. iView is the quickest DAM program to learn and to operate. It is effective, efficient, and serves the needs of most photographers splendidly.

Canto Cumulus

Cumulus from Canto is the Humvee of the asset management world. It's big and strong, capable of running over (or cataloging) just about anything that gets in its path. Like taking a Humvee to the grocery store, it's almost a shame to apply that much muscle

to the relatively simple task of cataloging a small image library. Cumulus is really designed to be a workgroup or enterprise-level asset management program used on a networked server by many users. To a photographer working on a single computer, the depth and breadth of Cumulus may seem daunting. An excellent interface and thorough user manual help get you cataloging images quickly. Before you jump in, I suggest configuring the catalog to import only your image files. This will expedite the import process considerably.

Once you begin to understand how Cumulus works, you'll see that there is very little that this program can't do. From creating custom search parameters to adjusting the display of your raw files and publishing HTML galleries, Cumulus has an answer for everything you can throw at it.

Users of Canto Cumulus need to be more technically savvy to use and configure Cumulus than with other asset management programs. For a photographer with a strong technical background and a large number of files to catalog, Cumulus gives the best bang for the buck of any DAM program on the market.

Extensis Portfolio

Extensis Portfolio (shown at top on the next page) is the top DAM program for medium to large photography studios needing to manage huge numbers of files. Portfolio's greatest strength lies in its ability to catalog, search, and keyword thousands of images. Images can be added to a Portfolio catalog directly through the contextual menu in the Finder, by dragging and dropping, or through the Folder-Sync feature. Folder-Sync monitors the contents of designated folders on your hard drive to intelligently keep the catalog up to date. The exclamation symbol on any of the watched folders (see next page at bottom) shows that the files in the folder differ from the images in the catalog. With a single click, you can synchronize the catalog with the files on your hard drive.

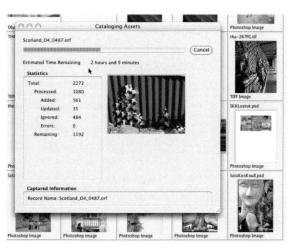

PERFECT DIGITAL PHOTOGRAPHY

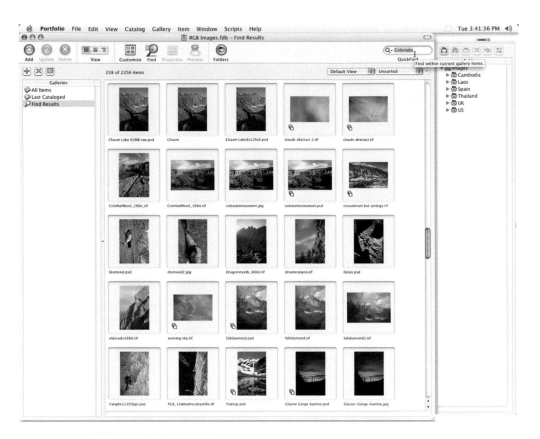

Keywording images in Portfolio is quick using the Master Keywords list. A separate palette, the Master Keywords list allows you to select a number of images, highlight a keyword from the list, and click Assign. The keyword is instantly applied to the metadata of the selected files. The Master Keywords list can also be used to search for images. Highlight a keyword in the list and click Find. Portfolio displays all of the images that match your keyword search.

and a simple, intuitive interface have made Portfolio the most popular DAM program for professional photographers.

Whether you are using a simple folder structure for your files or an asset management database, you need to find a system that suits your needs and then use it consistently. The best programs automatically watch a folder or set of folders that you specify to keep the image catalog up to date. All of the DAM programs listed here work with a wide variety of image types and import layered files, 16-bit files, and most camera raw formats. In Chapter 18, you'll see case studies of how DAM software is used in conjunction with Photoshop to create powerful, efficient digital workflows from image capture to print.

Portfolio is a deep asset management program with all of the features you need to effectively organize your entire image library. Once you understand how Portfolio manages your files, it is very easy to tailor the catalog to your workflow with features like Smart Galleries, and Web Galleries, and a new feature called Net Publish, which allows you to publish your image catalog to your website. Efficient integration with Photoshop

HOW TO: PICTURE EDITING at *NATIONAL GEOGRAPHIC* MAGAZINE

By Bert Fox

Bert Fox joined National Geographic *magazine in August 1996 as an illustrations editor. Since then, he has edited stories ranging from a global perspective on weapons of mass destruction to the hidden stories of Sudan's civil war. Prior to joining* National Geographic, *Bert art-directed and picture-edited the* Philadelphia Inquirer's *Sunday magazine and picture-edited the Sunday newspaper for 14 years. During his tenure, the newspaper won 17 Pulitzer prizes. He has been named Magazine Picture Editor of the Year five times by the University of Missouri and has been a faculty member of the Eddie Adams Workshop for 11 years. He has also taught at the Maine Photographic Workshop, the Anderson Ranch Arts Program, and the Julia Dean Photographic Workshop.*

I peer over my Garrett Box (a double-mirrored table-top contraption that reflects images from a carousel projector onto a small screen) where I've been editing 150 rolls of 35mm transparency film since early morning. The pictures made by Randy Olson arrived only days ago from Sudan. My typically sun-drenched office is nearly dark. I have 400 more rolls to review before his next shipment arrives.

What am I looking for? And why can't I find it in 30 or 50 or even 100 rolls?

Before I get to that, let me tell you that this is *National Geographic* magazine and I am the illustrations editor for our story on the Sudan. It begins on the battlefields of their 20-year-long civil war fueled by ideology and oil. We'll tell the story through its villains, its heroes, and its victims. The scenes will play out in mud huts and refugee camps, in lavish palaces and nomadic tents. The stage sprawls over varied landscapes from burning deserts in the north to oil fields and swamps and garrison towns in the south.

Randy's pictures show the contrasts of war. I see the suffering of a mother picking leaves from a tree, gathering the only nourishment her starving family will have that day. I see other mothers wrestling one another for control of food aid dropped from a passing airplane. In the palaces of Khartoum I see the opulence of men in power.

With each roll of film I open, I'm looking at the fruition of a year's planning and months of photographing. Each frame stays on the screen for about three seconds. The initial edit is a bit like watching a movie in slow motion. The frozen moments of a scene come onto the screen. I see Randy "working" the room as I view another roll showing men interacting amongst shafts of light that pierce the smoky air in a dimly lit barroom, their gestures and looks captured on film. He'll stalk the room looking for optimum angles or the perfect light. Textures and colors build his backdrops. He makes rolls of pictures before moving on.

Frames go by on my screen. I pull "moments" that come together either through gesture or touch or expression. The good pictures seem to leap at me. My selections become gut responses to what I see. Something inside me reacts on an emotional level, short-circuiting my intellect, and I pull pictures that move me because they speak about love, or hate, or revenge, or terror or about virtues like honesty or generosity.

I look for images lacking "visual noise," annoying light or color, or objects that take away from a picture's impact by cluttering its visual message. Pictures, like good writing, need clarity to tell their stories. The photograph's center of interest should grab the eye while the remainder of the frame supports it. If numerous parts of the picture compete for the viewer's attention, the picture fails.

Great photographers, like Randy, don't just "grab" moments. They lead the viewer through their pictures by orchestrating the scene. No, I don't mean he arranges the people, but rather he arranges scenes through his choice of lens and point of view to carefully create a backdrop that will drive the viewer's eye to the most important part of the picture. As a supportive background emerges, he photographs emotive moments between his subjects. If I can read his subject's feelings weeks later on my light table, he has succeeded.

Remember, the camera is an objective viewer of the scene, while the photographer's view is highly subjective. Think like a camera when you make pictures. Take control of the entire frame. Make it support the moment. And stay with a scene. Don't take a few frames and walk away. You should be making rolls of pictures as moments emerge.

Don't settle for simplistic pictures, because simple pictures won't hold a viewer's interest. I seek complex pictures with compositional order and layering of elements that capture a moment. *National Geographic* photographer David Alan Harvey is a master of the layered picture. He brings disparate moments together within different corners and layers of the frame. From their enjoinment, a meaning emerges that is more then the sum of its parts. Look closely at the subtle and nuanced pictures in his book *Cuba*. Their meaning transcends their moments.

If I find two dozen great pictures from a magazine assignment, we have the beginnings of a successful story. Wonderful pictures alone are not enough. Together, these images must create a narrative. The photographer must lead the viewer through a story by creating pictures that set the scene, introduce a crisis or dilemma, and end with resolution. It is analogous to writing a novel. No one wants to read a story that repeats its fourth chapter again and again. Picture stories are no different. If ten of the best pictures from an assignment say the same thing, all but the strongest frame are gone. This is why planning a coverage is vital.

Whether you're on assignment or holiday, think about variety. Think about varying your shooting perspective from tight to medium to loose. Bring the viewer into the scene with ever-tighter frames that eschew the surroundings for the moment. Plan to photograph different subjects that together give the viewer a broad perspective. Look for different qualities of light. Midday sun may be dreadful for landscapes but ideal for details and moments.

Seek out rituals like birthdays and baptisms and burials. In rituals are the symbols of culture, manifested not only in ceremony, but also in its trappings like clothing and song. From rituals emerge the fabric of the human condition. Dig into the event by going beyond obvious snapshots and find interpersonal and memorable moments. Ask yourself how a *National Geographic* photographer would shoot this scene.

Which gets me back to the question: How many pictures do you shoot? My answer is, "A lot." Captured moments, perfect in every way, are very hard to make. It's almost as if the demons of disorder are in charge when you look through the viewfinder. You have to wrestle them into submission by making the unimportant elements of the image recede and the important parts of the picture jump to the forefront.

And what about format? In the past the options were medium format or 35mm and transparency film or negative film. Now it's digital or film. At *National Geographic* between 20 and 30 percent of our pictures are made digitally. No doubt that figure will rise as we become more familiar with its idiosyncrasies. My computer is slowly replacing my Garrett Box. I create editing catalogues in iView MediaPro software just like I pulled frames from the yellow boxes. Workflow and archiving need to be addressed, but those will come in time.

Remember, it's about the picture, not the tools. Understand the camera you choose. Make it work for you instead of you for it.

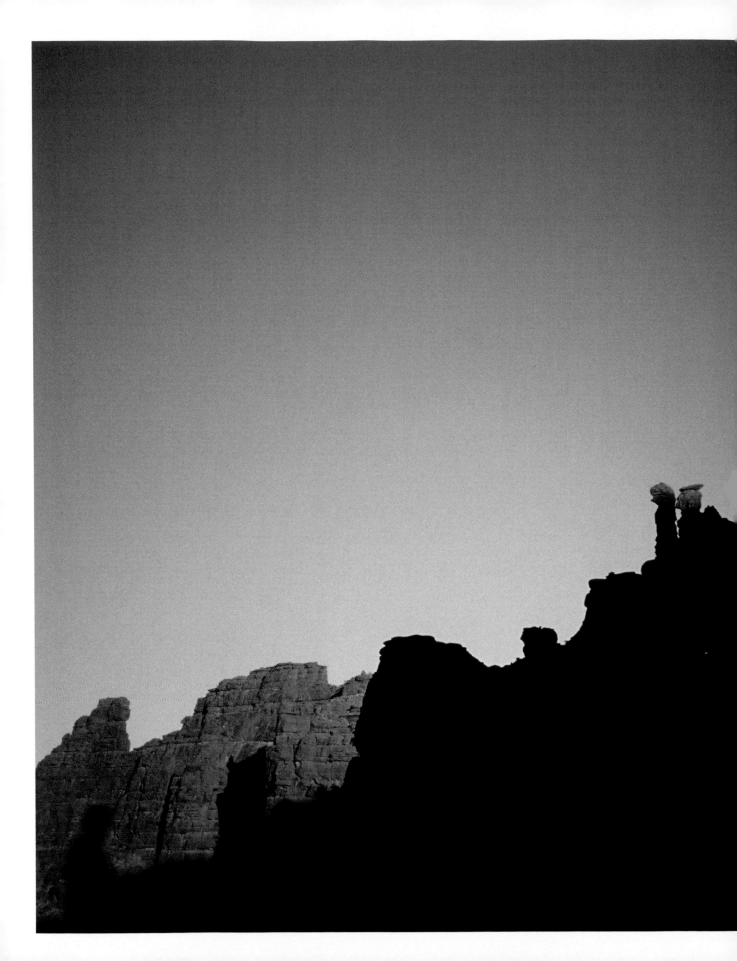

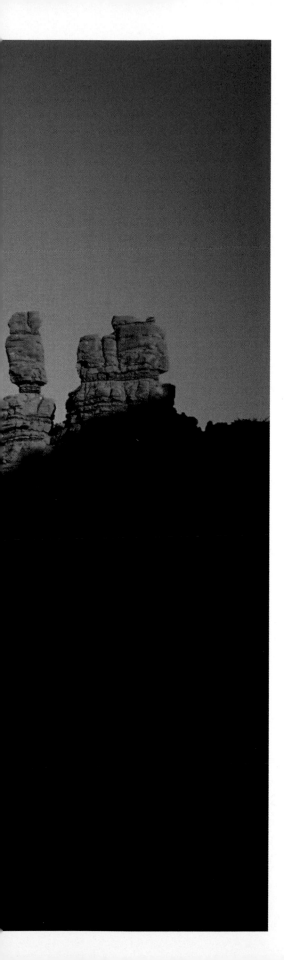

CORRECTING TONE and COLOR

Correcting digital images is more art than science. This chapter provides guidelines for crafting and refining your images and offers avenues for creative exploration. As you begin working in the digital darkroom, remember that great images are the result of a skilled practitioner guided by the creative heart of an artist.

Shadows and light. Onion Creek Canyon, Utah.

Much of what we will cover in this chapter emulates the common techniques found in a wet darkroom. Adjusting tone, correcting color, and determining appropriate contrast ratios are all traditional techniques that form the foundation of our work in the digital darkroom. The process of previsualization and the Zone System of photography can also be adapted for digital processes with great success. The Zone System, often attributed to Ansel Adams, is a systematic process to eliminate the guesswork involved in shooting film. Integral to the practice of the Zone System is previsualization, the creation of a mental image of the finished print before releasing the shutter. Previsualization guides photographers as they adjust the shutter speed and aperture, based on the tonal values in the finished print. Although the Zone System does not translate precisely from film to digital, many of the core themes in its practice apply directly to digital capture and manipulation.

THE DIGITAL ZONE SYSTEM

The Zone System divides the tonal range from black to white in ten successive steps or zones. Zone 0 is the darkest black that the photographic paper is able to reproduce. Zone IX is paper white, reserved for specular highlights without visible detail. Generally, we want our exposures to fall within the range between Zones I and IX, capturing both highlight and shadow detail. In the course of

your adjustments in Photoshop, you shape the image by changing the tonal values in the original digital file or scan to your desired tonal values. For instance, a Zone V skin tone might be reassigned to Zone VI to give the image a more pleasing appearance. More simply put, by previsualizing, you are creating a mental picture of your finished image and using it to guide your corrections.

- **Zone 0** RGB Value 0,0,0. No texture or detail.

- **Zone I** Deep shadows with barely discernable detail.

- **Zone II** Dark shadows with very slight detail.

- **Zone III** Fully detailed and textured shadows.

- **Zone IV** Dark or deeply tanned skin tones.

- **Zone V** Blue sky at a 45-degree angle to the horizon.

- **Zone VI** Typical Caucasian skin tone.

- **Zone VII** Lightest fully detailed and textured highlights.

- **Zone VIII** Highlights with slight detail, such as snow.

- **Zone IX** RGB Value 0,0,0. Paper white, no texture or detail.

Tip One important deviation between the traditional Zone System and the digital Zone System is the reversal of the old adage "Expose for the shadows, develop for the highlights." Because of the way raw camera data is stored, it is desirable to expose for the highlights and then correct the shadow values in Photoshop. This results in better shadow detail with less digital sensor noise or posterization. Accurate exposure is still paramount. However, it is better to err on the side of overexposure than underexposure particularly if you are shooting camera raw files. The raw files from most cameras allow you to "rescue" overexposed highlights in Adobe Camera Raw.

The Raw Advantage

A successful digital workflow is a series of progressive steps from coarse, global adjustments in the overall tone and color to precise, localized refinements of image detail. We discussed the initial round of adjustments to scanned images in the previous chapter and we now turn our attention to raw digital camera files. After our initial round of corrections on the raw camera files, we will bring the images, along with our raw scans, into Photoshop for more precise tone and color manipulation. This stage is the equivalent of a master chef working with his signature soup stock. He starts with a rich, savory, and full-bodied broth. Similarly, we start with a digital capture or scan for our raw material. Our global corrections will make the image 90–95 percent complete. The localized corrections demonstrated in Chapter 15 concentrate on refining the image that last 5–10 percent.

The raw file is the equivalent of the digital negative. We've discussed its importance already in Chapter 3, but it is a point worth reviewing here. A raw camera file contains the unprocessed data from the camera's sensor, along with instructions as to how the file should be processed by the software. This instruction set includes information on the camera matrix used, the white balance, and the overall tint of the image. You can replace the original instruction set with a totally different set of parameters to create a different effect, correct for exposure or white balance problems, or to take an entirely different creative path. The raw file brings a tremendous amount of flexibility to the digital photography workflow.

Raw File Converters

Raw data is stored in a proprietary format, which gives these files their unique suffix of NEF, CRW, ORF, and so forth. Camera manufacturers suggest the use of their proprietary software. This train of thought has a certain logic to it; however, camera manufacturers are excellent at designing cameras and very poor at writing software. A few intrepid, third-party software developers have deconstructed these proprietary raw formats to create programs that are generally more efficient, more powerful, and more usable than the manufacturer-supplied software. It is worth comparing processed

files from the third-party and manufacturer's software to determine which program yields superior results. Each program interprets raw data differently, and I've noticed dramatic differences between programs, particularly in shadow detail and camera noise reduction.

I've included a quick rundown of the most popular third-party raw file converters. Due to the large number of camera manufacturers, I've omitted their software offerings from this list for the sake of brevity.

- **Phase-One Capture One DSLR** Before the latest incarnation of Adobe Camera Raw, Capture One DSLR Pro was my favorite raw file converter. Performing tone and color corrections is a quick operation, and Capture One allows you to apply tone and color corrections to a group of images, making this program a favorite among wedding photographers who often need to process a thousand or more images a week. The conversions from Capture One are very good, but their file-structure system creates two new processing files for each original raw file, making it a hog for disc space. Capture One is the preferred raw converter for high-volume photo studios; however, the price tag for Capture One can be a deterrent for amateur photographers.

- **MacBibble** I think of MacBibble, or simply Bibble on a PC, as the indie-

rocker of the raw converter world. The raw material for stardom is all there, but the program is rough around the edges. I find the process of adjusting raw files in MacBibble to be very slow relative to the other programs available. Additionally, at the time of writing, MacBibble is only available for Nikon and Fuji cameras, which limits its broad appeal.

■ **Adobe Camera Raw** In Photoshop, raw camera files are processed using the Adobe Camera Raw (ACR) plug-in. First introduced in Photoshop 7, the latest version of ACR has undergone significant improvements. ACR supports a wide range of digital cameras. It is highly functional and is wrapped into a program we already use. ACR is the only raw converter currently supporting the DNG format. ACR has become my raw converter of choice and will be the raw converter on which we focus in this book. The following is an overview of the Adobe Camera Raw plug-in from Photoshop CS2. It includes the major features, listed clockwise from top right as shown below.

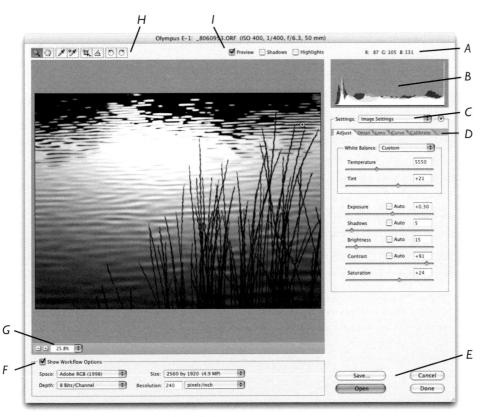

Adobe Photoshop's Camera Raw dialog box

A. RGB Readout Lists the RGB values for the pixels located under your cursor. Essential for color-correcting raw images.

B. Histogram As discussed in the previous chapter, the histogram shows the distribution of values through the three color channels. The white histogram shows the values of the composite RGB channel.

C. Settings and Preferences The Settings tab allows you to quickly recall a previous conversion setting or return to the camera's default settings. Additionally, the Preferences fly-out menu allows you to adjust the behavior of certain Camera Raw features.

D. Adjustment Tabs The focal point of the Camera Raw plug-in. The Adjustment tabs are home to all of the tone and color settings, along with several other functions to correct for lens deficiencies or noisy captures. The five tabs can be summarized as follows:

- **Adjust** This tab is on top for a reason. Almost every file will be manipulated using the Exposure, White Balance, Tint, and Saturation sliders found here. By default the auto checkboxes intelligently optimize the tonality of raw images.

- **Detail** Specifies the amount, if any, of sharpening to be done to the raw file during processing. The Luminance Smoothing and Color Noise Reduction sliders help to mitigate the digital noise found in low-light captures.

- **Lens** Corrects for chromatic aberration, color fringing that sometimes occurs with digital cameras and allows for the addition or removal of a vignette from the image.

- **Curve** New to Photoshop CS2, the Curves panel gives you advanced control over the distribution of tones throughout your image. Choose from one of three contrast settings, Linear (none), Medium, or Strong contrast, or create your own curve in the Custom field.

- **Calibrate** Not to be confused with ICC calibration, the Calibrate tab allows you to build a series of settings to compensate for the unique characteristics of your digital camera.

E. Button Cluster Home to several output options, Button Cluster lets you save the image in the DNG raw format, or convert the image while saving to a TIFF, JPEG, or PSD. Open brings the image into Photoshop for further editing, and Done updates the raw image and leaves it in its native file format.

F. Show Workflow Options The Show Workflow Options checkbox provides access to the image's color space, bit depth, image size, and resolution. The settings in this area are sticky, meaning that they remember the settings from the last converted image. The Size settings without a plus or a minus after the number indicate the native resolution of the camera. A plus indicates that the image will be upsampled when the file is processed, and a minus after the setting indicates that the file will be down-sampled during the conversion process.

G. Zoom Percentage Sets the zoom magnification for the preview window in Camera Raw. Bring this value to 100% to assess sharpness and fine detail of the image.

H. Toolbar The Toolbar contains the three tools carried forward from version 2 of Camera Raw along with three new options for version 3. All tools are listed from left to right.

- **Zoom tool** Used to adjust the zoom magnification of the image window. Double-click on the Zoom tool icon to quickly jump to 100% view.

- **Hand tool** Used for navigating through the image window at increased magnifications. A quicker shortcut is to hold the spacebar to temporarily access the grabber hand.

- **White Balance tool** Clicking on an area of your image that should be neutral (without color) with the White Balance tool adjusts the Temperature and Tint sliders to make gray by equalizing the red, green, and blue values. This is a great way to quickly remove a color-cast in a raw file.

- **Color Samplers** Although the icon looks similar to the White Balance tool, the two tools do very different things. The Color Sampler tool allows you to monitor the RGB values at up to four different places in your image. I use these to track color corrections in the important neutral areas and to make sure I don't push my highlights or shadows to pure white or solid black. Reference "Creating the Master File" later in this chapter to learn how to use the color samplers correctly.

- **Crop tool** New to Photoshop CS2, the Crop tool gives you the option of specifying how the image should be cropped when it is processed. The great benefit from cropping in ACR is that the image data outside the crop is never deleted, giving you the opportunity to export the image a second time using a different crop.

- **Rotate Image** Rotates the image preview clockwise or counterclockwise. This rotation is applied to the image as it is exported from Camera Raw.

I. Preview Checkboxes The Preview checkbox only toggles between the corrections made with the currently active adjustments tab. This is a departure from previous versions of Camera Raw where the preview would toggle between the original and adjusted images. The Shadows and Highlights previews give a false color overlay displaying the areas of the image that are either completely black or fully white.

Photoshop Elements gives you the ability to adjust raw files through a simplified raw file converter. The most important settings in the Adjustment tabs have been condensed into one panel. The auto-adjustments and the White Balance tool are present, but the Crop tool, sadly, is not.

Tip *New for Photoshop CS2:* Some important changes have been made to the way that preview is handled in Camera Raw. The Preview checkbox only previews the corrections of the currently active adjustments panel. Let's say you make an image black and white in the Adjust tab and add a strong contrast curve in the Curve tab. If you click the preview on and off while the Adjust tab is activated, the preview will toggle between BW and color with the contrast applied to both. If you are in the Curve tab and toggle the preview, you will see the BW image with and without the contrast curve.

Adjusting the Tonality of Raw Files

In Adobe Camera Raw, the first step is to correct the overall tone of the image with the Exposure and Shadow sliders. So, first, I'll visually adjust the image, using the image histogram for feedback, to achieve the desired exposure for image. Additionally, I use the clipping display to accurately set the lightest and darkest points of the image, maximizing contrast without sacrificing detail.

The histogram, as explained in Chapter 11, provides a visual graph of the distribution of tones and colors in your image. In a correctly exposed photo, there will be slight gaps between the highlights and shadows present

in the image and the absolute end-points on the histogram. When correcting images visually, it is always important to keep a close eye on the histogram to ensure that your changes do not push the histogram past the histogram's endpoints, resulting in a loss of image detail.

The clipping display is the most accurate method of setting the Exposure (highlight) and Shadows values in Camera Raw. To use the clipping display, hold down the ALT or OPTION key while adjusting the Exposure slider. The image preview window will turn black, and as you move the Exposure slider from left to right, the fully saturated areas of the image begin to appear as red, green, blue, or white patches, indicating areas that will lose detail in one or more color channels if you keep the current setting. In this image of

The Exposure clipping display

a woman crossing the street on a rainy day in Oban, Scotland, I see slight clipping in the red car and the yellow lines on the road. There is significant clipping in the sky; however, there is not much that I can do about it since it is significantly brighter than the rest of the scene.

The Shadows slider also offers a clipping display. This time, the screen turns white and fully desaturated areas that would lose detail are shown in the window as you move the Shadows slider from left to right. Increasing the Shadows slider shows clipping in the green channel in the car. It appears as magenta in this preview because magenta is the absence of green and there is no green information in the red car. I don't want to make the shadow clipping any worse, so I will leave the Shadows at a value of 0.

The Brightness setting adjusts the overall brightness of the midtones. The Contrast slider forces values further from 50% gray adding contrast through the midtones without losing detail in the bright highlights or deep shadows. Boosting the Brightness helps to make the image feel more "open," and a slight nudge of the Contrast slider gives the image a little more snap.

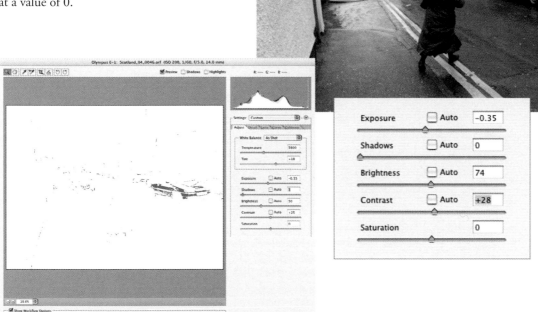

The Shadows clipping display

Tip *Turning Off Auto-Adjustments:* The new auto-adjustments in Photoshop CS2 and Photoshop Elements can be a great time-saver. However, if you want to adjust your images without the benefit of the auto-corrections, uncheck all of the auto boxes, choose Camera Default from the Settings menu, and choose Set Camera Default from the fly-out menu immediately right of the Settings menu. This will turn off the auto-adjustments. If you want to turn the auto-corrections back on, choose Reset Camera Default from the fly-out menu.

Adjusting the Color Balance of Raw Files

Learning to quickly and effectively adjust the color of a digital image is one of the most difficult techniques to master. This is in large part due to the complex nature of human color vision. Our eye will automatically see the lightest point as white even though there may be a slight blue or green cast to the image. The ability to visually detect color-casts is one that is learned with experience, however. Photoshop gives us RGB info palettes to help us easily read the colors in the image, and the White Balance tool in Camera Raw to instantly neutralize the color-cast in an image.

The White Balance tool

After adjusting the exposure of this image, the RGB values of the important neutral areas of the white wall, dark sidewalk, and darker street all show higher values for blue than either red or green. This indicates a faint blue cast that I can neutralize by selecting the White Balance tool and clicking on the white wall. This adds a tiny amount of yellow to the image and resolves the blue cast. If I want to warm the image, I can adjust the temperature and tint sliders manually to achieve the desired "feel" for the image. The Temperature is blue to the left and yellow to the right. The Tint slider is green to the left and magenta to the right. To warm the image slightly, I'll boost the temperature, by adding yellow, and nudge the tint slightly toward magenta. Correcting an image manually is often your best choice when you have an image that either doesn't contain any neutral tones or contains a color-cast you wish to keep. In those instances, you would bypass the use of the White Balance tool and go straight for the Temperature and Tint sliders. Use the RGB values in the neutral areas of your image and trust your monitor to make your changes.

Tip *Use the Arrow Keys:* Whenever I have to adjust the Temperature or Tint slider, I highlight the value in the Temperature readout, then position my cursor over an important neutral area. Using the arrow keys on my keyboard, I can control the Temperature and Tint sliders while keeping an eye on the RGB values in the info readout. I use TAB to jump to the next adjustment command in the menu or SHIFT-TAB to access the previous adjustment command. Holding SHIFT while adjusting the arrow keys multiplies your adjustment by a factor of ten. This works for all of the settings in Camera Raw.

Tip *Camera Raw Workflow*: When adjusting raw files, it is sage advice to correct the biggest problem first. If the image is dramatically underexposed or the color balance is way off, that becomes my first priority. If the image only needs minor adjustments, like the one shown in the preceding section, I'll generally use the White Balance tool to loosely set the color balance, adjust the exposure and tone settings, then make final adjustments to the color balance.

White Balance sliders

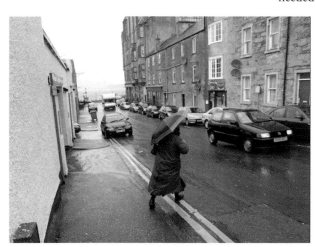

Image post after a White Balance correction

Creating the Master File

After a film image is scanned, or a raw camera file has been adjusted and processed, your next step is to begin work on a master file. This master file has been spotted to remove dust and scratches, contains all of your tone and color corrections in the form of adjustment layers, and is archived as a full resolution file in your RGB working space. This file can then be repurposed for various output devices, such as the Internet or wide-format photographic printer.

To create this master file, you progress from global edits affecting tone, color, and contrast to localized corrections that fine-tune your image. Your workflow is as follows:

Global Corrections:

Step 1 Use Levels to set the lightest and darkest points in the image.

Step 2 Add contrast to the image as needed with the Curves tool.

Step 3 Adjust the color balance using either the Color Balance or Curves tool.

Local Corrections:

Step 1 Make localized corrections to tone, color, or saturation of the subject.

Step 2 Adjust density or focus of the background through burning, dodging, or blurring, to draw attention to the subject.

Step 3 Perform any additional corrections as necessary.

Retouching or spotting can occur prior to the first Levels adjustment or in between any of the global adjustments. I usually prefer to spot the image before I do any tone or color correction. We will cover retouching in the next chapter.

I don't perform any sharpening on my master files, preferring instead to sharpen as the last step before printing or sending the file out the door to my lab. This allows me to tailor the amount of sharpening to the specific output device and output size used to create the finished print. Sharpening will be covered in greater detail in the next chapter.

The remainder of this chapter is devoted to the global corrections, and the next chapter will concentrate on retouching the master file and performing localized adjustments. Let's begin with perhaps the most valuable palette for photographers—the Info palette.

Mastering the Info Palette The information you get from the Photoshop's Info palette tells you where tone and color corrections need to be made. For example, if you move your cursor over a picture of a cloud and the Info palette displays a higher value for blue than red or green, you can easily ascertain that the image has a blue color-cast.

If the Info palette is not visible, go to the Window menu and make sure Info is checked. By default, the Info palette shows RGB values in the left column. We recommend leaving RGB as your primary readout but suggest changing the second readout to grayscale. This is done by clicking on the tiny black

The Info palette

arrow to the right of the eyedropper icon in the Info palette. Choose Grayscale from the menu that appears. The grayscale readout is helpful when you add contrast to the image, and later, when you prepare the image for printing.

While you are making tone or color adjustments to your file, the display of the Info palette changes slightly to show unadjusted values to the left of the slash and the new values based on your changes following the slash. This helps to track the accuracy of color corrections and can provide a warning if your changes will result in the loss of highlight or shadow information.

The Info palette displays before and after values, giving you the ability to track tone and color changes. By adding sample points to your image, you can monitor your progress in key areas of the image. Click on the Eyedropper Tool icon in the Tool palette and hold down your mouse button. The Color Sampler tool is hidden behind the eyedropper in the Tool palette. Select it, then click once in an important highlight, midtones, and shadow portion of your image. These sample points appear in the Info palette. They do not print, but remain when the document is saved. To remove these points, choose the sample point tool, click on the sample point, and drag it off the image area. You will use the sample points to track the changes you make as you adjust your images using levels and curves.

Using the Color Sampler tool, I typically set one point in the shadows, one in the midtones, and a third in the highlights. I set my final point in an area of critical detail. While making adjustments, the sample points display before and after values that allow me to monitor my changes to the image throughout the tonal range.

Tip *Using Color Sampler Points in Camera Raw*: The technique described here applies equally to the use of color sampler points in Camera Raw.

Using Levels for Tone Correction In both the scanning software and ACR, you loosely set the highlight and shadow points and adjusted the overall tonality of the image. Now it is time to tighten up the endpoints using the Levels tool. Accurately setting the lightest and darkest points preserves highlight and shadow detail and forms the foundation for successive corrections to the overall tone and contrast in the image.

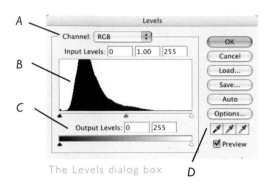

The Levels dialog box

The Levels dialog box consists of several important features:

A. Channel Levels always defaults to the composite RGB channel. Access the individual color channels through this pull-down menu.

B. Histogram The graphical representation of the tones in your image. The histogram window displays information for either the composite RGB channel or the currently selected color channel.

C. Shadow, Midtone, and Highlight Sliders The primary purpose of the Shadow and Highlight sliders is to set the darkest and lightest points in the image. Moving the sliders toward the center of the histogram adds contrast, but any information falling outside of either the Shadow or Highlight slider will be rendered as solid black or solid white, respectively. The Midtone slider controls 50 percent gray. Moving the Midtone slider toward the shadow end of the histogram compresses the shadows and stretches the highlights, resulting in a brighter image. Moving the slider toward the highlight end of the histogram compresses the highlights and stretches the shadows, resulting in a darker image.

D. Eyedroppers The eyedroppers allow you to set the lightest and darkest points in the image with a mouse click. Unfortunately, it takes a high degree of skill to pick the lightest and darkest pixel in the image, so we abandon the eyedroppers in favor of a more sophisticated tool—the clipping display.

The clipping display is the reason we use Levels for setting our highlight and shadow points. Holding the ALT or OPTION key while moving the Shadow slider activates the clipping display. The screen initially turns completely white, then as you move the Shadow slider closer to the center of the histogram, patches of black, cyan, magenta, or yellow appear indicating areas that would be clipped or rendered without detail if you choose to keep the current setting. Black indicates clipping in all three color channels, cyan indicates clipping in the red channel, magenta indicates clipping in the green channel, and yellow indicates clipping in the blue channel.

With the Highlight slider, the clipping display initially turns black, then as the highlights are clipped, patches of white, red, green, or blue appear. White indicates clipping in the composite channel, and the three primary colors represent clipping in their respective channels. Your goal when setting the highlight and shadow points is to bring the

sliders in until you begin to see information appear in the clipping display, then back off your adjustments so that no important detail is clipped.

Why Not Use Brightness and Contrast?

Unlike the Brightness and Contrast sliders in the Camera Raw dialog box, the brightness/contrast adjustments made in Photoshop affect all tonal values equally. For instance, an underexposed image could benefit from a boost in brightness; however, using the Brightness feature brightens not only the highlights and the midtones, but the shadows as well. This leaves us with bright shadows, which is unsavory. In addition, these controls do not have a clipping display, which makes it all too easy to inadvertently force pixels to all white or all black, losing important detail.

There are two methods of effectively setting the highlight and shadow points using the clipping display in Levels. The first is to set the highlight and shadow points individually in the three color channels. This is the most accurate method of setting highlight and shadow points and the one you will use most of the time. It has the added benefit of neutralizing slight color-casts, minimizing the amount of color correction we need to do later. Unfortunately, this is also the primary disadvantage of using this technique. Sometimes, we want to keep the color-cast present in the image, particularly

during the "golden hour" of photography. For these images, we use a second method, which uses the clipping display to set the highlight and shadow points on the composite RGB channel. This tends to enhance the saturation of the golden light and make it more pronounced. Here's how you do both methods of correction.

Using the Individual Color Channels

Use this method when working on an image that should have a neutral highlight and shadow point. This raw scan of koi at the National Botanical Gardens in Washington, DC, is flat and has a slight blue color-cast. I set one sample point in the darkest area of the water, then set a second point on a ripple near the koi's mouth. There really isn't a neutral highlight for me to track, so I'll make do with just two points.

The original image with sample points shown

Step 1 Create a Levels adjustment layer. Working on adjustment layers gives you the option to change your mind and readjust the correction later.

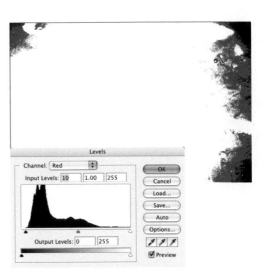

Step 2 From the Channel pull-down menu choose the red channel. While holding down the ALT or OPTION key, press the mouse button and move the Shadow slider toward the center of the image. When you begin to see patches of black in the clipping display, back off your adjustment until the black disappears. Release the mouse. In this image (at top right), I don't want any of the dark water to be rendered as Zone 0 absolute black, so when the first areas of black appear in the clipping display I reduce the amount of my correction until they disappear. This brings my shadow value from 0 to 10 in the red channel.

Step 3 Continue to hold down the ALT or OPTION key with the mouse button depressed and bring the Highlight slider toward the center of the histogram. When

patches of red appear in the clipping display, back off your correction until the red disappears. This image contains small specular Highlights on the water that should be rendered as Zone IX, paper white, so I'll bring the Highlight slider in until I see the specular highlights appear in the clipping display. This gives me a highlight point of 238. Release the mouse.

Step 4 Repeat steps 2 and 3 for the green and blue color channels. My values for the green channel are 14 for the shadow and 235 for the highlight. The blue channel has values of 19 and 215.

Step 5 Adjust the Midtone slider in the composite RGB channel to roughly set the midtone brightness in the image. Adjusting the Midtone sliders in the individual color channels will affect the color balance of the image. I'm happy with the distribution of tones in this image, so I'll opt to leave the midtones where they are. Both of the sample points show an improvement in the color balance, but they are still not neutral, indicating the need for additional color correction. In this photo, the result of the Levels adjustment shows better contrast and more saturated color. It is now ready for additional color correction.

Setting Highlight and Shadow Points While Preserving Color This image of sand dunes on the California coast has a nice amber light

filtering through the dune grass that originally attracted me to this little vignette. Setting the highlight and shadow points in the individual color channels gives me the result shown next. Yuck! For this image, I'll make my adjustments to the composite RGB channel in Levels, not only because it has a color-cast I want to keep, but also because it doesn't have a neutral highlight or shadow point to reference.

The koi image after correcting global tone and color with the Levels command.

Initially, this image has a pleasing color-cast. Individually adjusting the red, green, and blue channels removes this color-cast and leaves us with an ugly image.

Step 1 Activate the clipping display with the ALT or OPTION key and adjust the Highlight slider first. Previsualizing this image, I saw that there wouldn't be any areas of the image rendered as a Zone I shadow, so I decided to set the highlight point first using the clipping display, then set the shadow point visually. The clipping display picked up a few individual sand grains as the highlight point. I allowed a few of them to go to pure white and set my highlight point.

Step 2 For the shadow, I opted not to use the clipping display since there isn't a true shadow. Instead, I chose to visually bring up the shadow point until I felt the shadows had their correct density. Before releasing the mouse, however, I activated the clipping display to make sure there weren't any areas I was accidentally sending to pure black.

Step 3 I still felt the midtones were a little too dark, so I brought the Midtone slider toward the shadows giving the image a better distribution of tones.

Adjusting the Contrast of the Image

Now that we've set the lightest and darkest points in the image, we want to increase contrast through the midtones to give the image more snap. We'll do this using the Curves tool, but before we jump into working with Curves, it is worth spending a little time to understand how Curves works.

Introduction to Curves With the exception of the clipping display, anything you can do in Levels you can do with more control in Curves. The power and flexibility of Curves often scares new Photoshop users from really learning how to harness this amazing tool.

The Curves dialog box

A. Channel Just like in Levels, Curves gives you the option to work on the composite RGB channel or the individual color channels.

B. Curve This innocuous-looking straight line is one of the most powerful features in Photoshop. Imagine the histogram in Levels rotated 45 degrees with the highlight pointing up at the sky and you'll be correctly oriented in Curves. The bottom point at the left of the curve is 0,0,0 black and the top right is 255,255,255 white, or a fully saturated color if you are working on a color channel.

C. Eyedroppers Again like Levels, Curves gives you the option of setting your highlight and shadow points with the eyedroppers. Also like Levels, we will ignore them in favor of the Levels clipping display.

As a straight line, Curves isn't terribly useful to us, so we need to add an anchor point to the curve by clicking on the curve in the area we wish to adjust. For now, I suggest placing a point on the middle point of the curve around 50% gray. In the composite channel, moving the curve up and to the left increases RGB values, making the image brighter. Moving it down and to the right decreases RGB values, making the image darker. In the color channels, increasing values adds the primary color (red, green, or blue) and decreasing values adds the complementary color (cyan, magenta, or yellow). Here's where it pays to understand the relationship between additive and subtractive colors. You may wish to revisit the section on color modes in Chapter 11 or spend some time playing with curves in the three color channels.

Adjusting Contrast with Curves After setting the highlight and shadow points in Levels, our next step is to add contrast to the image. For this step, it is important to understand that areas of the curve steeper than 45 degrees add contrast to the image and areas of the curve less than 45 degrees lose contrast. We want to add contrast through the midtones to give them additional punch. To do this, make sure your Info palette is open and then create a new Curves adjustment layer.

Step 1 Imagine the finished print as you look at the image and use the readout in the Info palette to find the area containing the darkest *important* shadow detail. This is not the darkest shadow with detail, Zone II, but the darkest shadow containing detail essential to the image, usually Zone III. It may be helpful to look at the Grayscale values as opposed to the RGB values for this. When you find your Zone III shadow, CTRL-click or CMD-click on that part of the image. This will set a point on the curve corresponding to that pixel in the image. For the photo of the koi, the Zone III shadow is on the top of the head of the speckled koi at the top-center of the image.

Step 2 Find the lightest point containing *important* detail, Zone VII, then CTRL-click or CMD-click on the image. Photoshop will place a point on the curve that corresponds to your selection. The Zone VII in this image is on the top of the head of the most prominent yellow koi.

Step 3 Keeping a close eye on your Zone III shadow, click on the shadow point and drag it toward the bottom right of the Curves window and away from the center line of the curve. Stop when your shadow point reaches the density you desire. I adjusted my Zone III shadow from a value of 71 to 66, which made the water a deeper, richer black.

Step 4 Bring the Zone VI highlight point up and to the left, away from the center point of the curve, creating a slight S-curve. This brightens the highlights and adds contrast through the midtones between your Zone III shadow and Zone VI highlight. Stop when you've added the desired amount of contrast. My S-curve brought my Zone VI highlight from 194 to 203.

Step 5 Click OK.

Step 6 The addition of contrast results in a saturation boost for bright colors in the image. This is particularly problematic for portraits. The remedy is to 1) switch the layer blending mode from Normal to Luminosity, or 2) to reduce the layer opacity. Changing the blending mode to Luminosity tells Photoshop to add contrast through the luminosity and tone information and to leave the color information in its original state. Reducing the opacity of the layer is akin to turning down the volume of the correction. Both are valid methods for fine-tuning your adjustment. The finished image is shown here.

The finished image

Color Correction

Your eye is a highly adaptive tool, effective in a wide range of brightness ranges and light sources. The ability to see color and understand color is governed by the laws of physics, human physiology, and individual psychology. Our perception of color changes with age, stress, viewing environment, and even the amount of caffeine we have in our systems. In spite of these factors, we are able to use the tools Photoshop gives us, in concert with the use of a profiled monitor, to adjust the colors in our digital photographs to correct inaccurate color or enhance pleasing colors.

Tip *The Interaction of Color*, by Josef Albers, is an approachable and enlightening resource on color theory and color perception.

While adjusting color in Photoshop, you will rely on your visual sense of how the image "should look" supplemented with the RGB information from the Info palette. In order for your corrections to be reflected accurately in the finished print, there are a few important color management considerations we must address before proceeding.

1. For your visual corrections to be of any value to you, it is essential that your monitor have an accurate monitor profile. Without it, the preview you see on screen may not be accurate and you may find yourself correcting color-casts that really aren't there!

2. Every image needs to have an embedded ICC profile. For images lacking a color profile, Photoshop "guesses" at what the RGB values should look like, sometimes imparting a color-cast to the image.

3. Before you begin your color corrections, verify that the image has been converted to an *editing space*, like Adobe 1998, ProPhoto RGB, sRGB, or Color Match RGB. Editing spaces are always gray-balanced, meaning that equal values of red, green, and blue result in a neutral shade of gray. This is not necessarily the case with a scanner, monitor, or digital camera profile.

Color correction, perhaps more than any other aspect of the digital workflow, requires the judicious use of basic color management practices for best results.

Tools for Color Correction

Photoshop gives you three important tools for color correction; the Info palette and the Color Balance and Curves tools. We have already explored the Info palette and Curves tool in detail, so we will turn our attention to the Color Balance tool.

Color Correction Using Color Balance

The Color Balance tool is the more intuitive of the two color correction tools. Three sliders control the balance between cyan and red; magenta and green; yellow and blue. The three radio buttons at the bottom of the dialog box confine the corrections to the shadows, midtones, or highlights. The Preserve Luminosity checkbox ensures that your adjustment affects only the color information, leaving your previous tonal corrections unaffected.

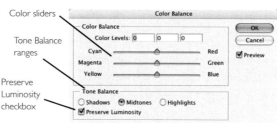

The Color Balance dialog box

In this image of a black-legged kittiwake and her chick, I set a sample point on the top of her head, which is both a highlight and an area of important detail. I set the second sample point in an area of rock I think should be pretty close to neutral. The third point I placed in an area of dark shadow behind

the nest. The last point I placed on the gray feathers on the mother's back.

The highlight point on the top of the head shows values close to neutral: 253,252,251. Points 2, 3, and 4 all show higher blue values than either red or green: 171,175,193; 11,14,18; and 143,149,182, respectively. This indicates a blue color-cast throughout the image. To remedy this, I create a new Color Balance layer and perform the following steps:

Step 1 Since the highlights appear to be neutral, I begin my corrections on the midtones, which is selected by default in the Color Balance dialog box. I move the Yellow-Blue slider toward yellow while watching the values for points 2 and 4 in

the Info palette. Point number 2 on the gray rocks is closer to neutral than point 4 so I focus my attention on creating equal RGB values for point 2 first. To achieve this, I have to reduce the blue value 45 points and add 8 points to the red. The resulting image is quite yellow, which leads me to believe that both the rock at point 2 and the feathers at point 4 are inherently blue, so I bring the yellow correction back to −30, which visually looks closer to the original scene.

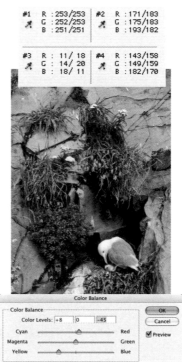

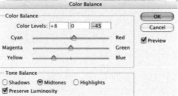

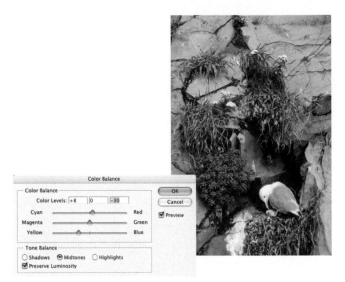

Color Correction Using Curves For comparison, I'll color correct the same image using the Curves tool. This time, instead of using the RGB composite channel I will adjust the individual color channels. I've kept the same sample points and will follow roughly the same methodology for color correcting this image. I always look to correct the highlights first because our eyes are most sensitive to color in bright areas.

Step 1 The highlights in the image are neutral, so I turn my attention to the midtones. Point 2 is closer to neutral, so I

Step 2 The shadow point now shows a slight green color-cast, so I click on the Shadows radio button and add 3 points of red and 6 points of blue to the shadows. This improves the greens of the grasses and the color of the shadows. Click OK and exit the dialog box.

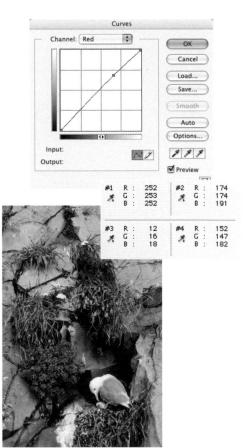

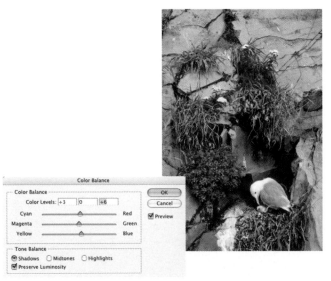

will work on evening out those RGB values first. First, I choose the red channel from the pull-down menu and CTRL-click or CMD-click on the image surrounding point 2 to add an anchor point to the curve. I increase the red value until it is roughly equal with the green value.

Step 2 Next, I switch to the blue channel, and CTRL-click or CMD-click on the image near point 2 to add an anchor point to the curve. I bend the curve downward to reduce the amount of blue in the image until I achieve equal RGB values for point 2. As

with the Color Balance layer, I find that this adjustment is too yellow, so I bring the curve back toward the center line and stop when the colors in the image look correct.

Step 3 The last step is to adjust the shadows. The Info palette shows values of 12,16,16 for point 3, indicating a slight cyan cast, which is easily mitigated by bringing the shadow point of the curve up 4 points. Click OK.

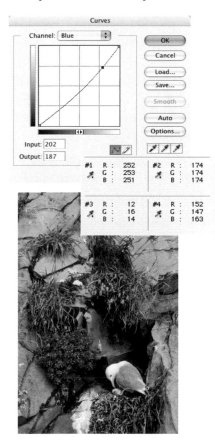

Step 4 The Curves tool doesn't have a Preserve Luminosity checkbox, so to achieve the same effect, we need to change the layer blending mode from Normal to Color. This isolates our changes to the color information and leaves our tonal values unaffected.

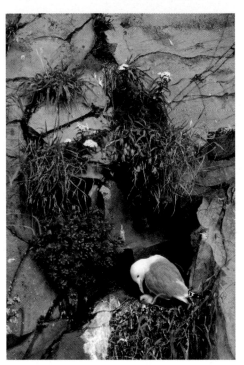

The finished image

While the Color Balance tool for color correction is very simple and intuitive, I find the Curves tool gives me greater precision and power. Work with the tool you feel is most comfortable. Initially, I found Color Balance to be the easier to understand, but as I've learned how to effectively use Curves, I've switched to using Curves almost exclusively for my color correction.

Color correction may seem difficult at first, but your ability to perceive slight changes in color will improve, making image correction much easier. Also remember that accurate color and correct color are not always synonymous. Rely upon your judgment as a visual artist to guide your adjustments.

Mastering the Shadow/Highlight Filter

Before the release of Photoshop CS, I had a great technique for bringing out hidden shadow detail that involved all sorts of complex chicanery—blending modes, copying channels, elaborate selections, and so forth. Since the introduction of the Shadow/Highlight filter I haven't used my old technique. Not only is Shadow/Highlight quicker and easier to use, it does a better job. In this section, I'll explain the features of the Shadow/Highlight filter and demonstrate how to recover deep shadow detail.

The Shadow/Highlight filter is accessed through the Image | Adjustments pull-down menu. You will notice other familiar tools in this menu, such as Levels, Curves, and Color Balance. We've avoided accessing these tools through this menu because the tools in the Adjustments menu make a permanent change to the file and lack the masking capability that we'll learn in the next chapter. For our adjustments, using adjustment layers makes the most sense. Unfortunately, there is no Shadow/Highlight adjustment layer, so we're forced to go through the Image | Adjustments menu and work on a duplicate layer to preserve the flexibility needed for a master file.

The Shadow/Highlight dialog box

The Show More Options checkbox allows access to the advanced features.

The Shadows and Highlights sections of the dialog box work identically on their respective portions of the tonal range. The Amount slider determines the intensity of the correction. A low Amount results in a slight adjustment, a high Amount results in a pronounced adjustment to the image. The Tonal Width slider determines how wide of a slice of the tonal range will be affected. Low amount values affect only the deep shadows or deep highlight. Moderate values for the Tonal Width begin to show a lightening of the midtones along with the shadows. The Radius slider sets the scale of the corrections on the image in pixels. The goal for setting the Radius correctly is to improve the relationship between subject and background and preserve the realistic shading of the subject. The effect of a Radius adjustment is shown next. The Amount and Tonal Width are constant at 66% and 29%, respectively.

The Adjustments section allows you to further refine the Shadow/Highlight adjustment. The Color Correction slider boosts the colors in the affected area by increasing saturation. A positive value increases saturation while a negative value reduces saturation. The Midtone Contrast slider helps compensate for the loss of contrast caused by boosting the shadows or reducing the highlights. Positive values add contrast, while negative values reduce contrast in the midtones. The Black and White clipping percentages specify the percentage of pixels forced to either pure white or pure black.

The Shadow/Highlight Filter in Action I'll demonstrate the use of the Shadow/Highlight filter on an image with extreme contrast and deep shadows to clarify the above concepts. Typically, I use the Shadow/Highlight filter before making any adjustments in Levels or Curves and I strongly recommend using Shadow/Highlight on 16-bit images whenever possible to keep the shadows from becoming mottled or posterized.

The shadows in the original image need a lot of help. The Info palette shows values of 10–15 for most of the shadows, which print as solid black on most printers. This image is in 16-bit mode.

Step 1 Since the Shadow/Highlight function isn't available as an adjustment layer, I duplicate the background layer by clicking on the fly-out menu at the top-right of the Layers palette and choose Duplicate Layer. This gives me a lot of the flexibility I would have from an adjustment layer.

Step 2 Looking at the image, I see that I want to adjust the deep shadows, and to a lesser extent the darker midtones. I want to set my Tonal Width first, so I set the Amount to 100% and the Tonal Width

to 0%. This allows me to incrementally increase the Tonal Width until it affects the desired shadows. Setting the Amount at 100% makes the adjustments to the Tonal Width more apparent. I set the Tonal Width at 20% as higher values made no adjustment to the shadows on the rocks but began to affect the shadow on the climber.

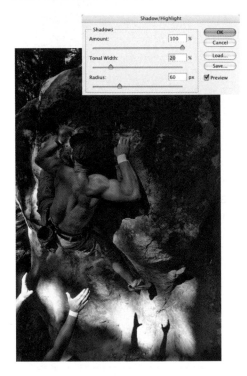

Step 3 Next, I reduce the Amount to achieve the desired effect. I find toggling the preview for a before-and-after comparison helps set the Amount correctly. This image shows an extreme adjustment and requires an amount of 82. Normally, small adjustments don't require more than 30–40% for the amount.

Step 4 Now I turn my attention to the Radius. Correctly setting the Radius is critical to keep the proper shading in the subject. As I increase the Radius, I pay close attention to the detail in the climber and the sunlit areas of the rock. Too low of a setting makes the climber's back look embossed. Too high of a setting obliterates the natural contrast that creates detail in an image. I set the Radius value at 128 and click OK. This brings out the shadow detail in the climber's left shoulder, but preserves detail in the sunlit right shoulder. Since the Shadow/Highlight filter is my first step before adjusting Levels or Curves, I leave the Color Correction, Midtone Contrast, and Clipping percentages at their default values. All of these aspects will be addressed during the course of successive corrections.

Step 5 Having the Shadow/Highlight adjustment on a separate layer gives me the flexibility to reduce the intensity of the adjustment by reducing the layer's opacity or to localize the correction through the use of a layer mask. At this time, I don't feel any further adjustments to the layer are necessary, so I leave the layer's opacity at 100%. I may change my mind after my Levels or Curves correction and having a separate layer affords me the flexibility to do so.

Radius 12: The radius is set too low resulting in adjustments in the shading on the muscles in his back and arm. This gives the image an embossed look and doesn't do a good job of separating the subject from the background.

Radius 88: A higher radius setting preserves the natural shading at the top of his shoulder while still doing a good job of brightening the background.

Radius 172: At 172 the radius setting is borderline too high as it is beginning to flatten out the natural contrast on the back of the shoulder. An ideal setting would be somewhere between 88 and 172.

Radius 494: This setting is much too high. It has flattened out the definition on the back of the shoulder and has begun to brighten the rock too much.

HOW TO: THE THREE-MINUTE CORRECTION

The three-minute correction combines the critical adjustments needed for every image into a series of steps that are quick, effective, and form the basis for the more refined, local adjustments to come. In this step, you will set the highlight and shadow points of the image, set contrast, and perform global color corrections. With practice, these steps should take you no longer than two or three minutes and will improve almost any image. Without further ado, let's jump right in!

Step 1

This scanned image of Middle Cathedral Rock in Yosemite, California, is a little flat, lacks definition, and has a color-cast that I can't quite assess visually. I begin by placing a sample point in the deep shadow area in the trees, a second point on the rock face, and a third sample point in an area of the clouds I would expect to be neutral. The Info palette tells me that the shadow point is a little bit green and the highlight is a little bit magenta. I am going to pay the most attention to these two points since I'm not exactly sure whether the rock under the second point should be neutral or not.

The original image

#1	R :	16	#2	R :	168
	G :	26		G :	158
	B :	21		B :	145

#3	R :	243
	G :	237
	B :	243

Step 2

I created a Levels Adjustment layer and used the clipping display in each of the color channels to achieve the levels adjustments shown below. For each channel, I brought the Shadow slider in until I began to clip detail in the deep shadows in the lower left portion of the image and brought the Highlight slider in until I began to see clipping on either the rock face or the bright clouds to the right of the buttress. The sample points indicate that I've neutralized the shadows nicely, but there is still a magenta color-cast in the clouds that I'll need to correct.

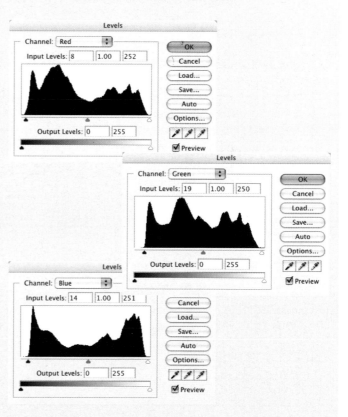

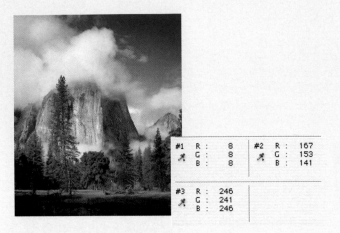

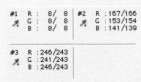

#1	R :	8	#2	R :	167
	G :	8		G :	153
	B :	8		B :	141

#3	R :	246
	G :	241
	B :	246

Step 3

To mitigate the magenta cast in the sky, I created a Curves Adjustment layer, went to the green channel, and added green until the Info palette gave me equal RGB values for sample point 3. Since I increased the value of one of the RGB primaries, I've added light to the image resulting in a slightly brighter image. This didn't fit with my vision of the image, so I changed the layer-blending mode from Normal to Color causing Photoshop to adjust only the color information and to leave the tonal values as they were. I also liked keeping some of the magenta as the rock face looked too green without it, so I reduced the opacity of the Curves layer to 64%.

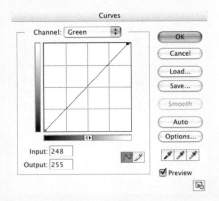

#1	R :	8/	8	#2	R :	167/166
	G :	8/	8		G :	153/154
	B :	8/	8		B :	141/139

#3	R :	246/243
	G :	241/243
	B :	246/243

Step 4

The final step was to give the image a little extra snap by adding contrast through the midtones. I created a Curves Adjustment layer and set one point in the Zone III shadow. For this image, this point will act as an anchor point that I won't adjust since I don't want to make the shadows any darker. Next, I set a point in the Zone VII highlights and raise the curve slightly. As the curve steepens through the midtones, it increases contrast. I am careful not to go too far, because the flattening of the curve in the highlight areas translates to a loss of subtle detail in the clouds. In this image, the clouds are an integral element, and I chose to pull back the opacity of the contrast curve to 54% until I felt that I had struck a nice balance between the contrast I wanted in the image and the preservation of detail in the clouds.

There you have it. In just a few quick steps I was able to mitigate a difficult color-cast, accurately set the highlight and shadow points, and add much needed contrast to the image. I use this three-minute correction for every image I bring into Photoshop. It finalizes the global changes I've made in the scanner software or Adobe Camera Raw and prepares the image for the precise localized corrections that follow in the next chapter. In case you're curious, the unadjusted image is at left, and the final, corrected image is on the right.

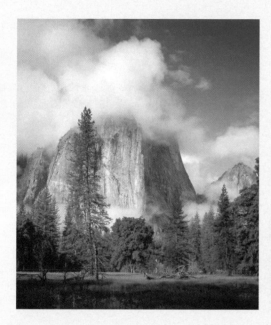 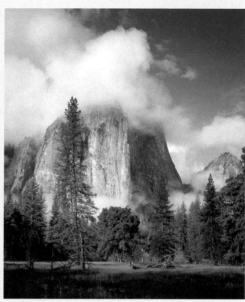

The original image is a little flat and has too much magenta in the clouds. The three-minute correction created richer shadows in the foreground, more snap through the midtones, and corrected the magenta cast in the clouds.

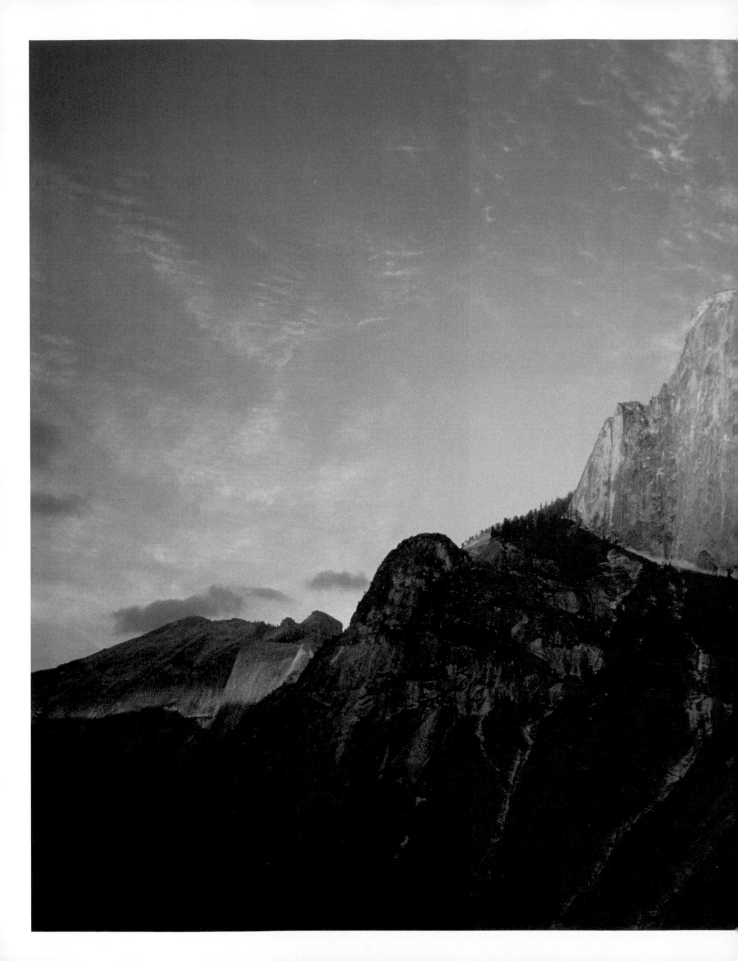

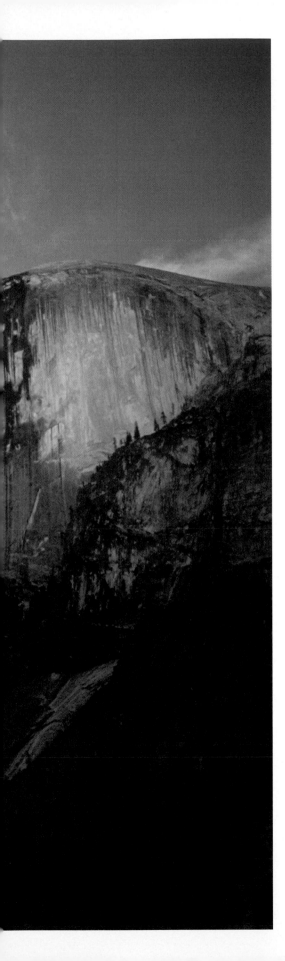

IMAGE REFINEMENTS

In the previous chapter, we explored Photoshop's ability to make global tone and color adjustments to images. This chapter takes the tools and techniques used for global correction, and applies them locally to adjust specific image areas. The ability to make subtle changes to specific portions of a digital photograph is one of the keys to harnessing the full potential of Photoshop. In this section, we'll begin with a thorough examination of Photoshop's tools for retouching, and then demystify the use of selections and layer masks.

Sunset on Half Dome. Yosemite National Park, California.

USING the BRUSH TOOLS

Integral to the techniques shown in this chapter is the brush tool. In Photoshop, brushes serve a similar purpose to their analog counterparts, but instead of spreading paint on a canvas, you're spreading pixels across an image. Digital artists and illustrators use the brush tool to create original artwork. Photographers use the brush tool and brushes in concert with the clone stamp and healing brush for retouching and for manipulating select areas of an image with a layer mask.

The brush-based tools are located in the center portion of the Toolbox. Adjusting the diameter of the brush, the hardness of the brush, and the opacity of the brush stroke control these tools. The brush diameter, measured in pixels, controls the size of the brush. The hardness of the brush determines whether the brush paints with a soft edge (low hardness) or hard edge (high hardness). The brush opacity determines how opaque each brush stroke is. We use varying brush opacities to disguise the edges of our adjustments when we

The brush tools
in the Toolbox

work with layer masks. The Brushes palette contains many options for customizing the behavior of brushes, though photographers do not commonly use these features.

The Brush Preset Picker with the location of the Brush Diameter slider and Brush Hardness slider shown

Brushes are used extensively for applying localized corrections to your images. Detailed examples of their use are incorporated into the "How To" section on retouching and layer masking.

Tools for Retouching

Often the first step after opening a scan or digital capture is to remove dust spots from the image and retouch blemishes on a portrait. There are four tools at your disposal for

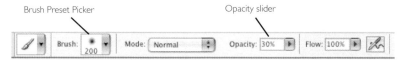

Brush tool Options bar with the location of the Opacity slider and the Brush Preset Picker

retouching digital images. The clone stamp, spot healing brush, healing brush, and patch tool each have their own unique strengths and weaknesses. I'll show you how each tool works, then demonstrate the most effective techniques for each.

Tip Brush Gotchas! When a brush tool is chosen, the cursor should reflect the current brush size. If the cursor appears as crosshairs, make sure CAPS LOCK is not active. If your cursor looks like the icon of the tool you've selected, access Photoshop's preferences (on Macintosh OSX, Photoshop | Preferences | Display and Cursors; on the Windows platform, Edit | Preferences | Display and Cursors). Choose Brush Size from the Painting Cursors pane and Precise from the Other Cursors pane. Click OK to update your changes.

Clone Stamp

The clone stamp, located in the Toolbox, is a simple but effective tool for retouching small areas in an image. It works by cloning pixels from one area of the image and placing the cloned pixels over the area to be retouched. The clone stamp is most commonly used to remove blemishes on a portrait or to remove dust and spots from a scan or digital camera file.

To use the clone stamp, choose it from the Toolbox, or use the keyboard shortcut "S". From the Options bar, click on the Brush Preset Picker and select a brush that is slightly larger than the area you wish to clone. Choose a hardness setting of 10–20% to clone pixels in an area of sky or retouch a blemish on a face. A low hardness setting helps the clone pixels blend with the surrounding area without leaving a distinct edge. Make sure the blending mode is set to Normal and the opacity to 100%. Zoom into 100% by pressing CTRL-ALT-0 (zero) on the PC or CTRL-OPTION-0 (zero) on the Macintosh. At 100% every pixel in the file is shown on the screen. This gives us the most accurate screen view for retouching. To move through the image, hold down the SPACEBAR. The cursor temporarily turns into a grabber hand allowing you to push and pull your way through the image. At first, this may seem less intuitive than using the image's scroll bars, but once you become familiar with this technique you will find it to be much faster.

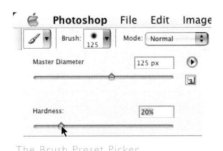

The Brush Preset Picker

Tip To zoom in and out of the image quickly, use the keyboard shortcuts: CMD/CTRL + "+" to zoom in CMD/CTRL + "-" to zoom out

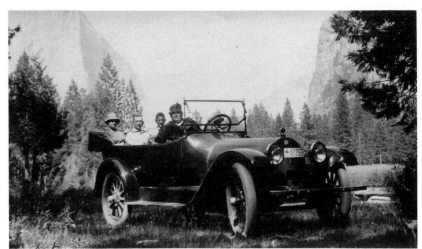

The affected image

This antique photo of Yosemite National Park (above) has a number of small pits and indentations on the surface of the print that appear as dark spots in the scan. I'll remove them with the clone stamp tool by ALT-clicking or OPTION-clicking on an adjacent area to set my source point, then clicking on the damaged areas needing repair. Photoshop takes the pixels from the source points and clones them onto the damaged areas. The key is to visually match the color and shading of the source point with the area surrounding the damaged portion of the image.

Using the Clone Stamp To use the clone stamp effectively, first zoom in to 100% view so that you are viewing every pixel in the image. Choose a brush that is slightly larger than the area to be retouched, set the hardness at 10–20% and the opacity at 100%. ALT-click or OPTION-click on an undamaged area of the image to set your source point, then click on the area to be retouched. The pixels from the source point will replace the pixels from the retouched area, smoothing blemishes or removing dust spots. Here you can see the corrected image (facing page, top) along with the source and clone points used for retouching.

Tip The most important keyboard shortcut for any photographer to know is CTRL-Z or CMD-Z. This undoes the last action done to the image. To go back more than one step, press CTRL-ALT-Z on a PC, or CMD-ALT-Z on a Macintosh.

Every morning just after dawn, the monks of Luang Prabang, Laos, make their daily alms procession through town. It is traditional for Buddhist monks to "beg" for their food in the ritual alms processional. The monks carry their begging bowl with a saffron strap slung over their shoulder. I used grainy black and white film to hint at the history and the timelessness of this ritual. I feel that the telephone wire

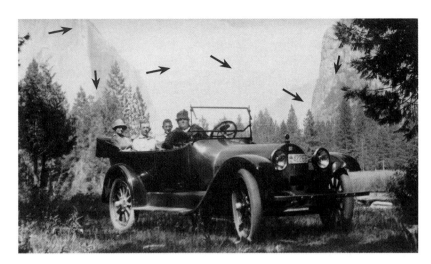

The corrected image

arcing across the top left of the image takes away from the feel of the image and doesn't match the memories I have of the soft light filtering through the trees.

To remove an object larger than a dust spot, like a scratch or a telephone wire, you will need to "paint" with the cursor as you would with a paintbrush, using short, direct

strokes. Setting the source point correctly is critical because the source point will parallel your cursor along your stroke lines. Let me show you how.

Step 1 Set the source point near the edge of the object you wish to remove. In this example, I set my source point at the start of the telephone wire, then I click and hold the mouse while dragging my cursor along the line. The source point follows the cursor, continually cloning and placing pixels until I release the mouse.

Remove objects from an image using short brush strokes with the clone stamp

Step 2 I don't try and remove the entire line in one stroke. Instead, I stop partway across the wire, reset my source point, and continue. Using several sample points helps blend your cloned area with the surrounding pixels and helps break up any patterning caused by cloning.

The finished image with the telephone wire removed

The retouched image is ready for additional burning and dodging. I don't feel I need to remove the remaining telephone lines because they are mostly obscured by the trees and aren't as prominent.

While learning how to use the clone stamp tool, I suggest working on a duplicate layer. This gives you an escape route if you find that your retouching doesn't blend as naturally

as you had hoped. To create a duplicate layer, drag the Background Layer tile onto the Create New Layer icon. The new layer will appear as Background Copy.

It will take some practice to become fluent in the use of the clone stamp. While you are learning, remember a few important points:

- Honor tone and color, light and shadow.
- Adjust your source point frequently to prevent patterning.
- Work on a duplicate layer to give yourself an escape route.

The ultimate goal of the retoucher is to be invisible. Work patiently, methodically, and change your source point often.

The Healing Brushes

As an electrically charged device, the CCD sensor on your digital camera is a magnet for dust. These spots are maddening because they appear in the same location on every frame taken with your camera. Fortunately for you and me, we can use the healing brush tools to

quickly remove these spots from our digital negatives. The healing brushes work in a similar fashion to the clone stamp, but instead of cloning actual pixels, they intelligently clone texture from one area to another. When the mouse is released, the healing brush blends the sampled texture with the original tone and color information. The spot healing brush bypasses the need for setting a source point by automatically blending the new pixels with the tone and texture of the surrounding area. This eliminates much of the visual tone and color matching required by the clone stamp tool. The healing brushes really shine in areas of broad tone and color, like skies, solid colors, or the side of a face. Unfortunately, the healing brushes do not work well near high-contrast areas like eyes or lips. However, when used in tandem, the clone stamp and healing brushes can address 95 percent of your retouching needs.

Spot Healing Brush

The spot healing brush made its debut in Photoshop Elements and is now incorporated in Photoshop CS2. It has quickly become the tool of choice of professional retouchers due to its clever ability to banish blemishes at the click of a mouse. It does this by intelligently sampling tone, color, and texture adjacent to

the blemish and replacing it with perfectly smooth, flawless pixels. I think the spot healing brush tool will rapidly become an integral part of your retouching routine.

The spot healing brush excels in removing acne or other blemishes from portraits in the smooth areas of the face. Like its close relative the healing brush, the spot healing brush is tripped up by high-contrast edges, requiring photographers to use the clone stamp tool in highly textured areas or along high-contrast edges.

To use the spot healing brush, open an image needing dust or blemish removal. Set your brush size slightly larger than the spots you will be removing and leave your opacity and hardness at 100%. Leave the Type at Proximity Match and begin clicking on the spots you need to remove—the spot healing brush doesn't even require that you set a source point. It does all the work for you!

Healing Brush

With the introduction of the spot healing brush, the original healing brush has been relegated to second-class status. The spot healing brush is faster to use and for the most part just as effective as the healing brush. There are, however, a few occasions when the healing brush is a better source for retouching:

- You need to replace something larger than a single spot or blemish. Flyaway hair, a telephone wire, or a distant telephone

pole tends to fail with the spot healing brush tool. The ability to manually set the source point gives the healing brush a distinct advantage for this type of retouching.

■ The retouching is done in close proximity to areas with lots of detail or near high-contrast edges. As mentioned earlier, both healing brushes have a tendency to smudge distinct areas, but sometimes the spot healing brush fails simply because it doesn't know what to sample from. Using the healing brush allows you to specify what texture should be sampled and from where.

The healing brush tools are located directly above the clone stamp tool in the Toolbox. Select your tool, choose your brush diameter through the Brush Picker, and check to see that the blending mode is set to Normal. For the healing brush, you need to set a source point as you did with the clone stamp. For the spot healing brush, you don't need a source point, just click on what you want to change. For both tools, Photoshop blends the texture from the surrounding areas onto the retouched area. This removes the dust spot or blemish while preserving the natural shading of the image.

Dust on my camera's CCD is apparent in the processed image when viewed at 100 percent. To remove it, I use a combination of the healing brush tools to "dustbust" the image. I set a new source point for each dust spot I remove. I need to be careful near the

high-contrast edges. The healing brush has a tendency to bleed across edges, making the edge look as though it had been smeared. The corrected image shows the retouching done to the image along with the tool used for each area.

The original image with dust from the camera's CCD visible in the processed file.

The corrected image. The icons indicate which healing brush was used for dust removal. The red circle indicates the spot healing brush. The cyan square represents the healing brush.

I use the healing brushes for all of my retouching in areas of a similar tone or color. This could be a blue sky, the side of a face, or an expanse of calm water. I use the clone stamp tool when I have to work near an important edge or maintain a consistent pattern. This could be an area near the eyes or mouth in a portrait, wood grain, or grass in a landscape.

Patch Tool

The patch tool is essentially the healing brush applied to a large area. It automatically blends the sampled texture with the existing tone and color. I use it to quickly retouch heavily spotted areas of sky, or larger blemishes on a portrait. The patch tool is located behind the spot healing brush tool in the Toolbox. To access it, click and hold on the small black triangle at the lower right of the healing brush icon in the toolbox.

Working with the patch tool is slightly different than the clone stamp or healing brush tools. Instead of ALT-clicking or OPTION-clicking to define the source for the clone, you use the cursor to draw a selection. If Source is chosen, draw your selection around the area you want to correct, then drag the selection to the portion of the image you want cloned onto your original selection. If Destination is chosen, the opposite occurs. Draw your

selection around the portion of the image you want to act as your cloning pixels, then drag the selection over the area that needs retouching. When you release the cursor, the pixels are blended with the new location. I've always found Source to be the easiest mode to use with the patch tool. It is more intuitive and offers a better preview of the finished correction.

Original Image

Step 1 With the tool set to Source, draw a rough area around a patch of sky containing several dust spots to create a selection.

Step 2 Next, click inside the selection boundary and drag the selection onto a section of sky that doesn't contain any dust. For a portrait, I would choose a section of skin on a similar part of the body so that the skin's natural texture is preserved. As you move the location of your selection, the original area will show a preview of the finished result. Use this preview to help match texture between the source and the destination. When you've found an appropriate match, release the mouse.

Step 3 It may take Photoshop a moment to blend the tone and color of the new pixels with the surrounding area. When it is finished calculating, choose Deselect from the Select menu (Select | Deselect) or simply press CTRL-D or CMD-D. Be sure to check the sides of the new patch to verify that they have blended smoothly with the surrounding area. If a visible line exists, use the healing brush or clone stamp to reduce the

appearance of the line. If the patch is a total failure, go back in time using the History palette (demonstrated in the next section) to return to the image's original state.

The History Palette

Late-night sports shows love to show clips of bungled plays, dropped passes, and gauche missteps, proving that even top professionals sometimes make mistakes. To prevent you the inconvenience of ruining your hard work on a photograph with a silly blunder, the engineers at Photoshop created the History palette to give you the ability to go back in time to the state of your image *before* the mistake was made.

What Retouching Tool to Use?

You need to replace:	You need to use:
Acne or blemishes	Spot healing brush
Flyaway hair	Healing brush
Dust spots on CCD	Healing brush
A telephone wire	Healing brush or clone stamp
A telephone pole	Clone stamp
A UFO in a blue sky	Patch tool
Your uncle Earl	Clone stamp with a lot of patience

The History palette shown here shows the corrections I've made to an image. The oldest corrections are listed at the top of the palette beginning with Open. The newest corrections, Curves 2 Layer and Curves 3 Layer, are listed at the bottom of the palette. Every adjustment, clone stamp, or brush stroke I make in Photoshop is listed as a history state in the History palette. When the number of history states exceeds the number specified in the Preferences, the older history states are deleted from memory. Photoshop allows you to save as many as 1,000 history states, but I strongly recommend that you leave the History States setting at the default value of 20 for three reasons. First, Photoshop needs a huge amount of memory to store all those history states. Increasing the number of history states virtually assures that everything Photoshop does to an image will take longer. Second, almost all of the corrections you do are on separate image layers or adjustment layers, which makes the need to go *way* back in the History palette irrelevant. Third, history states are not saved with the document. If you are embarking on a difficult retouching project and are concerned about finding yourself committed to corrections you might later regret, I suggest working on a duplicate layer.

The History palette

Using the History palette is easy. To step back in time simply click on the history state before the step you want eliminated. In the example shown here, I've gone back to the state prior to my creation of the Curves 2 and Curves 3 Layers. There's no need to delete these history states, as they will be dropped from Photoshop's memory as soon as I make any adjustments to my image.

Step backwards in the History palette to undo mistakes in your work.

I find that I use the History palette sparingly in my work. It does come in handy when I am retouching and am less vigilant in my corrections than I should be. Every once in a while, I find that a correction I've made has a hard edge or doesn't match the surrounding areas. For those occasions, I like having the ability to go back through the History palette to start my corrections over. When I am working on a complex retouching job, I prefer to work on a separate layer instead of relying upon the History palette. This allows me to access the original image, even if I have saved and closed the document.

Strategy for Retouching The most com-plex retouching job I've ever had to do involved "finishing" a building still under construction. I had to remove all signs of construction including a cyclone fence and construction banners. Then I had to complete the unfinished wall and sidewalk, and as a finishing touch, I needed to landscape the building by adding grass to the foreground. To complete this difficult assignment, I created a systematic strategy for retouching that I still use today.

■ **Always have an escape route.** A skydiver would never leap without a reserve parachute and no photographer should ever embark on a retouching assignment without an escape route. For simple jobs, like removing blemishes or spotting a digital capture, the History palette usually suffices. For complex retouching I recommend working on a duplicate layer.

■ **Build yourself a "safe area."** Really difficult jobs involve the creation or reconstruction of detail that may be fully or partially obscured. For this type of retouching, I will often begin working on a small portion of the image that I can clone repeatedly. This acts as a safe area and keeps me from painting myself into a corner.

■ **Honor lines, color, patterns, and shading.** Our eyes are attracted to high-contrast lines or hard edges. If the lines in your image are disrupted, disjointed, or blurred by the retouching process, it will spoil the illusion of the image. Be sensitive to the natural patterns in your images, the direction of light, and the smooth transitions between light and dark. Also, be very careful not to introduce unnatural patterns to your image. This is often the result of using a single source point too many times.

In the image of Half Dome at sunset, I want to remove the contrails from the upper-left portion of the sky. Since this is a fine art photograph, I don't feel that I would be misleading the viewer by eliminating the jet trail. The addition or removal of elements from a digital photograph is a topic of heated debate. We recommend not adding or removing any element in the image that would change a viewer's interpretation of a journalistic or newsworthy image.

To begin my retouching, I use the rectangular marquee tool to create a selection around a large area of sky. Then I copy this

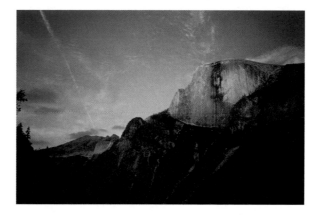

I want to remove the contrail from the sky in the left side of this image. To do this, I'll use a combination of retouching tools.

selection to a new layer using Layer | New | Layer via Copy. I will isolate all of my retouching on this new layer. This way, if I make a mistake, I can delete the retouching layer and start again. This provides me with an escape route in case my retouching goes awry.

I begin retouching at the horizon, working at 100% zoom percentage. I use the clone stamp tool with a hardness setting of 13% to

clone the thin, wispy clouds over the contrail. I choose a new source point for each section and paint in the new detail with short brush strokes. I'm careful to preserve the form and color of the existing clouds. In some areas, I don't need to remove the contrail entirely, just break up the visible edges of the contrail by blending them with the surrounding clouds.

As I move closer to the top of the image, the color of the sky begins a delicate transition from cyan to deep blue. Preserving areas of subtle tone and color transition requires careful attention. I find by placing my source point parallel to the area I am cloning, I am better able to maintain the integrity of the natural transitions in the image.

When I reach a broad area of deep blue sky, I switch to the patch tool and select an area of sky near the top of the frame, then drag the selection to the right, over a patch of clear, blue sky, and release the mouse. In this case, the patch tool does a very good job of matching the color in the sky, saving me many mouse clicks with the healing brush tool.

Lastly, I zoom out to check my work. Toggling the retouching layer on and off, I see a few areas I want to address. I zoom back in to 100% and use the clone stamp tool to touch up a few rough sections of clouds. The before and after images show that I was able to remove the contrail while preserving the natural texture of the clouds and the subtle color gradients in the sky.

The Ethics of Retouching

This example shows how effective Photo- shop's retouching tools can be at removing elements from a scene. Critics of digital photography feel that this lessens the craft of photography by diminishing the impor- tance of capturing the decisive moment entirely in the camera. Others feel that the ability to edit the content of the image brings photography as an art form closer to painting in the ability to interpret and adjust the scene to match the artist's vision.

We feel it is important when debating the issue of retouching to make a distinc- tion between photojournalistic and fine art photography. We feel strongly that

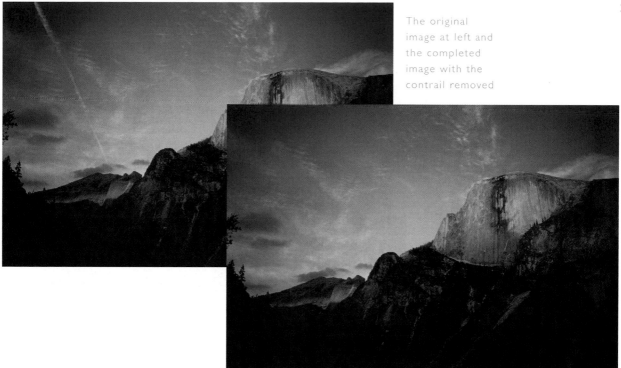

The original image at left and the completed image with the contrail removed

photojournalistic photographs used in the context of presenting factual or newsworthy material should never be adjusted in such a manner that would mislead the viewer or present an event that never happened. In the 2004 presidential campaign, photographs surfaced showing John Kerry seated next to Jane Fonda at a Vietnam War protest rally. The photographers who documented the rally were able to prove that the images given to the press in 2004 were composites of two separate images from the rally. When these images were composited together, they presented a misleading message to the public.

This type of manipulation has been widely and rightly condemned by the news media and the photographic community. In the past few years several news photographers have been fired for altering the content of their images. It is unfortunate that there will always be individuals who attempt to mislead or misinform others. This phenomenon is not unique to digital photography; however, digital images are looked at with greater suspicion than their analog counterparts. As photographers, we strongly encourage you to pursue your artistic vision, but use common sense and your own moral compass to determine what corrections are acceptable.

Creating Selections and Masks

In the last chapter we proposed a digital image processing workflow. Phase one begins with global tone and color corrections, then sets the overall contrast of the image. Phase two of this workflow focuses on making localized image adjustments. The key to isolating individual elements of your image is the effective use of selections and layer masks. This allows you to use Levels, Curves, and Hue/Saturation layers very precisely to adjust the color of a flower, brighten a smile, or soften harsh shadows.

The key to making these precise adjustments is the ability to select a portion of the image and be able to isolate your changes in the actively selected area. There are several methods of achieving this. The coarsest of these methods is the use of Photoshop's selection tools. They consist of the marquee tools, the magic wand, and the lasso tools. Selections with these tools often become the basis for more layer masks, discussed shortly.

The rectangular and elliptical marquee tools allow you to create simple geometric selections. Choose either tool from the toolbox, then click and drag to create a selection. Holding the SHIFT key constrains the selection to a 1:1 height to width radio. This is helpful for creating circular or square selections. The selected portion of the image lies inside the selection boundary affectionately called the marching ants.

Selections from the rectangle (top) and elliptical marquee (bottom) tools

The lasso tools allow you to draw freeform selections. This gives you a greater degree of flexibility than the marquee tools—although if you've had your morning cup of coffee, the result of drawing with the lasso tool may leave something to be desired. I use the lasso tool to create quick, rough selections of an object, then refine the selections in the quick mask mode.

The magic wand tool is the most sophisticated of the selection tools. When you click on a pixel in an image, the magic wand selects all the contiguous pixels of a similar tone and color value. The Tolerance field allows you to specify how much of the tone

A selection with the lasso tool

and color range is selected with each click. A low tolerance value selects a very narrow range of the tonal scale. A high tolerance value selects a broader swath of the tonal range.

A magic wand selection with the Tolerance set to 10

A magic wand selection with the Tolerance set to 50

Most often the selection tools are combined to create a complex selection. For example, to separate the subject of a portrait from the background, the elliptical marquee is used to select the subject's face, then the lasso tool is used to select the subject's shoulders. Finally, the magic wand tool is used to select the subject's hair. The selection is inverted so the selection is applied to the background and the Gaussian Blur filter is used to blur a distracting background. To add to a selection, hold the SHIFT key while using a selection tool. To subtract from a selection, use the ALT or OPTION key when using a selection tool.

The selections created with the selection tools leave a hard edge between the areas that are selected and areas that are not. *Feathering* the edges of the selection produces a more natural transition by slightly blurring the edges of the selection. To add a feather to your selections, choose Select | Feather from the Select pull-down menu. In the resulting dialog box, choose the width of the feather in pixels. If you add a feather value of 4, Photoshop will feather your selection 2 pixels on either side of the selection. The effect of the feathering is dependent upon the size of the document. A 2-pixel selection on a 2000 × 3000 pixel document is scarcely noticeable, while a 2-pixel feather on a 200 × 300 pixel document is

significant. Below are examples of the effect of feathering on a 600 × 900 pixel document.

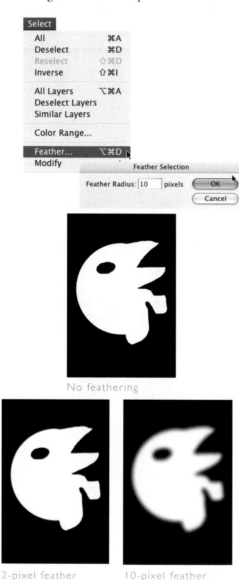

No feathering

2-pixel feather 10-pixel feather

From Selections to Alpha Channels

Many users of Photoshop never progress beyond the use of simple selections for localized adjustments. This is unfortunate, because layer masks and alpha channels are the key to unlocking the full potential that Photoshop offers digital photographers. I encourage you not to be intimidated by the technical terms alpha channels and layer masks. Their use is quite simple, as is their relationship to selections. Just as water has three forms—solid, liquid, and gas—a selection can be either a selection, a quick mask, or an alpha channel. Water can easily change from steam to water to ice, then back to water; selections can transform from a selection to a quick mask, back to a selection, then be saved as an alpha channel.

The three "forms" of a selection are used for different purposes. Here's a rundown:

- **Selection** Temporary and ephemeral like steam, selections are the active state of an alpha channel or layer mask.

- **Quick mask** Quick masks are more permanent than selections, but less so than alpha channels. Quick masks allow the use of the brush tool to create refined selections; however, quick masks are not saved with the document.

- **Alpha channel/layer mask** For the purposes of this book we will use the term layer mask instead of alpha channel even though there are subtle differences between the two terms. Layer masks are saved selections. Easily manipulated and adjusted, layer masks can be easily transformed into a selection when needed, and are saved with the document. We will use layer masks extensively in concert

with Adjustment layers to focus our adjustments onto very precise portions of an image. When working with layer masks it is important to remember that black always hides (either adjustments or pixels) and white always reveals.

Quick Mask

Quick mask acts as a bridge between selections and layer masks to make very precise selections. Most quick masks begin with a selection from the magic wand, lasso, or marquee tools. In this image of a climber on the 2,000-foot east face of Long's Peak, I wanted to blur the background to enhance the separation between the climber and the ground below to focus the viewer's attention on the climber.

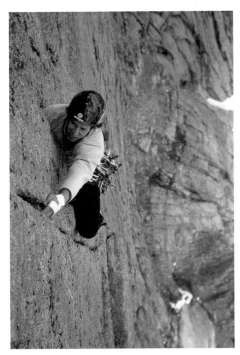

I begin by making a rough selection with the lasso tool around the background. I find it easiest to hold down the SHIFT key while using the lasso and creating my selection in small sections as opposed to trying to create my selection in one pass.

If I were to use the Gaussian Blur filter on this selection, the result would be an unnatural-looking transition between the cliff and the background. I also want to clean up the edge of the mask so that the blur follows the base of the cliff. I'll do this in quick mask mode. I enter quick mask mode, then click on the quick mask icon below the Foreground and Background color

swatches in the Toolbox. The red indicates a masked area that will not be affected by any subsequent adjustments, and the transparent area shows the currently selected area.

the mask, disguising my correction. With two passes of the brush at 60% and a third pass at 30%, I created a transition zone between the masked area that will remain in focus and the area to be blurred.

Next, I choose the brush tool from the Toolbox and press D to restore white and black as default colors in the foreground and background color swatches. By using the brush tool to paint with black, I can add to the masked areas. By painting in white, I am able to reveal more of the image to be selected. The double-headed arrow to the right of the foreground and background color swatches allows you to switch the two colors. The brush tool always paints with the foreground color, which is the topmost of the two swatches. A soft-edged brush combined with a reduced brush opacity allows me to feather the edge of

Exiting quick mask returns the mask to a selection. The marching ants show areas that are more than 50 percent selected. My transition area doesn't appear to be within the selection boundary, but that is only because it is less than 50 percent selected.

The final step is to apply the Gaussian Blur (Filter | Blur | Gaussian Blur). The preview window shows the effect of the filter at 100%, allowing you to preview the filter's effect on both a pixel level and image-wide. I enter a value of 4.0 and click OK. The finished image is shown at right.

Quick mask is simple to use and very quick. The downside is the fact that you are now stuck with the change. If you want to go back to refine the edge of the blur or decrease the amount of blur, you're out of luck. For this reason, I work almost exclusively with layer masks. They give me all of the functionality of selections and quick mask and are infinitely editable.

Using Layer Masks

You may have noticed that every Curves, Levels, or Hue/Saturation adjustment layer is accompanied by a white rectangle in the Layers palette. This rectangle is a layer mask for the adjustment layer. Since the layer mask is filled with white by default, any changes you make to the adjustment layer are applied to the entire image. Using the brush tools on a layer mask you can isolate your changes to a specific region of the image without affecting the rest of the image. Furthermore, you can

adjust, scale, blur, and sharpen the layer mask to achieve very exacting results. Layer masks give you a flexibility that cannot be matched with traditional darkroom techniques.

The simplest way to begin using layer masks is to create a new adjustment layer—like Levels or Curves—then begin painting in black over the areas you wish to mask. In this example, we'll revisit the image of the koi we used in the last chapter. Let's say I want to call attention to the main koi with its mouth open. To do this, I can reduce the saturation of the entire image, then mask out the adjustment on the yellow koi restoring its color to its original state. I begin by creating a Hue/Saturation adjustment layer and reduce the Saturation slider to –25. This gives the image a muted color palette. I then choose OK to close the dialog box.

Since I want to hide the saturation change in the area of the yellow koi, I want to switch

the foreground and background colors to make black my new foreground color. I do this by clicking on the double-headed arrows above and to the right of the foreground color. This makes black the foreground color (the one on top) and sets it as the color used by the brush tool when painting.

I begin painting with black over the portion of the yellow koi that is above the water. This restores the fish's original color. The first round of painting is shown at left and the corresponding layer mask is shown at right.

Since colors below the water are more muted than those above the surface, I reduce the brush opacity in the options bar from 100% to 60%. I use this to paint the fin and the upper dorsal area of the koi.

The last step is to carefully blend the remainder of the mask with the surrounding area. I do this by adjusting the layer opacity between 20% and 40% to feather the edges of the mask with the surrounding area. If I make a mistake, I can simply switch my foreground and background colors by pressing x, and correct my mistake by painting with white.

This simple masking technique is extraordinarily powerful. To give you a better understanding of the use of layer masks, I'll demonstrate the use of selections and layer masks for burning and dodging.

Burning and Dodging One of the most common techniques adapted from the wet darkroom, burning and dodging are easily accomplished using a Curves adjustment layer and its corresponding layer mask. Burning and dodging are used to make selected areas darker and lighter respectively in the finished print.

The east face of Long's Peak in Rocky Mountain National Park rises precipitously for 2,000 feet above Chasm Lake. It is one of the most breathtaking places on the planet when the sun rises and bathes the cirque in brilliant alpenglow. I've already made my global tone and color corrections to the image. At this point, my goal is to bring out some of the deep shadow detail in the foreground.

To do this, I create a new Curves adjustment layer. I know that I want to affect the deep shadows, so I raise the shadow point of the curve along the left margin of the Curves window. This brightens all of the tonal values darker than 50% gray, making the image appear slightly washed out. I want to restrict my changes to the deep shadows, leaving the rest of the tonal range unaffected. For this to occur, I need to mask off the majority of the image and allow this Curves change to be revealed in the shadowed foreground.

After clicking OK, I fill the layer mask with black (Edit | Fill), which hides the Curves adjustment from the entire image. Not only does the image window revert back to the original image, but the layer mask thumbnail in the Layer palette updates as well. I've named the active Curves layer "Shadows" for clarity.

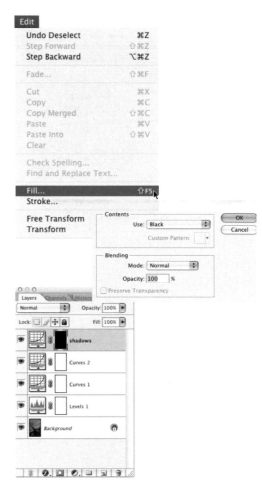

Next, I choose the brush tool, open the Brush Preset Picker, and choose a medium-sized brush with a hardness of 20%. I set my

foreground color to white by pressing D. I want to paint with white because the previous step "hid" the Curves adjustment. Now, I want to selectively reveal the change in the shadow areas. Painting at 100% I concentrate my brush strokes in the deep shadows in the lower-right corner of the image. After a few passes, I reduce my brush opacity to 60% and focus on painting along the edges where the shadows meet the sunlit areas of rocks. I want my adjustments to look natural so I take care to blend the edges of my mask with the sur-rounding area. I want someone viewing the prints to see the image, not the work I've done to it.

I always like to view the layer mask, since it can be difficult to determine how well you've painted over an area like the shadows. I do this by holding the ALT or OPTION key and clicking on the layer mask. This activates the layer mask in the image window. I see that there are a few areas of the mask I need to touch up, particularly an area in the lower-right section I've missed altogether. I can touch those up while I am viewing the layer mask. I've also taken the time to smooth out some of the noticeable transitions using a smaller brush set to 30% opacity. Remember, if I make a mistake, I can easily correct it by painting on the mask in black. Layer masks are forever editable. When I am finished, I return to normal view, by ALT-clicking or OPTION-clicking on the layer mask again.

The original image is shown on the next page at top; the completed image at bottom. The difference between the image is subtle, but significantly improves the finished print.

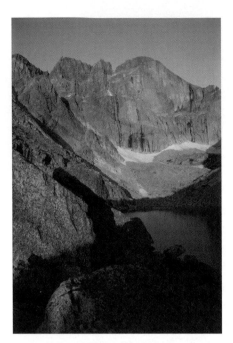

The original image

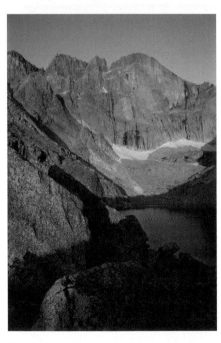

The image with the shadows corrected

The final example of the power and flexibility of layer masks is to revisit the image of the climber on Long's Peak that we blurred using a quick mask. My goal of blurring the background remains the same, only this time, I'll show you how the use of a layer mask adds a tremendous degree of flexibility.

First, I duplicate my background layer by dragging the layer tile onto the Create New Layer icon and blur the new layer using the same Gaussian Blur setting of 4.0. At this point, the blur is applied to the entire image.

To add a layer mask to the Background Copy layer, I click on the Add Layer Mask icon at the bottom of the Layers palette. This creates a layer mask using the selection I created in the previous step. A thumbnail of the layer mask is shown next to the layer thumbnail in the Layers palette. The pixels in the masked areas are hidden, allowing the unblurred pixels below the Background layer to show through.

Next, I draw a rough selection using the lasso tool.

I refine the edge of the selection in exactly the same manner as I did with the quick mask—painting in white to reveal more of the blurred image, or painting with black to hide the blurred pixels. I like being able to set my edge without a distracting red overlay and being able to see the changes with the blur already applied to the image. A few quick strokes at 60% and again at 30% opacity soften the transition between the sharp and blurred pixels.

commonly seen in less expensive point-and-shoot cameras, or on exposures taken at higher ISO sensitivity ratings, digital noise is often more objectionable and distracting than traditional film grain. In this section, we'll examine the causes of digital noise and look at ways to mitigate the appearance of digital noise in your finished images.

A noisy image caused by underexposure and heat buildup in the camera. The detail image (inset) shows the chroma (color) noise and luminance noise in the hull of the ferry.

Now, about that flexibility I mentioned earlier.... The layer mask is saved with the image as long as I save the file in a format that supports image layers and alpha channels (PSD and TIFF). This allows me to go back to the file next week, next month, or next year and either adjust the transition between the sharp and blurred image areas, or reduce the amount of blur applied to the image by reducing the layer's opacity. This allows more of the underlying layer to show through, decreasing the visual effect of the blur. If I decide I want to add more blur to the image, I simply run the Gaussian Blur filter a second time. The additional blur is isolated solely in the unmasked area of the Background copy layer.

Noise Reduction

Digital camera noise is often perceived to be the digital equivalent of film grain. Most

What Causes Digital Noise?

"The appearance of digital noise is easy to diagnose, although the source of the noise is more difficult to assess," says Jim Christian of PictureCode, the creator of Noise Ninja. "Digital noise comes from a number of different sources, including heat buildup

in the chip, the ISO setting on the camera, and the size of the image sensor." Heat is generated when electrical current passes through the sensor. This occurs when you are actively using the camera to take pictures or when the camera is turned on, but left idle. This becomes particularly problematic with longer exposures taken at night or in low-light situations. Ambient temperature also factors into the buildup of heat on the camera's sensor. Cameras will exhibit more noise on a hot summer day than they will on a crisp winter morning.

A second source of noise comes from the current itself traveling through the sensor. For most exposures, this sensor noise is very weak compared to the light striking the sensor, and thus the signal to noise ratio is very favorable. In low-light situations the difference between the light reaching the sensor and the inherent sensor noise can be very slight and is visible in the processed image. Increasing the ISO of the camera exacerbates this situation. By increasing the ISO sensitivity, you amplify the current traveling through the sensor. This is similar to turning up the volume on the stereo without any music playing. The signal noise on the stereo, which had been imperceptible at low volume, is now quite noticeable.

The third source of noise stems from the size of the photoreceptors on the camera's sensor. The difference between an 8-megapixel point-and-shoot and an 8-megapixel digital SLR is in the size of the sensor. Both have 8 million photoreceptor sites, but the SLR model has larger photoreceptors distributed over a greater area than the point-and-shoot.

"The result of this," Jim explains, "is that the larger photoreceptors on the DSLR sensor capture are able to count more photons per exposure than the point-and-shoot." This translates to a more accurate signal from each photoreceptor to the processing software and a significant reduction in "counting" errors that can result in a noisy image.

Noise Reduction Begins in the Camera The best method of reducing the appearance of digital noise in your images is to expose the image properly and use the lowest ISO setting possible. The way that raw image captures (even JPEGs) are processed in the camera devotes more bits to the highlights than the shadows. Accurate exposure and even a slight overexposure results in not only a stronger signal (more light reaching the sensor), but also more bits devoted to storing the information.

Noise Reduction Software

Noise reduction software aims to remove the undesirable digital noise from the image while preserving image detail. This is no easy feat. As Jim Christian explains, "Digital camera noise is random and contains both high frequency and low frequency noise. Additionally, some cameras have particularly noisy colors while others may remain unaffected. All of this contributes to a camera's noise signature." While the problem may be complex, there is no shortage of software programs that promise to remove the digital noise from your images. A few of the most popular are reviewed below. Common sense encourages you to demo several different programs to see which one does the best for your camera and fits in your workflow.

One note: The programs listed are all available for both Macintosh and PC platforms, and all work with 8-bit and 16-bit images. All but Adobe Camera Raw allow you to isolate your noise reduction on a duplicate layer.

Adobe Camera Raw For really savvy readers, you may have already come to the conclusion that it would make the most sense to apply any noise reduction algorithms to the raw file. That way your adjustments are based on raw data and don't incur the same data loss as adjustments made to the processed file. And yes, your astute observations would be correct; however, execution is everything. Although Adobe Camera Raw does offer the ability to correct both luminance and chroma noise, it isn't as effective as other plug-ins. I prefer to eliminate noise using Photoshop's Reduce Noise filter, or with a plug-in like Noise Ninja.

Photoshop's Reduce Noise Filter New for Photoshop CS2 is the Reduce Noise filter. Offering both a basic and advanced mode, the Reduce Noise filter does a tremendous job of removing chroma and luminance noise without making the image appear "cartoonish." The basic mode gives you control over the strength, or intensity, of the correction, along with sliders controlling the protection and sharpness of image detail; a separate slider controls the adjustment for color noise. The Advanced setting gives strength and detail preservation controls for each of the color channels. This is great for cameras or scanners that have one channel that is significantly noisier than the others. The Reduce Noise filter doesn't have camera-specific noise presets like many of the plug-ins, though you can save and load predefined noise reduction settings allowing you to batch process the correction.

Noise Ninja A large and very effective preview window makes Noise Ninja one of the easiest plug-ins to use. The camera profiles provided by Noise Ninja are very effective at removing chroma and reducing luminance noise. These profiles are automatically applied to the image based on the Exif metadata information created by the camera. Noise Ninja's interface is also the simplest to navigate, making noise reduction a simple and efficient process.

Kodak GEM Professional This is the most aggressive of the noise reduction filters in this test. It consistently does the best job of removing both chroma and luminance noise from images, but at 100% intensity GEM has a tendency to obliterate image detail, making the image appear as though it has been run through the Watercolor filter. This makes it critically important to remove noise on a duplicate layer.

Maximizing the Efficacy of Noise Reduction Plug-ins

To make the most of your noise reduction plug-ins, I recommend reading any documentation that comes with the software. Each plug-in has its own proprietary methods for noise removal and its own interface. Work within the software as much as possible. If you find that the software isn't as exacting as you had hoped, I suggest you try the following techniques. As a matter of course, I perform all my noise reduction as the very first step in my imaging workflow. Noise reduction programs are the most effective on files that have not

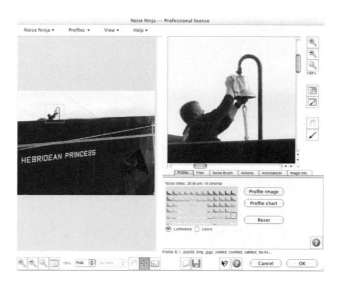

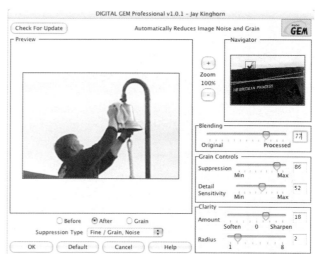

undergone tone and color corrections or image sharpening.

With all of the noise reduction methods, I suggest applying your adjustments to a duplicate layer. This allows you to reduce the layer opacity or add a layer mask to brush out changes in a specific portion of the image.

Soft Light If the camera noise is concentrated in the shadows, try switching the duplicate layer's blending mode from Normal to Soft Light. To avoid lightening the highlights, use the Layer Blending sliders to blend the highlight pixels with the underlying layer. Here's how it works.

Step 1 On the duplicate layer, change the layer-blending mode from Normal to Soft Light. The shadow areas will darken slightly depending on the image content. You may find that you want to reduce the opacity of the duplicate layer further to compensate for this.

Step 2 Choose the Layer Effects button on the bottom of the Layers palette. Make sure the Blend If is set to gray. Move the This Layer slider from right to left. At a value around 75, ALT-click or OPTION-click on the slider to split the slider into two segments. This feathers the transition between the blended and nonblended areas of the image. Move the leftmost portion of the slider closer to the shadows until the desired effect has been reached. This hides the highlight and midtone areas of the image, allowing the original background layer to show through.

The uncorrected image is shown at top. The image after the soft light correction is shown at bottom.

Selective Blurring　Are your shadows still not clean enough? Use the Color Range tool to select the shadow areas of the image. Feather the selection 1 pixel and add a Gaussian Blur of 0.5–1 pixel.

Step 1　Activate the Color Range tool (Select | Color Range). From the resulting pull-down menu choose Shadows. Alternatively, you can use the Color Range eyedropper to click on the areas of the image that you wish to affect. SHIFT-click to add more than one sample point to the Color Range. Click OK.

Step 2　Feather the selection 1 pixel (Select | Feather). This makes the edges of your adjustment less visible.

Step 3　Blur the selection 0.5–1 pixel using the Gaussian Blur tool.

Sharpening

Before the ink hits paper, it is important that the image is sharpened for maximum impact. Properly sharpened images snap, the detail giving the eye more to linger on as it travels across the print. Overly sharpened images look artificial. Smooth transitions are mottled and distinct edges have distracting halos. Here's how to give your images the extra snap they need to make a stunning print.

How Sharpening Works

The human visual system is marvelously fascinating. When light strikes your eye, two different sets of receptors sort the information your eye receives into "what" and "where" information. The "what" cells are responsible for shape recognition and color perception; the "where" cells are responsible for perceiving depth and spatial relationships. The "what" system is more nuanced in its perceptions and is able to discern slight differences in

color. The "where" system is colorblind, but is extremely sensitive to differences in contrast. When you sharpen a digital image, you exaggerate the edge contrast in an image to fool the "where" aspect of your visual system into thinking that there is more detail and depth in the image than actually exists. As digital practitioners, we need to be careful not to spoil the illusion. Sharpening requires a careful hand—add too much and the illusion is spoiled.

Our eyes are fooled by adding contrast to edges. In the top illustration, the only detail in the image is the subtle transitions between the four gray squares. In the unsharpened image, these transitions are difficult to see. Sharpening the image makes the four squares in the bottom illustration distinctly visible by exaggerating the contrast along the edges. If you look closely, you can see how Photoshop lightened one edge of the square and darkened the opposite edge. The RGB values in the center of the squares are unchanged even though the square in the top-left corner appears to have gotten darker. Photoshop takes advantage of this aspect of human vision to accentuate the appearance of image detail by exaggerating contrast between adjacent edges by applying the same phenomenon shown above to your image on a pixel-by-pixel basis.

Unsharp Mask: A Brief Introduction Applying the unsharp mask to your images may seem like the last thing you'd want to do to make them look sharper. The term *unsharp mask* comes from a darkroom technique used to sharpen a slightly out-of-focus image.

The four squares in this image show only subtle differences in tone. The RGB values of the four squares, clockwise from top-right: 131,131,131; 128,128,128; 125,125,125; 122,122,122.

Even though the RGB values of the four gray squares are unchanged, you are able to see the edges of the squares more clearly. Under close examination, you can see how Photoshop lightens one side of an edge and darkens the other. This enhances edge contrast and causes your eye to perceive more detail in the image.

Photoshop's Unsharp Mask dialog box (Filter | Sharpen | Unsharp Mask) consists of an image preview and three powerful sliders: Amount, Radius, and Threshold. When used judiciously, they offer scalpel-like precision for image sharpening. Used carelessly, they can be a chainsaw to destroy your images. Over-sharpening is one of the most common pitfalls for digital neophytes. Learning to master the controls of the unsharp mask is the best way to avoid a sharpening disaster.

The Unsharp Mask dialog box

A. Detail Window The preview window defaults to 100% view, representing each pixel in the file with one pixel on the monitor. This gives you the most accurate onscreen preview.

B. Preview Checkbox The preview checkbox controls the sharpening preview on the image itself, not in the preview window. To toggle the preview in the preview window, move your cursor over the preview window, then click and hold the mouse.

C. Amount Slider The amount slider controls the intensity of the sharpening adjustment. Most images are well served with an amount setting between 100% and 180%.

D. Radius Slider The most critical of the three settings, the radius controls the width of the sharpened edge. Images with fine detail like hair require a Radius setting of less than one and a higher amount. Images with broad, coarse detail need a larger Radius setting to give the edges the contrast needed to make the image appear sharper. Additionally, the image's dimensions in pixels is an important factor in determining the correct Radius setting.

E. Threshold Slider The Threshold setting allows you to restrict your sharpening to the high-contrast edges, while leaving the smooth transitions unaffected. With a Threshold value of 8, neighboring pixels with differences in tone of 7 (on the scale of 0–255) will not receive any sharpening, but adjacent pixels with a tonal difference of 9 will receive sharpening. This helps to minimize mottling or a loss of smooth gradations in blue skies and skin tones.

Unsharp Mask in Action This image of the veterans' memorial in Glasgow, Scotland, can benefit from some sharpening before being sent to the printer. The Unsharp Mask filter will only work on an image layer, so make sure the Background layer or other image layer is selected before proceeding. Also, your image should be at its final output size. Upsampling or downsampling the image affects the image sharpness and will require additional sharpening.

Tip Make sure you have saved your master version of the file without any sharpening. Each form of output (web, inkjet, photographic) requires its own level of sharpening. Leaving your master files unsharpened gives you the flexibility to print on many different printers and paper types.

My first step is to set my zoom percentage to 50% if I am printing to an inkjet printer or 100% if I am taking my file to my digital photo lab for printing on a Fuji Frontier or LightJet printer. I press CTRL-ALT-0 (zero) on the PC or CMD-OPTION-0 on the Macintosh to quickly reach 100% view. For inkjet printers I use the keyboard shortcut CTRL-- or CMD-- twice to reach 50%. Access the Unsharp Mask tool from the Filter menu on the menu bar (Filter | Sharpen | Unsharp Mask).

Begin by moving your cursor over the image and notice that your cursor has changed into a small box. This box indicates that by clicking in the image you will update the preview window. I like to click on a point on the image that contains important detail before adjusting my Amount and Radius settings. For this image, I used the lettering on the memorial behind the lion. When setting the radius, it is important that I find the portion of the image with the finest detail. I will use this area as my guide for determining the correct sharpening radius.

Next, set the Radius at 0 and the Amount at 500. Begin slowly increasing the radius until the sharpening begins to eliminate the subtle, fine detail in the image. In this example, the lettering becomes obscured by the halo created by the sharpening. With most images, this is a subjective assessment, and I suggest previewing several important image areas while determining the correct radius setting.

Amount 500, Radius 0.5, Threshold 0

Amount 500, Radius 1.0, Threshold 0

Amount 500, Radius 1.5, Threshold 0

The three images at left demonstrate the effect of adjusting the Radius setting. Notice at the Radius setting of 1.0 the image appears visually over-sharpened, but the lettering is still legible. At a Radius setting of 1.5 (right), the exaggerated contrast caused by sharpening has rendered the lettering illegible. The optimal Radius setting for this image lies around 1.2.

Once the optimum Radius setting has been determined, reduce the Amount to 0 before increasing it slowly. Keep a close eye on the preview to look for artifacts or halos that develop from sharpening. Increase the Amount until you feel that the correct amount of sharpening has been added. Use your artistic discretion to know when to stop. Remember, an image that is slightly under-sharpened is less objectionable than one that is over-sharpened.

Amount 150, Radius 1.2, Threshold 0

Amount 300, Radius 1.2, Threshold 0

Amount 450, Radius 1.2, Threshold 0

Look at the three images where the Radius and Threshold are constant (1.2 and 0, respectively) and the Amount has been adjusted. In the first image, an Amount of 150 doesn't have much effect. At 300, the image looks very good at 100% and this is the setting I would choose for a continuous-tone photographic device. At 450% the image begins to break up and the edges look artificial.

If I was sending this image to a paper that was highly absorbent, like a fine-art rag paper, this would probably be the setting needed to maintain detail. This particular image requires a much higher amount of sharpening than usual because this particular digital camera doesn't apply any in-camera sharpening to the raw files. For most digital cameras, I find I rarely have to set the amount greater than 250% since they perform some in-camera sharpening.

As mentioned earlier, the Threshold setting allows you to restrict the unsharp mask from adding any sharpening to continuous tone areas. This is an incredible feature, as it allows you to preserve smooth transitions like skies or skin tones, while adding sharpening to the high-contrast edges like eyes and smiles. Generally, I choose a low Threshold setting, around 4 to 6, for most digital images shot with a high-quality camera at an ISO setting of 100–200. For noisy digital images, or scans of high-grain black and white film, I will increase the Threshold value to 20–25 so that my sharpening does not exaggerate digital noise or film grain, but still sharpens high-contrast areas.

Amount 450, Radius, 4.3, Threshold 0

Amount 450, Radius 4.3, Threshold 20

Amount 450, Radius 4.3, Threshold 90

This set of images shows the effect that the Threshold tool has on image sharpening. (The image has been intentionally over-sharpened to exaggerate the effect.) At a Threshold of 0, sharpening is applied to all of the pixels in the image. When the Threshold is set to 20, the sharpening is still applied to the leaves with greater contrast and the tips of the flowers, but has not been applied to the dark green leaves containing subtle tonal differences. A Threshold value of 90 isolates sharpening to only the highest-contrast edges—the edges of the red flowers and a few of the bright leaves adjacent to dark shadows.

My final sharpening settings for this image were Amount 310, Radius 1.2, and Threshold 4. The original image is shown at left and the finished image at right on the next page. Notice the significant increase in detail in the foreground and the heightened illusion of depth in the image.

Like most Photoshop skills, sharpening is an art that takes practice to fully develop. Experiment by sending files to your inkjet printer or photo lab files with different USM settings. First, choose the settings that you feel are correct, then create duplicate files that are over- and under-sharpened to see how the sharpening you see on screen translates to the finished print.

The unsharpened image

The sharpened image

Tip Immediately after clicking OK in the USM dialog box, go to the Edit menu and choose Fade Unsharp Mask. Switch the mode from Normal to Luminosity. This sharpens only the tonal information in the file and prevents any color fringing caused by sharpening.

Smart Sharpen

The Smart Sharpen filter is the best tool I've found for sharpening digital camera images. By using three separate sharpening methods, the Smart Sharpen filters intelligently tease out the hidden detail in your digital images.

A

B

C

D

E

A. Detail Preview Window Defaults to 100% zoom to provide the most accurate preview. The larger preview window makes correction easier.

B. Basic and Advanced Tabs The basic tabs control sharpening globally on the image. Advanced controls allow you to fine-tune your adjustments in the shadow and highlight regions of your image.

C. Settings Once you've found a correction that works well for a particular shoot, you can save the Smart Sharpen settings and apply them to the remaining images in a shoot as part of an action.

D. Remove The sharpening method Photoshop uses on your image. Gaussian mimics the unsharp mask, Lens Blur gives better results on images from digital cameras, and Motion Blur attempts to correct camera shake or movement by the subject. When Motion Blur is selected, choose the angle that best matches the direction of the movement.

E. More Accurate When checked, Photoshop makes multiple passes of the filter for the best results. This may be a bit slow on older machines or large files, but the results are usually worth it.

One Pass Sharpening or Two?

In this lesson, all of the image sharpening was done as the very last step before sending the file to the printer. Some photographers prefer to sharpen very lightly before preforming any tone or color corrections, then sharpen again to prepare the image for output. This practise certainly has its merits for ensuring the highest quality fine-art prints. If you choose to apply two rounds of sharpening, use very low settings for the first round to compensate for the capture process, then apply the second round of sharpening immediately prior to printing to target the image to output device.

Using Smart Sharpen

In this tutorial, I'll take you through the steps necessary to effectively use the new Smart Sharpen filter.

An unsharpened image along with three areas outlined in red that we will pay close attention to.

Step 1 Access Smart Sharpen from the Filter menu (Filter | Sharpen | Smart Sharpen). For best results, use Smart Sharpen on high-bit images whenever possible. It is also recommended that you run any noise reduction techniques before sharpening. If you are used to using Unsharp Mask, you'll find that most of the commands in Smart Sharpen are very similar. The primary differences in the Basic window are the lack of a Threshold slider and the three choices in the Remove menu.

The mode chosen in the Remove menu determines the math that Photoshop uses to sharpen your image. The Gaussian Blur setting is similar to Unsharp Mask. I find that it is the best of the three settings for sharpening film images, though when I am scanning film, I still prefer to use Unsharp Mask to take advantage of the Threshold slider. The Lens Blur mode is the best for digital captures. Use the Motion Blur setting if you are trying to minimize the appearance of either camera shake or subject movement caused by a slow shutter speed. Since this image is a static scene shot with a digital camera, we'll use the Lens Blur setting.

Tip *Sharpening Reminder.* The Preview checkbox controls the sharpening preview on the full image. To toggle the preview of the Preview window bring your cursor into the Preview window, click and hold the mouse button. This recalls the unsharpened image. Releasing the mouse button previews the image based on the currently selected sharpening settings.

Step 2 Before adjusting any of the sliders, activate the More Accurate checkbox. Photoshop will perform additional processing on the filter for more accurate sharpening. The superior results are worth the additional processing time unless you have a slow computer or exceptionally large files.

As with Unsharp Mask, setting the Radius correctly is critical. Choosing a Radius that is too high will obliterate the fine detail in your image. There is no magic number for choosing the Radius; you have to use the sophisticated diagnostic tools called your eyes to balance the intensity of the sharpening with the preservation of image detail. Further, the optimal Radius setting depends on the image size. A Radius setting of 1.0 is much more pronounced on a web-sized 800 × 600 pixel image than on a 4000 × 2400 pixel image.

This image is 1920 × 2560 pixels and con-tains a lot of fine detail in the concrete of the pier and the fine threads of the rope, so a Radius setting of 0.6 seems appropriate. I find that I use a lower Radius setting with Smart Sharpen than I do with Unsharp Mask.

Tip *Avoid odd zoom percentages:* We've already mentioned the importance of setting your zoom percentage at 50 or 100 percent for the most accurate results, but if you forget and leave your image at an odd percentage, say 33.3 percent or 66.6 percent, the main window may look *really bad.* This is because Photoshop can only display full pixels, not a third of a pixel. At odd percentages, Photoshop has to guess which pixels to display. This is particularly noticeable when sharpening and can lead many novice users to believe their sharpening corrections are too strong.

Step 3 Once the Radius is chosen, setting the Amount is easy—simply increase the value until you've reached your desired level of sharpening. When setting the Amount,

I set the Preview window to the area of the most important detail. This could be a person's eye in a portrait or, in this case, the fibers of the mooring rope. Once I've set the Amount, I click on several important areas in the image to check the effectiveness of the sharpening—reducing the Amount if necessary. I am also looking at the fine detail in the image asking myself, "Has my sharpening enhanced the detail or eliminated it?" If my sharpening appears detrimental to the detail in the image, I'll reduce the Radius setting accordingly.

An Amount of 192 percent does a nice job of bringing out the detail in the ropes and the pier. Clicking on our three key detail areas shows that we've done a good job of bringing out the key detail in the image, but we've also brought out some digital noise in the boat's hull. Although it is difficult to see in the finished print, the noise is easy to remove using the Advanced settings.

PhotoKit Sharpener

The PhotoKit Sharpener from Pixel Genius LLC was created by some of the best and brightest minds in digital imaging. It is no surprise then that PhotoKit Sharpener does an excellent job of teasing out the fine detail in your images. The PhotoKit Sharpener works on sharpening your images at three different stages in your workflow:

- **Capture Sharpening** To compensate for the scanning or digital capture process. Choose the sharpening set that best corresponds to the form of capture and the medium used to create the image, then choose the sharpener effect that best matches the content of your image.

- **Creative Sharpening** The creative sharpening effect gives you the ability to apply sharpening to key image areas like the subject's eyes or lips. Choose your sharpening set, then experiment with different sharpening effects.

Several other third-party sharpening plugins are currently available. The sheer volume of sharpening and noise reduction software makes it impossible to include a detailed comparison of the pros and cons of each in the space provided. They exhibit varying degrees of usability and effectiveness. Many offer a free demo allowing you to experiment with their software before committing to buy it. I encourage you to take the time to test each piece of software not only for its effectiveness, but also its ease of use and its ability to integrate into your existing digital workflow.

- **Output Sharpening** Used to target your image for printing or delivery to the Web, choose the sharpening set that best matches your output device (inkjet, continuous tone, and so on). Next select the sharpener effect that best matches your image resolution and paper type.

For each form of sharpening, PhotoKit creates an additional layer (or layers) containing the sharpening effect. The advantage of sharpening on layers is that it is nondestructive and allows you to tailor the intensity of the sharpening effect by increasing or decreasing the layer opacity or through the addition of a layer mask.

HOW TO: RETOUCHING a PORTRAIT

Retouching a portrait is one of the most delicate balancing acts you will encounter in the digital darkroom. Fashion magazines have set the precedent for glossy, airbrushed skin, perfect hair, pearly white teeth, and sparkling eyes. Most of us photograph real people, and our goal with portraiture is to capture the character and the essence of our subject. It is the smile lines, crow's feet, and unique features that give us our character. Artful retouching focuses the viewer's attention on the most expressive features of the face—eyes, smile, and overall gesture—and removes temporary blemishes and errant freckles and whitens teeth while preserving the essential character of the subject.

Jessica's bright eyes and broad smile framed by her curly tresses characterize her cheerful demeanor. My goal in retouching this image is to call attention to her distinguishing features and reduce or eliminate any distracting elements. The figure below shows the specific areas I want to address in this portrait.

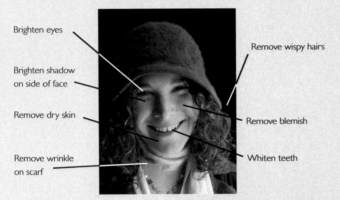

Brighten eyes

Brighten shadow on side of face

Remove dry skin

Remove wrinkle on scarf

Remove wispy hairs

Remove blemish

Whiten teeth

The areas of the portrait I want to address during my retouching

Step 1

My first step is to zoom in to 100 percent and use the spot healing brush to remove any blemishes on her face. Along the way I decided to remove the wrinkle in her scarf. I use the healing brush on the upper section of the scarf followed by two passes of the clone stamp set to 50% opacity to smooth out the subtle color transitions. For the wider section of the

scarf, I use the patch tool to blend the wrinkled areas with the smoother portions of the scarf. Again, I use the clone stamp set to 50% to help smooth out any visible discontinuities in the color.

Step 2

Next, I want to clean up the flyaway hairs on the right side of the portrait. I use the clone stamp, though the healing brush or the patch tool would also work well in this situation. Since this is a prominent light to dark transition, I wouldn't use the spot healing brush.

Step 3

The next step is to brighten her eyes using a Curves adjustment layer. I brought the highlight point of the curve along the top margin of the Curves window to brighten the highlights considerably. I switch the Layer Blending mode from Normal to Luminosity to prevent a big saturation boost around her eyes. I fill the layer mask with black to hide the Curves correction, then selectively paint the change back around her eyes using a soft brush set to 40 percent. I then create another Curves layer, set the blending mode to Screen and again fill the layer mask with black. This time, I only paint in her eyes to give them a little extra snap. These adjustments really help to draw the focus of the image to her eyes, as they were too dark in the initial capture.

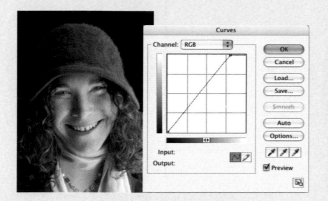

Step 4

I felt the image could use a little contrast, so I create a Curves layer and apply an S-Curve to enhance contrast through the midtones. I switch the Layer Blending mode to Luminosity to keep her skin tones from becoming too saturated and reduce the layer opacity to 60%.

Step 5

America is in the midst of a teeth-whitening craze. Whitening toothpastes, whitening dental strips, and even whitening chewing gum crowd the marketplace. Why not whiten teeth digitally with a Curves adjustment layer? Boost the highlight end of the RGB curve to brighten teeth and brighten the highlight end of the blue channel to counteract the yellowing from the morning cup of coffee. I then fill the layer with black and use a soft brush set to 40 percent opacity to brush the digital whitening over her teeth.

Step 6

The very last step is to add a slight vignette to focus the viewer's attention on the center of the portrait. This is done with, you guessed it, a Curves adjustment layer. This time I don't make any adjustment to the curve, but set the Layer Blending mode to Multiply to darken the image. Again I fill the layer mask with black and set white as my foreground color. I choose a large, soft brush to paint my vignette into the lower corners of the portrait.

Comparing the before and after images, I feel that I achieved my goal of calling attention to Jessica's natural beauty without making her look plastic or artificial. What do you think?

The original portrait The retouched portrait

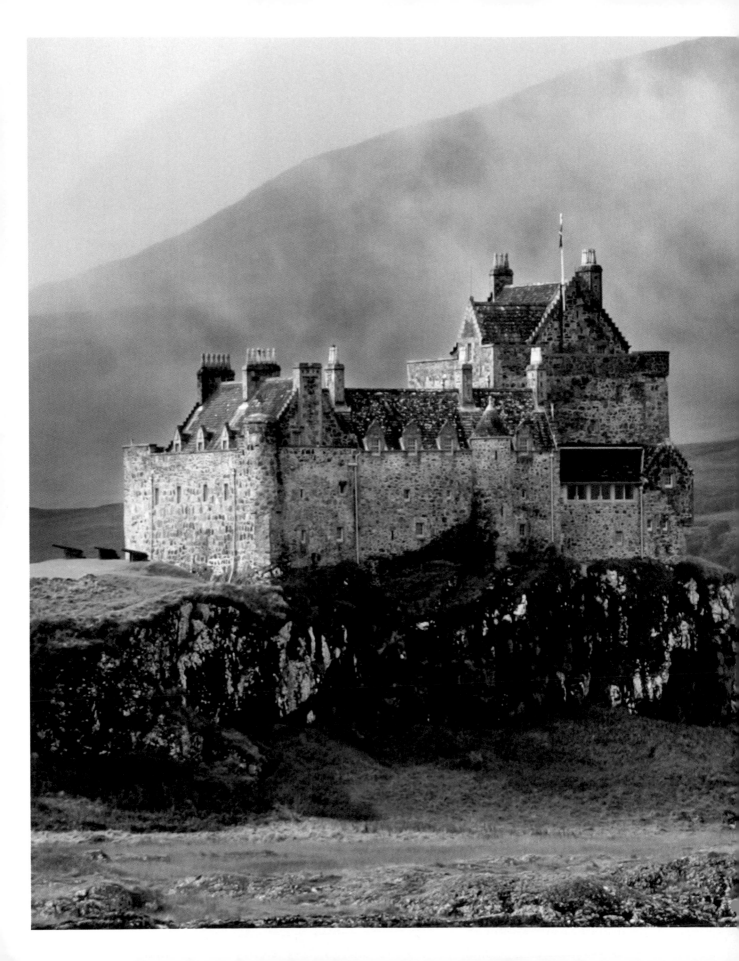

PRINTING and OUTPUT

The negative is similar to a musician's score, and the print to the
performance of that score.

—Ansel Adams

Until now, our exploration of digital photography has centered
on composing, capturing, and manipulating pixels, the ever-
ephemeral building blocks of digital images. But pixels aren't
easy to hang on walls, carry in your wallet, or place in an album.
Even in the digital age, people still like the tangible qualities
of a print.

Duart Castle, Isle of Mull, Scotland.

Because the print is the final step in the creative process, it deserves as much care and consideration as the composition and the exposure of the initial image. This chapter is devoted to preparing an image for printing and to the act of printing, whether to a desktop inkjet printer or to a wide-format photographic printer at a professional lab. We'll also explore some of the modern versions of a finished photograph: the Web and digital slideshows, and multimedia presentations, which blend music, text, and interactivity in a medium that holds great promise for telling a compelling story.

There is an impressive range of printing options available to photographers today. We've traveled well past the traditional glossy vs. matte era into a world of options that provide a photographer an unprecedented amount of control for creating a compelling, expressive print.

PRINTING

Digital photography, with all of its technology and its wonderment with ones and zeros, is essentially a latent idea until the print is created. Printed photos have a wonderfully tangible and tactile quality to them that seems at times magical. When we think about our most treasured heirlooms, often an old box of photographs, a wedding album, or a family album tops the list. Through memory and intent, that piece of paper representing a moment in time has been imbued with the magic of nostalgia, the ability to freeze time, and the power to tell a story. The print,

whether from a drugstore minilab or a million-dollar wide-format printer, is the completion to a photographic journey and is the subject of this chapter. Along the way, I'll introduce you to the current printing technology and show you how to improve your prints on any printer from desktop to digital lab.

Printing Digital Photographs

Humbly sitting on your desk is a revolutionary device. The desktop inkjet printer has dramatically changed how photographs are printed. The ability to create photo-lab quality prints affordably and easily has brought printing back within the grasp of the photographer. Before the advent of color printing and transparency film, the printing of one's own photographs was a craft equal to the exposure and composition of the original image. It was expected that a serious photographer would have their own darkroom and perform their own printing.

When color photography gained popularity, attaining the correct chemistry for developing color negatives and digital prints became more difficult and more expensive. Particularly with transparency film, it became less practical for a photographer to develop and print their own film, and photographers became more reliant upon a photo lab to handle their color developing and printing needs. Now that digital photography has progressed past its infancy, the quality of printers and the range of options available to photographers is astounding. For $100 you can buy a printer that will make reasonable

prints up to 8 × 10 inches in size. For $600 you can make beautiful 13 × 19-inch prints. For upwards of a thousand dollars you can make wide-format prints that will knock your socks off.

In addition to the wide range of printers to choose from, there is an ever-increasing array of paper on which to print your images. No longer is it simply a choice between matte and glossy. Photographers have at their disposal a tremendous selection of weights, finishes, textures, and gloss. Some printers even allow you to print on canvas or art board. In this section I'll help shed light on the types of printers available to photographers from desktop printers to their larger wide-format brethren.

Choosing an Appropriate Printer

With a wide range of choices from several different manufacturers, it can be difficult to determine which is the printer that best suits your needs. While I can't tell you which printer is best for you, I can give you guidelines that will narrow the selection process and help give you the confidence to buy the printer that best meets your needs and your price range.

What Size Print Do You Want?　It may seem like an obvious question, but one of the best methods of narrowing the list of potential printers is to consider what size print you normally make. As the potential print size increases, so does the cost—often exponentially.

- **Desktop format**　Many photographers find a nice balance with a desktop model capable of printing 11 × 14-inch or 13 × 19-inch prints. Larger prints can be taken to a lab. This size is often the best balance of price and quality. Some models in this category offer roll paper and auto-cut options, making it quite easy and economical to print a series of 8 × 10-inch images. One disadvantage of the desktop printers is that the price per print tends to be about twice as much per print as wide-format printers due to the need to buy the ink in smaller cartridges. The Epson R1800 is an example of a robust desktop format printer.

© 2005 Epson America, Inc.

- **Medium format**　Photographers who print a large volume of photos or who find themselves frequently printing 16 × 24-inch or 20 × 30-inch prints are better served by a wide-format model. With larger ink tanks, medium-format printers are often much less expensive per print than a similar desktop model and may print faster. These printers usually require a dedicated printing table or print stand as they would quickly crowd all but the most spacious desk. The Epson 4800 is worth mentioning here, as it is a beautiful hybrid between the smaller desktop models and the medium- and large-format professional printers. It is

capable of quickly creating prints up to 17 inches wide and does an outstanding job of printing both color and black and white images.

© 2005 Epson America, Inc.

- **Large format** The domain of professional photo labs and high-volume photography studios, large-format printers are the workhorses of the inkjet world. These printers are the most economical per print, but their initial price tag can rival that of a used car. While they might be on the wish lists of some photographers, they are generally more machine than is needed for most photographers. These machines print to paper rolls 24 inches wide and larger and often require a specialized software RIP to run effectively.

© 2005 Epson America, Inc.

Dye-Sublimation Printers

For photographers looking for a desktop printer, inkjet isn't the only game in town. Dye-sublimation printers are often favored by photographers who value print speed over print consistency or print longevity. "Dye-sub" printers use heat to transfer dye from a colored ribbon onto the paper. Some dye-subs add an overcoat layer to improve print longevity and protect the dyes from fingerprints. The most significant advantage to dye-sub printers is the print speed. Most dye-sub printers can make an 8 × 10-inch print in less than a minute, while an Epson R1800 printer takes about three minutes to make the same print on semi-gloss paper. Dye-sub prints have an acceptable color gamut for portrait photography, but landscape and travel photographers will find the limited color gamut stifling. The most significant disadvantage to dye-sub prints is their fugitive nature. Wilhelm Imaging Research recently conducted a comparison of 4 × 6-inch printers, and two dye-sub models included in the test were given an archive life of only four and eight years. At this point, dye-sublimation printers are best suited for making keepsake prints as opposed to fine-art printing.

Price vs. Quality vs. Printer Longevity

Image quality is usually very good to excellent for all but the cheapest inkjet printers. The quality of the construction of the printer and its corresponding longevity become an important buying consideration, particularly when you look at the medium- and large-

format printers, which cost several thousand dollars. The adage "You get what you pay for" is often true in this case. The less expensive photo printers have no serviceable parts and have a usable life of one to three years depending on print volume. The medium- and large-format printers often include a service and repair plan and are built for printing tens of thousands of pages. Look on the manufacturer's website for specifications on duty life.

Dye vs. Pigmented Inks A critical decision for photographers choosing an inkjet printer is whether the printer uses dye-based or pigment-based inks. Dye-based inks are by far the most commonly used and are standard on virtually all models that cost less than $400. They are inexpensive to manufacture and provide rich, saturated colors. The primary problem with most dye-based inks is that they are not as archival as pigment-based inks. New ink formulations tested with select papers are proving to have a long archival life; however, the paper used in the tests makes a huge difference in print longevity. Pigmented inks, including Epson's Ultrachrome ink, offer an acceptable color gamut for photography and are significantly more archival across a broader range of paper types. Unfortunately, they are often significantly more expensive than dye-based ink printers and are more prone to metamerism, a condition where the color appearance changes based on the light source. If you've ever picked out paint samples at the hardware store and then found that the color was radically different when you looked at the

sample in your kitchen under daylight, you've experienced metamerism. Currently, the Epson line of photo printers controls the lion's share of the market inkjet printers for the serious photographer, although Hewlett-Packard and Canon are quickly making inroads with their newest line of printers.

A three-dimensional plot of the color gamut of Epson's Photo Dye ink and Epson's Ultrachrome ink on an Epson 9600 printer. The center axis represents the grayscale from black to white. The farther a color lies from the center axis, the more saturated that color is.

Tip Wilhelm Imaging Research is one of the best sources of print permanence information. Test results can be found on the Web at www .wilhelm-research.com.

Choosing an Inkjet Paper

Inkjet printers have opened up a range of paper choices that go far beyond the traditional glossy vs. matte dilemma. Glossy papers come in high-gloss, semi-gloss, pearl, satin, and luster. Matte papers come in watercolor, fine art, smooth, textured, and a variety of finishes, weights, and textures.

When choosing a paper, you need to first ask whether the paper is compatible with your printer and inks. Inkjet papers have either a microporous or swellable coating on the top of the paper that allows the ink to bond with the paper. This bond between the ink and the paper is critically important for both the look and the longevity of the print. Papers formulated for dye inks often are incompatible with printers using pigmented inks. Also important, the way that the ink bonds with the paper's coating significantly affects the print's life.

The printer manufacturer's papers often will provide the best results with the least amount of effort because the microporous coating on the paper's surface has been engineered to work with the printer's inks. Epson, HP, and Canon offer a wide selection of papers to match most photographers' needs. Third-party papers vary widely in terms of quality and price. The papers marketed as generic inkjet papers commonly deliver sub-par results, but papers specifically engineered for fine art photography produce many of the finest digital prints on the planet.

Resolution

High-quality digital prints require sufficient information present in the original file. Inkjet printers translate the image information to ink dots small enough to fool the human eye into thinking the print contains a range of continuous tones instead of a series of complex dot patterns. In Chapter 11, we introduced the concepts of image resolution and print resolution. These concepts are so essential to the art of printing that it's worth revisiting and expanding upon them.

Image Resolution Pixels in an image are distributed along an invisible grid to give us height and width dimensions for printing. Setting the desired print dimensions in the Image Size dialog box with the Resample Image box unchecked helps you determine your effective image resolution for output.

- **72 ppi** The average resolution needed for multimedia and web usage

- **150 ppi** The minimum resolution needed for photographic output devices (Fuji Frontier, LightJet)

- **200 ppi** The lowest desirable image resolution for inkjet prints that will be viewed at a close distance

- **240-360 ppi** The "sweet spot" for most inkjet and photographic printers

It is important to take into account the finished size and the expected viewing distance of the print. Our ability to resolve fine detail diminishes the farther we are from the print. Very large prints or images that will be seen from a distance can be made from a lower image resolution than the guidelines listed above without a loss of image quality.

Print Resolution Print resolution is measured by the number of ink dots or data points placed on an inch of paper. Print resolution is completely independent of image resolution. Most inkjet printers have a maximum print resolution that is between 1440 and 2880 dots per inch. Choosing the

appropriate print resolution is a function of the printer, the type of paper, and the expected viewing distance of the print.

- **Printer** One school of thought teaches that you should always print at the printer's maximum print resolution. This presents the obvious drawback of being the slowest possible method of printing. In my experience, the vast majority of prints show negligible differences between prints made at 1440 dpi and ones made at 2880 dpi. In the tests I've conducted at workshops and seminars, the attendees have had a difficult time finding differences in prints made at both 1440 and 2880 when comparing them side by side. I suggest that you try this experiment at home and see if you can tell the difference at a normal viewing distance.

- **Paper** The paper's gloss, or lack thereof, can make a big difference in the visible detail of a finished print. Very absorbent fine-art or rag papers may show no difference between a print resolution of 720 dpi and 1440 dpi because of the high absorbency of the paper. Many print drivers will not allow you to choose the highest print resolution for matte papers for this very reason. Again, I suggest you experiment to find the "sweet spot" for the paper and printer you use most often.

- **Viewing distance** Our ability to discern fine detail diminishes at a distance. Images viewed at arm's length or less can reveal differences between photos with an image resolution of 240 ppi and 300 ppi. Billboards, on the other hand, are often printed around 50 ppi or less, and appear to be high resolution when viewed from a car zooming by at 65 mph. At a close distance, these billboards look like an abstract mess of dots, but from several hundred yards, our eye perceives the photo correctly.

Printing Black and White Black and white prints hold a special magic. More journalistic, more venerable, and more artistic, black and white prints have an elite status in the world of photography. The early digital black and white prints were disappointing, but huge advances have been made in the last few years. We'll devote the next chapter entirely to converting color images to black and white and to making expressive black and white prints from your digital files.

Putting Ink to Paper

Learning to control the color management in your printer driver is the single most important thing to learn for consistently great prints. The optimal situation is to be able to use Photoshop's superior color management capability to perform the color conversions and to turn off color management in the print driver.

Almost all photo printers come with acceptable ICC profiles for the manufacturer-branded papers. The difficulty lies in navigating the myriad of radio buttons, pull-down menus, and checkboxes to turn off color management in the print driver.

Soft Proofing　In life, wouldn't it be great to be able to accurately predict the outcome of an event before it actually happened, like asking for a raise or investing in the stock market? Soft proofing takes the guesswork and surprises out of printing by allowing you to preview on screen what the finished print will look like. This saves a huge amount of paper, ink, and time. The effectiveness of a soft proof is contingent upon two things: you absolutely must have an accurately profiled monitor, and you have to be able to control the color management functions in the print driver. The first ingredient, building an accurate monitor profile, was covered in Chapter 11, and the second ingredient, controlling color management in the print driver, will be covered shortly.

To soft proof an image in Photoshop, access the Soft Proof command under the View | Proof Setup | Custom menu. In the resulting dialog box, choose the color profile that best describes the printer, paper, and ink combination you will be printing with. If your printer doesn't appear in Photoshop's list, see the upcoming sidebar "Where Are My Profiles?"

I'm printing to an Epson 2200 on Enhanced Matte paper using Matte Black Inks, so I chose the SP2200 Enhanced

Matte_MK profile from the Device To Simulate pull-down menu. In earlier versions of Photoshop, this menu was simply titled Profile. For the Rendering Intent, I chose Relative Colorimetric. This preserves as accurately as possible the color appearance of printable colors. Colors that lie outside the printer's color gamut are printed as saturated as possible. This is the option I choose for almost all of my color conversions. Be sure to check Black Point Compensation; this will help preserve the shadow detail in your images.

Use the Preview checkbox to toggle the Soft Proof on and off. Look for areas of color or tone that change between the original and the proof simulation. Are there areas of color that shift or change? If so, do these areas contain important detail? If yes, try changing the Rendering Intent from Relative Colorimetric to Perceptual. This scales the colors in the original file sacrificing the accuracy of colors for the relationships between colors, thus preserving detail in saturated areas. The primary disadvantage of using the Perceptual rendering intent on a regular basis is its tendency to make images lose contrast and appear flat. I find that I use the Relative Colorimetric rendering intent for 85 percent of my images.

Once you've chosen your Rendering Intent, click OK to exit the Customize Proof Condition dialog box. In multi-window mode, the color space used for your soft proof is listed after the bit depth at the top of your image. This reminds you that you are working in Soft Proof mode and your image, along with any changes you make, is being previewed through the printer's ICC profile. You can continue to make changes to fine-tune your image to match your printer's characteristics. I suggest making these changes on separate adjustment layers and labeling them in a way that quickly allows you to turn them off or discard them if you decide to print to a different printer or paper type.

One final tool you can use to have Photoshop show which colors might change when you send the file to the printer is Gamut Warning (View | Gamut Warning). When used with the Soft Proof tool, Gamut Warning

will cover the colors in the file that are not printable with a gray overlay. You can continue to make adjustments to the file to shift the unprintable colors within the printer's color gamut, or you can let the rendering intent take care of the change. In this image, the gamut warning shows that the red truck behind the dog is out of gamut. There isn't any important detail in the red truck, so I'll continue to use the Relative Colorimetric rendering intent and let Photoshop convert the original color of the truck to the most saturated red that my printer is able to print.

The Soft Proof and Gamut Warning features are powerful tools to help you predict any potential color or tone shifts in the finished print without using any ink or paper. The accuracy of the Soft Proof is highly dependent upon the accuracy of your monitor profile and your printer profile along with your ability to control the color management in the print driver.

Where Are My Profiles?

After installing your print driver and using your printer successfully, you may still find that your printer's color profiles do not appear in either the Soft Proof or Print With Preview menus. Unfortunately, most print drivers install the color profiles needed for printing in the deep, dark recesses of your hard drive in folders that are inaccessible to Photoshop. If you want to use Photoshop's color management tools for printing and soft proofing, you'll need to copy those profiles into one of the folders Photoshop looks into for color profiles. On the Windows platform, I usually do a search for all files with the extension .icm. When I find the profiles that correspond to my printer, I make a *copy* of those files (*very important*) on my desktop. Then I select all of the copied profiles, right-click, and choose Install Profiles. With Macintosh OSX it's a little more complicated. Take a deep breath and follow along this labyrinthine tour.

1. Open your hard drive (usually called Macintosh HD).
2. Open your Library folder.
3. Open the Printers folder.
4. Open the folder corresponding to your printer's manufacturer.
5. Find the plug-in that corresponds to your printer model and CONTROL-click on it.
6. Choose Show Package Contents.
7. Open the Contents folder.
8. Open the Resources folder.
9. Open the ICC Profiles folder.
10. Keep the ICC profiles window open and open a new Finder window (CMD-N).
11. Open your hard drive.
12. Open your Library folder.
13. Open your ColorSync folder.
14. Open your Profiles folder.
15. Copy all of the files from the ICC Profiles folder of your print driver to the Profiles folder in your ColorSync library.

Whew! Wasn't that fun? The location of the printer profiles may differ slightly within the printer plug-in for HP or Canon printers. Your profiles should now be ready to use in Photoshop for Soft Proofing and the Print With Preview command. I find that the Soft Proof menu updates faster than the Print With Preview window and recommend using the Soft Proof tool first. You'll notice a slight pause as Photoshop rebuilds its profile list. Windows users may need to quit Photoshop and relaunch the program before the profiles are accessible.

Printing from Photoshop The most important step in printing consistently and predictably to an inkjet printer is to specify your color conversion in Photoshop and turn off color management in the print driver. Unfortunately, this is not the default setting for any of the popular photo printers (including the really expensive ones) and involves navigating a twisted path of pull-down menus and radio buttons to configure the printer driver for optimal photo printing. This section is devoted to helping you

understand the features and options available to you when printing from Photoshop and to outline a clear path to printing nirvana. I'll primarily concentrate on the Epson print drivers since they are by far the most commonly used printers among both amateur and professional photographers.

In Elements, the Print With Preview features can be found by choosing File | Print and selecting More Options.

Print With Preview Your printing workflow begins in Photoshop with the Print With Preview command (File | Print With Preview). The layout of the Print With Preview menu has changed slightly between Photoshop CS and CS2, though the functionality is essentially the same. Be sure that Show More Options is checked and that Color Management is visible from the pull-down menu.

Tip *Take Shortcuts:* In Photoshop CS and CS2 you are able to customize your keyboard shortcuts. I suggest reversing the keyboard shortcuts for Print and Print With Preview. Since PWP is the most commonly used printing command from Photoshop, give it the more sensible shortcut of CTRL-P or CMD-P. That leaves the Print command with the more convoluted CTRL-ALT-P or CMD-OPTION-P.

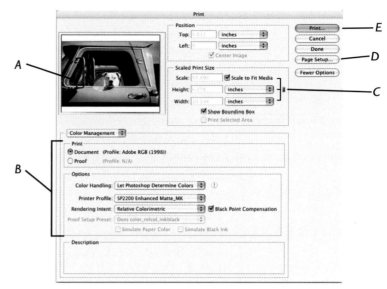

The Print With Preview dialog box

A. Image Preview Displays a preview of the current image and page settings for checking page orientation and paper size settings.

B. Color Management and Output Panels
The color management panel is the most useful for your printing needs. Here you will find a listing of the document's ICC profile along with your printing options. The Options section allows you to specify whether Photoshop will handle the color management conversion from your RGB editing space to your print space, or whether you'd prefer to have the printer driver handle the conversion. When Let Photoshop Determine Colors is chosen, the Printer Profile list is used to select the correct ICC profile for the printer, paper, and ink combination you are printing to. The Rendering Intent menu allows you to specify the rendering intent used for the

conversion and to activate Black
Point Compensation, which helps
to preserve shadow detail.

C. Scaled Print Size

Options Shows the current
image scaling in percent and inches
and allows you to quickly scale an
image to fit the currently selected
page size. I'll use this option if I
am making a proof of a large print
on a smaller piece of paper and I
don't want to go back to adjust the
image size in Photoshop. I *don't* use
this option to make a large print
out of a smaller file. (See "Going
Big: Image Interpolation" later in
this chapter for more information.)

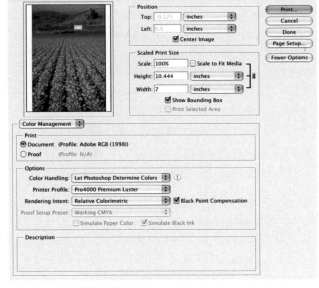

Use the Print With Preview command when printing to an
inkjet or dye-sub printer.

D. Page Setup Accesses the page settings
menu to adjust the document's page size or
print orientation, or to create a custom paper
size.

E. Print Exits Photoshop's Print With
Preview menu and enters the Print Driver
menu.

**Printing from Photoshop Using Print With
Preview** Using the Print With Preview
command to specify your document's color
management conversion, then turning off
color management features in the Print dialog
box, is the most consistent and most accurate
method of printing from Photoshop.

 Step 1 In the Print With Preview dialog
 box, first use the Page Setup button to access
 print orientation and paper size settings.

Next, choose Let Photoshop Determine
Colors from the Color Handling pull-down
menu. This activates both the Printer Profile
and Rendering Intent menus.

Step 2 From the Printer Profile menu,
choose the profile that best describes the
printer, paper, and ink combination you are
printing to. In this example, I'm printing on
Epson Premium Luster paper with an Epson
4000 printer, so I'll select the Pro4000
Premium Luster profile from the list of
available profiles.

Step 3 Set your Rendering Intent to
Relative Colorimetric and check Black Point
Compensation for maximum color accuracy.

Step 4 Once all of the image and color
management settings have been configured,

choose Print to access the printer driver. Be sure to disable printer color management in the print driver to prevent your image from receiving double color management.

Printing to an Epson Printer

In the Epson Print dialog box, you need to accomplish three primary things:

- Choose the appropriate Media Type. This ensures that the correct amount of ink is applied to the paper.

- Set the Print Resolution.

- Disable Printer Color Management. Printer color management interferes with the color management you've performed in the Print With Preview menu.

Although the settings you want to choose are identical on the Macintosh and PC platforms, their location and the arrangement of the dialog boxes are different enough that I will walk you through the driver settings separately.

Printing to an Epson Printer in Macintosh OSX The Print dialog box in Macintosh OSX is quick to navigate once you know what to look for. Once you've chosen your media type and print resolution and turned off Printer Color Management, you can save a preset, which expedites future trips through the printer driver.

Step 1 Choose the appropriate printer from the Printer list. OSX treats each type of printer driver (roll paper, borderless, and so on) as a separate printer. Be sure to choose

the printer that matches your paper (roll vs. sheet). If you are printing borderless, you'll need to specify that by choosing the appropriate printer. If you don't see your printer listed, look on your installation CD for a document titled *Read This First for OSX Users*. If it is not on your original installation CD, perform a search on the Epson support site for the document. This PDF contains step-by-step instructions on installing all of the available printer options.

Step 2 Next, choose Print Settings from the pull-down menu. Choose the correct media type from the list. Epson 2200 users, you will notice that you only have a partial list of media types to choose from. If you have Photo Black ink installed, your media choices will be limited to those papers that have a gloss, semi-gloss, or luster finish. If Matte Black is installed, only papers with a matte finish appear in the Media Type listing. This is because the two types of black ink are formulated to work only on specific media types. Enhanced Matte is the only Epson paper that will work with either black ink.

Step 3 From the Mode menu, select the Advanced Settings radio button and choose your desired print resolution from the Print Quality menu. I use 1440 dpi for almost all of my printing. I also like to uncheck High Speed, which improves the print quality.

Tip Forgetting to turn off Printer Color Management usually results in prints with a pink cast. Double-check to be sure you've disabled Printer Color Management.

I'm now ready to choose Print and send the image data to the printer.

Printing to an Epson Printer with Windows Here are the steps needed for optimal printing on the Windows platform:

Step 1 After clicking Print in Photoshop's Print With Preview menu, you will see the Epson print driver's basic screen. Click Properties.

Step 4 Go back to the pull-down menu and select Printer Color Management. Choosing No Color Adjustment will disable the printer's color management.

Step 2 The Properties dialog box allows you to set a few Basic functions in the print driver. You want to have more control over your printing than this dialog box allows. Click the Advanced button in the lower-right corner of the dialog box.

Step 3 The Advanced dialog box is where you will set all of your printer options. I recommend checking the Show This Screen First box to save you having to repeat step 2 every time you print. Starting at the top-left corner of the dialog box, choose either roll or sheet paper depending on the media loaded in your machine. Check Borderless if you plan to make borderless prints. Next, choose your media type, print resolution, and paper size from the three pull-down menus. Set the orientation of your image to either Portrait or Landscape.

Step 4 The final, critical step is to select the ICM radio button and from the resulting menu, choose No Color Adjustment. This prevents your image from receiving double color management. You are now ready to click Print.

Although you can save these print settings using the Save Setting button in the lower-left corner of the dialog box, I don't normally do

so on a PC. The page size and page orientation attributes are saved along with the media type, print resolution, and color management setting. This means that I would need to have a portrait and a landscape setting for every paper type and paper size I print to. Unless you commonly print to a single size I find this process more cumbersome than manually making my selections.

Advanced Printing Options

Using the manufacturer-supplied print driver usually provides good results for most images. However, for the most demanding photographers the quality of the prints from the print driver is not accurate enough. This is particularly true for black and white aficionados who are disappointed by the quality of the prints from the manufacturer's print drivers. Two options available to improve the quality and the accuracy of their prints are custom profiles and software RIPs.

Custom Printer Profiles The ICC profiles supplied by the printer or paper manufacturers are meant to be representative of the average printer. The quality of these profiles is more or less acceptable for most users printing to the manufacturer's paper (Epson 2200 and Epson Premium Luster), or to a paper from a company that supplies ICC profiles for their paper and your printer (Epson 2200 and Moab Entrada Paper). If you want more accuracy in your prints, or if the paper you prefer doesn't come with an ICC profile

for your printer, you may want to enlist the services of a company that can create a custom ICC profile for you. These profiles generally cost around $100 and are only effective for one printer/paper and ink combination. A custom profile is an inexpensive solution if you want a higher degree of accuracy in your prints than the manufacturer's profiles are able to provide. A partial list of reputable companies offering custom ICC profile creation is listed in the "Custom ICC Profiles" sidebar. Custom profiles are used instead of the manufacturer's profiles in the Print Space portion of the Print With Preview dialog box.

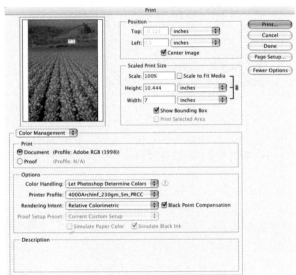

Inkjet Printer Profiling Packages If you commonly use a number of different papers and are technically inclined, it may be more economical to build your own profiles instead of hiring a profiling service. The EyeOne Photo system from GretagMacbeth and the

Pulse system from X-Rite are reliable, easy to use profiling systems for inkjet printers. They can be used to create custom printer profiles on a wide variety of papers and media types. The spectrophotometer measuring device can be used in conjunction with the ColorBurst RIP (described next) to maintain consistent output by regularly calibrating the printer back to a known state.

Custom ICC Profiles

These are just a few of the reputable companies offering custom ICC profile creation services.

- **Renaissance Photo Imaging**
 www.rpimaging.com/services/
 customiccprofiles
- **Chromix Profile Valet**
 www.chromix.com/colorvalet/
- **The Digital Dog**
 www.digitaldog.net/services.html

Software RIP A raster image processor (RIP) replaces the manufacturer's print driver with an ultra-robust, standalone software package that controls the printer more intelligently than the manufacturer's driver and provides better color management. These benefits don't come cheap. Most RIPs cost between 50 to 100 percent of the cost of the printer. For photographers printing a high volume of images to a large-format printer, or discerning black and white photographers, the print quality justifies the additional expense.

RIPs are often designed for a specific type of printing like fine art or pre-press. Fine art RIPs are better suited for the needs of photographers. Two of the most popular fine art RIPs available for both Macintosh and PC are the ColorByte RIP from ImagePrint and the X-Photo RIP from ColorBurst. Both RIPs include an extensive list of high-quality print profiles and deliver excellent color and black and white prints. An increasing number of professional photographers are considering a RIP essential to achieve the highest degree of control from their printers.

Preparing Images for a Digital Photo Lab

Desktop inkjet printers have made it easier and more affordable for photographers to make their own prints. That said, printing to an inkjet printer is not always the best or most economical printing solution. Digital photo labs are often the best source for smaller 4 × 6-inch and 5 × 7-inch prints, and for larger fine art prints.

The services of professional digital labs often fall into two separate categories: prints 8 × 10 inches and below, and large-format printing. Smaller files are printed on a Digital Minilab machine like a Fuji Frontier. These printers expose photosensitive paper with red, green, and blue lasers to transfer your digital images to paper. The paper is exposed to a minimal amount of chemistry to fix the print, and since there is no ink involved and very little chemistry, these prints are very archival. Prints from these machines are good quality, and it

is often less expensive to have a minilab make small prints than it is to print them at home.

Larger prints are made on an Océ LightJet or a Durst Lambda printer that is the size of a compact car and prints on a 48-inch roll. Like the smaller minilabs, these printers use lasers to expose the image on photosensitive paper. The image quality from these printers is outstanding and the archive life is excellent. The brilliance of the LightJet prints is something to behold. This is a great option for photographers who want to make large prints, but don't want to spend a lot of money for a wide-format inkjet printer and a RIP.

Choosing the Right Lab

When you were shooting film, did you take your film to the 1-hour photo or to a professional lab? If you were happy with the results you received from the local 1-hour photo for your film, you may want to consider using them for your digital prints as well. The turnaround is fast and the prints are very inexpensive. If you only trusted your film to a professional lab, I suggest you continue to trust them with your digital printing.

Developing a relationship with a high-quality lab is essential for achieving the best prints. Communicating effectively with my lab has saved me thousands of dollars as they are often able to foresee a potential problem in the way a file is set up, a bad paper choice, or an incorrect color setting. A good lab has the experience of printing thousands of digital files and they will often share that information with you if you ask the right questions.

It is important to remember that the customer service rep behind the counter is not clairvoyant. You need to communicate to them your expectations for the print, along with the print size and paper type. I suggest that you first ask yourself, "What do I intend to do with this print?" Will you frame it? Is this a simple snapshot or an image that is really important to you? What size print would you like? Once you have these questions answered, you are ready to begin asking questions at your lab.

Questions to Ask Your Lab The first question I ask my lab is, "What printer will you be using to print my files?" If I want a good print, but not a great one, or the finished print size is less than 11 × 14 inches, I would expect the file to be printed on a minilab machine like the Fuji Frontier. If this print is very important, I want to hear that they will be printing to a wide-format photographic printer like the LightJet, or to a wide-format inkjet printer like the Epson 9600 driven by a professional-quality RIP. If the customer service rep doesn't know, quickly pivot on your heel and make a beeline for the nearest exit. If a lab can't give you the most basic of information, they don't deserve your business.

Next I ask for their file preparation guidelines. For minilab prints, I'll accept some pretty vague answers, but if it is obvious that I've stumped them, I'll leave. If it is a large print or a fine art print I want specific information on file size, image resolution, color space, and file type. A top-notch lab will have a prepared flyer or web page containing the specifications. A lab that has

this information readily available tells me that 1) they value my work by making it easy for me to prepare files for their machines, and 2) they value their own time and have an efficient workflow in place. Incorrectly prepared files are the bane of the professional lab as they disrupt the workflow and printing queue, and result in a higher than normal percentage of jobs that need to be reprinted. Again, if your lab doesn't have this information, I suggest you take your work somewhere else. If the lab provides you with a custom ICC profile for their wide-format printer, you know they are serious about quality. Color management in a digital lab is the equivalent of process control and chemistry testing for the film lab. Would you take your important film to a lab where they never checked their chemistry?

If a lab is color managed, I will often ask them how often they linearize their machines or calibrate them back to their profile. Linearizing and calibrating bring the device's output back to a known state, either a factory default or a profile. This helps to ensure print consistency from day to day as all devices have a tendency to drift. A lab that performs frequent calibration will produce identical prints today, next week, and next year. This is particularly important if you think you might produce multiple fine art prints from a single negative. The lab I use calibrates their LightJet back to their profile once in the morning when they print on glossy paper and a second time in the afternoon when they print matte.

The fourth question I ask for important jobs is whether the print price includes a printed proof. For all of my fine art work I will always soft proof the image and make a hard proof on the same device that will print the final job. It gives me that extra peace of mind before spending the money for a large print.

My final questions to the lab involve the specifics about my print. What are my paper choices? Are they able to do any in-house framing or mounting? This helps me get an idea of whether this lab is capable of handling my entire job, or if I need to take my print to an outside framer. I've encountered a few framers who are reluctant to take digital prints for fear that they might damage them. A lab that can put together a finished print gets higher marks in my book.

You'll notice that none of my questions involves price. If I am taking my files to a professional lab to be printed, I expect to pay a little more. It has been my experience that I get better service, have fewer reprints, and end up with a nicer print than I do if I try and save a few dollars. For an important photograph, the premium you pay for professional-quality service becomes insignificant over the life of the print and the enjoyment you receive from having a stunning piece of art hanging on your wall.

If you are hesitant to ask your lab for guidance, or they simply don't know the answers to your questions, I've compiled some quick rules of thumb for submitting files to minilab printers as well as wide-format machines. If you receive instructions from your lab that differ greatly from these guidelines, you may want to ask them why.

If they don't have a good answer, you may want to do a test print before giving them an important print order.

Preparing Images for a Digital Minilab
Most digital minilabs make prints up to 8 × 12 inches, while a few models are able to crank out 11 × 14-inch prints. These are high-volume machines that make good quality, inexpensive prints. It is very rare to find a minilab that uses color management, so don't be surprised if the minilab operator gives you a blank stare when you ask what color profile you should be submitting your files in. These machines assume that a file is in the sRGB color space. Files submitted in the Adobe 1998 color space tend to look flat and lifeless when they are printed, so I strongly recommend converting your images to sRGB before delivering them to a minilab.

Preparing Files for a Digital Minilab Make sure that you've already saved your high-resolution, layered master file to your hard drive. You always want to have a full-resolution master file for making future adjustments to the file and to give you the flexibility of printing to several different printers.

Step 1 Flatten the image. This can be done either from the Layer menu (Layer | Flatten Image) or from the fly-out menu on the Layers palette. This fuses the corrections from your adjustment layers onto the original image. Sending layered files to your lab is a sure way to invoke their displeasure as it may choke their RIP and bring their workflow to a grinding halt.

Step 2 Set the image to the correct print size. The quickest way is to use the crop tool to simultaneously crop and resize the image for printing. Choose the crop tool from the Toolbox and enter the print's width and height along with the image resolution specified by your lab. If possible, I try and set my image resolution to 300 ppi at the finished print size. Be forewarned; if your image is smaller than the dimensions specified in the crop settings, Photoshop will upsample the image to reach the desired size. If I'm unsure whether I have enough data to reach my target resolution, I set the Width and Height fields and leave the Resolution field blank. I can then set the appropriate resolution in the Image Size dialog box. Draw your crop and press ENTER or RETURN on your keyboard. Your file is now set to the correct size for printing.

Step 3 If your image is in high-bit mode, be sure to convert it to 8-bits/channel before sending it to the lab (Image | Mode | 8 Bits/Channel). High-bit files are another no-no for your digital lab. Very few service providers are able to accept high-bit files. I always manually check either the Image | Mode menu or the title bar to make sure I don't inadvertently deliver an unprintable file to my lab.

Step 4 Using the Convert To Profile command (Edit | Convert to Profile), convert your document from your current working space to sRGB. Minilab machines don't understand color management and simply assume that the file has been prepared for sRGB. This isn't an ideal situation, but it is what we have to work with, so I highly recommend converting to sRGB to make sure your colors print accurately.

Step 5 (Optional) Add Unsharp Mask to the file. This is always my last step before saving the file. I never add any more than slight sharpening to my master files, but always sharpen my print files based on the type of output and print size.

Step 6 Now save a copy of the file in either TIFF or JPEG format. Make sure that your file does not contain Alpha Channels or Layers. JPEGs can't have either, so many labs will request them for that reason. I always put the finished print size in the filename so that I can quickly identify my print-ready files from my master files. If I'm ordering prints at several different sizes, I'll make a folder for each print size and save my files into the appropriate folder.

Minilab Preflight Checklist

- ☐ Flatten image.
- ☐ Crop and resize to finished print size and resolution.
- ☐ Convert to 8-bits/channel.
- ☐ Convert to sRGB.
- ☐ Sharpen for output.
- ☐ Save print-ready image as TIFF or JPEG.

does an amazing job of upsampling an image with very little artifacting. For images that do not contain the necessary image resolution at size, I uncheck the Resample Image checkbox in the Image Size dialog box and enter the width and height of the finished print. I submit that file as is, without any interpolation and let the LightJet take care of it.

Preparing Images for the LightJet or Lambda Printer Wide-format printers like the Océ LightJet and the Durst Lambda are carefully controlled, precision machines capable of making stunning prints. The cost of the machine and the skill level of the technician running it cause prints from wide-format printers to be more expensive than those from a minilab. The quality of the prints more than justifies the cost for important prints, but extra care must be taken when preparing files for wide-format printing to make sure you don't ruin a $150 print due to a careless mistake.

To prepare images for a LightJet printer, follow steps 1, 2, and 3 from "Preparing Files for a Digital Minilab." It is not uncommon to fall below the recommended printing resolution for large prints. The LightJet printer

Steps 1 through 3 Follow the first three steps from "Preparing Files for a Digital Minilab."

Step 4 If the lab provides a color profile for its LightJet, I always soft proof the finished output. I've been able to head off some unpleasant surprises with a quick soft proof. Open the Custom Soft Proof dialog box from the Proof Setup menu and choose the profile that matches the wide-format printer and paper type you will be printing to. I'm preparing my image to be printed on the LightJet with Fuji Crystal Archive Matte paper. I use Relative Colorimetric for my rendering intent and check Black Point Compensation. Toggling the Preview

checkbox on and off helps identify tones or colors that will shift in the finished print. Choosing OK and exiting the soft proof dialog keeps the soft proof active and allows me to make changes to the file and further target the image for printing.

printer. When the LightJet upsamples the image, it has a tendency to sharpen the image as well. It takes a little practice to get a feeling for exactly how much sharpening to add. If it is an important print and you are concerned about over-sharpening, I recommend printing a second proof containing an important section of detail. See the section "To Proof or Not to Proof?"

Step 5 After making final adjustments to the file based on your soft proof, convert the image to your final print space using the Convert To Profile command. If your lab requests that you give them files in the Adobe 1998 or sRGB color space, convert your file, if necessary, at this time.

Step 7 Save a copy of the finished file. Include the print dimensions and an abbreviation of the paper type in the filename. In this case, I use FM to denote Fuji Matte paper. Be sure to embed the appropriate color profile and check to make sure there are no layers or alpha channels in your file.

Step 6 Sharpen your image for output. I add much less sharpening on files destined for the LightJet than I would for an inkjet

Wide-Format Printing Checklist

- ☐ Flatten image.
- ☐ Crop and resize to finished print size and resolution.
- ☐ Convert to 8-bits/channel.
- ☐ Soft proof using lab's ICC profile (optional).
- ☐ Convert to lab's ICC profile or lab's preferred color space.
- ☐ Sharpen.
- ☐ Save a copy of the finished file.

To Proof or Not to Proof? With the improvements in color management and the advent of soft proofing, some have wondered whether or not a hard copy proof is as important as it used to be. For any important prints, particularly large prints, I always have a proof. Soft proofing is very accurate and very helpful for making critical color decisions, but the monitor is a different medium and I feel more comfortable making my final judgments on a hard copy proof.

For *really* important prints, I will create a second proof to judge an important area of detail. The first proof is usually the complete image, printed at 8 × 10 inches for critical analysis of tone and color. The second proof is an 8 × 10-inch cutout of an important area of detail printed at 100 percent of the final print size. I've found this invaluable for testing image sharpness.

To create a detail proof, duplicate your print-ready image (Image | Duplicate). Choose the rectangular marquee tool, then in the Options bar set the Style to Fixed Size. Enter the size of the proof in the Width and Height fields.

Click to draw the marquee around the most important area of detail. Reposition the marquee by clicking inside the selection and dragging the marquee. For this 20 × 40-inch panorama, I wanted to test the detail on the face of Half Dome.

Finally, choose Image | Crop to create an 8 × 10-inch section of your final image. I print this along with the traditional proof of the full image to test color, tone, and image sharpness.

Going Big: Image Interpolation

When you trip the shutter of your digital camera, the size of your image is determined by the size of the camera's sensor. The number of pixels in your image divided by the image resolution gives you your print size. If you want a larger finished print than your current print size, you need to interpolate, or upsample, the image by adding pixels to the image to make up the difference. This section will give you the information you need to make large prints from your digital files.

How Many Pixels Do I Need?

The first step is to figure out how many pixels you currently have and how many pixels you need for your final print. To find your image's current size, use the Image Size (Image | Image Size). Look at your current image resolution. At 72 ppi, the image size listed is not indicative of what you can expect for a finished print size. 72 ppi is too low of an image resolution for a good quality print. Ideally, you want to have between 240 and 300 ppi for the best print. Uncheck the Resample Image checkbox. This locks the image size, but allows you to adjust the image resolution. Set the image's resolution to 300 ppi. This gives you a good baseline idea of the print size you can make without interpolating your image. It is always preferable to print without image interpolation if possible. Image interpolation is getting better all the time, but it can't create detail that wasn't present in the original file. For that reason, it is always better to scan at the highest scan resolution and capture at the camera's highest quality settings.

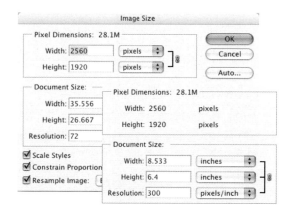

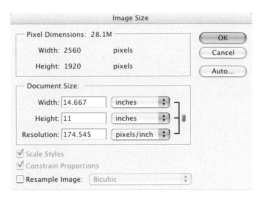

This image has a document size of 36 × 27 inches at 72 ppi. At 300 ppi, your desired resolution for printing, the image size drops to 8.5 × 6.5 inches.

Note The file size of an image does not always correlate to the number of pixels the image contains. JPEG and RAW files are able to compress the image data into a smaller file size, while still preserving all of the pixels from the camera's sensor. For example, I never use the TIFF mode on my digital camera. Although the file size is larger on the card, camera TIFFs contain exactly the same number of pixels as a JPEG at the highest quality setting or a RAW file.

Let's say that I have 11 × 17-inch paper loaded into my printer and I would really like to make an 11 × 14-inch print of this image. At the native image size, at 11 × 14, I will only have 175 pixels per inch—not enough for printing. I'm going to need to add pixels to this image to reach my desired print size. I have several interpolation methods at my disposal.

Image Interpolation Methods

Before I upsample this image, I'll walk you through the pros and cons of several of the most commonly used method of upsampling.

Adobe Camera Raw The Workflow Options palette in Adobe Camera Raw gives you the opportunity to upsample your raw file during processing. Common wisdom held that this was the best method of upsampling in Photoshop. The results from my interpolation test (see the sidebar "Testing Interpolation Methods") showed Camera Raw to be a good method of interpolating images, but not the best. It scored consistently lower than both methods of interpolation within Photoshop on all types of images though the differences were very slight. Upsampling in Camera Raw does have the workflow advantage of being very quick, but Camera Raw interpolation is limited to 200 percent.

Testing Interpolation Methods

I've always been a bit of a skeptic, particularly when it comes to the claims surrounding image interpolation. In preparation for this book, I wanted to sort fact from fiction regarding different interpolation methods. I created a composite test image containing elements from four different digital camera images. I wanted to be able to compare the interpolation methods on skin tones, smooth gradations, high-contrast edges, and a synthetic target with fine diagonal lines. The composite image was created in Photoshop and each image was individually sharpened using the Smart Sharpen feature prior to upsampling.

The first phase of the test used five different methods to upsample the original image 200 percent. This is representative of taking an 8 × 12-inch file and printing it at 16 × 24 inches. The second phase of the test used four different methods to upsample the original image 400 percent. This is to simulate enlarging an 8 × 12-inch file to 32 × 48 inches. (Adobe Camera Raw is limited to 200 percent upsampling so it was excluded from the 400 percent test.)

I wanted to make the test indicative of the results a normal user would encounter in a typical printing environment. None of the images were taken in a studio or on a tripod. After upsampling, the images were printed on an Epson 4000 using the Epson Print Driver and Taos MicroPore Luster Paper at 1440 dpi with High Speed turned off. The back of the prints was labeled with the interpolation method and the prints were shown to nine photographers and imaging professionals. The testers were asked to rank the images from best to worst based on image quality.

Overall, the quality of the finished prints greatly exceeded my expectations. I was impressed by the level of detail contained in the 400 percent interpolations, particularly in the portrait. Fine detail like the pores of the subject's skin, hair, and eyebrows held up very well. Choosing between the different interpolation methods was a difficult process and more than one photographer commented that the differences between the processes were negligible. As impressive as these tests were, the interpolation methods are still no match for having enough image data in the original capture. Although the software is able to do a good job of "guessing" what the missing pixels should look like, it simply isn't possible for the software to add detail that isn't there in a file from a smaller megapixel camera, but is present with a larger megapixel camera. All things being equal, the camera with the larger sensor will always come out on top. For more information on the interpolation tests, visit the *Perfect Digital Photography* website at:

www.PerfectDigitalPhotography.com to download the complete test results.

Bicubic Smoother Photoshop offers five choices in the Interpolation menu. Of the first three, Bicubic has long been the preferred interpolation option. In Photoshop CS, two new choices appeared on the scene, Bicubic Smoother and Bicubic Sharper. Both are variants on the Bicubic method engineered for different purposes. Bicubic Sharper is designed to give a better image when downsampling. It adds a slight bit of sharpening to the edges of

the image to eliminate the need for additional sharpening to compensate for the image softness introduced while downsampling. Bicubic Smoother is of more interest to this discussion as it is designed to give a better result while upsampling. In the interpolation tests, using Bicubic Smoother interpolation to reach the desired print size in a single pass consistently scored high across all types of images in both the 200 percent and the 400 percent tests.

Step Interpolation Before Bicubic Smoother was introduced, photographers went to great lengths to find the best method of upsampling images using the standard Bicubic interpolation method. Some found that increasing the image size in small increments gave a better result than increasing the image size in a single pass. This form of step interpolation has been adapted to work with the new Bicubic Smoother interpolation. Instead of making lots of small increases in file size, the Bicubic Smoother algorithm is better suited toward a 50 percent increase in file size. To use step interpolation, check the Resample Image box and choose Bicubic Smoother from the Interpolation menu. In the Pixel Dimensions field, change the increments setting from pixels to percent and type 150 into either the Width or Height field. Choose OK. Repeat the process until your desired image size is reached.

The combination of Step Interpolation with Bicubic Smoother narrowly edged out the single-pass Bicubic Smoother on a regular basis, though some testers found the two to be virtually indistinguishable. If you are printing an image with lots of fine detail, on a glossy or semi-gloss paper, you may find the step interpolation method to be an improvement over the single pass. It is slightly less convenient from a workflow perspective, but for those photographers who want the highest image quality, multiple passes of Bicubic Smoother is the best option without needing to purchase a plug-in.

Interpolation Plug-ins Interpolation plug-ins like the venerable Genuine Fractals and Smart Scale from Extensis are sophisticated interpolation programs offering the greatest control over the interpolation process. Smart Scale provides control over the overall image sharpness, edge contrast, and the preservation of edge detail. The testers preferred the results from Smart Scale more often than any of the other interpolation methods because of the sharpening Smart Scale adds to the images. The only disadvantage to Smart Scale is the additional cost of the software. If you routinely print large files, Smart Scale is a handy tool to have at your disposal.

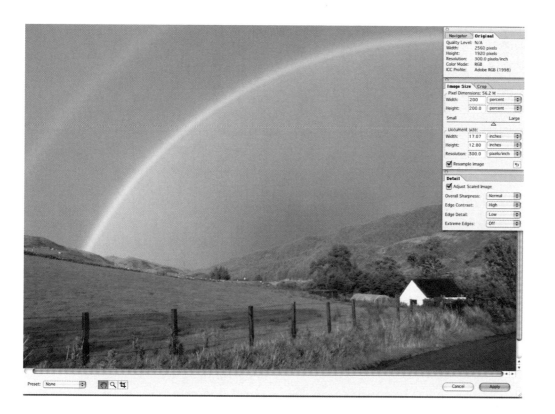

Printer Driver The last interpolation method tested was to send the file at its native image size. For the 400 percent interpolation test, this meant sending a 75 ppi file to the printer. At close examination, the prints visibly lagged behind other methods; however, at a distance of six feet it was very difficult to see any difference between the low-resolution file and the others that had been upsampled. At 200 percent the image quality was comparable with the other methods making Scale To Fit Media a viable option for slight upsampling although I wouldn't use it for any large jumps in image size.

Based on the results from the Interpolation tests, I've chosen to use the step interpolation method to increase my image to 11 × 14 inches. Since I knew I wanted to make a large print of this image, I exported the file in 16-bits/channel to improve the quality of the upsampled image. Having the high-bit data is

particularly beneficial in keeping the smooth transitions in the image during interpolation.

The first pass with the Bicubic Smoother interpolation set to 150 percent gives me an image that is 12.8 inches wide by 9.6 inches tall.

A second increase of 150 percent would give me an image that is too large, so I skip to the Height field of the Document Size and enter my finished size of 11 inches. The width is slightly longer than the 14 inches I need for my finished print, but I can easily crop to my final print size. I want to be sure to sharpen my image at the new size before printing.

Preparing Images for the Internet

The Internet has caused a revolution in the way that we access information. Today it is quicker for most people to do a Google search than to thumb through the phone book. The venerable Yellow Pages are quickly becoming antiquated. Our methods of sharing photos are changing as well. Internet photo albums and personal web pages allow the sharing of images around the world. It is becoming more commonplace to see someone carrying photos of their spouse and children on a PDA than as prints in a wallet. The Internet opens up exciting new possibilities for blending images with sound, movement, and text into entirely new forms of visual storytelling.

Resolution and Quality Settings for the Web

Although your output medium may be changing, there is still a need to optimize your digital images to fit the parameters of your output device. In this case, your output device is a computer monitor displaying images over the Internet.

Image Quality vs. File Size The great tradeoff with images destined for the Web is to balance image quality vs. image size. Even though broadband Internet is becoming increasingly common, it has not totally displaced dial-up connections for access to the Internet. A page of images that is too large takes a painfully long time to load and even broadband users quickly become impatient with web pages that don't load quickly. So, for every image destined for the Web or email,

you need to reduce its size and compress the data intelligently so that you still preserve the quality of the original while making for a quick download.

Save for Web Since computer monitors display pixels in a coarser arrangement than printers, you are able to reduce your file sizes considerably by throwing away a large number of pixels. A quick rule of thumb is to resize your images to your expected viewing size at 100 ppi. Sending any more information than that is slow to download and a display larger than the size of the screen causing the viewer to have to scroll to see the image. I find that images around 600 × 800 pixels in size are large enough to see detail, but not too large that they clog in-boxes and cause lengthy download times.

Tip *Convert to sRGB*: The Internet lacks widespread support for color management, which makes it difficult to achieve consistency in how the colors in an image appear on various monitors. For this reason, we recommend converting all images destined for the Internet to the sRGB color space. sRGB was designed to represent the "average" Windows monitor and has become a best-guess target for Internet images.

The Save For Web feature in Photoshop helps to find the balance between file size and image quality. I've already resized this image to 600 × 800 pixels, converted it to sRGB, and am ready to use Save For Web (File | Save For Web) to prepare it for the Internet. Many of the features found here, like slices, color

palettes, and matte colors, are for professional web designers creating an entire site. We only need to use a limited range of features to accomplish our goal. I suggest selecting the 2-up view from the palettes at the top-left portion of the Save For Web (SFW) dialog box. This allows you to see your original (left) and compressed (right) images side by side for comparison. The goal in SFW is to make the quality setting as low as possible without introducing a noticeable loss in image quality.

Step 1 Begin by changing the image Preset from Unnamed to JPEG-High and bring the Image Size palette to the front by clicking on it. If you forget to resize your image prior to entering SFW, you can do so in the Image Size palette.

Step 2 Compare the important details in the original image on the left with the optimized image on the right. Are you noticing any loss of fine detail or sharpness? Are areas of solid color looking blocky or patchy? If the answer to these questions is no, then reduce the quality setting slightly.

Step 4 Immediately below the optimized image are the statistics for the compressed image. By choosing a JPEG with a quality setting of 40, I am able to compress the 1.4M original to just under 70K. My new image takes up only 5 percent of its original size!

Step 3 At a quality setting of 50, my image still looks very good. At 40, it looks pretty good as well. At a quality setting of 30, the hills behind the castle are beginning to look splotchy with odd color patches, so I bring the quality slider back to 40.

JPEG
67.21K
25 sec @ 28.8 Kbps

40 quality

Step 5 It's time to save our compressed image. I like to place compressed files into a separate folder labeled Web and include "web" in the filename to help me identify which files are appropriate for emailing.

Creating a Web Photo Gallery

Now that you are able to save a single image for the Web, you're probably wondering how you can save an entire group of images for the Web, particularly if you don't know any HTML code or web design programs. Fortunately, Photoshop makes it quick and easy to build professional-looking Web Photo Galleries (WPG).

Step 1 The first step is to select a series of images in the Bridge or File Browser. SHIFT-click to select a series of contiguous images or CRTL-click or CMD-click to select noncontiguous images.

Step 2 From the Photoshop section of the Tools menu, choose Web Photo Gallery.

Step 3 From the Styles menu, choose the type of web gallery you would like to create. You will probably need to experiment to find the style you like best. Enter your email address in the space provided. Most of the gallery templates display your email address, and a few even let the viewer of the gallery send you an email directly from their web browser.

Web Photo Gallery

Site

Styles: Centered Frame 1 – Info Only

Email: jay@prorgb.com

Source Images

Use: Selected Images from Bridge

Choose...

☑ Include All Subfolders

Destination... Seagate:Users:jaykinghorn:Desktop:

OK

Cancel

Options: General

Extension: .htm

☐ Use UTF 8 Encoding for URL

☑ Add Width and Height Attributes for Images

☐ Preserve all metadata

Options: General

Extension: .htm

☐ Use UTF 8 Encoding for URL

☑ Add Width and Height Attributes for Images

☑ Preserve all metadata

Options: Banner

Site Name: Asia Travel Gallery

Photographer: Jay Kinghorn

Contact Info: 303–474–4577

Date:

Font: Arial

Font Size: 3

Options: Large Images

☑ Add Numeric Links

☑ Resize Images: Large 450 pixels

Constrain: Both

JPEG Quality: High 8

small large

File Size:

Border Size: 0 pixels

Titles Use: ☑ Filename ☐ Title

☑ Description ☑ Copyright

☐ Credits

Font: Arial

Font Size: 3

Options: Thumbnails

Size: Large 100 pixels

Columns: 5 Rows: 3

Border Size: 0 pixels

Titles Use: ☑ Filename ☐ Title

☐ Description ☐ Copyright

☐ Credits

Font: Arial

Font Size: 3

Step 4 The Use portion of the Source Images section should be set to Selected Images From Bridge. Click on the Destination button to set a destination folder that the web gallery and the accompanying files will be placed in. This should be a folder separate from your image library that contains only the WPG.

Step 5 The Options menu houses six submenus to customize the look and the content of your Web Photo Gallery. Use the following screenshots as a template for setting up your first WPG, then customize the settings to suit your needs. I've omitted screenshots for the Custom Colors and the Security menus as I leave them at the default settings. When you've configured your WPG, click OK to build the gallery.

Step 6 After Photoshop completes the gallery, it will open in your default web browser. Depending on the type of gallery you've chosen, you can view the file's metadata through the Image Info tab.

Once you've checked to make sure the gallery was built successfully, you can FTP the files to your personal or company website. If you have other pages on your site, you will need to rename the index.htm file unless you want the WPG to be the first page seen by visitors to your website.

The 21st Century Slideshow

The term "slideshow" often conjures memories of being trapped in a stuffy basement watching Bill and Irma's endless slides of their trip to Europe. The 21st century slideshow is a multimedia presentation blending text, music, and images. Easily created and easily shared, modern slideshows just might banish the negative connotations of the word slideshow from your memory.

PDF Presentation Building a PDF presen-tation in Photoshop is the easiest way to create a 21st century slideshow. All that is needed to view the presentation is the Adobe Reader, available as a free download from the Adobe website. To create a PDF presentation, start by selecting images in the Bridge exactly as you did when you created the Web Photo Gallery.

Step 1 Once the images are selected, select PDF Presentation from the Photo-shop portion of the Tools menu. The images selected in the Bridge are shown in the Source Files pane. You can add, remove, or reorder files using the Browse, Duplicate, and Remove buttons, though I find it easier to make adjustments to the quantity or order of files in the Bridge. Select PDF Presentation from the Output Options and set the duration your images are displayed in the Advance Every field. I find the most attractive transition in the PDF Presentation menu to be None.

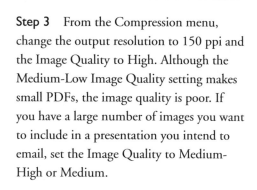

Step 3 From the Compression menu, change the output resolution to 150 ppi and the Image Quality to High. Although the Medium-Low Image Quality setting makes small PDFs, the image quality is poor. If you have a large number of images you want to include in a presentation you intend to email, set the Image Quality to Medium-High or Medium.

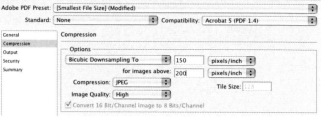

Step 2 Save the presentation. In the Save Adobe PDF dialog box, choose Smallest File Size from the Adobe PDF Preset menu. Leave the Standard at None and make sure the Compatibility is set to Acrobat 5. Earlier versions of the Adobe Reader (then called Acrobat Reader) do not support the JavaScript used to advance the slideshow.

Step 4 In the Output menu I like to set the Color Conversion to Convert To Destination and the Destination profile to sRGB. This helps the images display consistently on all computers. As an extra precaution, I include the Destination profile, especially since the increase in file size is negligible.

Note Photoshop CS and Photoshop Elements users will not see the additional options listed in steps 3 and 4.

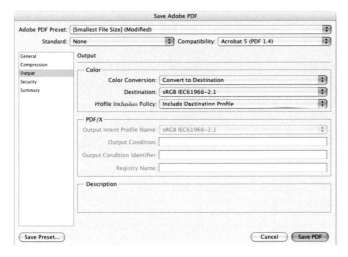

Multimedia Presentations

CHAPTER 16: PRINTING AND OUTPUT

Step 5 PDF documents support 128-bit encryption to protect your sensitive documents. I don't often add password protection to my PDF presentations, though I might restrict printing, editing, and other tasks if I'm sending the file as a promotional piece to someone I don't know. For this presentation, I'll forgo the security. I can trust you, can't I?

Lastly, click Save PDF to create your presentation. The PDF presentation opens in full-screen mode to display your images against a black background. To exit full-screen mode, press the ESCAPE key to return to the normal window.

Taking the slideshow concept one step further, programs like iPhoto, Extensis Portfolio, and iView Media Pro can create QuickTime movies from your slideshow presentation. These multimedia formats blend images, text, and music to create a rich experience for the viewer. The way that we share and display photography is rapidly changing. The photo-capable iPod is a prime example. It is a photo album, music player, calendar, address book, and hard drive rolled into one. The convergence of electronic music, digital photography, and digital video in formats that are accessible to the average consumer will continue to create new hybrids that defy current artistic categories. I am very excited to see what new uses photography will have in the near future. Although the medium may change, the essential core of photography will be to capture that moment in time that tells a story about us as human beings and the world we live in.

HOW TO: THE FINE ART PRINTING PROCESS

I love the art of printmaking. While I enjoy the process of sculpting and shaping a digital image, I get the most satisfaction from seeing the finished print. For me, it is the best means of sharing and enjoying the fruits of my labor. I wanted to give you some insight into how I prepare an image for printing. Duart Castle sits on the southwest coast of the Isle of Mull in the Hebridean Islands of western Scotland. For several days the weather had been classically Scottish with gales blowing sheets of rain off the Atlantic, but for a brief window, the rain stopped and the clouds lifted. Sunlight splashed across the verdant hillsides and I took this picture of a landscape that, to me, exemplifies Scotland.

Step 1
To prepare the image for printing, I open the raw file through Adobe Camera Raw and adjust exposure, contrast, and white balance. Before opening the image in Photoshop I set my crop to a 2:1 ratio for a finished 20-inch by 10-inch print and choose to export the image at 16-bits per channel since I know I will need to upsample the image in Photoshop to reach my desired print size.

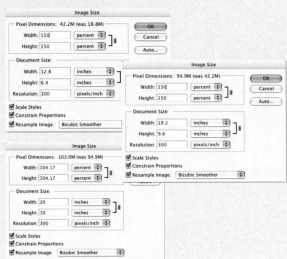

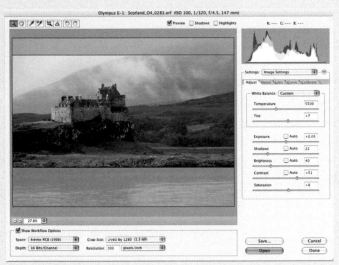

Step 2
My first step in Photoshop is to bring the image up to its finished print size. I do this through three passes of Bicubic Smoother interpolation. The first two passes each increase the image size by 150 percent, and the last by 104 percent.

Step 3
Next, I perform my image corrections on separate adjustment layers. I want to make the sunshine (a rare thing in Scotland in the fall!) more prominent and darken the clouds behind the castle to make the castle appear brighter. The image on the top is the original file without corrections. The image on the bottom, along with the Layers palette, shows the corrections I've made to the image. At this point, I will save this layered file as my master image. This file can be reused to print on different media or can be flattened, resized, and used on the Internet. The rest of the changes I'll make to the image are print-specific, so I don't want to save them as part of my master file.

Step 4

I activate the Soft Proof tool (View | Soft Proof | Custom). I will be printing to Epson's Enhanced Matte paper, so I choose a custom ICC profile I've created for that paper on my printer. I click OK to leave the soft proof active while I continue to work on the file.

Step 5

The soft proof shows me that the deep shadows on the cliff below the castle are going to lose detail. So I'll bring them back into the printable range with a Levels Adjustment layer. I increase the shadow value of the Output levels until the abrupt transition disappears from the face of the cliff.

Step 6

I want to increase the saturation of the greens in the image, but want to make sure that I don't over-saturate colors beyond what the printer can print, so I turn on the Gamut Warning feature, which places a gray overlay on out-of-gamut colors. Next, I create a new Hue/Saturation Adjustment layer and add 10 points of saturation to the image. This makes the green grass more vibrant.

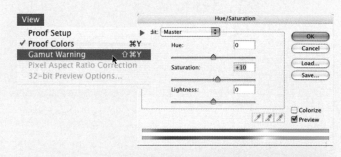

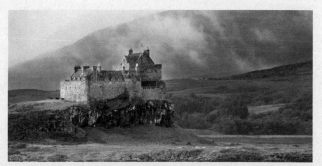

Step 7

I feel that the soft proof of the image looks a little flat. To add some contrast to the image to give some extra punch to the print, I create a new Curves Adjustment layer and add an S-curve to add contrast through the midtones. This accentuates the splash of sunlight on the west side of the castle and helps visually separate the castle from the background.

Step 8

Before sharpening, I turn off the Gamut Warning and Soft Proof. I'll use the new Smart Sharpen feature, which does an amazing job of sharpening digital camera files. I set my full image to 50 percent zoom for an effective preview of the finished print, while using the Smart Sharpen preview window at 100 percent to assess critical detail. I find the Amount setting of 250 and the Radius of 0.8 to my liking in the Lens Blur mode with More Accurate checked.

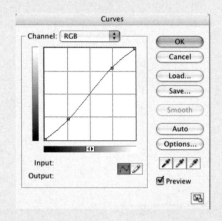

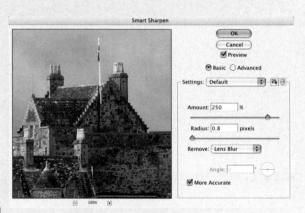

Step 9

I'm now ready to print. I'll check to make sure that I have the media type chosen in the print driver and that No Color Adjustment is checked.

After printing, I'll let the print dry on a flat surface for 24 hours, then spray the print with Premier Art Print Shield Lacquer to protect the surface of the print from scratches and ultraviolet light.

WORKING in BLACK and WHITE

The era of Ansel Adams, Edward Weston, Minor White, and their contemporaries is widely considered to be the zenith of modern photography. Black and white prints from this period contain a luminance and a grace as expressive and as captivating as any photographs made before or since. As photographers began to transition to digital printing, it was the color processes which arrived first. The brilliance of colors, the quality of the detail, and the rapid results allowed color digital prints to be adopted very quickly into the photographer's repertoire.

Sky Pond, Rocky Mountain National Park, Colorado,

As inks, papers, printers, and techniques have improved, digital black and white prints are beginning to gain the nod of approval from dedicated aficionados. This chapter is dedicated to the pursuit of the elusive black and white print. Along the way, we'll discuss several techniques for converting color images to black and white that range from simple to complex.

CONVERTING from COLOR to BLACK and WHITE

Unless you are working with scanned black and white film, you have a color image that needs conversion to black and white. There are several methods of converting color images to black and white that range from quick and simple to complex and precise. I'll give you a rundown of the most popular conversion methods along with recommendations on when to use each.

Convert to Grayscale

Grayscale is one of the simplest methods of converting a color image to black and white. This conversion blends a preset amount of red, green, and blue tonal information to achieve a black and white version of the original image. Although quick, this method produces only average black and white images, with slightly above average results on portraits of Caucasian skin tones. To make a grayscale conversion:

The color image used for each of the black and white conversions

Step 1 Choose Image | Mode | Grayscale. Choose Flatten if you are prompted to flatten the image.

Step 2 Convert the image back to RGB if you intend to colorize the image or add a sepia tint (Image | Mode | RGB).

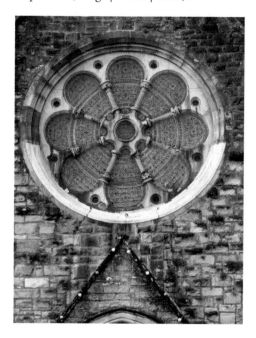

Convert Using Lab

When we convert a color image to black and white, we want to extract the luminance or tone information and throw away the color. Converting through Lab Color mode allows us to do just that. Unlike RGB and CMYK where tone and color are interrelated, the Lab Color mode stores tonal information in the L channel, and color information in the a and b channels. It is a fairly simple procedure to strip the a and b channels from an image in Lab mode and retain the important tonal information. To convert through Lab Color mode:

Step 1 Convert the image to Lab (Image | Mode | Lab Color).

Step 2 Open the Channels palette (Window | Channels, if it isn't currently visible) and click on the Lightness channel so that it becomes the only channel highlighted. Drag the a and b channels to the trash icon at the lower-right corner of the Channels palette.

Note After trashing the first color channel, the two remaining channels will become Alpha 1 and Alpha 2. Keep the channel that looks like a black and white rendition of your image and trash the channel that looks like an underexposed black and white negative.

Step 3 Bring the image back to RGB mode by first converting it to grayscale (Image | Mode | Grayscsale), then to RGB (Image | Mode | RGB Color).

I favor this method of BW (black and white) conversion when I need to convert a large number of images. I am able to automate this conversion with a Photoshop Action (see Chapter 18). The Lab conversion produces a consistently acceptable BW image across a wide range of image subjects.

Converting with Channel Mixer

Channel Mixer is the most precise of the conversion methods outlined here and consequently produces the best results. It is also the technique that requires the most skill as it takes some practice to really refine a BW conversion using the Channel Mixer. The trick is to spread your adjustments out over two or three separate layers and not try to make the entire conversion at one time. With Channel Mixer it is easy to drive your fine highlight or deep shadow detail to all white or all black. Having your changes distributed across two or more layers allows you to use layer masks to protect your highlight and shadow information when making strong tonal corrections. To convert using Channel Mixer:

Step 1 Create a new Channel Mixer Adjustment layer from the Create New Fill and Adjustment layer icon at the bottom of the Layers palette, and check Monochrome at the bottom of the dialog box. Channel Mixer defaults to using 100 percent of the Red channel for the conversion. Our goal in Channel Mixer is to blend information from the individual color channels into one black and white image. There is no magic recipe for red, green, and blue percentages, as the adjustments we make are dependent upon the image content and the look we are trying to achieve in the finished image.

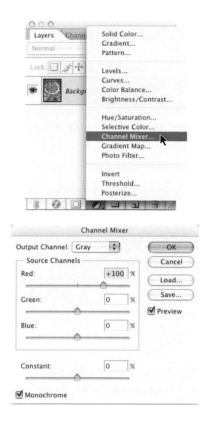

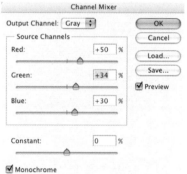

Step 2 In this first Channel Mixer layer, our aim is to create a base conversion that will set the overall tone and contrast of the image while allowing us to make slight adjustments to the Highlight, Midtone, and Shadow values independently in subsequent adjustments. If you want to map a specific color like a blue sky to a particular tone, you want to make the adjustment on this layer.

Step 3 Now we'll begin independently adjusting the Shadow, Midtone, and Highlight portions of the tonal range. I like to work on the highlights first to anchor the image. To select the Highlights, use the Color Range command (Select | Color Range) and choose Highlights from the pull-down menu. Click OK. Feather this selection 1 pixel (Select | Feather) and create and name a new Channel Mixer Adjustment layer for the highlights. The selection becomes a layer mask for the new Channel Mixer layer and will restrict the changes we make on this layer to the highlight areas of the image.

Step 4 Increase or decrease the Red slider to lighten or darken the highlights. Move your cursor over important highlight detail in the image and check the Info palette to make sure you aren't clipping important highlight information.

Note From this point forward, it is safe to make all of your tonal changes with the Red slider. Attempting to balance the individual color channels has no effect on the tonality of the image.

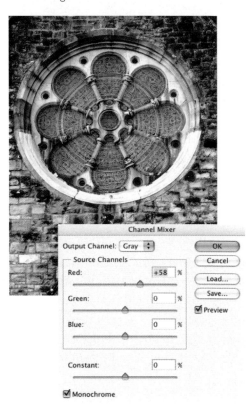

Step 5 Repeat step 3 for the midtones.

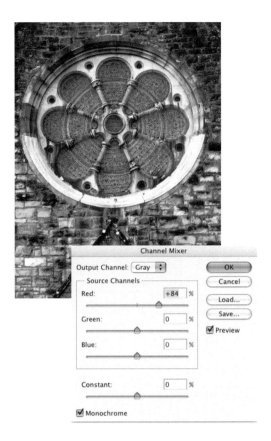

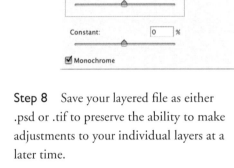

Step 6 Repeat step 3 for the shadows.

Step 7 After making your adjustments, feel free to fine-tune the overall look of the image by adjusting the values in the Channel Mixer layer, or paint on the layer masks to selectively lighten or darken specific areas of the image.

Note Be sure to make your Channel Mixer adjustments on high-bit files whenever possible. Radical corrections in Channel Mixer can introduce posterization to the shadows or add mottling to continuous-tone areas such as sky.

Step 8 Save your layered file as either .psd or .tif to preserve the ability to make adjustments to your individual layers at a later time.

Converting Through Adobe Camera Raw

Russell Brown of Adobe came up with an ingenious method of making black and white conversions in Adobe Camera Raw (ACR). Making your BW conversions to a raw file preserves the integrity of the file as the adjustments are always made to the high-

bit information before processing. Now that Photoshop CS2 allows you to place a raw file as a Smart Object you can make several BW conversions of a single raw file, each targeting a specific tonal range. To create black and white images using Camera Raw:

Step 1 Adjust the Exposure, Shadows, and Brightness normally. For black and white as well as color, it is important to have a true highlight and a true shadow to maximize image contrast.

Step 2 Reduce the saturation slider to −100. This removes the color information from the image.

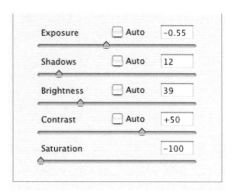

Step 3 Set the Contrast slider visually to add or subtract contrast from the image. Alternatively, use the Curve palette to make specific tonal corrections (Photoshop CS2 only).

Step 4 Play with the Temperature and Tint sliders in the Adjust tab as well as the Red, Green, and Blue Hue and Saturation sliders in the Calibrate tab to simulate

traditional black and white filters. The adjustments made to the Calibrate sliders give results very similar to Channel Mixer, although they are less predictable.

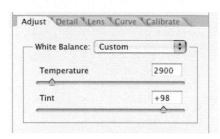

Step 5 When you are finished, you can either save those settings as a BW preset or open the image into Photoshop for further editing.

I find that I am increasingly making my black and white conversions in Camera Raw as opposed to using either Lab mode or Channel Mixer. I can make strong changes to the files without creating posterization as sometimes occurs when using Channel Mixer on 8-bit images. It is also faster for me to make a base BW conversion in ACR and apply those settings to the rest of a shoot if I want to batch convert a large group of images.

The four options listed here are simply an overview of several different methods of creating black and white images. Black and white is one of the most exciting aspects of digital photography. No longer do you have to choose between black and white or color. You can have both, sometimes simultaneously, as I'll demonstrate in the next section on hand-coloring black and white images and adding a sepia tone to BW photos.

The finished black and white images. From left to right: Grayscale, Lab, Channel Mixer, Adobe Camera Raw

HAND-COLORING DIGITAL BLACK and WHITE IMAGES

Hand-coloring black and white photos in Photoshop is only slightly less time consuming than hand-coloring traditional black and white photos. The advantage of doing it in Photoshop is that it is less tedious and provides a greater degree of control over the finished tints and the balance of colors. I really like the softer color palette that comes from this method of hand-tinting. It gives an image a timeless, slightly ethereal quality that is sometimes missing from full-color images.

The full-color image

To tint digital images:

Step 1 Duplicate a color version of the image you wish to hand color (Image | Duplicate). I prefer to tint images that haven't been converted to black and white, but the technique works the same provided you have a color original and the image you wish to tint is in RGB mode. By defini-tion, grayscale doesn't allow any color information.

Step 2 Tile the images so that you can see both the color and the soon-to-be-tinted images (Window | Arrange | Tile Horizontal). Create a new Hue/Saturation Adjustment layer on the tint image and reduce the Saturation to –60. This leaves a little color in the background and reduces the amount of hand-coloring you have to do.

Step 3 On the tint image, create a new image layer and set the Layer Blending mode to Color. Name the layer by double-clicking on the layer name.

Step 4 Using the Eyedropper tool, click on an area of the color image to set that color as the foreground color. Choose the Brush tool and select a medium-sized brush with a low hardness setting. Keep the opacity at 100 percent. Target the newly created layer on the Tint image and begin painting. The Color Blending mode preserves the underlying tonal information while blending the new color information taken from the color image. I painted all of the foreground flower petals with the same color (see next page, top left). The natural variances in hue are a result of the underlying tone. At this point, the color looks slightly unnatural. I'll adjust that in a little bit after painting the remaining elements. If you make an errant paint stroke, either use the Undo command (CTRL-Z or CMD-Z) or use the Eraser tool located below the clone stamp to erase the offending pixels.

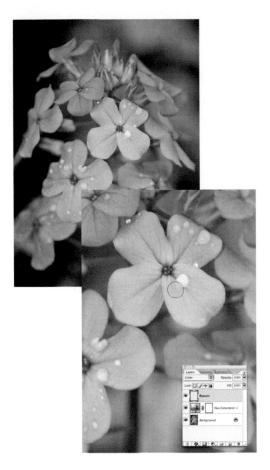

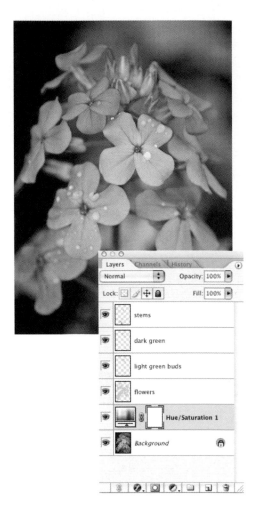

Step 5 Repeat step 4 for each of the remaining elements of the photo. I made one layer for the flower buds on the top of the stem, another for the stems themselves, and a third for the light-green portion of the flower buds. Each time I used the Eyedropper to sample color from the corresponding element in the color photo. Since this is a time-consuming process, don't forget to save your image frequently.

Step 6 At this point the colors in the image don't look very well balanced, and as a result, the photo is a bit garish. The first step is to bring back a little more color to the background. Open the Hue/Saturation Adjustment layer by double-clicking on the Hue/Saturation icon and bring the Saturation back to −45. Next I reduce the opacity of the individual layers to give the image more balance and more of an

antique look. I reduce the flowers, light-green, and dark-green layers to 60 percent, and reduce the stems layer to 50 percent. This causes the image to more closely resemble a traditional hand-colored black and white image.

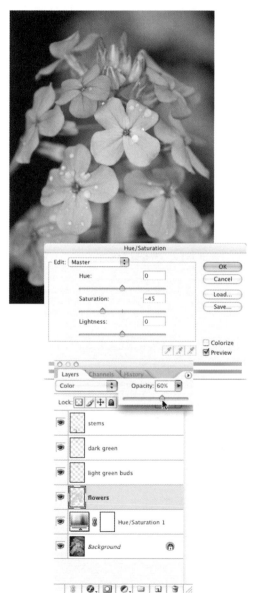

This technique produces very nice results when printed on watercolor or other fine art paper.

Tinting, Sepia Toning, and Split Toning

Photographers spent huge amounts of time in the darkroom experimenting with the addition of subtle tints and tones to black and white prints. Much more predictable and easier to achieve, digital toning, like its analog counterpart, falls into three categories: tinting, sepia toning, and split toning. I'll demonstrate a method for simulating each process. For all three, I'll begin with a black and white photo of a gravestone in an old cemetery in Charleston, South Carolina. The black and white is a little stark and ominous. Let's add some color and see what we come up with. Feel free to experiment with different tints, colors, or effects.

Life Forever More, Charleston, SC

Tip Tinting Gotcha! Make sure that your image is in RGB mode before attempting to add a tint. Grayscale images can't have any color to them. If you need to convert, simply choose Image | Mode | RGB Color.

Tinting

Tinting is a simple process of adding a color overlay to a black and white image. The easiest way to accomplish this in Photoshop is to create a new Hue/Saturation Adjustment layer and check the Colorize box. This adds a color tint to your image. Control the color of the tint with the Hue slider and the intensity of the tint with the Saturation slider. For a sepia tone, set your Hue in the 30–40 range and set your Saturation to 20 percent. I chose to add a cool blue tint by setting the Hue at 218 and setting the Saturation at 12 percent.

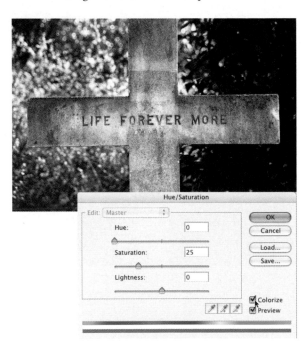

Sepia Toning

Sepia toning a digital black and white image does carry a certain sense of irony. We're using the latest in technology to try and convincingly make images look antique. It is a very popular technique for a very good reason. Sepia-toned images are imbued with warm nostalgia. One method of replicating this effect is to use a Photo Filter Adjustment layer.

Step 1 Create a new Photo Filter Adjustment layer. From the drop-down menu, choose Sepia. The Density slider controls the intensity of the tint. I set the Density at 46 percent. Initially this is too strong, but in the next step I'm going to pull some of the color out of the highlights and midtones to make the sepia toning look more natural.

Step 2 In the lower-left portion of the Layers palette, just to the left of the Add Layer Mask icon, lies the Layer Effects icon. We don't use this much, but this icon holds the key to one of Photoshop's best-kept secrets—the Blend If sliders. Access them through the Blending Options tab of the Layer Effects. In the resulting Layer Style dialog box, we want to focus our attention on the Blend If sliders at the bottom. If we bring in the highlight portion of the This Layer slider, Photoshop will blend the contents of this image with the underlying layer. In this case, Photoshop will drop the sepia tint out of the highlight layers, while leaving the tint in the midtones and shadows.

Step 3 Move the highlight slider toward the center until you begin to see the sepia tint disappear from the highlights and brighter midtones. Once you've reached that point, ALT-click or OPTION-click on the highlight slider to split it into two pieces. Continue to move the leftmost slider toward the midtones until the two pieces are separated by a difference of 20 or so levels. This will smooth the transition from tinted to untinted and give a more subtle tone to the image.

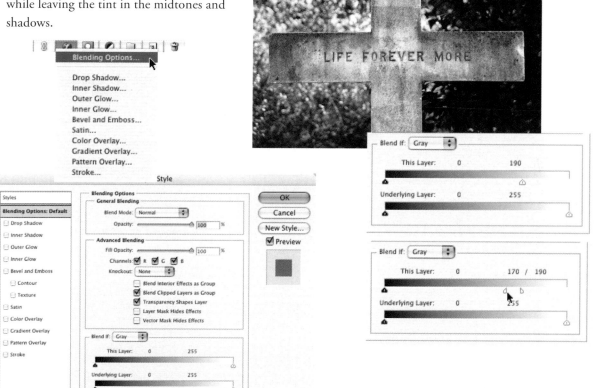

Split Toning

Split toning is an advanced darkroom technique using two different toners to apply different tints to the highlights and the shadows. We'll accomplish this digitally through the use of a Curves Adjustment layer.

Step 1 In the Curves dialog box, access the Blue channel and set one point in the center of the curve, place a second in the shadows, and a third in the highlights. Increase the amount of blue in the shadows by raising the shadow point as shown. Add yellow to the highlights by dropping the highlight point slightly. Try not to put too radical of a kink in the curve, otherwise you'll end up with an abrupt change from one color to another.

Step 2 Add some red to the midtones and highlights while adding some cyan to the shadows as shown. These aren't curves that you need to replicate exactly, but these

curves can give you an idea of where to start. If you find that your curve adjustments change the tonality of your image, switch the Layer Blending mode from Normal to Color.

The finished image has an interesting blend of cool shadows, purple midtones, and sepia highlights. Which version of the image do you think is the most evocative?

PRINTING BLACK and WHITE IMAGES

Printing images in black and white would seem to be a rather simple exercise. Use only

the black ink—right? Actually, printing black and white images is at least as complex as printing color images. Blending seven colors of ink or three primary lasers so that the gray tones in the image appear neutral is a difficult task considering the mechanics of the printer and the complexity of the human eye.

Unfortunately, the quality of digital black and white prints directly correlates to the cost of acquiring the necessary hardware and software to make them. As your demand for better black and white prints increases, the lighter your pocketbook will become. Here's a quick rundown on the options available to you in terms of black and white printing quality and price.

- **Generic ICC profiles for your inkjet printer** When designing the behavior of a printer, companies must choose between maximal color saturation or gray balance. Until recently, saturated colors sold printers, black and white didn't, so printer manufacturers engineered their print drivers to put as much color on the page as possible at the expense of black and white printing. The upsurge of interest in black and white has resulted in new and exciting printers capable of producing brilliant BW prints right out of the box.

- **Custom ICC profiles for your inkjet printer** A custom ICC profile for the printer and the paper you use can be tailored for better black and white printing. This is the least expensive

improvement you can make for your BW prints. A custom profile goes a long way toward making your BW images neutral and can make a significant improvement in your color printing as well.

- **LightJet prints from a reputable lab** A high-quality digital lab can make beautiful black and white prints on their LightJet or Lambda printer. This is often the least expensive solution if you print a few black and white photos, or would like to make large-format prints up to 48 inches wide.

- **Carbon-pigment ink sets** These ink sets replace your manufacturer's inks, transforming your color printer into a dedicated black and white unit. These inks start with black ink, then add two or more shades of gray. Some ink sets add cool-blue or warm inks to allow you to adjust the "color" of the finished print. These dedicated black and white packages have long been the best choice for digital black and white prints. The major downside to this approach is the need to have a dedicated black and white printer, as there are no colored inks in this ink set. For serious black and white enthusiasts, a dedicated BW system or a fine art RIP is the best choice for the highest-quality prints.

- **Software RIP** Photographers look to a RIP solution primarily for improved black and white printing and for a workflow boost when printing to large-format printers. Fine art RIPs take the place of the manufacturer's print drivers. They

offer superior control over the print engine and usually provide improved ICC profiles resulting in improved color accuracy. RIPs are only written for medium- to large-format printers. As a rule of thumb, you should expect to pay almost as much for the RIP software as you did for your printer. The two leading fine art RIPs that are both Macintosh and PC compatible are ColorByte's ImagePrint and ColorBurst's X-Photo.

A RIP on the Cheap

Roy Harrington's QuadToneRIP is an inexpensive, shareware RIP for black and white printing on the Macintosh and PC platforms for the Epson R800, 2100, 2200, 4000, 7600, and 9600 printers. Older Epson models can be used with the Ul-tratone inks from MIS. The QuadToneRIP produces high-quality black and white prints that rival prints from the more expensive RIPs. At the time of writing, the QuadToneRIP is available for a free trial download. If you use the RIP and you like it, Roy asks that you contribute $50 to the continued development and support of the product. In my preliminary tests, I was very pleased with the quality of the output and the ease of use. If you are looking for an inexpensive black and white printing solution, I recommend you download the trial version at www.harrington .com/QuadToneRIP.html.

Digital Prints from a Traditional Darkroom

A few photographers have begun to create hybrid black and white prints using an inkjet printer to produce a contact negative that is then printed using traditional darkroom techniques. More information on this unique process can be found in Dan Burkholder's book *Making Digital Negatives for Contact Printing* or on his website at www.danburkholder.com.

Special Considerations for Printing Black and White

Creating a beautiful black and white print requires that you look at the printing process with a different set of parameters. The black and white printing process requires that we are more attentive to color management, the types of ink and paper used to create the print, and the dynamic range between the darkest shadows and the white of the paper.

Image Neutrality

Achieving a neutral image from highlight to shadow is usually the cornerstone of any black and white printing system. It stands to reason that a good black and white image should not have any color in the finished print unless it is specifically added for an artistic effect. Unfortunately, this is much more difficult to achieve than one would think. Most manufacturers' print drivers have color impurities that creep into black and white images. This is caused by the necessity with

color inks to make shades of mid-light gray out of combinations of cyan, magenta, and yellow inks. The carbon-pigment ink systems solve this problem through the use of several different tints of gray ink. RIPs solve this by carefully controlling the ink percentages throughout the tonal range and removing yellow from the equation as much as possible.

Inks

Black and white photographers debating the merits of different types of inks focus their discussions on the print's archive life, print metamerism, and the density of black. These three concerns, along with the neutrality of the finished print, drive photographers' decisions about which printer to buy.

Archive Life Perhaps the most important question to ask when producing black and white prints is "How long will they last?" Ultrachrome inks have undergone the most testing at the Wilhelm Imaging Research facility. Their tests show a print permanence of between 60 and 100 years for prints framed behind glass. Most dye-based inks have an archive life of less than 30 years, making these inks too fugitive to be called truly archival. New formulations of dye inks show promise for print permanence, but the tests are highly paper-dependent on swellable media at this point. The strictly carbon-pigment inks appear to be the most archival of the black and white printing methods; however, it is currently difficult to find independent research on carbon-pigment print longevity. I suggest thoroughly researching any carbon-pigment

system for its archival life prior to purchasing. The archive life of prints made from the Frontier, LightJet, and Lambda printers has been tested to be in excess of 60 years for framed prints kept behind glass.

Metamerism Technically, metamerism is a phenomenon where two colors are a visual match under one light source, but are not a visual match under a second light source. Practically, this phenomenon manifests itself as a print that shifts colors under different light sources. This is particularly noticeable in black and white prints as our eyes are better able to perceive slight shifts in color in a black and white print than in a color print. Ultrachrome inks have a tendency to turn pink under cool white fluorescent lights. Both the Image Print and X-Photo RIPs reduce the amount of yellow in black and white prints to reduce metamerism and for better image neutrality. Dye inks don't suffer from metameric changes as considerably as the Ultrachrome inks, and prints made on Fuji Crystal archive are better still. It is possible to tailor custom printer profiles for a light source other than the assumed standard of 5000K to help reduce print metamerism. Since the carbon-pigment ink systems are not using colored inks to make gray, the incidence of metamerism is greatly reduced with these inks.

The Richness of Black The density of black is particularly important to black and white prints because it controls the richness of the shadows and the overall contrast of the finished print. This print contrast,

measured in D_{max}, is a common source of comparison between papers and inks. A weak black produces tepid shadows and a flat print because the overall difference between white (the paper color) and black (the maximal black of the ink) isn't as great as it should be. Prints made with a good, rich black have crisp shadows and a wonderful contrast range.

Dye inks are able to achieve a deeper, richer black than pigmented inks, with a D_{max} on glossy paper as high as 2.9. The Ultrachrome Photo Black is weak on matte papers. Because of this, Epson offers the Matte Black ink, which gives much deeper blacks on matte and fine art papers. The Matte Black ink and carbon-pigment ink sets have a D_{max} of 1.6 to 2.0 depending on the paper used. This is comparable to a traditional silver print, which has a D_{max} of 1.9 to 2.2.

For most photographers, choosing which printer to buy is a matter of finding the best compromise between printing color and printing black and white. For that reason, the Epson printers with Ultrachrome inks usually come out on top although the new dye inks from HP are strong challengers. Rabid black and white enthusiasts will have to carefully weigh their options to choose the ink that strikes a balance among print quality, archive life, and print contrast.

Paper

Choosing the right ink for printing black and white involves a number of tradeoffs to balance both your color and black and white printing. Paper choices, on the other hand, are much more flexible. With most printers it is possible to choose a matte paper for black and white prints and a glossy or luster paper for color prints. Selecting a paper for black and white printing is a subjective process as every photographer has their own preferences for paper color, finish, and paper weight.

An array of fine art papers. From left to right. Epson Somerset Velvet, Epson Radiant White Watercolor Paper, Arches Infinity 230gm Smooth Fine-Art, Arches Infinity 355gm Textured Fine-Art, Moab Entrada 190gm Bright White, and Epson Enhanced Matte.

The first important piece of information you need to make a paper choice is to find a paper that is compatible with the inks in your printer. This is less of an issue for matte papers than it is for glossy color papers. Matte papers are more absorbent and are more versatile than glossy or luster papers. Next, you need to make sure you can physically run the paper through your printer. While almost any lightweight fine art paper is flexible enough to run through your paper feeder, heavyweight fine art paper and posterboard need to be run through the printer flat, requiring a rear paper feed.

Now that you've met the physical requirements for making a print, you'll need to make some aesthetic decisions regarding the thickness and the finish of the paper. I strongly suggest experimenting with a number of different papers to find the one that best matches your aesthetic tastes.

When handling fine art papers, be sure to use a pair of cotton darkroom gloves to keep the oils from your hands off the surface of the paper. Gregory Schern of Moab Paper Company recommends using a drafting brush to sweep the fine cotton dust from the paper factory off the face of the paper. After printing, it is a good idea to lay the prints on a flat surface to let the ink dry for 24 hours before matting or mounting the prints. When storing prints, try to lay the print flat, and separate prints with a piece of tissue paper to prevent the surface of the paper from scuffs and scratches. A frame with an acid-free matte or a UV spray will help protect the print. A few simple steps can go a long way toward

How Do the Experts Choose a BW Paper?

I asked two experts in the field of digital black and white printing how they choose a paper for their fine art printing.

Paul Roark is widely considered to be the guru of digital black and white printing. His black and white prints are on permanent display at the Gallery Los Olivos in Los Olivos, California. "I look for a paper that is buffered and acid-free with a good D_{max} (1.6 minimum for matte, 2.0 minimum for glossy). For maximum longevity, a paper without optical brighteners and an appropriate surface texture (I like smooth)."

Kyle Bajakian is the former program director for photography and digital imaging at the Anderson Ranch Arts Center in Aspen, Colorado. An accomplished darkroom technician, Kyle is currently an adjunct photography instructor at the University of Colorado and Naropa University. "I look for a paper with good image sharpness, D_{max}, and durability. I prefer papers with a warm tone, as I am not so fond of bright white papers."

maximizing the longevity of your print. Who knows, today's images might become tomorrow's heirlooms.

Controlling Print Tonality and Tonal Range

Critically important to black and white print quality is the preservation of shadow detail. Unless you are printing through a RIP, there will be some clipping of the shadows caused by

the print driver. A series of simple tests allows you to target the values in your image to the printable range of your printer.

Download the Highlight and Shadow test file from the *Perfect Digital Photography* website (www.PerfectDigitalPhotography .com). Open the test image in Photoshop.

Step 1 Print the test target using Print With Preview and your preferred print profile, paper type, and driver settings.

Testchart © 2004 Jay Kinghorn RGB Imaging
All Rights Reserved

The highlight and shadow test chart

Step 2 Under an appropriate viewing light, examine the highlight and shadow steps. Look for the deepest shadow square that exhibits difference from its neighbor. This shows the deepest shadow that your printer is able to reproduce. Repeat the process for the highlights. At which point can you differentiate very light gray from paper white? Write down these numbers on a sheet of paper. This print made on Arches Infinity Smooth Fine-Art paper shows a loss of detail in shadow values less than 18 and a loss of highlight detail at values above 252

when printed on the Epson 4000. This is very typical of the Epson print drivers.

Step 3 Create a new Levels Adjustment layer. Enter the values from step 2 into the Output Levels fields. This compresses the image information, in this case the test chart, to the printable range of the printer.

Step 4 Print the test chart again. This time all the shadow and highlight squares should be visible, and the abrupt banding in the shadow area of the grayscale ramp should have disappeared.

Step 5 Now, test this output Levels Adjustment on an image containing important shadow detail. If you find that your prints look a little too flat, reduce the value in the shadows of your output Levels correction. I like to have some true blacks in my prints to help "anchor" the image. Given the above example, I would experiment with setting my shadow correction at 15 instead of 18 so that a few areas of the image print as solid black.

HOW TO: THE FINE PRINTING PROCESS and ME
by Jack Duganne

Master printmaker Jack Duganne, one of the original architects of digital fine art printmaking and the originator of the term giclée, is currently teaching all levels of Photoshop at Santa Monica College in the Academy of Entertainment and Technology.

In the early years of Nash Editions, he became a one-man research and development department, testing inkjet printers and qualifying inks, substrates, and coatings for use in the digital printmaking process. He has worked as a consultant to the printmaking industry for 20 years.

Throughout his career, Duganne has freely shared his knowledge with printers and emerging artists. He currently runs his own studio at Duganne Ateliers, printing fine art digital prints for artists. He also runs Workshop, a co-operative studio in Santa Monica, which is home for 12 artists of varying disciplines.

Printmaking became a way of discovery for me a long time ago. I was first exposed to printmaking when I was referred to an artist by the name of Max Hein at UCLA. He was a graduate student in the design department and had a studio on the top floor of the art department building. I had been looking for a way to create large prints of images seen through a microscope. I had the life-changing idea of showing the world what the little-seen universe of blood smears and stained pathology tissue would look like if it were created large and life-size. Max was working in a print media called photo-silkscreen. The whole process was vibrant and pregnant with possibility. I was hooked. My imagery didn't matter as much as the process anymore. The imagery was just a path into the possibilities that might occur when combined with other images and colors. My life path changed during that time. I had been studying pre-med and had always been drawn to the art of my painter wife. I was always mesmerized by her creations that seemed to evolve late at night in quiet studios under the house. And now I understood what went on, when I started playing with concept and color and form and, most of all, process!

The years following that rebirth were filled with discovery and learning. I moved from a house into a studio and started teaching photo-silkscreen printing. I worked on my own work using techniques found in primitive photography technique books and journals. I woke up each day with new ideas of new combinations of color and stencil that would create entirely new images. The process was intoxicating! Using this newfound technology, I set myself up as a master printer for doing other artists' work in a way never before realized.

I was now going in a new and different direction. This new direction, however, proved to be difficult. I was creating beautiful work for other artists and was spending all of my time doing it. I was working with a process that was extremely labor- and materials-intensive, not to mention the toxic element of the inks, cleansers, and wash-up solvents. I needed to simplify! I began to look for ways to make the whole process more efficient. I began to look to computers and computer technology to help me.

I discovered, one day, a process being used by the design department at UCLA. They had set up a studio in Westwood, California, for a machine from Japan called a Fuji printer. It was a combination of a large scanner and a drum printer. The drum was very large and it printed with four colors that were sprayed from nozzles, which moved across the drum while the drum was spinning.

When the drum stopped, the image that had been scanned earlier was now printed on a piece of paper that had been adhered to the spinning drum. I was amazed again! Only this time, I was not very impressed with the final product. It was very dull, drab, colorless, and the image was composed of many large dots. I found that unacceptable. As I was leaving the studio, however, I was shown an image that was beautiful. It appeared to be a color photograph of a woman in a wedding dress holding a bouquet of multicolored flowers. I was wrong! It was a print made on an IRIS printer—another type of inkjet printer similar to the large drum printer I had just seen. Now I was impressed!

I was directed to another source, a man named Steve Boulter, who sold the IRIS printers. He was working on a project with a color and computer scientist, David Coons. Together they were developing a series of prints on the IRIS printer for an artist by the name of Graham Nash. Graham Nash is a well-known musician who is also noted for a very large, private collection of modern and vintage photography. In addition, he is an accomplished and published photographer himself. Steve and David were helping Graham to create a body of his black and white photographs as IRIS prints on heavy Arches watercolor paper. David had written an algorithm that printed a full-tone black and white print from the four process colors printed by the IRIS printer. He is brilliant! The images printed from the IRIS were beautiful and impressive. I was hooked! I had to see more, learn more, and work with this new machine and technology. A new journey was created. I now needed to know everything I could about this new way of creating prints. It was the new printmaking!

In a short while, after I had been spending all of my time printing these new prints, another person appeared on the scene. Mac Holbert, who had been the road manager and personal friend and confidant of Graham Nash, had decided with Graham to start a small enterprise using the IRIS printer as a new business and venture. Mac wanted to get off the road and settle down with his wife and new baby girl in a situation that would allow more time with his family and allow him to pursue something new. He agreed to hire me as a printmaker and together we began the formation of a studio called Nash Editions. Mac was the head of the studio and developed ways of working and doing business that allowed it to thrive and grow. I was allowed to do as much R&D as was needed to make the printmaking side of the studio also expand. Mac had a deep knowledge of computer skills and understanding. He brought in graphics programs and Macintosh and Linux computer systems, which allowed for a greater and more developed exploration into this new world of computer-generated printmaking.

During the journey of the beginning days at Nash Editions, an artist for whom we had created a new body of work (which she was to hang at her annual Christmas show) raised the question about the name to call the process. I researched what I believed was to become a standard for printmaking soon. The process was too beautiful, the results too perfect, for it not to catch on with a bang! I came up with a word from the French language referring to the nozzle—which would have to be utilized in any digital printing machine—present or future. The word is *giclée*. That word has now become a standard in the lexicon of printmaking terminology.

As time went on, Nash Editions became more dedicated to the development of photographers and photography-based printmaking. After all, Graham Nash is a photographer and it was only natural that the studio pursued that direction. I left Nash Editions to form my own studio, Duganne Ateliers. The rest of this story is about that adventure and my preferences for those things that have become my trademarks of equipment, materials, and process.

I love color! All of my own work has been about color and the interaction of color to image. My choice of printers following my departure from Nash Editions was to

take color into account. I immediately started looking for printers, other than IRIS printers, which would be able to expand and evolve the possibilities of greater color gamut. Most printers of the time were only printing the process colors (cyan, magenta, yellow, and black), or a variation of those four colors by adding light and medium cyan and magenta and/or extra blacks. I wanted something more. I discovered a printer called the Colorspan DM12. It was a printer capable of printing the eight values of CMYK plus four new colors. The new colors were red, blue, orange, and green. I could not believe it! Here was a printer that had the ability to expand the limited 65,000 CMYK color gamut to a range that extended into the millions. The new printer that I am using now is the Epson 10600. It is a durable, efficient, high-resolution printer that is able to keep up the demands of a production, fine art printmaking studio. Work needs to be done on time and without flaws and the constant need to reprint. I also have a longevity requirement now because of the archival needs dictated by galleries, museums, and collectors. The Epson uses an Ultrachrome ink set that is pigment. That fact alone satisfies most of my clients who have those requirements.

I have also begun to work with some of the finer photographic printers, namely the HP DesignJet 130 and the smaller format, multicolor ink set printers—the Photosmart 8450 and, most recently, the Photosmart 8750, which has a new blue and three grays in the ink set groupings. They are a durable dye set which means that, when coupled with the swellable media from HP, the inks are in the archival range of over 80 years longevity. I have also started using the HP DesignJet 130 as a dependable proofer.

Proofing is one of my most critical and valued services. I will work with clients on an image until they are not only satisfied, but also happy with the results. Proofing in my studio is a process where the image is printed at a smaller size on the substrate and printer that is to be used for the final prints. We will print many, sometimes, in order to capture the color and essence of their artwork.

Papers and canvases, both hand- and machine-made, are open to investigation. I have made some of the most beautiful prints on unstable but gorgeous paper. Pedro Mayer, a famous and well-documented photographer, wanted to print on a paper made from bark. This bark is found in the jungles of his native Mexico and has an incredible look, color, and feel. To print on the IRIS, we had to move the heads back considerably because the paper is very thick in places and the heads of the printer can hit it and ruin the surface. After solving those problems, we found that the paper had a residual chemical makeup that causes the rich black and white imagery to start changing colors. The colors start going to red and gold and bronzes of green and blue. The changes delighted Pedro! He is a staunch supporter of archival inks and papers, but the organic nature of these ink and paper combinations charmed him. This happens from time to time in the creative proofing process. For this and other reasons too numerous to mention, we adhere to a time reserved for proofing with every artist.

Printmaking is now in the realm of plug and play. In the early days of trial and error and forging the printers to new levels of creation, we had fun and never knew the outcome of some of our effort, but that was the thrill of the process. I love the process and joy that comes from the random nature of its use. I love not knowing what the result might be, but continue to try many combinations of approach to see what might happen. This is for my own work only, of course, but the desire to start combining new and exciting digital printing technologies with the old hand-applied techniques of non-silver photography and even painting, drawing, and collage is calling me.

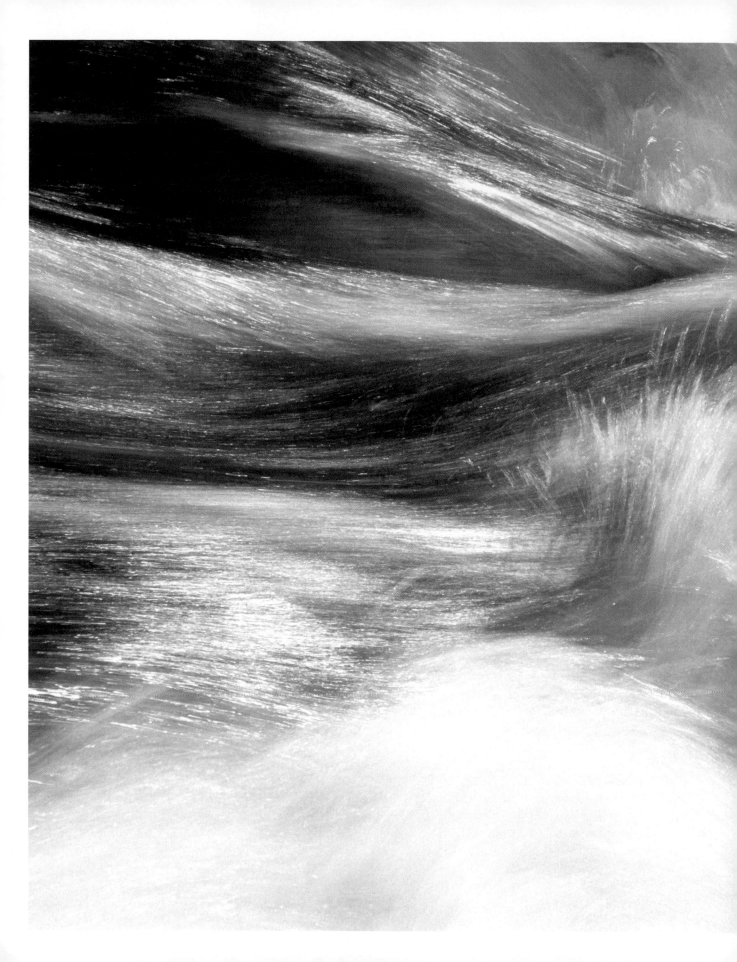

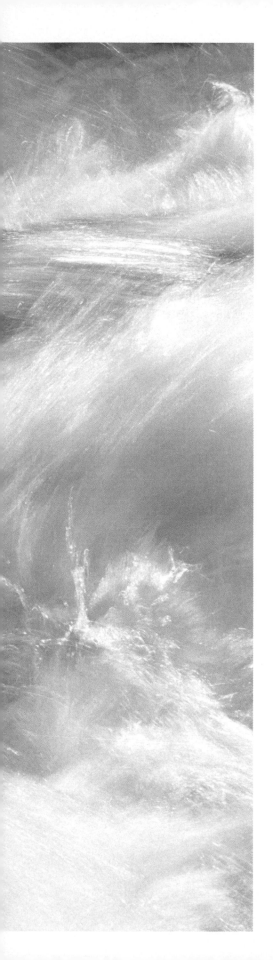

AUTOMATION and WORKFLOW

The digital darkroom has brought a tremendous degree of control and flexibility to the photographer. A direct result of this newfound control is that the photographer is now responsible for not just the photography, but also the developing, processing, cataloging, archiving, and storing of images. For professional photographers capturing hundreds or thousands of images per week, the time spent behind the lens comprises only a fraction of their time. For these high-volume shooters, having an efficient and effective workflow is critical to the success of their business.

Rushing water, Prince William Sound, Alaska

For amateur photographers, a solid workflow is no less essential. Your time is valuable. This chapter is devoted to maximizing the efficiency of your image processing workflow by streamlining each stage of the process and by using automation to eliminate repetitive tasks like renaming files or converting from TIFF to JPEG. This frees up more time for you to spend behind the lens.

AUTOMATION

Photoshop will never be able to assess image quality or composition or refine an image as well as you can. Therefore, most automated tasks focus on the most menial of image processing chores: image resizing, color space conversions, and building contact sheets. Photoshop has a number of built-in automation features, some of which we've already begun to use, namely PDF presentation and the Web Photo Gallery. In this section, we'll explore two other built-in automation features and learn how to build our own Actions to customize the image-automation process.

Contact Sheets

A staple of the black and white darkroom, contact sheets were traditionally used to help locate a particular frame on a roll of negative film. Digital contact sheets serve a similar function—to help locate an image on a CD, DVD, or in a folder. Photoshop makes it easy to build simple contact sheets from a group of images or an entire folder.

To build a contact sheet, target a group of images in the Bridge or File Browser. I used the Filter feature in the Bridge to show all images with the green label from my recent trip to Scotland. Select all images using CTRL-A or CMD-A, then access the Contact Sheet Generator through the Tools | Photoshop | Contact Sheet II menu.

For the Source Images, use Selected Images From Bridge. If you want Photoshop to add images contained in subfolders in the contact sheet, check Include All Subfolders.

The next section of the Contact Sheet II dialog box sets the size of the finished contact sheet. The default 8 × 10-inch size is great for printing on a full sheet of paper, but I recommend that you increase the resolution to 300 ppi for the highest quality thumbnails.

I've selected a total of 28 images for my contact sheet. The Thumbnails section gives you control over the size of the thumbnails on the finished contact sheet by specifying the number of columns and rows on a single page. I try to keep the number of columns and rows as equal as possible to create even spacing for both portrait and landscape images. The diagram below the OK and Cancel buttons tells you how many images your contact sheet will contain, the size of the thumbnails, and the number of pages needed to create your contact sheet(s). Currently the 28 thumbnails on my contact sheet will be roughly 1.5-inches square. I find that to be a little small for my liking, so instead of placing all the thumbnails on a single page, I'll spread my contact sheet across two pages. Decreasing the number of columns and rows from 5 and 6, respectively, to 4 each adds a half-inch to the width and three quarters of an inch to the height of the finished thumbnails.

Finally, I like to add the filenames to each of the thumbnails by checking the Use Filename As Caption checkbox. The font choices for your contact sheets are limited to the three pedestrian, yet functional, fonts listed. I find 12-point type to be sufficiently legible for my contact sheets. You may wish to decrease the point size if you have a large number of images on a single page.

Picture Package

Remember the packages of senior prints you bought in high school—two 5 × 7-inch photos for grandma and the 8 × 10-inch print Mom wanted for the mantle? The Picture

Package feature in Photoshop makes it quick and easy to make multiple print packages to give as gifts or to sell to the local Little League team.

The Picture Package command is located in the File | Automate menu.

The Picture Package dialog box

Mode Choose RGB color for inkjet printers.

Flatten All Layers Uncheck if you want to have access to the individual print layers in the layout.

In the Source Images section of the dialog box, by default, Photoshop builds a picture package with the frontmost open image. Typically this is sufficient, though you can also build picture packages from an individual file or folder of images.

Note Choosing a folder of images will create an entire picture package for each image (two 5 × 7s of picture 1, two 5 × 7s of picture 2, and so forth).

The Document section of the dialog box sets the size and resolution:

- **Page Size** Allows you to choose between three convenient page sizes for the finished layout.

- **Layout** Determines the size and quantity of the finished prints.

- **Resolution** The image resolution of the finished layout.

I rarely add a label to my Picture Package layouts, but some professional photographers need to add a copyright or other text to the finished images.

- **Content** Choosing Custom Text activates the Custom Text field to add a catchy slogan or contact information to the prints. The remaining options add copyright, image title, or caption information from the file's metadata.

 The remaining options in the Label section control the font, point size, location, and color of text added to the layout.

The Layout section provides a preview of the finished sheet. A little-known feature

in Picture Package allows you to substitute additional images in the layout by clicking on the thumbnail of the print. Choose a second image in the resulting dialog box and it is added to the layout.

Click OK to generate your Picture Package layout.

Photoshop Actions

Photoshop Actions are the backbone of any efficient digital photography workflow. Actions are used to resize images, convert between different file types, add a watermark, or convert from a digital camera profile to an editing space profile. Initially, creating Actions may seem intimidating. After all, you are effectively creating a mini–software program. Fear not: building simple Actions doesn't require that you learn any programming language or write software code; you only need to be able to use Photoshop. Photoshop records the steps you take, then allows you to play back your steps on a single image or on an entire folder of images. These are similar to the macros you may have used in Microsoft Word or Excel.

What Actions Can and Can't Do

Actions may sound like a dream come true, but there are limits to what you can do with them. First, no matter how great Photoshop is, it will never be as intelligent as you are. So you will have to make subjective decisions on what looks right. You can record these corrections into an Action, but Photoshop can't make the decision for you. Actions can't make specific brush strokes to remove dust spots on your CCD. You have to do this manually. Almost all of the other repetitive tasks like resizing, adding a watermark, or performing a color space conversion can be incorporated into an Action and automated. Actions are quick to build and easy to use. Let's start our tour with the Actions palette—central station for creating and playing Photoshop's Actions.

Looking at the Actions Palette

Before you can use an Action, you must first build an Action. And before you can build

an Action, you need to understand how to use the Actions palette.

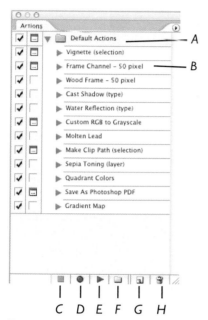

The Actions palette

A. Action Sets Group Actions together into folders for organization and backup. Action sets are created using the New Action Set icon at the bottom of the palette.

B. Actions Clicking on the disclosure triangle next to the Action set reveals all of the Actions contained in the set. Clicking on the disclosure triangle next to the Action reveals all of the steps contained in the Action. To play an Action, highlight it by clicking once on the Action's title, then click the Play button at the bottom of the Actions palette.

C. Stop Recording

D. Begin Recording

E. Play Action

F. Create New Action Set

G. Create New Action

H. Delete Action

Building Simple Actions

Sitting on your desk is a powerful piece of machinery capable of executing millions of calculations per second. You have on your desk (or in your lap) more computing power than NASA had when they sent Apollo 13 to the moon. Let's put some of that computing power to use by building a simple Action to resize a folder of images to 800×600 pixels for the Internet.

Step 1 In preparation for building the Action, open a full-size image in Photoshop to serve as your test image.

Step 2 You can't save individual Actions, only Action sets, so for your first Action, create a new Action set and title it Workflow Actions.

Step 3 With your newly created Action set highlighted, click on the Create New Action icon at the bottom of the Actions palette. In the resulting dialog box, name the Action 800 × 600 pixels and click OK. You'll notice that the Record icon in the Actions palette is now illuminated indicating that Photoshop will begin recording all of the commands you perform to the image and build them into the Action.

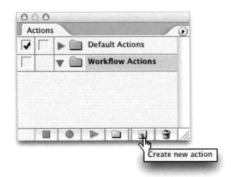

Step 4 Choose the Fit Image command from the File menu (File | Automate | Fit Image). Fit Image resizes by proportionally reducing the longest dimension of an image to your target size. This eliminates the need for separate Actions to resize horizontal and vertical images. To resize your images to 800 × 600 pixels, enter 800 in both the Width and Height fields of the Constrain Within section. This ensures that vertical and horizontal images are resized identically.

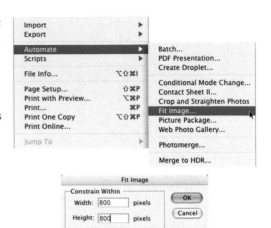

Step 5 Now you need to save a copy of the resized image in a separate folder. Create a new folder on your hard drive labeled 800 × 600 (see facing page, top left). Save the image as a JPEG and choose a compression of 7.

Step 6 Close the image (File | Close) and click the Stop Recording icon.

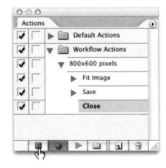

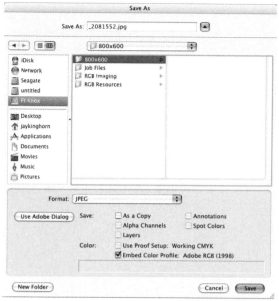

It is critical that you test your Action before running it on an entire folder of images.

Step 8 Open a second image. Run the Action by first highlighting the Action's name in the Actions palette, then clicking the Play Action icon.

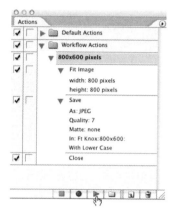

Step 7 Click on the disclosure triangles next to the Action's name and each of the steps of the Action. Notice that Photoshop has recorded a listing of each of the steps you've performed from the time you started recording until the time you clicked the Stop Recording button, including the values in the Fit Image dialog box and JPEG quality settings.

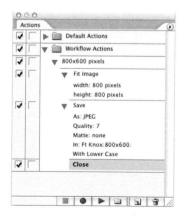

Step 9 Check the 800 × 600 destination folder to make sure the processed image was placed in the correct folder.

Step 10 Now comes the fun part. Launch the Bridge and select the folder of images you want to process (see top next page). If you want to process the entire folder, select all of the images using CRTL-A or CMD-A. Choose the Batch command from the Tools | Photoshop menu in the Bridge.

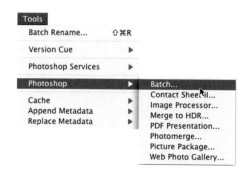

Step 12 In the Source field make sure Bridge is chosen and select Suppress File Open Options Dialogs and Suppress Color Profile Warnings. Suppress File Open Options Dialogs prevents Adobe Camera Raw from opening when a raw file is selected as part of the Action. Suppress Color Profile Warnings prevents the Profile Mismatch and Missing Profile dialog boxes from appearing. Both of these checkboxes override potential snags in the Action.

Step 13 In the Destination field you have three options: None, Save and Close, and Folder.

■ **None** Use this option when you've built commands into your Action to save files into a particular folder. This is what you'll use since as a part of your Action you specified that files should be saved into the 800 × 600 folder.

■ **Save and Close** This is a dangerous option. Save and Close overwrites your original file with the processed file. Only use this option if you are working on a duplicate set of files.

Step 11 In the Play section of the Batch dialog box, make sure that the Workflow Actions set is selected, followed by the 800 × 600 pixels Action.

- **Folder** When used in conjunction with the Override Action "Save As" command, Folder allows you to specify a separate destination from the one included in the Action. Let's say you want to save your resized images in a new project folder instead of the 800 × 600 folder. You would choose Folder, check Override Action "Save As" Commands, and use the Choose button to select a new destination for your images. Selecting Folder also gives you the option to rename your files as part of the batch process.

For your Action, you'll choose None for the destination since you want your images to be processed into the 800 × 600 folder. Your Batch dialog box should now look like this.

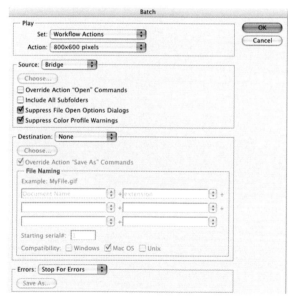

The Batch dialog box reflecting your selections for processing the 800 × 600 Action.

Click OK to begin processing your images.

Building Complex Actions

The previous Action was a basic example to show you how to create Actions and structure the steps in an Action. When creating complex Actions, it is important to think of all the possible "gotchas" and incorporate steps to address them so they don't cause your Action to fail. An example would be if you are sepia toning black and white images, you need to have a step to convert any grayscale images to RGB, otherwise the Action will fail.

It is also important to know that there are some steps in Photoshop that are not actionable. You can, however, specify a specific crop, add a watermark to your images, embed metadata, sharpen, and convert your photo to an output profile. When building complex Actions, I recommend testing them on a number of different images prior to running the Batch command. I also suggest leaving yourself an escape route whenever possible by using Adjustment layers and always adding preparatory steps to ensure that your Action accounts for different color modes, color spaces, file types, bit depths, and the presence of layers. You'll find Actions to be an indispensable part of your image processing in Photoshop.

Droplets

Droplets are encapsulated Actions that can be used outside of Photoshop. All of the processing of an Action is performed in Photoshop, but the Droplet can be accessed through your operating system or programs like Photo Mechanic and iView. Droplets are an effective means of tying together different elements of your workflow and making your processing between your editing and asset management programs more efficient.

Creating a Droplet Return to the 800 × 600 pixels Action we created in the previous example. Be sure that it is highlighted in the Actions palette and select File | Automate | Create Droplet.

The Create Droplet dialog box looks very similar to the Batch Processing dialog box with a few modifications. First, instead of selecting a source for the images, you will select the location where you want the Droplet

saved. Some photographers like to have their Droplets located on the desktop, others like to store them in a dedicated Droplets folder. For this exercise, we'll use the Choose button to save the Droplet to the desktop.

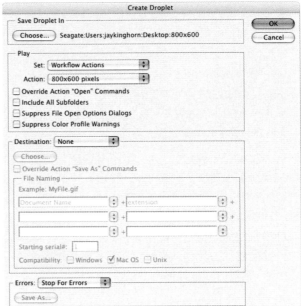

The Play section is identical to the Batch dialog box. Choose your set and your Action and select Suppress File Open Options Dialogs and Suppress Color Profile Warnings checkboxes as you did when processing the Action.

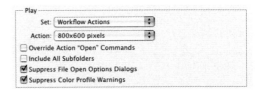

Set the Destination to None to send the images to the 800 × 600 folder we created

earlier. Be forewarned, if you delete the 800 × 600 folder or move it to the trash, Photoshop will still process the images normally, but they won't be anywhere to be found. Click OK to save the Droplet.

Once the Droplet has been created, you can use it several different ways. Here are a few ideas:

Step 1 Drag a folder of images to be processed onto the Droplet icon.

Step 2 Add the Droplet to your list of Helper applications in iView Media Pro. Do a keyword search or select a group of images and right-click (PC) or CMD-click (Macintosh) to access the contextual menu. Choose the Droplet from the contextual menu to process images using the Droplet.

Step 3 In Photo Mechanic, add the Droplet to the Droplets menu and choose Send Photos To Droplet to process images directly from Photo Mechanic.

Droplets are great tools for a photographer's image processing arsenal. As more third-party applications like raw file converters and asset management programs support Droplets, automating large aspects of your photography workflow will become easier.

Image Processor

Shortly after the release of Photoshop CS, the ebullient Russell Brown created a JavaScript that he distributed over the Internet, called Dr. Brown's Image Processor. It took advantage of the new JavaScript support for creating uber-Actions with user selections and a user interface. Dr. Brown's Image Processor was a hit and has been introduced into Photoshop CS2 as part of the standard installation. Although Adobe has dropped the Dr. Brown's prefix and spruced up the interface, the Image Processor is still an incredibly powerful automation tool for digital photographers.

The Image Processor is used for converting and resizing images from one file type to another; from TIFF to JPEG, Camera Raw

to PSD, or any combination in between. It can even be used to create multiple files in different formats from a single image. Many photographers use it to batch convert their adjusted raw images into PSDs or TIFFs. We'll use it to resize a number of images for the Web and will incorporate an Action to sharpen images during processing.

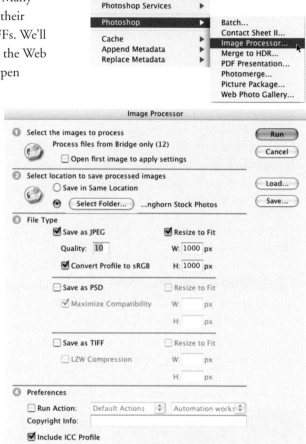

The Image Processor is accessed through the Bridge (Tools | Photoshop | Image Processor) or through Photoshop (File | Scripts | Image Processor). The Image Processor dialog box differs slightly depending on whether you access it from the Bridge or through Photoshop. Here's an example of accessing the Image Processor through the Bridge because this is the most common use of the script.

Step 1 To use the Image Processor, select the files you wish to process in the Bridge. Access the Image Processor from Tools | Photoshop | Image Processor. The Image Processor dialog box will show the number of files you've selected along with an indication that they were selected from the Bridge. If you are processing raw images, you may wish to check Open First Image To Apply Settings if all of your images will need identical corrections.

Step 2 Select a destination for your files. For this example, I created a new folder named Processed and Sharpened.

Step 3 Select the types of files you want. Image Processor will make a copy of the file for each file type selected and deposit it into a separate folder for each file type.

For example, if I select JPEG and TIFF, the Image Processor will create a JPEG file and a TIFF file and place the JPEG into the JPEG folder and the TIFF into the TIFF folder. Each file type can be resized independently so you can create full-size TIFFs and Web-sized JPEGs. In this example, I've opted to create a JPEG file with a quality of 7 and resize the image with the Fit Image command to 800 × 600, just as I did in our sample Action. I've also chosen to save a full resolution TIFF in a separate folder. For the JPEGs I've selected Convert Profile To sRGB to prepare the JPEGs for the Web.

Tip Don't check the Convert Profile To sRGB checkbox if any of your images are currently in the sRGB color space. This will cause Image Processor to fail.

Step 4 The new Image Processor allows you to incorporate a Photoshop Action into the Image Processor. I created a simple Action to add sharpening to the image using the Smart Sharpen command and selected it through the pull-down menus. I've also chosen to add my copyright information to the file's metadata and include the ICC profile to properly color manage my files.

If you use a particular set of image processing parameters regularly, you can save the settings used by the Image Processor and load them the next time they are needed.

Once you've saved your settings, start the Image Processor by clicking Run.

STORAGE

If the prospect of losing your entire photo library due to a magnetic aberration, fried hard drive, software glitch, or power spike keeps you up at night, take comfort in the fact that backing up your image collection is easy and inexpensive.

If your photos are not currently stored in at least two different locations, it's time to begin backing up your files. You should worry less about losing your digital photos than with film. It is prohibitively expensive to make duplicates of all of your transparencies and negatives. In the digital age it is possible to inexpensively make exact copies of your digital originals and to store them in several different physical locations. With film, if your basement studio flooded or your house caught fire, it is likely that you would lose your entire collection. With digital, you can have a copy of

your image library in your studio, a second at a neighbor's, and a third in a safe deposit box.

There are several backup solutions, from simple to complex. Choosing a system that meets your storage needs and that you will actually use takes a little bit of research. You have two primary avenues of storage for your digital files: optical media (CDs and DVDs) and magnetic media (hard drives). In this section, we'll weigh the pros and cons of each approach to help you pick the solution that will offer the best protection for your files at the best price.

Archiving to CD/DVD

The simplest method of archiving your images is to burn them to CDs or DVDs. These are sometimes referred to as optical media. CDs and DVDs are inexpensive, easy to burn, and convenient to store. If they are handled correctly, optical media are sufficiently archival for photographic purposes. The primary disadvantage with using optical media for backing up your image library is that they are slow. Think about how long it takes for you to find a music CD. Further, you know that "Like a Rolling Stone" is on *Highway 61 Revisited*, but you might not know which CD your really cool cloud photos are on.

To use writable CDs and DVDs effectively, it helps to take a moment to learn how the writing process works. The laser in a CD writer burns information onto the dye layer

of the media creating a complex array of pits and lands. The pits and lands encode the information to the disk allowing the data to be read and interpreted by the computer. For a disk to be read by your computer, it is essential for the data to be burned correctly to the disk. Sounds obvious, doesn't it? Jerry Hartke of Media Science, an independent CD and DVD testing laboratory, confirms that this is one of the most critical stages in the disk creation process. "If a disk isn't burned correctly, it doesn't matter how it is handled and stored because it can't be read by the computer." Investing in a high-quality CD-burning software like Roxio Easy CD/DVD Creator (PC) or Roxio Toast (Macintosh) is a good first step toward preventing unreadable disks.

Tip *Where To Find More Info:* The FAQ section of the Media Science website, www.mscience .com, has a wealth of information related to disk permanence and storage. Also look at *Care and Handling Guide for the Preservation of CDs and DVDs*, published by the National Institute of Standards and Technology. This free report can be found at www.itl.nist.gov/ div895/carefordisc.

Once the disk is burned, it is important that it be kept free from fingerprints and stored vertically (like a book) in jewel cases. The paper sleeves commonly used for storing CDs can, over time, release chemicals from the paper processing that react with the materials in the disk. Keep the disks away from direct sunlight and avoid placing any adhesive labels on the face of the disk. Using single-burn CD-R disks, instead of CD-RW rewritable disks, is recommended, as the data storage layers of the rewritable disks are thinner and more prone to damage. The same precautionary measures hold true for DVD disks as well.

If you follow these simple guidelines, the CD and DVD copies of your photo archives should last for years to come. However, it can be difficult to keep CD and DVD archives up to date. Your image library is always changing; you're adding new images and adjusting old images. A burned disk is merely a snapshot of your image library at one point in time. This is one of the reasons that photographers have begun to gravitate toward additional internal and external hard drives to back up their image library.

Hard Drives

Sometimes referred to as magnetic media, hard drives are quickly becoming the backup media of choice for photographers. They are inexpensive, reliable, and quick. Plus, hard drives can be updated on a weekly or even daily basis to reflect the current contents of your image library. Hard drives are available as either internal drives or external drives.

What you choose depends on the computer you have, its capacity for storage, and your workflow needs.

Internal Drives

Internal hard drives, as the name would imply, are disk drives that are mounted internally within the chassis of the computer. Most desktop towers have two or more slots for internal drives, while laptops and iMacs have only one built-in drive. Internal drives are less expensive than external drives because they run off the computer's power source and take advantage of the computer's built-in cooling fans. Reading and writing to internal drives are faster than external drives because the data transfer via internal cables is faster than either FireWire or USB 2.0.

Photo courtesy of Seagate Technology LLC

When choosing an internal hard drive, it is important to take note of whether your computer uses parallel-ATA or serial-ATA (SATA) drives. The cable connections are different between the two types of drives. Parallel ATA is quickly falling by the wayside as SATA drives can transfer data more quickly and fit more storage into the same physical space. For these reasons, SATA drives are becoming standard on all new computers.

Tip *Maximum Storage Gotcha!* When purchasing an internal drive for an older computer, it is worth checking the computer's documentation to determine the maximum size drive that the computer can access. Many of the newest drives exceed the storage parameters that existed when the computer was built. If you purchase a drive that is larger than the computer is able to use, the drive may not be seen by the operating system.

External Drives

External hard drives are essentially an internal drive in a protective case. External drives need their own power source, protective case, and cooling system. Therefore, they are more expensive than internal drives. This additional cost leads some consumers to try and save money on a drive by purchasing the cheapest external drives on the market. This is a dangerous equation for photographers. The least expensive external drives on the market do not adequately protect the drives from heat and vibration, the two most common drive killers. I strongly recommend investing a little extra money for a top-of-the-line drive with a built-in heat dissipation system and features to absorb shock and dampen vibration.

The two common connection options for drives are FireWire and USB. Macintosh users will want a FireWire

Photo courtesy of Seagate Technology LLC

connection, while PC users should look for USB 2.0. Macintosh users should try to avoid using USB drives unless they have a newer machine with USB 2.0 support. Most Macintoshes run on USB 1.1, which is painfully slow to use for copying files. Macintosh users may want to consider FireWire 800 drives, which transfer data at twice the speed of traditional FireWire drives.

Backing Up Your Images

Now that you probably know more than you've ever wanted to know about hard drives and optical media, you might be wondering how you can apply this new knowledge to ensure a good night's rest.

To create an effective backup scheme, the first thing you need to do is look at how you organize your images. Are they organized by a particular shoot, by date, or by subject? Files organized by shoot are easier to back up to optical media because the contents of the shoot don't change as often. How much data do you have to back up? If you routinely have less than 700MB per shoot, then archiving a copy of your shoot to CD is a snap. If you shoot 6–8 gigabytes at a time and spend a lot of time in Photoshop adjusting your master images, then you will need to look at a hard drive. The ideal situation is to have backups of your photos on both optical and magnetic media. This improves the odds that your photos will survive a catastrophic computer failure.

One successful backup scheme incorporates both optical and magnetic media to give you a simple, redundant copy of all of your files. It requires a second internal hard drive, a FireWire or USB 2.0 external drive, and a CD or DVD burner. Keep only the operating system and your software applications on your primary hard drive. All of your images and documents are stored on your second internal drive. In case of a drive failure, operating system upgrade, or virus, you can reinstall your operating system and application files without losing any of your images.

Here's how the system works. After copying your images to your second internal hard drive, burn a copy of the files to a DVD or CDs. This serves as an archive copy of your images to be accessed only in case of a severe hard drive failure. Use the contact sheet feature in Photoshop, Photo Mechanic, or iView to print contact sheets containing thumbnails of the images stored on disk. Some photographers store these disks in a safe deposit box or at a friend's house to protect against a catastrophic loss like a house fire.

The second internal hard drive serves as your working hard drive and the external drive is a mirrored duplicate of your working drive. You can drag individual files from the internal drive to the external drive and overwrite previous versions of the files, but a more sophisticated approach would be to use a program like Retrospect Backup to update on the external drive only the files that have changed since the last backup.

Tips for a Happy Hard Drive

Your hard drive is a miraculous device capable of storing thousands of photos in an enclosure the size of a hardback book. It does this by carefully adjusting the polarity of magnetically sensitive disks called platters to encode your photos to disk. In order for you to continue to be able to read your images, you need to protect your hard drive from excess heat, abrupt shocks, and prolonged vibration, all elements that shorten the life of your drive. Joni Clark of Seagate Technologies provides the following guidelines for keeping your hard drive happy and healthy:

- Defragment your hard drive. Once a day is overkill, but not harmful. Do it somewhere between once a week for heavy users and once a month for an average shooter.
- Use the diagnostic software that came with your third-party drives.
- Keep your drive out of the heat and direct sunlight.
- When you purchase your drive, look for good shock protection for the drive itself and, if it is an external drive, the quality of the housing.
- Don't put drives in external cases they weren't designed for. These cases may or may not have the ability to dissipate the heat generated by regular use.
- Back up your drives regularly.
- Keep your drive away from excess noise or vibration when possible.

Retrospect Backup

The sole function of Retrospect Backup is to back up the files on your hard drive to protect against a computer crash, Internet virus, or corrupted hard drive. You have the option of scheduling daily or weekly backups to internal or external hard drives or CDs and DVDs. Unlike simply mirroring one drive to another, Retrospect can perform incremental backups to copy only the files that have changed since the last time Retrospect was run. This is nice because it can store multiple versions of a file, protecting you against accidentally deleting a photo or saving a flattened version instead of a layered copy.

Retrospect is simple to configure and very effective. Several of my clients are currently using Retrospect very successfully and they find that it gives them added peace of mind to know that their data is protected.

Given the ease and low cost of DVDs, internal and external hard drives, there really is no excuse for not backing up your files regularly. For a small investment in time and money you can store identical copies of your files on multiple hard drives and optical media. In the next section, we'll demonstrate how automation and backup fit into a digital photography workflow.

HOW TO: BUILDING a DIGITAL WORKFLOW

And now for perhaps the greatest challenge in digital photography… assimilating all that you've learned in the last chapters into an efficient workflow that uses automated tasks to prepare your images for the creative processes and artistic decisions you need to make. Ideally, a workflow should address all aspects of the image creation, editing, optimizing, archiving, and printing processes. You may choose to begin by concentrating on specific aspects of the workflow. I want to give you a couple of real-life examples of how photographers have structured their digital workflows. The first example is an amateur photographer who wants to keep his processes simple. The second is a more advanced fine art photographer who sells limited edition prints at art fairs and shows. She needs to have greater consistency in her workflow, and thus, there is greater complexity in the process from image capture to print. Let's have a look.

Simple Workflow

Bill is a lawyer during the week, but in his spare time, he loves to photograph wildflowers during the spring and summer months. He finds it to be a meditative escape from the high-pressure environment at work. Since he doesn't shoot a large number of images and his free time is precious, Bill prefers to keep his workflow as simple as possible. He makes occasional prints at the local lab and keeps a website of his work that he shares with his friends, family, and coworkers.

Image Creation

- Shooting from a tripod allows Bill to compose and carefully meter his images.

- Paying close attention to his histogram, Bill shoots JPEGs in the field for the ease of processing, always performs a custom white balance, and sets his camera to sRGB.

Editing and Adjusting

- Once he returns home, Bill creates a new folder on his hard drive labeled with today's date.

- He copies the images from his CompactFlash cards into a subfolder titled Raw Images within the newly created folder.

- Next, Bill opens the folder of unedited images into the Bridge and deletes any out of focus or poorly exposed images.

- He renames all of the images from the shoot with a new filename based on the shoot date and a unique number. Out of a shoot of 50–60 images he usually selects three or four of his favorites and optimizes them individually in Photoshop.

- He saves the layered PSD files in a separate folder labeled Selects.

Archiving and Asset Management

- Bill burns a CD or DVD (depending on the size of the shoot) of the raw images and the selects, and labels the disk with the date created.

- Using the Contact Sheet feature in the Bridge, he creates jewel case–sized contact sheets with thumbnails to help identify the contents of the disk.

- Using iView Media Pro, Bill imports the "select" images from the shoot into his Favorites catalog.

Output

- Using iView Media Pro, Bill selects a group of images and batch processes them into an HTML gallery to be posted on his personal web page.

- Bill selects images manually from iView that he wants to sharpen and burn to CD for printing on the Fuji Frontier at his digital lab.

Bill's workflow suits the type of shooting he does and the output devices he commonly uses. Since he likes to shoot flowers that aren't likely to get up and move

to another location, he can take his time to meter and white balance his camera, which allows him to shoot JPEGs. He uses sRGB in his camera and in Photoshop because it is the color space that best matches his intended output devices, the Fuji Frontier, and the Internet. His backup scheme is simple, but effective. He burns his CD after editing, but before erasing his CompactFlash cards, ensuring that he always has his files on at least two different types of media. Using iView as his image database gives him the freedom to visually select the images he wants to print and the flexibility to add keywords and captions for the species of flower and the location of the images if he so desires. Bill's workflow is simple enough to be unobtrusive, but flexible enough to be easily adapted to larger numbers of images or different subjects.

Advanced Workflow

Angela's photography reflects her energy and enthusiasm. She could be described as a "stream of consciousness" photographer. She points her camera at anything and everything that catches her eye. This approach has served her well. She won several awards at a regional photo conference last year, and she has a successful business selling fine art prints at art shows and festivals. Because of her "shoot first and edit later" mentality, she needs an industrial-strength editing program to help separate the wheat from the chaff.

Image Creation

- Shooting in raw mode gives Angela the flexibility to refine tone, color, and white balance in Photoshop.

Editing and Adjusting

- Angela uses Photo Mechanic to ingest files from her CompactFlash cards for initial editing.

- During the ingest process, Angela uses the IPTC Scratchpad feature to add the location where the images were taken along with a brief description of the shoot.

- During this initial edit, she deletes out-of-focus images and compositions that fail to elicit any emotion. She frequently checks the sharpness of the images using the zoom feature in the editing window to preview and compare images at 100 percent view.

- For the second edit, she goes through the images again and sorts the shoot into two categories using the Color Classes feature in Photo Mechanic. Typically 10 percent of the shoot is labeled Best and moved into the corresponding folder, while the remaining images are moved into a Snippets folder on her secondary hard drive for use in collages and montages.

- The Snippets folder is synched with an Extensis Portfolio catalog of the same name. For her collages, she often sifts through the Snippets catalog to grab a single element from the photo, like a cloud, a background, or an expression. She blends these snippets to create abstract, painterly works that sell quite well.

- The best images are opened into Adobe Camera Raw for individual white balance, exposure, contrast, and saturation corrections. After being corrected, the images are exported as 16-bit files in the Adobe 1998 color space.

- In Photoshop, Angela burns and dodges the image to focus the viewer's attention and strengthen her photographic message. Once she's satisfied with the results, she saves the layered images to her Masters folder on her hard drive.

Archiving and Asset Management

- The Masters folder is synchronized with a second Extensis Portfolio catalog. In Portfolio, Angela adds keywords describing the image content along with the image's status as either a master file or a print file, which have been optimized for a particular paper and are part of a limited-edition print run.

- Angela needs to be able to access her images at all times, so she uses a large internal drive to store her images and has configured Retrospect Backup to perform an incremental backup of all new and changed files to an external hard drive. Once a month she uses Retrospect to perform an additional backup to a drive that she stores in a safe deposit box. This ensures that she can never lose more than a month's work even if her computer is stolen.

Output

- Angela saves a set of print files that have been thoroughly adjusted, sharpened, and targeted for a particular fine art paper.

- Since Angela wants all of the prints from a particular photo to be identical, she uses the ColorBurst X-Photo RIP to drive her Epson 4000.

- For all of her fine art papers, she builds custom profiles using the X-Rite Pulse spectrophotometer, then uses the custom profile in the X-Photo RIP to very precisely control the color and black and white output of her printer.

Angela places greater demands on her images than Bill, so she needs to have the flexibility of correcting tone and color that shooting raw affords her. Since her livelihood depends on her fine art print sales, she has higher expectations from her finished prints than Bill and for that reason has invested in a RIP to drive her printer and the color management software and hardware that allows her greater control over the printing process.

As evidenced by these two case studies, your workflow should address the type of shooting you prefer, your level of skill, your preferred methods of printing or outputting images, and, most importantly, your expectations. When you build your workflow, start simple and only add elements when they make your life easier. As Antoine de Saint-Exupéry wrote: "You know you've achieved perfection in design, not when you have nothing more to add, but when you have nothing more to take away."

Index

digitaldays

DIGITAL DAYS PHOTOGRAPHY WORKSHOPS

Since the very dawn of digital, Sony has been engineering not only great digital cameras, but the vital ingredients from which most digital cameras are made. So who better to eliminate the confusion of digital photography? This is why Sony proudly presents the Digital Days Workshops.

JAY KINGHORN, INSTRUCTOR

Cyber-shot® DSC-M1

Cyber-shot® DSC-H1

Cyber-shot® DSC-R1

Cyber-shot® DSC-V3

An Adobe Photoshop Certified Expert and co-author of *Perfect Digital Photography,* Jay Kinghorn draws upon his background as an assignment and fine-art photographer to develop training programs that fulfill the essential needs of photographers. His approachable, comfortable, and efficient training style makes Jay one of the most sought after digital imaging specialists. In 2003, Jay created a landmark digital imaging survey with ASMP Colorado to assess the adoption of digital photography among professional photographers. An accomplished lecturer as well, Jay has developed custom seminars for the Art Institute of Colorado, Photo Craft Labs, and ASMP Colorado.

Whether you're a novice or a pro, or maybe you don't even own a digital camera, there's plenty to learn from Popular Photography magazine's trained experts who provide in-depth, hands-on demonstrations featuring the latest in digital imaging technology and software.

From advanced tips and tricks to figuring out which camera is right for you, Digital Days is the perfect way to explore all of your picture-taking possibilities. It's an experience unlike any other. And it's only from Sony.

TO LEARN MORE ABOUT DIGITAL IMAGING, PLEASE VISIT
WWW.DIGITALDAYSPHOTO.COM OR CALL 1-888-243-6464

Valid until December 31, 2006. Mention Code PPAP1633 for a **20% DISCOUNT** on any Digital Days Workshop.

 SONY
 Adobe
 Windows xp
 Photography POPULAR & IMAGING
 AMERICAN PHOTO

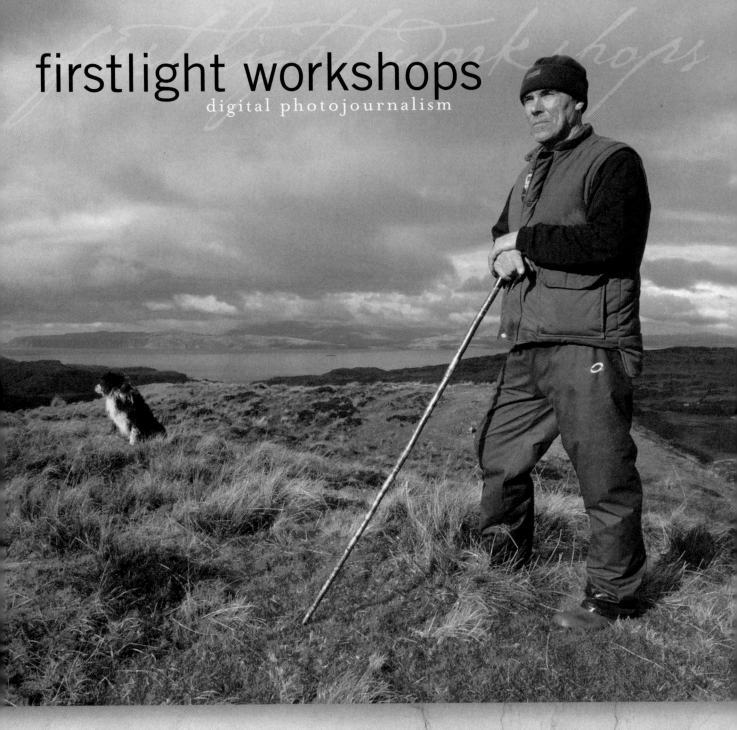

firstlight workshops
digital photojournalism